AFTERLIFE AS AFTERIMAGE

MUSIC
(MEANINGS)

General Editors
Steve Jones
Joli Jensen
Anahid Kassabian
Will Straw

Vol. 2

PETER LANG
New York • Washington, D.C./Baltimore • Bern
Frankfurt am Main • Berlin • Brussels • Vienna • Oxford

AFTERLIFE AS AFTERIMAGE

Understanding Posthumous Fame

EDITED BY

Steve Jones and Joli Jensen

PETER LANG
New York • Washington, D.C./Baltimore • Bern
Frankfurt am Main • Berlin • Brussels • Vienna • Oxford

Library of Congress Cataloging-in-Publication Data

Afterlife as afterimage: understanding posthumous fame /
edited by Steve Jones; Joli Jensen.
p. cm. — (Music/meanings; v. 2)
Includes bibliographical references and index.
1. Popular music—Social aspects. 2. Fame—Social aspects.
3. Celebrities—Death. I. Jones, Steve. II. Jensen, Joli. III. Series.
ML3470.A36 781.64'092'2—dc22 2004027913
ISBN 0-8204-6365-5
ISSN 1531-6726

Bibliographic information published by Die Deutsche Bibliothek.
Die Deutsche Bibliothek lists this publication in the "Deutsche
Nationalbibliografie"; detailed bibliographic data is available
on the Internet at http://dnb.ddb.de/.

Cover Design by Erin Baker and Angelene Ripley,
Third Floor Design, University of Tulsa, School of Art

The paper in this book meets the guidelines for permanence and durability
of the Committee on Production Guidelines for Book Longevity
of the Council of Library Resources.

Dedicated to those we love,
who have left us memories.

What do you think about the way it feels when I say, "It doesn't matter to the world, but I'm with you anyway?" Whatever happens to the wishes made on a dying star?

"ELECTROCULTURE," AREA (*BETWEEN PURPLE & PINK*, 1989)

Contents

Part 1. Fans and the Production of Posthumous Fame

Part 2. Mediating Meanings:
Case Studies in Posthumous Celebrity

Part 3. Technology, Process, and Immortality

Acknowledgments

We are indebted to many people, not least of whom are the contributors to this volume. Beyond adding their words and insights in these pages, they also added them between the lines, via email, phone, and in person. In one way or another all of them contributed more than is seen in text, and we are very grateful for their criticisms and comments throughout the making of this book. We are grateful, too, for the enthusiasm of the panelists and participants who joined us during the International Communication Association conference in May, 1997, where we first began discussing some of the work presented in this book. Julie Andsager, David Eason, M. Mark Miller, and James W. Carey were particularly encouraging and urged us on. Steven H. Chaffee was the respondent to the papers we gave at our conference session, and his response, both in its depth of intellectual insight and depth of emotion, remain with us. Though he passed away before this book's publication and did not contribute to its text, his spirit infuses it.

We would also like to gratefully acknowledge the co-editors of the Music/Meanings series, Anahid Kassabian and Will Straw, for their encouragement. The help and understanding of those with whom we worked at Peter Lang Publishing, particularly Chris Myers, Damon Zucca, Lisa Dillon, and Patty Mulrane is much appreciated. Camille Johnson provided superb copyediting skills, and any errors or omissions are entirely our responsibility. Mamie Gray took care of all the small details that, were it not for her, would have quickly become mountains.

Mick Black, Jack Drag, Mick Rock, and all the Ben Frank types provided regular musical relief and sustenance.

We are also most thankful for the support of our families, Jodi, Eleanor, and Martha White Jones and Craig, Charlie, and Tom Walter, as we are grateful for sharing in their memories of music and meaning.

Steve Jones
Joli Jensen
January, 2004

Portions of "Posthumous Patsy Clines: Constructions of Identity in Hillbilly Heaven" by Joli Jensen also appear in "Patsy Cline's Crossovers" in A *Boy Named Sue* (2004), edited by Kris McCusker and Diane Pecknold, forthcoming from the University of Mississippi Press.

In Memoriam

A late-night conversation at the 1996 International Communication Association conference was one of the seeds of this volume. Somehow, Steve Chaffee, Steve Jones, M. Mark Miller, and I embarked on a discussion of celebrity; Steve Chaffee argued that if Marilyn Monroe were alive, she would still be a big star. I disagreed, citing the glamorization of beautiful celebrities who tragically die at their peak. Chaffee was adamant, however—and I realized that I was arguing empiricism with *Steve Chaffee*.

That was the beginning of a cherished friendship, though we had known each other for several years. When Frank Sinatra died in 1998, Steve wrote to say that he was surprised that the death had impacted him emotionally because he wouldn't call himself a Sinatra fan. In fact, Steve said he "never cared much about his bobby soxer fans or his dance movies with Gene Kelly or even his dramatic movies or his later 'My Way' songs when his voice had gone below control" (Chaffee, personal communication, May 28, 1998). And he added a few choice descriptions of Sinatra's offstage character for good measure.

But Sinatra reminded Steve of his twenties, when he listened to the Capitol albums over and over: "I think it isn't the dead celebrities that bring all this back exactly, it's in each of us like so much trivia, and we store the emotions somewhere so that a death like this can evoke them once again," he wrote.

At the 2000 ICA conference in Acapulco, Steve was positing a new dead celebrity thesis on the glorification of popular celebrities who die at their peak of fame. All one had to do to guarantee fans' adoration was to do one good thing, then die at the right time, and myth would erase any negative reality to focus on that one good thing.

There was never a "right time" for Steve Chaffee to die; but he left us suddenly on May 15, 2001. My hope is that he is having a glass of wine with Marilyn Monroe and explaining to her his ideas on death, fame, and fandom.

Julie Andsager, May 22, 2003

On Fandom, Celebrity, and Mediation

Posthumous Possibilities

JOLI JENSEN

Analyzing posthumous fame in popular music illuminates how and why audiences are fans, how and why the celebrity process works, and how and why the mediation of music matters. The essays in this collection deepen and reorient what we understand about fandom, celebrity, and the mass media.

Celebrities and fans (like popular culture itself) are often stigmatized. When social critics want to demonstrate how inadequate modern culture is, they often illustrate their critique with what they see as the problem of celebrity. That people long to connect with, and even to become stars; that publicity sustains fame; and that performers inspire love—and grief—from people who "know" them only through the mass media, is seen as evidence of (at best) cultural shallowness, and (at worst) cultural pathology. The studies in this volume help us see that this "pathological perspective" on celebrity—still widespread in intellectual, journalistic, and even popular understanding—requires rethinking.

Interestingly, aspects of the celebrity process are even denigrated by participants in it. The starmaking machinery is spoken of with contempt by the same celebrities, publicists, producers, and fans who create and sustain it. So the world of fandom is ridiculed not just by journalists and social critics, but also by fans—of other figures. Entertainment forms that make money and engage people can be repudiated as "too commercial." The celebrities who seem to create popular art are dismissed as puppets in the publicity process, while fans who respond especially passionately to celebrities or genres are dismissed as duped losers.

Are celebrities and fans in popular music merely pawns in a larger media game that exploits their worst instincts? Is the fame game being played at our expense? The macabre truism that death can be a good career move, as Steve Jones writes in his essay, captures the cynicism that many have for a process that, if we examine it with respect rather than denigration, reveals much about how and why we make meaning in the modern world. These chapters support Jones's argument that, when fans mourn dead celebrities, they are symbolically negotiating authenticity, ownership, memory, and identity, all within the institutional processes of mass mediation.

The following chapters offer a portrait of fandom that respects the richness, diversity, complexity, and importance of fan experiences. Julie Andsager considers how fans' grief (as they mourn the loss of "their" celebrity) is socially disenfranchised. To publicly mourn the death of someone famous, who you know only through mediated connections, is to risk shame and ridicule, unless you are in the company of others who understand your loyalty and your loss. In Andsager's analysis, fans are able, via tribute pages on the Web, to express their fandom in a way that acknowledges the validity of their experience.

Webshrines offer temporary communities of mourning, where conflicting feelings of betrayal, loss, and identification can be worked out, in ways that magnify and honor the connection between fan and celebrity. In Andsager's words, "webshrines provide tangible evidence of how memory frees individual fans to reimage celebrity . . . we as fans become the managers, agents and publicists for the dead." Far from being duped, or pawns, the fans who visit and contribute to tribute pages are using new media technologies to sort out, and make sense of, their star's life, death, and legacy.

This process of actively maintaining posthumous celebrity is best known (and most often ridiculed) in the case of Elvis. Elvis fans serve as the quintessential example of posthumous mourning, and the annual rite of Elvis Week, in Memphis, sparks an annual rite of bemused coverage in the mass media—"What on earth are these pathetic fans up to?" the annual reportage asks. How and why does Elvis inspire so much loyalty, so long after his death?

The Elvis fans that Van Cagle talks with are understandably angered by journalistic accounts of their passion—they continually find themselves portrayed as hapless fanatics, obsessive freaks, pathetic fools. But in Cagle's account, British Elvis fans—via particular rites, rituals, dress, and demeanor—are embracing the methods they see Presley having used to maneuver class relations. They "utilize certain class-culture myths about Elvis in ways that allow them to connect him to their group-based identity regarding what it means to be young, British, working class, and Elvis fans."

As Cagle details, the Elvis celebrated by British working class Elvis fans is different from the Elvis celebrated by U.S. fans—there is no "final product" in the contradictory cultural category of Elvis fandom. Different kinds of fans deploy various images of Elvis, they "pick and choose images of the mythical Elvis that best fit their sense of dislocation within a system that often seeks to deny, ignore and discredit aspects of their identities." In this account, Elvis fandom—including the annual communal mourning of his death—is about constructing and transforming both identity and connection, especially in relation to social class.

The fact that there are many different Elvis images is part of why Elvis is consistently deified, as Erika Doss points out. Elvis is "layered in contradiction," his role as a popular culture icon is less about his music, and more about "what these diverse and conflicted images mean to the people who look at them, make them, and collect them: his fans." What Doss describes is how, for many fans, Elvis is increasingly perceived in explicitly religious terms.

This returns us to the ways in which fans are frequently denigrated—as deluded cult members who worship commercially constructed icons. In the perspective that dominates social and cultural criticism, fans' fervor is evidence of their fanaticism—deifying Elvis is proof of their delusion. But Doss points out that "Americans . . . generally make a religion out of much of what is touched and understood." Her account demonstrates that the fans "privatizing veneration of Elvis is one strong historical form of American religiosity."

Following Doss, we can acknowledge the sacralizing elements that fandom shares with other forms of cultural expression. We can see celebrity mourning as one of a number of ways that people address and enact mystery and transcendence. The image of Elvis is iconic—used by fans to construct "a series of cultural and social practices that foster a sense of belonging . . . and which also allow room for individual beliefs." As communally constructed practice, fandom becomes a vernacular effort toward transcendence; as Doss concludes, "Faith in Elvis corresponds to American needs for spiritual community and spiritual solitude, which makes Elvis a profoundly democratic American icon."

In these accounts, the afterlife of pop music celebrities is constructed by fans who deploy mass mediated images in ways that make sense of the celebrity's power, talents, life-path, and death. Tribute pages are created, rooms decorated, vigils held, pilgrimages made, fandom enacted in ways that allow emotional expression, social and cultural alliances, symbolic resistance, and spiritual engagement. The fans that Andsager, Cagle, and Doss describe are far from the pathetic, fanatic, or delusional figures that critics imagine and journalists describe. Instead, these fans select and deploy celebrity images, using them to address and negotiate individual as well as communal, social, cultural, and political meanings.

The multiple meanings that can be negotiated via posthumous fandom are also clearly evident in the case studies that make up the central portion of this collection. In studies of the posthumous careers of Selena, Karen Carpenter, Patsy Cline, Tupac Shakur, John Lennon, Louis Prima, and Robert Johnson, we find evidence not only of how reputation operates in popular music, but also of how celebrity operates as a cultural process, grounded in economic, social, and political circumstances. In these case studies, aspects of race, of class, of gender, and of ethnicity are being negotiated, as are the roles of fans and critics in constructing and constraining celebrity image.

Posthumous reputation is clearly a contested process, one that is continually being negotiated with and against mass mediation. Janne Mäkelä's description of the debate over the "real" John Lennon resonates with concerns over the "real" Selena, Karen, Patsy, Tupac, Prima, and Robert Johnson. Eric Rothenbuhler's focus on the search for Robert Johnson describes what fans (and journalists, critics, and scholars) ask whenever they tell stories about popular music figures—who were they, really? What is their legacy? What can their life and their music tell us, after their death?

In each case, fans, critics, and journalists generate a variety of conflicting stories of legacy. The struggle to "own" a celebrity, especially after death, foregrounds the problematic differences between personal and familial claims, fan desires, and critical commentary on who can constitute the star's legacy. As Peggy J. Bowers and Stephanie Houston Grey describe, "memory becomes a battleground where differing groups may carry ideological agendas to particular readings." In the case of Karen Carpenter, there are important contradictions between the family's portrayal of a virginal secular saint, the fans' perception of a victim of anorexia, and the critical repositioning of Karen as critical allegory about femininity and passivity.

A startling posthumous contradiction is found in George Kamberelis and Greg Demitriadis's study of the denial of Tupac's death. In this case, the "real" Tupac, for his adolescent fans, simply couldn't have been killed. Kamberelis and Demitriadis show how "participants' stories were produced within a cultural logic of remembering and commemorating that is rooted in and sustained by stories told both within and across generations." The mythical Shine or Stackolee figures that fans implicitly drew on to reinterpret Tupac's murder "both embody and stand for the liberatory and transformative possibilities of a marginalized people in a violently radicalized society." Stunned by Tupac's apparent death, fans drew on a cultural narrative of invincibility to convince themselves that he was still alive—evidence of the "affective investment" that fans had in Tupac's invincibility. For his adolescent fans, the "real" Tupac not only could not scream in pain when shot, he simply could not die.

The desire of fans, journalists, and critics to locate the "real" person inside the celebrity image can be seen as a desire to "see through" the starmaking machinery, but also as a desire to lay claim to their own version of the meaning of a particular figure's life. In this way, family, fans, journalists, critics, and scholars are all in the same business of defining a legacy, even if they usually work at cross-purposes. Families seek to fix a particular public image, while fans seek to define the celebrity in ways (as with Tupac) that honor what they see in them, while journalists both comment on this interpretive process and seek to get underneath and behind it, while critics seek to deepen and complexify, or supercede, these different portrayals, while scholars seek to analyze and explain them. But notice how, in each case, we are laying claim to our own interpretation of what the celebrity's life and death can and should tell us.

This is especially clear in Eric Rothenbuhler's analysis of Robert Johnson's posthumous reputation. Johnson's legacy is almost completely posthumous, and so reveals what happens when only critics and scholars construct a legacy. The grief and mourning of family, friends, and fans, as well as journalistic coverage of the celebrity's life and death, are absent in this case. All that we have of Robert Johnson is the afterlife of critical and scholarly analysis. Rothenbuhler details a spectacular mythology that allows "Robert Johnson" to figure in accounts of lineage in popular music, the nature of artistic genius, the dignity of African-Americans under exploitation, the nature of authenticity, and the definition of greatness. "Robert Johnson" comes to represent primitiveness, originality, purity, the simplicity and truth that has allegedly been lost, in music and in American life. Robert Johnson, whoever he may have been in his brief life, became after death and discovery by critics and scholars, "a hook to hang the stories on."

So what stories do we tell, once we have a celebrity onto whom to hook them? In Johnson's case, as in many others, they are stories about what we want and need the celebrities to be. But who is the "we" who tells stories, and what can we learn about how particular celebrities get reshaped in the retellings? As Mary Beltran demonstrates, the Selena who "crossed over" into mainstream popularity after her death was the more palatable Jennifer Lopez–defined version. As Joli Jensen argues (my essay), the Patsy Cline who became famous years after her death was just country enough to be authentic, but not country enough to be white trash. As John Pauly demonstrates, the posthumously rediscovered Louis Prima is a homogenized and deracinated version of a performer who, in his time, was denigrated as being "too Italian."

"Our" posthumous celebrity stories wash out the differences in the "we" that is collectively remembering. As Pauly recognizes, this tames the wildness of our cultural differences. These case studies suggest that we tell stories that both explore and contain issues of race, class, gender, and ethnicity. When various groups strug-

gle to fix the "meaning" of a celebrity, troubling social and cultural issues are simultaneously raised and reshaped, set loose but then quickly corralled. Pauly's account suggests that one of the many reasons we tell ourselves stories is to recognize and domesticate that which troubles us.

Mäkelä notes that the typical posthumous career of cultural heroes begins with elegies, praise, and idealization in an atmosphere of shared grief, then proceeds to criticism, reevaluation, even iconoclastic interpretations, then ends up in some kind of resolution of the two positions. We can understand this trajectory to be the result of a collaborative struggle over the meaning of celebrity legacy, conducted by families and fans, as well as journalists, critics, and scholars. Commentators are forced to take the fan's grief seriously, eventually. Fans must find ways to accommodate the more critical and evaluative accounts of their stars' image offered by journalists and critics. Scholars must make sense of fan, journalist, and critical versions of a celebrity. These groups may use different strategies, and they usually generate different versions of the star image, but it is important to recognize (as we can through this collection) that fans, journalists, critics, and scholars share the same goal. In each effort, our goal is to locate—and claim—the "real" legacy of the dead celebrity.

So how are we to understand the exceptions to the typical posthumous celebrity path? Prima, Cline, and Johnson are three "rediscovered" figures whose posthumous careers did not follow the usual path of grief, idealization, criticism, and resolution. Instead, their rediscovery suggests that we also use celebrities, especially safely dead celebrities, as a cultural resource. Thanks to the potentialities of recording that Jonathan Sterne analyzes, we have access to an unprecedented amount of creative effort from dead people. Drawing on these three examples, it seems that the figures that are posthumously "rediscovered" are mobilized to help validate notions of musical authenticity lost and found. In the case of Prima, it is a story of jubilant energy with a dash of ethnicity, in the case of Cline it is a story of valor with a dash of class issues, and with Johnson it is the story of authentic greatness with a dash of racial references. We selectively bring back the musical dead on our own terms, to help us out with our own, contemporary issues of what music means.

What happens when we remember our famous musical dead? There are clearly constraints on the process—commercial as well as symbolic constraints. Posthumous celebrity is an interaction between these constraints that also enacts possibilities. During the payola scandals, Dick Clark famously said that no amount of airplay could "turn a stiff into a hit." What he disingenuously ignored is that, nonetheless, airplay is required for all hits to become hits. Commercial processes are what make posthumous celebrity possible, what give fans, journalists, critics, and scholars the materials we use to tell ourselves stories. These essays prove that

only some stories can get told, or stick around. For the fans that Kamberelis and Demitriadis studied, Biggie Smalls had to be the villain, because Tupac was the hero. In this and in many other cases, the starmaking machinery can only work with the hooks that offer the stories that the fans need or want them to tell.

One of the stories we never seem to tire of is the story that Marko Aho references—from amateur to legend. Each celebrity tells us of the interaction of talent (from amateur to artist) and of fame (from obscurity to renown). That story gets told in the music, and in the ancillary cultural products—of both projection and reflection—that Aho charts. Death, as many of our contributors note, both constrains and enables the ability of the celebrity to "speak."

And apparently we have lots of stories we want told—in these accounts celebrities offer ways to tell stories about what it means to be an artist, about the personal costs of fame, about what it means to "crossover" in musical, class, ethnic, and racial terms. Dead celebrities can tell us stories as embodied as anorexia, and as abstract as commercialization, urbanization, and industrialization. But there are still limits to the range of stories any single celebrity can tell—the "hook" can only hold so many congruent stories.

This is one of the key constraints of afterlife as afterimage—the narrative of a single celebrity ends up being particular to him or herself, and ever more coherent. It is in the nature of story telling to seek that overworked concept "closure," and in the afterimage of dead musical celebrities, we see how fans seek to keep the image "alive" by adding to the story. But without contradiction, or maturation by a living figure, the posthumous celebrity is constrained by the ever-simplifying story hook he or she has become.

The processes of posthumous celebrity analyzed in this collection belie the charge that fame is a construction by and for the media. After death, only some figures achieve and sustain fame, and only some figures spark negotiation of their posthumous legacy. The mediation process can try to promote some over others, but, as always, it cannot predict or control the celebrity process—the media can only attempt to locate and profit from it.

The media will tell us the stories we want to be told, and in contemporary life we have an extraordinary fund of stories on which to draw. Celebrities are figures we deploy for caution, as well as for inspiration. In posthumous celebrity, part of the story is about tragic outcome, no matter how inspiring the quest or cautionary the tale. In this collection—and in the posthumous celebrity process—we find that the dead can speak, but only about what we want or need them to tell us.

Interestingly, we also ask celebrities to "speak" about the connection and contrast between the private and the public. This becomes an issue of performance, and it may well be that celebrities—dead or alive—are fascinating partly because they graphically demonstrate the modern requirement to perform a self. The bio-

graphical facts, the insider knowledge, the unguarded moments, the special insight—all of these matter to those who seek to know the "real" person behind the "mask" of fame. The fan wants to believe that he or she has gotten past the publicity machine, to the genuine person inside. We enact this same quest in modern friendships, and in modern therapy. Fandom is a metaphor for most relationships in contemporary life—getting past the surface, to the "real" that is supposedly inside.

For the posthumous celebrity, the "real" person can no longer shape his or her story, but this doesn't stop the process of story evolution and transformation. These essays, in combination, tell us that the mediated celebrity process offers us continuing narratives of richness and contradiction. Posthumous celebrity offers us multiple stories of how to live meaningfully, what it means to die, what it takes to matter in the world. Seeking to understand this process helps us see, as Sterne notes, how remarkable this unremarkable process really is.

The mass media are remarkable. Because of them, we live in a world of dead people who continue to speak—we are surrounded by, and have extraordinary access to, the creative expression of varieties of peoples past and present, into the future. We both take for granted, and make into a metaphor, the celebrity processes that Aho describes—the levels and categories of creativity and renown, the products that promote and sustain them. We are conversant with backstage and front stage in our own lives, and in the lives of the celebrities we hang our stories onto.

This is not, as some social critics would have it, a postmodern hell, or a compensatory modern process. We are not miserably alienated in a sea of simulacra, or desperately seeking genuine relationships with chimera. Fans are not pathetic losers, and living in a celebrity culture is not a fall from grace. Instead, these essays show that posthumous celebrity involves a democratized participation in reading the present and the past, in finding commonality, in exploring anonymity and fame, in connecting across time and space, race, class, and ethnicity, and—all along—recognizing the constructedness of the interpretive process.

Most critics of the media, and of modern society, make much of the loss of face-to-face communication in modern life. Mourning dead celebrities seems the ultimate evidence of how pathological modernity is—grieving for someone you've never met, with whom you've had no personal contact, a projection, an illusion. These chapters, instead, detail an interpretive process that enriches, deepens and makes life more meaningful for all concerned.

Popular culture gives access to people and to stories about people. The cultural conversation that popular culture enacts—and that fans, journalists, critics, and scholars sustain—is a more creative and complex cultural conversation than ever before. The days of face-to-face communication could not offer anything like the depth, varieties, and contradictions of today's narrative mix. The mass

media offer democratized access to creative expression, they give us various stories of possible modes of being, including possible stories of what it means to live, and then to die. Posthumous celebrity is a testament to, as well as illustration of, the extraordinary, remarkable power of the mediation of meanings.

Fans and the Production of Posthumous Fame

chapter 1

Better Off Dead

Or, Making It the Hard Way

Steve Jones

When someone dies on the screen, elegiac music immediately comes on, but when someone dies whom we knew in real life, we don't hear any music.
—Milan Kundera, *Immortality* (1991, p. 327)

A truism in the music business is that death is a "good career move." Sales figures bear this out: Rarely does any performer with the slightest bit of popularity fail to increase sales immediately after death, and often those who only have the slightest bit of popularity are the ones whose sales benefit most. Notorious B.I.G.'s posthumous album *Life After Death* dueled Tupac's posthumous album *Don Killuminati: The Seven Day Theory* in 1997 for record-setting sales.[1] Writing just after John Lennon's murder, David Fricke and John Orme noted that "One near certainty is that Lennon's death will reactivate sales of his 'Starting Over' single—the title now has a tragic irony—and the 'Double Fantasy' album, probably giving Lennon his first Number One for more than half a decade" (1980, p. 25).

Indeed, that "death is a good career move" is enough of a truism that it has inspired some conspiracy theorists to speculate that Kurt Cobain's death was engineered by his record label, who had learned that Cobain wanted to quit the music business. The record label, this line of thinking goes, was loathe to give up Cobain's sales potential (as demonstrated by Nirvana's multimillion sellers), knew that it could guarantee continued record sales (perhaps greater than those from new

recordings) if Cobain met a tragic end, and thus hired a hit man (an ironic reflection on pop's notion of a "hit," to say the least) to set up his death.

That theory, right or wrong, points out that several ingredients must be present for the "death = sales" formula to work. Tragedy is one of them. Conspiracy, or at least uncertainty, is another. Potential, or "promise," is still another. Of course youth helps, particularly in regard to the first and third ingredients.

In rock 'n' roll, death is almost a constant. Books like Jeff Pike's *The Death of Rock 'n' Roll: Untimely Demises, Morbid Preoccupations, and Premature Forecasts of Doom in Pop Music* (1993) and Gary Katz's *Death by Rock 'n' Roll: The Untimely Deaths of the Legends of Rock* (1995) list the numerous pop and rock stars who have died, their cause of death, and discuss the constant themes of death in pop and rock. As Jordan Mills puts it:

> Rock musicians have traditionally stereotyped themselves as hedonistic individuals on the fast track to an early demise. This creates a dilemma for the Rock fan. On one hand, their favorite Rock stars are most engaging when they flirt with death. On the other hand, devoted fans are often bewildered and despondent when their favorite star dies prematurely. Rock stars are expected to be both self destructive and indestructible. (1996, p. 1)

Mills does not tease out the ways in which destruction and indestructibility are part of the mythmaking process surrounding rock music, nor does he examine the complicity of the fan in rock's industrial routines that demands the myths he identifies.

Indeed, mythmaking is itself now a part of industrial processes, and it is not enough to simply understand the mediation (and manipulation) of death and image for the purposes of "moving product" in an industrial sense. Why does death sell? What role does the mediation and sense-making of a performer's fans play? How are the ways in which fans are emotionally moved connected to the way the music industry plans on "moving" product? What of others who play a more general role in the sense-making process (journalists, publicists, media, etc.)?

As I noted in an article about journalists' response to Cobain's death:

> "The death of anyone "in their prime" and in the public eye, whether by suicide, murder, or natural causes, causes these and other questions to surface: Why this person? Why now? What, if anything does their death *mean*? Such questions are, of course, ones that journalists ask quite commonly, whether in relation to a death or any variety of other events. (1995, p. 103)

The article goes on to note that three themes—authenticity, racism/urban culture, and mass culture—are the ones most commonly employed and deployed as part of the sense-making that takes place after the death of a popular musician.

Here, I wish to address a broader issue related to those themes: What are the connections between celebrity, authenticity, possession, memory, nostalgia, iden-

tity and industrial process? This is a complicated matter, likely too complicated for a single book chapter, and thus the focus will be on highlighting the importance of these themes, making connections between them where possible, and not on defining the important role each one plays in larger cultural debates.

Possession

. . . ridiculous immortality lies in ambush for everyone . . . even though it is possible to design, manipulate, and orchestrate one's immortality in advance, it never comes to pass the way it has been intended.

—MILAN KUNDERA, IMMORTALITY (P. 80)

Safe in your place deep in the earth
That's when they'll know what you were really worth
Forgotten while you're here
Remembered for a while
A much updated ruin
From a much outdated style.

—NICK DRAKE, "FRUIT TREE" (1969)

Who does the work of making sense of the dead? Obviously family and friends of the deceased do. But when it comes to celebrity deaths, many others do as well. Certainly journalists are implicated in the process of sense-making and mythmaking. Biographers are often involved, too. But fans are part of that process as well. As Richard Schickel points out, in the case of celebrities "after death, we are finally allowed to take full possession of (their) lives" (1985, p. 129).

It is important to examine this notion of "possession." While it is certainly the case that audience and performer are both involved in the symbolic construction of celebrity, it is not the case that such symbolic activity *requires* both audience and performer to be present physically or synchronously. To a great extent, the performer's presence, once mediated, provides sufficient material with which ongoing construction of celebrity can proceed. Consequently, in the realm of the symbolic construction of celebrity, the performer's "real" presence is only necessary insofar as the performer may provide additional grist (mediated or otherwise) to add to the potential pool of symbolic material already in the mill. New material may also come postmortem from artifactual sources: archives, correspondence, and so on.

But who "owns" these symbolic constructions? They circulate through a variety of communication media, sometimes mass-mediated and other times not. They

are the stories we tell each other about who we think "they" are, who we think "we" are, and who "we" would like to become. In short, our symbolic constructions of celebrities (dead or alive) are part of our collective memory. Dead celebrities, however, provide opportunities for rather more transcendent stories. Instead of existing in a realm straddling memory and reality (mediated or not), the dead celebrity "belongs," if anywhere, entirely in the realm of memory.

Now, clearly, in many ways, and thanks to the many modes of mediation, a celebrity is part of a kind of externalized memory. It may be true of celebrity generally that memory is a prerequisite for celebrity, for, as Leo Braudy puts it, "the real definition of fame is memory" (1986, p. 440). Death is not a prerequisite for remembrance. But death makes anything but remembrance, memory, impossible. No matter how well we may record a celebrity's words and actions, no matter how clear they may be in our own mind, those recorded memories will be all we shall have. Like some form of mass-mediated embalming fluid, memory, whether internal or externalized, keeps before us a figure, an image. In this case it is an image of someone who, if not once with us in person, we have felt has been with us. Another way to restate this, and to move the discussion forward to address other themes mentioned earlier, is to borrow from David Wall's study of Elvis Presley: When Elvis's body was interred on 18 August 1977, his image and its economic

> value did not go into the coffin with him. Rather, the image entered the public domain and faced the ultimate threat of dilution through unlimited access. Once control was established, the intellectual property known as Elvis, which bore quite distinct qualities from the person formerly known as Elvis, became an area of "intellectual" real estate that contained characteristics similar to physical property. (1996, p. 117)

In some sense, then, a dead celebrity is commodified along with his or her death, in a manner perhaps morbidly similar to embalming or mummifying, and exhumed each time the deceased-as-commodity circulates through the media and through culture.

Property (Or, Do Not Go Gently into That Public Domain)

So I hold commerce with the dead
Or so methinks the dead would say
Or so shall grief with symbols play
And pining life be fancy-fed.
— DANTE, PARADISE, (IN A.S. BYATT'S [1992] "THE CONJUGIAL ANGEL")

I considered my life as my property, and therefore at my disposal.
— WILLIAM COWPER (IN BRAUDY, 1986, P. 536)

The words "star" and "dead" don't go together.
—AD EXEC PETER ARNELL (IN JACOBS, 1995, P. 26)

Whatever one can possess must be by nature a form of property, whether intellec-tual or real. And, consequently, it is something that must "be policed in order to maintain its security and protect it from theft" (Wall, 1996, p. 117). Irrespective of the nature of "image" as intellectual property, an image is nevertheless a com-modity. Though an abstraction, the distribution of an image means that at some point it is "fixed," like a recording "fixes" sound, even if that "fixing" is a purely mental activity. Thus legal and economic issues surrounding copyright are also part of the postmortem of celebrity, and form the core of the continuing industrial process that envelops celebrity.

David Wall identifies three steps in that process:

> The first is the development of a property where it does not previously exist. . . . The sec-ond . . . establishes its boundaries and who owns it. . . . The final . . . process (is) to police the property in order to protect it from being appropriated . . . by keeping predators at bay and thus maintaining both the integrity and value of the property. (p. 138)

These steps are not unlike those that accompany the industrial processes associat-ed with living celebrities. However, it should be noted that copyright laws have a fixed term of expiration (generally a "death-plus-something" rule) that allows not only the works created by a performer to go into the public domain but allows prop-erties associated with the performer (name, likeness, style) to also become part of the public domain. So, while "to knowingly use for trade purposes the 'name, por-trait, or picture' of any living person without written consent gives rise to crimi-nal and civil liability" (Gaines, 1991, p. 88), to do so with a dead person does not, unless there is effort made to establish another commodity. Thus we find relatives of celebrities quickly moving to secure rights after death, and so creating essential-ly "new" rights. That, in turn, leads to the second of Wall's three steps, the deter-mination of how rights (in most cases copyrights and trademarks) "descend" to other family members or to those with no family connections but only commer-cial interests.

As I mentioned earlier, death is a good career move as far as the music busi-ness is concerned. If nothing else, the publicity surrounding a performer's death stimulates record sales. In recent years the violent deaths of Tupac Shakur and Notorious B.I.G. have been cited as being responsible for near-record album sales. A less-than-tactful Reuter's news story about Biggie Smalls's record sales led with the headline "Notorious B.I.G. Shoots To Top Of Album Charts" and character-ized the slain rapper as "larger-than-life" (Goodman, 1997). There is also the case

of Selena, whose *Dreaming of You* album was called her "musical last will and testament" by an *Entertainment Weekly* reporter (Morthland, 1995, p. 20) in a cover story with a subhead noting the "tragic irony" that she "has become bigger than ever."

The same issue of *Entertainment Weekly* included a story with a list of dead celebrities titled "Estate Sales," subtitled "Images Have a Life of Their Own" (1995, p. 24). Celebrities on the list included John Lennon, Greta Garbo, Audrey Hepburn, Marlene Dietrich, John Belushi, and Kurt Cobain, and contained the following information:

- "Estate Stats," a tally of what the dead celebrities were worth and are now "making,"
- "In Charge," identification of the persons in charge of the estate,
- "Deals," a summary of current deals involving the celebrity's image, work, and so on,
- "In the Vaults," a synopsis of the celebrity's work that may yet be commodified and made available to the public, and, rather gruesomely,
- "Shelf Life," an estimate of the celebrity's ability to continue to move product (in Lennon's case the estimate reads "Imagine there's no limit," and in Jacqueline Kennedy Onassis's case it states "Like an eternal flame").

One author of an article in that issue noted that "Kurt Cobain . . . is a licenser's nirvana," and closes his story with a quote from Camille Paglia who says "Cobain's a martyr to the god of rock in some way. Buying his merchandise is like buying the relics of the saints" (Jacobs, 1995, p. 27).

As I wrote in an analysis of journalistic narrative after Kurt Cobain's death, most everyone aware of his death was, in fact, also very cognizant of the ways it would both be commodified and serve to sell Nirvana-related goods. Reporters in the music trade magazine *Billboard* quickly reported on the surge in sales of Nirvana albums following Cobain's death and speculated on the unreleased material available to Nirvana's record company, calling the entire affair "a grim accident of timing" (Rosen and Morris, 1994, p. 9). England's *Melody Maker* reported that:

> Copies of Nirvana's albums straight away started selling faster in shops throughout the world. At Tower Records in LA, Nirvana videos showed in the store. In London's Piccadilly, Tower Records started playing (the band's album) *Nevermind*. A member of staff was quoted in the April 10 issue of *Independent on Sunday* as saying, "I know, it's really awful. Somebody dies and you try to make money out of it. But it's not just a sell-out thing. It is kind of like a tribute as well." ("Kurt Cobain 1967–1994," 1994, p. 28)

Clearly there is big business at stake both immediately and well after a rock star's death, and it should not be surprising that there have been numerous legal

efforts in recent years to shore up property rights related to dead celebrities generally. Groundbreaking work in this area has been done by none other than Bela G. Lugosi, son of the actor Bela Lugosi. A practicing attorney and partner in a Los Angeles–based law firm that specializes in intellectual property law, Lugosi wrote an article in 1999 that crystallizes much of the thinking about protecting intellectual property rights of dead celebrities:

> Celebrities can enjoy immense commercial value in their identities—a value that frequently remains high, and may even intensify, after a celebrity's death. . . . The commercial value of celebrity identity is a side effect of celebrity status, but that does not mean that a celebrity's good fortune must be shared freely with the public at large. (Lugosi and Mankey, 1999, p. 41)

He goes on to list the numerous steps heirs should take to protect those rights, including registration, transfer to heirs, and licensing.

The right he discusses most in that article, and one that has garnered a great deal of attention in the legal community, is the right of publicity. It was Lugosi's efforts at securing the right to use his father's likeness as Dracula that both created the foundations of case law and increased awareness of this right. After his father's death in 1956, Universal Studios began licensing the Count Dracula character for commercial purposes, giving it to those selling everything from pencils to soap to T-shirts. Lugosi sued, and:

> was found to have a protectable proprietary interest in the commercial use of his appearance as Count Dracula, independent of the protection afforded by the common law right of privacy . . . (and it) did not terminate on Lugosi's death but descended to his heirs (Rohde, 1985, p. 52).

Universal won on appeal, but the court left its decision largely unexplained.

At present there is still a fair amount of confusion about these rights. For one thing, they are similar to other intellectual property rights, and they are transferable. But they are unlike other intellectual property rights because their duration is at issue. Unlike copyrights, publicity rights are descendible. Yet some of the same issues at stake in copyright law (commercial exploitation and pursuit of knowledge) come up with regard to the right of publicity. As Hamm (1995) noted, "Family control over personal information about famous people after their death is common" (p. 313). In the case Hamm examined, that of George Gershwin's family's efforts to control George Gershwin's posthumous reputation, commercial exploitation was less at stake than the effort to study, analyze, and historicize Gershwin. As Felcher and Rubin noted in *Yale Law Journal*:

> The social policy underlying the right of publicity is encouragement of individual enterprise and creativity by allowing people to profit from their own efforts. When publicity rights are

involved, recognition must be given, however, to the countervailing policy of the First Amendment interest in the free use of information. Consequently, publicity rights must be limited to those areas outside the scope of First Amendment interest where other social policies prevail. (1980, p. 1128)

These interests are clear and present in life as well as in death, of course, and can be connected to the advent of new media forms in the late nineteenth century. As Viera writes, photography (and other media new to that era) changed the social relations between individuals and between individuals and celebrities. What gave momentum to celebrity was, as he points out, the reconception of privacy brought about by new media technologies: "With the concept of privacy came the idea of "inviolate personality," the notion that the individual had the right to be an individual, with his/her own unique and secret, private side. Interestingly, this "need" for an expansion of the individual's domain was a reaction to life in the nascent media society of the late nineteenth century" (1988, p. 137).

It is interesting to consider the further reaction to increasingly privatized life in which interactions grow more mediated. In a sense the mediated relationships we form and maintain with celebrities are like private rituals of public interaction. In a less technologically mediated world one might have had such interactions with sacred figures, whom we might consider the celebrities of their day (and typically posthumous ones at that). The commodification of celebrity and fandom, the development of "collecting" commodities, should lead to consideration of the collector, the buyer of "the relics" Paglia mentioned. There is an odd mix of capitalism, ownership, and connection among collectors. For example, after Kurt Cobain's death it was reported that record stores were raising the price of collectible Nirvana records ("Kurt Cobain 1967–1994," 1994, p. 28), and one reporter noted that:

> The most sought-after Nirvana title in (Seattle) was "Bleach," the band's first album, released by Sub Pop (Records) in 1988. The day after Cobain's death, a teen-age customer asked a clerk at the Seattle Cellophane Square store if "Bleach" was a collector's item yet (Borzillo, 1994, p. 102).

There may be multiple interpretations of that exchange, including understanding it as the search for status, for value, or for a relic—or perhaps for all three.

There is in this a sense of canonization (both as a form of sainthood and as a form of what Derrida [1996] calls "archive fever"). Witness the attempts to situate Kurt Cobain's death among other rock star deaths. The dead star is part of a variety of tributes and eulogies, as Karen Foss (1983) found after John Lennon's death. And many fans are moved to try to interpret lyrics, music, and interview material to partake of a kind of mediated grieving process. As Plec, et al. put it in a study of "eulogistic music":

the development of mass communication technology over the last century has given stardom a new meaning. Pop stars are seldom known personally by their audiences and yet many fans perceive their relationship with the star as being somewhat intimate. Musicians may be particularly susceptible to this sort of scrutiny and attention because their song lyrics, like poetry, are thought to reflect the thoughts and emotions of the songwriter. (1996, pp. 4–5)

This is the less-crass version of the collector, perhaps characterized best by those who consider themselves "students" of a genre, artist, or medium. There is an almost immediate historicizing of mediated works, itself of course part of the sense-making process associated with artistic expression. Elliott Murphy explains it well in relation to rock 'n' roll. He wrote, in the liner notes to the Velvet Underground's *Live 1969* album:

It's one hundred years from today, and everyone who is reading this is dead. I'm dead. You're dead. And some kid is taking a music course in junior high, and maybe he's listening to the Velvet Underground because he's got to write a report on classical rock 'n' roll, and I wonder what that kid is thinking. . . .

I wish I was writing this a hundred years from today. Then, I'd be writing about music made by dead people. There'd be a beginning and an end. As it stands now, I don't know where this album fits in. I think all of the people on this album are alive today. I know that at least one of them is still at it. I don't know if this will be considered one of Lou Reed's greater or lesser contributions. . . .

I wish it were a hundred years from today. (I can't stand the suspense.) (1974, n. p.)

The link between death, history, and—essentially—*closure* is an important one to consider in terms of the ongoing mediation of a dead celebrity's works. Though one might consider that with death the "work" of a collector is over, typically the opposite is true. After death the work of the historian begins, and never ends.

One might characterize collectors (and, perhaps, historians) as a kind of pathological fan, along the lines Joli Jensen (1992) describes in her article "Fandom as Pathology." Jensen, however, notes that our very ideas about fandom are saturated with our understandings of modern life and modern mass media, and that the pathological fan is thought of "as desperate and dysfunctional, so that he or she can be explained, protected against, and restored to 'normalcy,'" but ultimately "fandom is an aspect of how we make sense of the world, in relation to mass media, and in relation to our historical, social and cultural location" (p. 27). Indeed, our understanding of mass mediation now permeates our understanding of celebrity death. Leo Braudy noted that:

The modern preoccupation with fame is rooted in the paradox that, as every advance in knowledge and every expansion of the world population seems to underline the insignifi-

cance of the individual, the ways to achieving personal recognition have grown correspondingly more numerous. (1986, p. 553)

In the case of Kurt Cobain's death some journalists placed the blame on media and mass culture, arguing that it was fame itself that killed him. One reporter in the U.K., combining both Cobain's fame and fandom in an interesting fashion, wrote:

> Full circle. The former obsessive Lennon fan was now the greatest, most reluctant rock star of his generation.
>
> Nobody teaches you how to be a rock star. Nobody gives instruction in what to do when 10 million people own a sliver of your soul. The stampede doesn't stop. And fame cures nothing. Perhaps it's thrilling at first. But what's it like to see your modest ideals ripped out of your hands as a thousand bands start up in the race to repeat what you've achieved? (Arundel, 1994, p. 33)

Or this, from Powers, one of Cobain's peers:

> Kurt Cobain is not a person. . . . He's turned into something that represents different things for different people. I understand the press is going to be all over it, but I wish they would leave it alone completely. Because that attention is why Kurt died. (Powers, 1994, p. 32)

Certainly claims that fame killed others are not uncommon. However, no other dead rock musicians, whom journalists and critics were fond of naming in the same sentence as Cobain, were seen as media victims in the way Cobain was. In those cases, fame led to other causes of death, usually via drugs and decadence. In some ways his death is an astonishing twist on fame, for as Leo Braudy put it, "fame . . . promised a way to evade death and deny its ultimate power" (1986, p. 553). And yet fame, it seems, can also cause death.

Rock 'n' Roll Heaven

In a way, the continuing presence of deceased musicians makes it hard to believe in their death. If Elvis is still singing "Are You Lonesome Tonight?" on the stereo, maybe he'll show up at the convenience store. . . . And who's to say whether somewhere, long after midnight at some beer-soaked collegiate hangout, that's not Kurt Cobain plunging head down into the mosh pit?

—Jon Pareles (1994b)

If there is such a thing as a rock 'n' roll heaven, then we're probably living in its purgatory. Does any other medium of popular art have a history both as studied and as alive (thanks to "classic rock" radio, records, etc.)? Even television seems to have

less a sense of its own history as rock music. It certainly seems that we live in a rock limbo, almost conflating past and present (and possibly future) as musical styles and tastes evolve, or perhaps re-evolve, over time.

To again use Kurt Cobain's death as an example, it is interesting that almost immediately after news of his death spread many began adding him to the "dead rock star club" by assigning him a place alongside the likes of Jimi Hendrix, Janis Joplin, and Keith Moon. Most numerous were the comparisons to John Lennon, like this one from Los Angeles critic Lorraine Ali :

> I can't recall exactly where I was when I heard the news that John Lennon had been shot. . . . I will always remember where I was when the news of Kurt's death reached me. (1994, p. 28)

Or, as one critic wrote:

> After his death, people were comparing Mr. Cobain to John Lennon; in fact, he shared Lennon's combination of pop craftsmanship and primal self-expression. But Lennon didn't kill himself, and none of the other 1960's rock martyrs—Jim Morrison, Jimi Hendrix, Janis Joplin—is an exact analogy either. Where each of those troubled souls saw a sense of possibility, Mr. Cobain was always facing dead ends. He was never one to accentuate the positive. (Pareles, 1994a, p. 11)

The narratives that formed in the wake of Cobain's suicide focused around authenticity, and served to solidify and stabilize Cobain's and Nirvana's place in the continuum of popular music's history. As another critic put it, Cobain's suicide stamped not only *his* music with the mark of the authentic (for he lived, and died, by the beliefs he seemed to espouse in his lyrics) but it stamped *all* popular music (and attendant subcultures) of the era and style as authentic:

> . . . however tragic and squalid a rock 'n' roll death may be, it inevitably confers significance upon the victim and upon rock music as a whole.

> Crudely put, Kurt Cobain is the Slacker Martyr. The whole grunge ethic of dropping out because life sucks strikes many as lazy, parasitical and apolitical in its supine, despairing refusal to stand up and fight back. But Kurt Cobain might well have died for this principle. (Stubbs, 1994, p. 31)

So in some sense rock stars (and I do believe we can generalize to celebrities) do not die, they just continue to be mythologized and mediated. But it is not the same sort of mediation that took place when they were alive. There is a sense, already discussed, that the industrial process surrounding them lives on, but without them at its center. Even the economics shift. As one advertising executive put it, "using a dead celebrity is usually cheaper than hiring today's biggest stars" (Goldfarb, 197, p. 13). There is a "finite" quality to the products that may come

along after their death, a quality likely closely linked to the sense of "lost promise" often associated with the death of young artists whose best work, it is believed, was ahead of them.

But if there is not promise then there is potential that remains, for, once they have passed away, it is left to others to make sense of their legacy. The case of Jimi Hendrix serves as an example. The recordings Hendrix made, many of which were unreleased at the time of his death and consisted of various demos, live recordings, outtakes, and the like, have been fought over during the past quarter-century by his bandmates, family, attorney, record label, and producers. But as far as Hendrix's fans were concerned about his estate, one critic noted:

> . . . the most critical . . . development was . . . choice of Alan Douglas to administer the unused tapes. Douglas had befriended the guitarist during the final year of his life, and at Hendrix's invitation had briefly tried to impose some order on his chaotic recording sessions. (Jones, 1997, p. 30)

Clearly the importance of Douglas's "closeness" to Hendrix made it an important issue for fans who believed Douglas would know Hendrix's "intentions" with his music and ensure that his legacy would remain, somehow, intact. But Douglas's relationship with Hendrix became a subject of much argument among fans. Hendrix's estate is now back in the hands of his family, after his father had entered into several ill-advised agreements with publishers and record companies, and managed by his stepsister's business Experience Hendrix. The same critic wrote:

> Whether Janie Hendrix-Wright can navigate the shark-infested waters of the music industry more successfully than her father remains to be seen . . . future releases will test her commitment to her stepbrother's memory: Experience Hendrix, she reports, will release "several albums as he would have intended them to go out." (p. 33)

Thus Hendrix's legacy is preserved by the very industrial process that made him a celebrity. Though having "cheated" death by recording, technology decouples sound from its medium, and thus decouples those recorded from context and control.

Conclusion (Pun Intended)

Belief in the Wizard was irrelevant once he taught you to become your own audience . . .
—LEO BRAUDY (1986, P. 553)

Immortality means eternal trial.
If it's eternal trial, there ought to be a decent judge.

—KUNDERA, IMMORTALITY, (1991, P. 81)

Plec's connection of the fans' perceived intimacy to the perception of lyrics and music as coming "from within" is particularly important to an understanding of what happens after a rock star dies. Celebrity is inextricably bound up with notions of authenticity and identity, as Charles Taylor described:

> . . . the forms of equal recognition have been essential to democratic culture. . . . the importance of recognition has been modified and intensified by the new understanding of individual identity that emerged at the end of the eighteenth century. . . . Being in touch with our feelings . . . comes to be something we have to attain if we are to be true and full human beings. (1995, p. 227)

Celebrity relies as much on difference as on its affirmation. Fame confers a sense of "otherness," rooted in the individual, alone. As Braudy sees it, fame

> . . . (emphasizes) the immediate force of individual will ("I did it my way"), it longs as well for a spiritual fame that rises out of history and becomes part of the permanent language of human images by which individuals measure themselves and their accomplishments. The exemplary famous person here is especially the person famous for being himself or playing himself (1986, p. 554).

Musicians, particularly since the demise of Tin Pan Alley and the rise of the singer/songwriter, have had special claim to the form of authenticity Taylor describes in his work; even adjectives like "feeling," used to describe musical performance, are ones used to locate individual authenticity. In the case of dead musicians the phrase "once more, with feeling," takes on a new poignancy, as does another of the adjectives associated with musical performance: soul.

Note

1. Both albums were ironically if not gruesomely titled, and had equally gruesome song titles like "Somebody's Gotta Die." In another somewhat macabre twist, both albums vied with Aerosmith's then-number one-selling album "Nine Lives," for the top spot on the sales charts.

References

Ali, L. (1994, April 17). Kurt Cobain Screamed Out Our Angst. *New York Times*, Sec. 2, p. 28.

Arundel, J. (1994, April 16). In Bloom: The Musical Legacy of Kurt Cobain. *Melody Maker*, 32–33.

Borzillo, C. (1994, April 23). Cobain Mourned by Fans, Industryites in Memorials, Music Stores. *Billboard*, 102.

Braudy, L. (1986). *The frenzy of renown: Fame and its history*. New York: Oxford University Press.

Byatt, A. S. (1992). *Angels and insects*. London: Chatto and Windus.

Derrida, J. (1996). *Archive fever*. Chicago: University of Chicago Press.

Estate Sales. (1995, Aug. 18). *Entertainment Weekly*, 21–24.

Felcher, P. L., and Rubin, E. L. (1980). The descendibility of the right of publicity: Is there commercial life after death? *Yale Law Journal*, 89, 1125–1132.

Foss, K. (1983). John Lennon and the advisory function of eulogies. *Central States Speech Journal*, 34, 187–196.

Fricke, D., and Orme, J. (1980, Dec. 13). John Lennon. *Melody Maker*, p. 25.

Gaines, J. (1991). *Contested culture: The image, the voice, and the law*. Chapel Hill: University of North Carolina Press.

Goldfarb, J. (1997). Employing the deceased. *American Advertising* 13(2), p. 13.

Goodman, D. (1997, April 2). Notorious B.I.G. shoots to top of album charts. *Reuters news wire*.

Hamm, C. (1995). *Putting popular music in its place*. New York: Cambridge University Press.

Jacobs, A. J. (1995, Aug. 18). Wanted: Dead or alive. *Entertainment Weekly*, pp. 26–27.

Jensen, J. (1992). Fandom as pathology: The consequences of characterization. In L. Lewis (Ed.), *The adoring audience* (pp. 9–29). London: Routledge.

Jones, J. R. (1997, May 9). Recycled hero. *Chicago Reader*, pp. 30–33.

Jones, S. (1995). Covering Cobain: Narrative patterns in journalism and rock criticism. *Popular Music and Society*, 19(2), 103–118.

Katz, G. (1995). *Death by rock 'n' roll: The untimely deaths of the legends of rock*. New York: Citadel Press.

Kundera, M. (1991). *Immortality*. New York: Grove Press.

Kurt Cobain 1967–1994. (1994, April 16). *Melody Maker*, 28–29.

Lugosi, B. G., and Mankey, C. H. (1999). Life after death. *Los Angeles Lawyer*, 22(2), 40–45.

Mills, J. (1996). *Before he got old: Keith Moon, autodestruction and rhetoric in the social field*. Paper presented at the annual convention of the Speech Communication Association, San Diego, California, November 25, 1996.

Morthland, J. (1995, Aug. 18). Selena born again. *Entertainment Weekly*, 18–22.

Murphy, E. (1974). Liner notes. *Live 1969*. [Recorded by the Velvet Underground]. London, UK: Mercury Records.

Pareles, J. (1994b, April 17). Music Confers an Afterlife as Cacophony Lingers On. *New York Times*, Sec. C, p. 11.

———. (1994a, April 11). Reflections on Cobain's Short Life. *New York Times*, Sec. C, pp. 11–13.

Pike, J. (1993). *The death of rock 'n' roll: Untimely demises, morbid preoccupations, and premature forecasts of doom in pop music*. Boston: Faber and Faber.

Plec, E., Betts, G., and Gilboard, M. (1996). *Falling to pieces: A generic approach to eulogistic music and the aircraft deaths of three generations of pop stars*. Paper presented at the annual convention of the Speech Communication Association, San Diego, CA, November 25, 1996.

Powers, A. (1994, April 19). No Future: Kurt Cobain's Final Denial. *Village Voice*, 31–35.

Rohde, S. F. (1985). Dracula: Still undead. *California Lawyer*, 5(4), 51–55.

Rosen, C., and Morris, C. (1994, April 23). Cobain Death Spurs Rush at Retail. *Billboard*, 9, 102.

Schickel, R. (1985). *Intimate strangers: The culture of celebrity*. Garden City, NY: Doubleday.

Stubbs, D. (1994, April 16). I Hate Myself and I Want to Die. *Melody Maker*, 30–31.

Taylor, C. (1995). *Philosophical arguments*. Cambridge, MA: Harvard University Press.

Viera, J. D. (1988). Images as property. In L. Gross, J. Stuart Katz, and J. Ruby (Eds.), *Image ethics* (pp. 135–162). New York: Oxford University Press.

Wall, D. (1996). Reconstructing the soul of Elvis: The social development and legal maintenance of Elvis Presley as intellectual property. *International Journal of the Sociology of Law*, 24, 117–143.

Altared Sites

Celebrity Webshrines as Shared Mourning

Julie L. Andsager

Sometimes I look up at the sky and wonder what Kurt is doing up there. It really sucks that Kurt is gone; He had everything, fame, fortune, a lovely daughter and a loving wife, but yet, he killed himself and Nirvana is no more.

("Lone Memorial," 2002)

When a family member, close friend, or spouse dies, we are allowed to grieve. We attend the funeral or other services; we receive condolences; we are allowed to publicly acknowledge our loss. Postdeath rituals such as funerals or memorial services, spreading of cremated ashes, or placing of a tombstone, provide temporal outlets for the legitimate expression of grief, and, significantly, provide individuals a means of receiving external validation for their emotions (Doka, 1989; Kamerman, 1988; Kollar, 1989; Stephenson, 1985). The purposes of social gatherings for funeral rites entail "central motifs of a culture; their performance usually helps to bolster the solidarity of the social group" (Mandelbaum, 1959, p. 189). Aside from the physical gathering, mourners have traditionally saved evidence of their beloved, such as locks of hair or photographs, even photographs of the dead bodies or burial caskets (Pike, 1980). This means the nature of our relationship to the deceased is presumed to be publicly acknowledged and communally shared.

Some losses, however, may be deeply felt but not socially recognized. If a married lover, distant business associate, closeted gay partner, or pet dies, our grief can

be neither deeply demonstrated nor is it considered legitimate. This type of loss is called "disenfranchised grief" (Doka, 1989). Disenfranchised grief is "the grief that persons experience when they incur a loss that is not or cannot be openly acknowledged, publicly mourned, or socially supported" (p. 4). In mourning literature, this form of grief refers to interpersonal relationships that are less intimate—or at least, so they appear to the outside observer—than traditional familial bonds.

Bereavement instills strong emotional reactions in us. We often experience feelings of anger, guilt, sadness, depression, loneliness, hopelessness, and numbness (see, for example, Worden, 1982). For the disenfranchised mourner, these emotions (particularly anger and guilt) tend to be intensified because they cannot be expressed (Doka, 1989). The postdeath rituals that acknowledge and justify mourning are not available to the disenfranchised. Because such ritual "builds community as well as presupposes community" (Kollar, 1989, p. 275), eliminating it from the disenfranchised griever's experience serves to exacerbate the feelings of loneliness and isolation accompanying his or her loss. Thanatology scholars strongly argue that society must provide ways for individuals experiencing disenfranchised grief to ritually express that grief (Doka, 1989).

In this chapter, I argue that mourning the death of a beloved popular music star also constitutes disenfranchised grief. Our individual "relationships" with favorite celebrities can last for years and run deep. Since the 1950s, the U.S. media's ubiquitous coverage of celebrity has allowed stars "to make a more profound emotional impact on the individual's life than had ever been possible" (Schickel, 1985, p. 132). We absorb ourselves in celebrity: we buy the albums or attend the concerts; we read the interviews; some may join the fan clubs. We refer to our celebrated object of worship by his or her first name as if we are close friends. But when the celebrity dies, we hear about it—appropriately—through the media. We cannot attend the postdeath ritual. We cannot very well take bereavement days from work or allow ourselves to publicly grieve for fear of appearing adolescent. In the United States at least, public displays of emotion are viewed as a sign of weakness. Individuals often internalize shame along with disenfranchised grief because their peers ridicule them for mourning someone they did not know, a phenomenon that can occur when individuals *expect* that they will lose face among friends (Kauffman, 1989).

In addition to fear of shame, the geographically widespread, public nature of celebrity may isolate fans, denying them a public space for expressing grief among like-minded people who will empathize. Fans want to seek information, comfort, and community when their beloved celebrities die. For example, when John Lennon was murdered in New York City in December 1980, thousands of New Yorkers poured into Central Park in a candlelight vigil. Fans outside the area were

left to mourn via television on their own or with close friends. As a member of the Beatles and a solo artist, Lennon had been an internationally known celebrity with a huge fan base for nearly twenty years. Not all celebrities are as well known or beloved at the time of their deaths, though, which may increase feelings of isolation among their fans. As an anonymous fan of the late actor River Phoenix wrote, "I'd just like to say all my family friends think that I'm a weirdo because I like River Phoenix and because he passed away" ("The River Phoenix Pages," 2002). Like established forms of disenfranchised grief, "the loss itself is not socially defined as significant" (Doka, 1989, p. 5). Except among established communities such as fan clubs, then, mourning the loss of a beloved celebrity has been a private matter—until recently.

Webshrines

The World Wide Web, aside from establishing a global network for communication, offers a venue for public expression of disenfranchised grief over celebrity deaths. It provides a venue for public solidarity in mourning that transcends space and time constraints (Walter, 2001). Fans from around the world have built what they call "tribute pages" to their favorite celebrities, whether those celebrities are living or dead. Tribute pages for dead celebrities contain many of the elements of traditional mourning rituals: memorial items—those that perpetuate the memory— and ritualistic items—those described for use in the ritualized etiquette of mourning (Pike, 1980). Memorial items on webshrines include biographies, disc- or filmographies, audio clips, and photos. Birth and death dates under a favorite photo, fans' eulogies and poems, and photos of suicide notes or tombstones exemplify ritualistic items. Because these tribute pages are often elaborate and filled with reverential references to dead celebrities, I use the term "webshrine" to describe them. Ewen (1988) argued that the media's ability to magnify and create universal recognition for celebrity "invest[s] the everyday lives of formerly everyday people with a magical sense of value, a secularized imprint of the *sacred*" (p. 93). Via webshrines, dead celebrities can be transformed into sacred beings.

In examining webshrines for this study, I have viewed and read shrines for a wide variety of dead popular music celebrities, from Elvis Presley to Tupac Shakur to Aaliyah to Joey Ramone. I include data gathered from e-mail interviews with webshriners and from fans' comments posted on various webshrines. It should be noted that omnibus dead celebrity sites such as "Find A Grave" (www.findagrave.com), "The Dead People Server" (www.dpsinfo.com), and the "Lee Atwater Memorial Invitational" (a celebrity death prediction competition; www.stiffs.com) are not considered webshrines, though clearly they are further evidence of our societal fascination with celebrity death.

Much as traditional mourning rituals for the dead, tribute pages facilitate the fulfillment of the needs of the living. Webshrines seem to serve three basic functions: (1) building community among mourners; (2) negotiating conflicting feelings over the death; and (3) immortalizing and magnifying celebrity. This chapter explores these functions.

Webshrines exist for dozens of dead pop music stars, no matter when they died, how they died, or the status of their careers at the time of death. For example, Elvis Presley was a longtime, international celebrity when he died in 1977, and it is not surprising that many webshrines are devoted to him. His fans participate in regular pilgrimages to his Memphis home and gravesite on the anniversaries of his birth and death. Andy Gibb, on the other hand, had a short but extremely successful recording career during the late 1970s. When he died at the age of thirty in 1988, however, his career had been dormant for several years. Nonetheless, at least one of Gibb's webshrines was created and maintained by a fan who "never met Andy, nor did I discover his music until he had already passed" ("An Everlasting Starlight," 2002). In a series of searches online (www.google.com, 2002), I was unable to find a dead pop star who did not have at least one webshrine in his or her name.

Building Community

The definition of community in cyberspace has been widely debated (see, for example, Chayko, 2002; Costigan, 1999; Jones, 1995, 1998). Chayko has argued that these sociomental bonds developed among people who never meet are just as powerful as those in traditional communities. Thus, fans who connect over a celebrity may particularly illustrate the notion of cybercommunity put forth by Fernback (1999) who summarizes much of what appears to occur in building, visiting, and negotiating webshrines: "It is an arena in which passions are inflamed, problems are solved, social bonds are formed, tyranny is exercised, love and death are braved, legacies are born, factions are splintered, and alliances dissolved" (1999, p. 217).

The predominant feature of webshrines is often the guestbook. Anyone visiting the site is asked to "sign" the guestbook and register comments. This consistent component helps to allay a major harm accruing from disenfranchised grief, that of isolation (Kollar, 1989). Postdeath rituals such as funerals alleviate that harm for those whose grief can be socially recognized by drawing them together as a community. While in the case of disenfranchised grief for a dead pop star, fans may feel particularly isolated, especially if their icon had not been popular at the time of his or her death.

Thanatology scholars argue that communal awareness is vital in assuaging grief by providing "a recognition that by the death of the deceased the bereaved have become a new community" (Kollar, 1989, p. 275). Nowhere is the newness of such community so pronounced as for the disenfranchised mourners who build and respond to webshrines. Every webshrine I have found invites its viewers to contact the shrine's builder. Each provides many links to other webshrines for the celebrity and to related sites. And, for many of the shrines, visitors number in the tens of thousands within about a one-year period. Despite Aaliyah's brief career as singer and actor, which ended in August 2001 in a plane crash, one of many webshrines devoted to her indicated that about 22,000 people had signed the guestbook ("Aaliyah Online," 2002), most following her death.

Webshrine builders tend to note that one of the main satisfactions they derive from their pages is the recognition and response from other fans. Andrea, an American with an Elvis Presley webshrine, wrote that she received e-mail from "all kinds of people from all over the world. From 10-year-old children to members of the US Congress" (personal communication, May 5, 1997). Unlike traditional communities, the webshrine-derived communities are global. "People from South Africa to Sweden have written to me," wrote Msapozhn, builder of a Nirvana page focusing on Kurt Cobain's death (personal communication, May 2, 1997). "Most of them seem like nice guys. They appreciate the effort I put into the page." The fan community provides a comfort, as Lex, another Elvis webshriner from the Netherlands, noted: "It takes a lot of my spare-time. But the recognition and the new friends it gave me are certainly making it worth the effort" (personal communication, May 3, 1997). By affording the webshriners the opportunity to express their feelings in a public forum that acknowledges them, webshrines provide an outlet for ritually expressing grief. This is particularly necessary for disenfranchised grief. It is apparent that the webshriners appreciate this acknowledgment.

Another vestige of the shared community that webshrines create is the public space—the guestbook—for posting comments and feedback from fans visiting the pages. Most of the webshrines I visited include page after page of comments from fans from all over the world. Many such pages contain comments in a variety of languages. Often the comments congratulate the webshriner on the quality of the shrine; sometimes they ask for answers to trivia questions or information about finding, for example, a certain single or import release on CD. The fans write that they enjoy visiting the pages and return frequently, another sign of deriving comfort from ritual. An obvious example of these phenomena appears on a webshrine for Joey Ramone, leader of the 1980s punk band "The Ramones," who died of cancer in spring 2002:

> Thanks so much for providing an area for fans of friends of joeys [sic] to convene . . . and also for the diligence in adding the shrine for him on the site. it means a lot to those of us who cant [sic] be there right now. Ive [sic] actually met a few new friends vis a vis I [sic] post I made - thus proving that joey truly is and was the gift that keeps on giving.—Best, M (Joey Ramone Memorial, 2002).

Some of the fans forming these communities seem to perceive themselves as being an elite community, the "true" fans, perhaps establishing a stronger bond among them. For instance, Angie wrote about her devotion to Kurt Cobain, the late lead singer of Nirvana:

> [Being a fan] was better before they were so popular, and it's better now, because all the casual fans have moved on to other bands, but some of us will always stick by Nirvana. Kurt won't die out if we remember him and what he gave ("Lone Memorial," 2002).

On the same page, Hung takes this type of exclusive community a step further:

> There are some jerks in my U.S./Va [Virginia] history class that disgrace there [sic] memory by saying nirvana sucks and Kurt was just a druggie loser who accidently [sic] shot himself. One day I am going to kill all those people.

For the fans, then, the public posting of their thoughts and feelings seems to allow for a deep expression of grief. The candid nature of these comments suggests that they do feel a real sense of community among their peers.

Negotiating Feelings

Survivors experience grief as a complex series of emotions, summarized by Elisabeth Kübler-Ross's (1969) pioneering work on the stages of grief: denial, anger, bargaining, depression, and acceptance. Although the length and depth of these stages may vary, they are consistent enough that biologist Robert Sapolsky called their "universal predictability . . . an emblem of our kinship and an imperative of empathy" (1994, p. 14).

When a celebrity dies from violent or unexpected means, such as suicide, murder, or a drug overdose, fans must work especially hard to reconcile their feelings of betrayal and anger. One necessary outlet for grief is that of identification, or the survivors' recognition that they will be responsible for guarding the values for which their beloved lived (Kollar, 1989). Shneidman entwines the notion of identification with that of the "postself," which "relates to the concerns of living individuals with their own reputation, impact, influence after death—those personal aspects that still live when the person himself [sic] does not" (1973, p. 45).

Because celebrity is constructed primarily of image, though, we may not always be aware that our object's values, lifestyle, and goals differ from our own.

Manufacturing and retaining celebrity status means that performers must increasingly control their images "by appearing not to control them" (Gamson, 1994, p. 143). Dyer, in turn, noted that negotiating authenticity and image means that the image itself has to be somehow more real than an image (1993). Some fans may believe that their attitudes are congruous with that of the celebrity; that is, when the singer yells "I love you all!" to fans at a concert, they may perceive that their individual feelings are reciprocated. This means that a suicide or other socially unacceptable form of death is a betrayal, a particularly difficult matter to negotiate. The formation of "cults around dead heroes . . . involves the inability to accept the finality of death" (Kamerman, 1988, p. 85). This is especially true for younger fans, whose heroes tend to be more likely to die in these ways.

Movie actor River Phoenix and Nirvana lead singer Kurt Cobain died within six months of each other in October 1993 and April 1994, of a drug overdose and suicide, respectively. Perhaps not coincidentally, these two young celebrities had more webshrines devoted to them in the years immediately following their deaths than any other dead celebrities except Elvis Presley and Marilyn Monroe, both of whom died under the same kinds of circumstances decades ago. The shrines to Elvis and Marilyn, however, tend to focus more on immortalizing these idols, while the fans of River Phoenix and Kurt Cobain remain in the negotiating stage. The webshriners' attitudes toward their pages reflect this subtle difference. Lex, an Elvis page creator, says that he obtained an Internet connection specifically to make his tribute page because Elvis is one of his hobbies (personal communication, May 3, 1997). For the older fans who have had time to accept the loss of their beloved, webshrines can afford satisfaction and a kind of hobby. It is clear, though, that fans do not lose sight of the source of their attraction to the beloved. Marcy, one of Andy Gibb's fans, wrote:

> [T]here are certain people who win pieces of our hearts. They are the people who bring happiness, joy and yes, even sorrow to our lives. They wedge themselves so deeply and firmly into our hearts that it's impossible for us to ever let them go. Andy, you have done that to my heart. ("Shining Star," 2002)

The younger fans of more recently deceased celebrities have not yet reached that point. Rather, they tend to publicly negotiate the emotions associated with their subjects' death, sometimes to a point at which the celebrity becomes the receiver of the communication, not the webshriner or fan community. Michael Hutchence, the lead singer of the 1980s band INXS, hanged himself in Australia in November 1997. The site master of one tribute page to Hutchence posted a remembrance several years after his death:

> Its [sic] hard to believe three years has gone by since we lost you. The pain in my heart that remains makes it all seem like just yesterday. It's hard to believe that you have left this world

to become part of another . . . Remembering you Michael on this November 22, 2000 with Love, Joy and Tears. ("Michael Hutchence Tribute Page," 2002)

An effort by one of Aaliyah's fans also reflects the convergence between community and an individual's negotiating feelings upon her loss. Dat Gul wrote in "Alex's Guestbook" (2002) that she sent condolences to Aaliyah's family and friends, thanking the webmaster for the site for showing "my favorite singer so much love. It's been a year now and I still haven't got over [sic] the tragic death of Aaliyah. . . . R.I.P. Babygirl a.k.a. Aaliyah—You'll never be forgotten!"

Similarly, Phoenix and Cobain fans' posted comments reflect their attempts to come to terms with conflicting feelings over both their losses and the manner in which those losses were obtained. One way to accomplish this task is to displace the blame from the celebrity himself. Despite the coroner's ruling of suicide in Cobain's death, Ben blamed Cobain's widow, actor/singer Courtney Love: "It's a shame somone [sic] like Courtny Love [sic] had to take him out of this world. If your [sic] a true Nirvana fan never listen to [Hole, Love's band]. Courtny Love should be shot just like she shot Kurt" ("Lone Memorial," 2002). For River Phoenix fans, the blame ironically seems to lie with the media and their promotion of celebrity. An anonymous fan wrote:

We all know that drugs were the main cause of River Phoenix's death. However, sometimes I feel that it is the society that killed him; the society that put a burden of stress on him, which led him to take drugs to ease the pain. ("The River Phoenix Pages," 2002)

These fans do not want to tarnish their idolized images of the celebrities, both of whom died in less than socially acceptable circumstances. So in the early stages of mourning, they look for someone else to shoulder their anger.

A more advanced stage of grief is evidenced in a greater number of the comments posted on webshrines devoted to these two men. This stage seems to recognize that, in the end, Phoenix and Cobain died by their own hands. However, their deaths are not the product of fault or weakness but of superiority: they were misunderstood geniuses, unappreciated by the celebritymaking culture that brought them to their fans. FozzieK wrote of Cobain that "I know he is looking down on all of his 'true' fans and smiling. We didn't disown him for committing suicide but instead we celebrated his life, his music, him" ("Lone Memorial," 2002). Many of Cobain's fans believe he is "looking down" and smiling upon them, implying that he is a deity. Caroline explained:

I catch myself looking up at a clear night sky or something and get all at ease because he's up there happy (or at least I hope so) and is looking down at all of us. He knew what he was doing . . . This may sound dumb but if I got into it enough again I could cry all day over Kurt, but I know he wouldn't want that from any1 [sic]. Or to be idolized or worshiped by any1. He was truly great in his humbleness. ("Lone Memorial," 2002)

Phoenix's fans also suggest that he was larger than life. His death from a drug overdose is perhaps slightly easier to negotiate than Cobain's self-inflicted gunshot wound. Like Cobain's posthumous place above us, Phoenix's life—or his fans' conceptualization of it—is the focus of his tributes. Rachel wrote:

> River's tragedy was his intelligence and ability to see the truth. Like most people who see, he couldn't cope with what he saw . . . If he read this, he would be laughing, I hope, at the futility of words after death and the irony of his canonisation-the junkie saint. (The River Phoenix Pages, 2002)

The fans who write these kinds of comments have gotten beyond blame and begun to (re)construct the images and identities of their idols in the identification facet of grief (Kollar, 1989). Identification imbues the mourner with the responsibility of perpetuating the deceased's values. The validity of these attributed values is not important in celebrity death, according to Schickel, who contends that when a celebrity dies, he or she becomes:

> . . . a public possession, in which his or her image is completely internalized by the fans. In death, we have them exactly where we want them . . . the fantasies that we wished to impose upon them can now be freely grafted on their unresisting ghosts. (1985, p. 129)

By providing fans with a public arena for voicing such sentiments, webshrines allow them the opportunity to share in the mourning and negotiating processes. If negotiating the identification phase results in a slightly skewed conceptualization of the celebrity's life, who is to say that this product is any more fictitious than the carefully managed image that his or her handlers attempted to maintain during life?

Immortalizing Celebrity

This final function of webshrines reflects the "shrine" aspect of tribute pages. Comments from both webshriners and visiting fans magnify dead celebrities' talents and imagined personal characteristics through the use of personal anecdotes and superlatives. In mourning, one coping mechanism that survivors must employ to deal with their grief is regeneration, in which the deceased lives again in memory so that survivors can face up to their past and future relationship with the deceased (Kollar, 1989). Regeneration for dead celebrities involves reconstruction as well. When a celebrity dies, his or her fans' regard seems to escalate from admiration to worship, literally. Like the religious tones apparent in the Phoenix and Cobain fans' comments mentioned above, fans' feelings about celebrities who have died from more socially acceptable means or who have been dead for a longer period contain a reverential fervor. In discussing why she created an Elvis web-

shrine, Andrea jokingly touched on this point when she explained that "some sort of 'divine inspiration' caused me to come up with the idea to make [a Web site] about Elvis" (Andrea B., personal communication, May 5, 1997). Marcy wrote to Andy Gibb that "of course you are in heaven, you are our angel" ("Shining Star," 2002).

Webshrine hosts are consciously aware of their newly established relationship between the beloved star's postself and their own identity. We are free to commandeer the deceased's legacy, to some extent, and propagate our interpretation of the celebrity image. Thus, for Tupac Shakur, "The Official Unofficial Tupac Site" clearly states the goal of the site:

> We represent for Tupac with the intensity and passion with which he represented for us, he spoke for us, the oppressed with no voice, and in turn we must speak for him, represent for him, and keep his words and spirit alive. ("HitEmUp.com," 2002)

Nirvana webshriner Msapozhn wrote that he built his page "to pay back to the wonderful band" (personal communication, May 2, 1997).

The fans who post their thoughts on webshrines are particularly aware of the need to regenerate celebrity. Both fans and webshriners employ superlatives to describe their feelings for the celebrities, many of which suggest that the deceased are now larger than life. Interestingly, some of them address their comments directly to the celebrity: "Elvis, the hole you left behind is too big that somebody else could fill it. There is only one humen [sic] who is king-like . . . it's you. We'll never forget you," wrote Steffen ("Elvis-Fan-Guestbook," 1997).

Other fans pay tribute to the webshriner for providing the tribute that keeps their celebrity alive. Spreading the memory of the celebrity is an important motivation for the webshriners themselves, as in the case of the "Aaliyah online: Tribute to an angel site" (2002): "We've been asked why we still maintain this site after she's passed. And to answer, we do it because we love her and we want to keep her legacy alive for people to see how truly remarkable she was." This sense of direct contact with both the dead celebrity and the webshriner not only links the two in visiting fans' minds—as if the webshriner is almost a medium—but further reinforces the sense of community that mourners share.

Superlatives dominate the discourse on webshrines. Any hint of negative or unpleasant traits and incidents in the celebrities' lives has been erased, replaced with nearly deified icons and idols. Time and regeneration of the beloved's memory combine with the fans' ability to reconstruct images to fit their idealized conception of the dead celebrity. While regeneration of deceased family members and friends may allow mourners to cope with their loss, the process seems to magnify when it occurs for celebrity, reinforcing Schickel's notion that "those elements in the biography that discomfited fantasy in life now wither and eventually disappear"

(1985, p. 129). Thus, webshrines provide tangible evidence of how memory frees individual fans to re-image celebrity. In a sense, we as fans become the managers, agents, and publicists for the dead.

Conclusion

Tribute pages on the World Wide Web afford fans the opportunity to surpass disenfranchised grief, offering them a public forum to ritually mourn their beloved dead celebrities. By publicly sharing their feelings, fans can build global cybercommunities that comfort them and reinforce their mutual adoration for dead celebrities. In so doing, the fans can build webshrines that fit their own individual conceptualizations of deceased stars. Reconstruction of the celebrity allows fans to be more intimate with the celebrity than they could ever be in life because they are now in control of his or her image. The images reflected in webshrines will replace the tarnished actuality that was the living celebrity, thus immortalizing a generation of larger than life entertainers.

In returning to the webshrines I had studied in spring 1997 for a panel at the annual conference of the International Communication Association, *After-Life as After-Image: Death, Fame and Fandom* (Andsager, 1997), I found that many of the originally cited shrines had disappeared completely. (In searching for specific phrases via Internet search engines, I was unable to locate many of these shrines. Some had moved from their original locations but were still maintained and updated.) Unfortunately, there is no way to learn when or why most of them were no longer maintained. Did the fans who participated in these webshrines negotiate the stages of grief and decide it was time to move on? Perhaps the maintenance of a webshrine for a period of time serves the same purpose as keeping a deceased loved one's clothes in the closet; it provides a tangible reminder of his or her existence. In socially recognized or "enfranchised" grief, individuals realize that though their beloved is gone, he or she will live on in memory. The nature of celebrity makes one wonder, though, if fans reconciled their grief over a deceased idol or shifted their attention to a new focus, as fame tends to be fleeting.

The webshrines that remain, however, appear to be regularly updated, with more recent comments on the guestbooks. It is not clear why certain shrines are maintained; no pattern seems to appear in terms of the magnitude of celebrity, means of death, or length of time elapsing. The most consistent theme in the ongoing webshrines is the transformation or resurrection of celebrities into godlike creatures. Such beings never die, after all. Perhaps these cybercommunities are indeed the "true" fans.

The fact that the webshrines are created, often in the face of strong emotion, supports the notion that we as individuals need to share our grief, and, more

importantly, to have that grief acknowledged by like-minded others. In doing so, webshrines can render disenfranchised grief acceptable, public, and empathetic— much like traditional, socially sanctioned mourning. Whether the pages are maintained "eternally" or not, they serve a vital function in negotiating the initial shock of a beloved celebrity's death and surpassing early stages of disenfranchised grief. The shrine aspect of the tribute page is an important one because, as celebrity is magnified and purified, it offers evidence that there are aspects of the sacred in our adoration for dead celebrities. If celebrities become immortal, superlative beings, they share characteristics inherent in supreme deities. This dead-celebrity worship suggests that an entertainment culture may mimic a religious culture. Indeed, in the United States, at least, grieving has tended to move to a secular nature in the past few decades (Stephenson, 1985), in part due to the social contexts that shape people's judgments about appropriate mourning and acceptable time frames for grief. Kamerman noted two trends in public mourning at the end of the twentieth century: deritualization, reflecting an "increasing irrelevance of the dead," and rationalization, managing grief as a business-like function (in the planning of a funeral, for instance) (1988, p. 87). If webshrines to dead pop stars can affect society's negotiation with death and attitudes toward the grieving process, perhaps death will begin to regain its importance and grief its acceptability.

As celebrity suffuses more and more facets of our society, the knowledge of how and why individual fans deify dead entertainers becomes vital in understanding our ability to negotiate the cult(ure) of celebrity. Moreover, the technological aspect of cybercommunities may challenge our styles of mourning and in turn our understanding of the grieving process.

References

Aaliyah online: Tribute to an angel. (n.d.). Retrieved October 7, 2002, from http://www.aaliyah online.com/frames.html

Alex's guestbook. (n.d.). Retrieved October 7, 2002, from http://two.guestbook.de/gb.cgi?gid= 94266&prot=&eid=21058&dir=gt

An everlasting starlight: Andy Gibb. (n.d.). Retrieved October 10, 2002, from http://devoted.to/ AndyGibb

Andsager, J. (1997, May). Altared sites: Celebrity webshrines as shared mourning. In D. Eason (Chair), *After-life as after-image: Death, fame and fandom.* Symposium conducted at the annual conference of the International Communication Association, Montreal.

Chayko, M. (2002). *Connecting: How we form social bonds and communities in the internet age.* Albany: State University of New York Press.

Costigan, J. T. (1999). Introduction: Forest, trees, and internet research. In S. Jones (Ed.), *Doing internet research: Critical issues and methods for examining the net* (pp. xvii–xxiv). Thousand Oaks, CA: Sage.

Doka, K. J. (1989). Disenfranchised grief. In K. J. Doka (Ed.), *Disenfranchised grief: Recognizing human sorrow*, pp. 3–12. New York: Lexington Books.

Dyer, R. (1993). *The matter of images: Essays on representations*. London: Routledge.

Elvis-Fan-Guestbook. (1997). Retrieved September 7, 2002, from http://www.presley.de/elvis/guestbook/oldguestbook1.htm

Ewen, S. (1988). *All consuming images: The politics of style in contemporary culture*. New York: Basic Books.

Fernback, J. (1999). There is a there there: Notes toward a definition of cybercommunity. In S. Jones (Ed.), *Doing internet research: Critical issues and methods for examining the net* (pp. 203–220). Thousand Oaks, CA: Sage.

Gamson, J. (1994). *Claims to fame: Celebrity in contemporary America*. Berkeley: University of California Press.

HitEmUp.com—The official unofficial Tupac site. (n.d.) Retrieved October 5, 2002, from http://www.hitemup.com/history.html

Joey Ramone Memorial. (n.d.). Retrieved October 10, 2002, from http://www.cbgb.com/shrine/joeyramone/letter2.htm

Jones, S. (1995). Understanding community in the information age. In S. Jones (Ed.), *CyberSociety* (pp. 10–35). Thousand Oaks, CA: Sage.

———. (1998). Information, Internet and community: Notes toward an understanding of community in the information age. In S. Jones (Ed.), *CyberSociety 2.0* (pp. 1–34). Thousand Oaks, CA: Sage.

Kamerman, J. B. (1988). *Death in the midst of life: Social and cultural influences on death, grief and mourning*. Englewood Cliffs, NJ: Prentice Hall.

Kauffman, J. (1989). Intrapsychic dimensions of disenfranchised grief. In K. J. Doka (Ed.), *Disenfranchised grief: Recognizing human sorrow* (pp. 25–29). New York: Lexington Books.

Kollar, N. R. (1989). Rituals and the disenfranchised griever. In K. J. Doka (Ed.), *Disenfranchised grief: Recognizing human sorrow* (pp. 271–286). New York: Lexington Books.

Kübler-Ross, E. (1969). *On death and dying*. New York: Macmillan.

Lone Memorial. (n.d.). Retrieved October 11, 2002, from http://www.geocities.com/SunsetStrip/8761/memorial.htm

Mandelbaum, D. G. (1959). Social uses of funeral rites. In H. Feifel (Ed.), *The meaning of death* (pp. 139–217). NY: McGraw-Hill Book Co.

Michael Hutchence Tribute Page. (n.d.). Retrieved October 10, 2002, from http://www.geocities.com/SoHo/Cafe/6297/mike.htm

Pike, M. (1980). In memory of: Artifacts relating to mourning in nineteenth century America. In R.B. Browne (Ed.), *Rituals and ceremonies in popular culture* (pp. 296–315). Bowling Green, OH: Bowling Green University Press.

Sapolsky, R. M. (1994, November). On human nature: The solace of patterns. *Sciences*, 34(6), 14–16.

Schickel, R. (1985). *Intimate strangers: The culture of celebrity*. Garden City, NY: Doubleday.

Shining star: Andy Gibb. (n.d.). Retrieved October 7, 2002, from http://www.geocities.com/Hollywood/Lot/3813

Shneidman, E. S. (1973). *Deaths of man*. New York: Quadrangle/The New York Times Book Co.

Stephenson, J. S. (1985). *Death, grief, and mourning: Individual and social realities*. New York: Free Press.

The River Phoenix Pages. (n.d) Retrieved October 14, 2002, from http://www.chez.com/aleka/

Walter, T. (2001). From cathedral to supermarket: Mourning, silence and solidarity. *The Sociological Review*, 49, 494–511.

chapter 3

Flaunting It

Style, Identity, and the Social Construction
of Elvis Fandom

My favorite scene in Quentin Tarantino's *Pulp Fiction* is actually a scene that was never included in the theatrical release, but one that is available on DVD and video. In the scene Uma Thurman (as the quirky wife of a gangster) aims a camcorder at John Travolta (her "date" for the evening), while he sits and waits for her to enter her downstairs living room. For a few moments the audience is allowed to focus on Travolta through the eyes of the camcorder, which, when held by Thurman, is destined to arrive at a pop culture truism. "People can be divided into two types," she states; "they are either Elvis people or Beatles people." The camera then scans Travolta's torso, thereby allowing us as viewers to contemplate this claim while observing his pointy black shoes, his snug black pants, his tailored jacket, his skinny tie and white shirt, his slightly greased shoulder-length hair, his slouching posture. As the shot concludes we hear Thurman state with clear-cut assurance: "You. You are *definitely* an Elvis person."

This brief but noteworthy scene offers a specific kind of credence to the lengthy restaurant sequence (that would have followed); the infamous sequence that culminates with Travolta (and Thurman) doing a wicked twist to Chuck Berry's "You Never Can Tell." In light of the unreleased footage, what becomes most noteworthy is not only Travolta's Elvis-inspired clothing style, but also his Elvis-related moves: as Elvis-Person he devises a twist that is both deadly serious and a parody of itself, a twist that is so provocative that it manages to blend the

original "steps" with one of the great forgotten dances of the 1960s, The Batman. Whereas a Beatles person might have given us a winsome yet slightly serious twist, Travolta confronts the boundaries of seriousness and superficiality head on, and in so doing contrives a dance that is itself contrived (but not fake), funny (but not laugh-inducing), self-consciously kitschy; and yet he's unconcerned as to what others may think. In essence, in *Pulp Fiction* Travolta qualifies as Elvis-Person because he embodies the kinds of rich contradictions that permeate the mythological figure of Elvis.

Because this image of Elvis-Person also offers a clever counterbalance to media representations of Elvis-Person-As-Fool, I want to use the anecdote as a means for introducing and illustrating a more specific idea. Travolta-as-Elvis-Person possesses many of the stylistic traits and attitudes that are apparent among young (18–29-year-old) *British* Elvis fans, in particular those fans that express their allegiance to Presley through elaborate dances, extraordinary fashions, and methodical physical codes. At the same time, British fans cannot be reduced to a simple analogy. Like many fan cultures, British Elvisans are a dynamic and complex group, one whose members have developed intricate ways of organizing and interpreting their position(s)-*as*-fan(s). More specifically, young British Elvis fans act as mythologists in that they have sanctioned particular myths regarding Elvis— while downplaying and/or ignoring others—and they have incorporated these myths into their everyday lives. As I will explain, British fans utilize certain class-cultural myths about Elvis in ways that allow them to connect him to their group-based identity regarding what it means to be young, British, working class, and Elvis fans. In an organized manner, Elvis-related myths serve to unify a broad range of seemingly contradictory activities, including but not limited to serious musicological writings about Elvis and the development (and recontextualization) of rockabilly-inspired 1950s fashion styles. As ritualized components of fandom, these activities operate coherently through homological relations to reflect a kind of "subcultural embracement" of the "methods" Presley employed to maneuver class relations to suit his own needs. For these reasons then, one cannot discuss British fans without also taking into consideration the ways in which Presley confronted and confounded certain class/taste boundaries that have dominated American culture during the postwar era.

By way of introducing the central themes of this chapter, I want to stress that my analysis is based on an investigation of fan activities that have occurred posthumously, in Elvis's "absence." Indeed the themes that are most central to contemporary Elvis fandom—class, "individuality" via subcultural style, and spirituality—interlock so brilliantly because the life story of Elvis offers a signifying parable about how it was possible for a "truck driver from Tupelo, Mississippi," to consistently exist in a number of polarized worlds at once, thereby defying the

kinds of power relations and practices that might have otherwise placed a stranglehold on one's social and cultural ascendancy. While this study does not attempt to answer the question of why a dead celebrity such as Elvis appeals to fans that were born during or after the year of Elvis's death, it is significant that a majority of the young fans that I studied did not experience the Elvis phenomenon first hand, so to speak, but instead as it has existed, in "afterlife."[1]

For those who have attended the many fan-related festivities in Memphis, these claims present no startling revelations. However, for those who are unaccustomed to witnessing Elvis-inspired fan rituals these claims may indeed be revelatory, especially when giving consideration to the ways in which such events offer explicit methods for alternately denouncing and glorifying the most potent Elvis-myths, methods that are especially noteworthy because of the ways in which mythic articulations are constructed by "Elvis celebrities," methods that indeed would not have even been laudable during the years of Presley's performing career.

For young Elvis fans, in particular, one of the central rites of passage occurs each year during "Elvis Week" in Memphis at a day-long, August 16 tribute ceremony at the University of Memphis, where fans gather in an auditorium to listen to the testimonies of many of Elvis's closest friends and acquaintances, including members of the Memphis Mafia and musicians who recorded with Presley.

Among the invited guests at one of the tributes was author and Elvis expert Dave Marsh, a somewhat uncustomary choice because, while he had experienced the King via rock and roll, films, and other media, he did not know Elvis personally. Chosen presumably because he was already speaking at a University of Memphis–sponsored conference on Presley, Marsh bounded to the podium to announce, "I'm here today to say, 'Elvis is dead. He won't be around in the twenty-first century.'" Marsh then appeared to be startled as fans were unwilling to allow him to immediately qualify his remarks; they responded with loud outbursts of disapproval. Who was this foreign demon?

As chants of, "We Know He's Dead!" resounded throughout the auditorium among fans of all nationalities, a befuddled Marsh went on to attempt to explain that his intentions were noble. He was there to disqualify certain scandal-ridden press reports, and in so doing he intended to "wake up" fans by supplementing their myths with a pragmatic, yet still mythical point of view. In Marsh's terms, Elvis as "mystical" figure should not be grounded solely in metaphors regarding "what he means in death," so to speak, but rather fans should consider broader implications regarding what Elvis represents "in life": the American Dream, liberalism, social justice, and the "spirit" of New Deal.[2]

While these were myths that many fans had already incorporated into their social rituals, what Marsh did not understand was that on "death day" it was insulting to be reminded that Presley was, well, indeed dead. Thus, at the begin-

ning of the lecture, as he stumbled embarrassingly through the first few sentences, some fans arose and stated, "We're going to Graceland!" One angry woman even stood, front row center, and announced to the audience: "He's *not* dead!" As Marsh learned on that day, there are some places where, despite all good intentions, you just don't spit.

When Sam Phillips followed, he took the stage in the style of a Pentecostal minister, screaming:

> These writers! Well, they mean well, but they didn't know him! You people know him! I knew him!

> We are here today to talk about a real, *true* spiritual human being! You fans, you make up the heartland, no matter where you are from. You understand Elvis! You know about Elvis! You will champion Elvis' spirit until the day you die! By God, I want to make sure that history records this man like he should have been recorded! I knew this individual, and not just his nose and eyeballs, I tell you! I knew what was inside of him, from the top down. No writers can tell me about the mystique of Elvis! His goodness was transcendental! His frailties transcended human flesh! You people know this! You understand it![3]

As he spoke the fans went wild, cheering him on, applauding, collectively standing to show approval. Yes, here were a series of death-myths that *truly* resonated with them.

While others also spoke on that day it was Phillips who scorched the ceiling; it was Phillips who—because of the way he connected Elvis-myths with the already cherished myths of the mythmakers—held the most sway; he was the speaker who had the crowds charging the stage afterwards. For he suggested forthrightly that they too are of the same flesh as Elvis; they too are of the same social ilk and class; and because of these connections they are privy to a special understanding of the mystical-Elvis; they are allowed a spiritual connection, as opposed to the "writers" who use the term "death" too loosely; woe unto them. Adoration is *not* blind. And fan worship is *not* the worship of fools. These are powerful lessons for young fans.

In this chapter I present a scheme that identifies some of the most potent features of young (18–29-year-old) British Elvis fans. In order to provide a more comprehensive analysis, I compare the subcultural fan club styles and rituals of British-based Elvis fan cultures with those that are most common to fan cultures in the U.S. In turn, I explore the reasons that various U.S. and British Elvis fan cultures embrace vastly different themes in Elvis's life/career (the "1950's Elvis," the "Vegas Elvis"), and in doing so vividly reflect differing interpretations of Presley's expressions of American class contradictions. In the last section of the chapter I analyze press accounts of Elvis fandom to demonstrate that even as Elvis fans no longer pose explicit, collective threats to social order, their public displays suggest to the media a kind of insurgent insurrectionism that is so powerful that it must be

normalized through descriptions that depict the fan as buffoon, the fan as "other," and fandom as pathological.

Description of Study

From 1988 to the present I have interacted with members of the *We Remember Elvis* fan club, which is based in Pittsburgh, Pennsylvania, yet maintains membership bases in states such as Ohio, Indiana, and Illinois. In 1994, I posted a request in the club's *We Remember Elvis* newsletter, asking readers to respond to a series of questions regarding the impact Elvis has had on their lives. I also asked fans to provide details regarding the "particular Elvis" (1950s/rockabilly, 1970s/Vegas, etc.) that they found most appealing, and I asked for information regarding age, race, gender, and income level. I received twenty-four responses that directly addressed all pertinent questions and issues. Of these twenty-four, all respondents identified as Caucasian; eighteen identified as women; six identified as men; eight indicated a yearly household income of $25,000–$29,000; nine indicated a yearly household income of $30,000–$34,000; five indicated income of $35,000–$39,000; and two indicated income of $40,000–$44,000. Three respondents ranged in age from 25 to 29; seven respondents ranged from 35 to 39; twelve ranged from 40 to 44; and two ranged from 45 to 49.

From 1988 to 2001 I attended fan club conventions in Illinois and Ohio, where I interacted with fans and conducted forty-four interviews (based on the same questions posted in the newsletter). In many cases, I also presented fans with a more extensive printed questionnaire, and as a result received fourteen mail-in responses that addressed all questions and issues. Of these fifty-eight interviews and responses, thirty-seven identified as female; twenty-one identified as male; and all identified as Caucasian. Five respondents did not provide income; five indicated a total household income of below $25,000; twenty-two indicated a total household income of $25,000–$29,000; twenty-four indicated $30,000–$34,000; and two indicated $40,000–$44,000. One interviewee/respondent ranged in age from 21 to 24; three ranged from 25 to 29; six ranged from 30 to 34; four ranged from 35 to 39; thirteen ranged from 40 to 44; twenty-four ranged from 45–50; and seven ranged from 51 to 55. Based on observations at all U.S. fan club events that I have attended, I estimate that the general age range is typically from 35 to 50.

During the summers of 1989, 1990, 1991, 1994, 1997, 2000, and 2001, I interacted with British fans that came to the United States by way of tours that were organized by Todd Slaughter and the Official Elvis Presley Organization of Great Britain and the Commonwealth. In turn, between 1994 and 2000 I interviewed forty-two fans, and corresponded regularly by mail or email with sixteen fans. Of

these fifty-eight fans, thirty-one identified as male and twenty-seven identified as female. Ten identified in the 18–20 age category; sixteen identified as 21–24; twenty-eight identified 25–29; and four identified as 30–34. All fans identified as Caucasian. In accordance with standard polling terminology used by the British government, I asked participants to identify by labor division. Thirty-three identified as C1 (non-manual jobs); twenty-two identified as C2 (skilled manual); and three identified as D (semi-skilled).

While there are an abundance of British Elvis fans that are above the age of 35, for the purpose of this study I specifically targeted fans that were below the age of 30. Also worthy of noting is the fact that I have never interacted with British Elvis fans that have identified in the government-defined A or B class occupation categories. For the sake of clarity, it should be noted that one's perception of social class might differ from government-imposed definitions of class. Nonetheless, all interviewees identified, in one way or another, as "working class."

In addition to gathering structured interview data, I have also attended yearly British fan club parties in Memphis, Tennessee, and Tupelo, Mississippi, where I have conducted numerous unstructured interviews. In order to broaden my understanding of British fans, I have subscribed to this group's monthly fan magazine, *Elvis Monthly*,[4] and I have talked with fan club organizers and tour administrators.

In addition to conducting interviews and researching fanzines, I have also had numerous experiences that have allowed insight into the social construction of Elvis fandom. I have had conversations with members of both fan groups while attending fan-organized social gatherings, Elvis-related events at the University of Memphis, Elvis film and video festivals, and Elvis Week activities (candlelight vigils, auctions, fan meetings). From 1989 to 2001 I have also attended yearly tributes at Elvis Presley's birthplace in Tupelo, Mississippi, and impersonator contests in Memphis, Tennessee, and Chicago, Illinois. In addition, I have attended and participated in a number of academic conferences on Elvis, and I have served as a source of information for foreign journalists that have written about the Presley phenomenon. Along related lines, from 1995 to 1999 I served as a research consultant for Butterfield and Butterfield of San Francisco, where I researched and appraised one of the largest assembled collections of items belonging to Elvis Presley. Part of my duties included interviewing fans to determine their preference for particular items as well as the prices they were willing to pay for items. In addition to the above, I have talked with and interviewed a new sector of Elvis "stylists," Elvis *interpreters*—young males (18–24 years old) who provide audiences with modern rap and rock interpretations of standard Elvis songs. I have also viewed Elvis's films, documentaries on Elvis, and videotapes of Elvis's concerts.

While my experiences, interviews, and interactions do not allow for the same kinds of deductions that a random sample might provide, they do permit significant inferences about the kinds of social rituals and styles that have consumed particular groups of Elvis fans. And because my interviews were often *necessarily* constructed from the perspective of a fan as well as a scholar they have allowed participants to *openly* discuss their fan-related experiences and to respond to questions in an arena where trust was established through mutual commitments to fandom. In taking Norman Denzin's methods of participant observation seriously, I used to my advantage personal, fan-related characteristics that I possessed as a way to enhance observational activity (1970, p. 162). This approach was particularly useful, as I will discuss below, because Elvis fans are generally dismissive of scholars and journalists as a result of having been subjected to contemptuous coverage in news and other media.

In analyzing interview transcripts, I utilized Bruyn's (1966) method of identifying "consensus" to note instances where individual meanings converged thematically to correspond with group expressions demonstrated at fan gatherings and in fanzines. In addition, following Cohen's (1991) method for analyzing "frameworks of relevancy," I noted instances where respondents indicated the reasons that their social/cultural backgrounds/interests intersected with mythic interpretations of Presley that circulate in fan groups.

While Denzin's, Bruyn's, and Cohen's methods have proven appropriate for my analysis, I should also point out that studies of Elvis fan cultures are not without problems. When one presents oneself as an Elvis fan one is granted a certain amount of social acceptance at Elvis events. However, when that same person mentions academic credentials or forthcoming studies on Elvis, the person is often viewed with a certain amount of mistrust. For example, Elvis researcher John Strausbaug found that his biggest hurdle was persuading participants that he was not going to "mock them" (1994, p. 46). I experienced a similar dilemma when I placed an ad in several fanzines in an attempt to correspond with fans. The responses I received were cautious and several made references to journalists who have belittled fans. Thus, from that point onward my goal was to develop a bond with fans through discussing Elvis-related topics and through casual conversations over a period of several years *before* requesting interviews.

A Note on Interpretation

It is important to point out that while I operated from the position of "fellow Elvis fan," I hardly qualify as a "fanatic." Likewise, I was often not of the same age group

as some of the fans that I studied, nor am I British. In addition, because of my cultural capital it was not possible for me to identify as "working class." At the same time, I was able to "get inside" the groups that I analyzed because I regularly participated in fan club events, and because there was a bond established through shared interests. Put simply, as Elvis fan, music journalist, and popular culture researcher, I had enough knowledge to talk the talk. I also grew up in Tupelo, Mississippi, and fans' knowledge of this fact gave me a particular stamp of approval. My point is that my studies would not have been as productive if I had simply acted, first and foremost, as a researcher.

Because this chapter is part of a much larger project, I have chosen to offer a descriptive analysis that requires that readers investigate on their own some of the more intricate aspects of the theories that I employ. One of the goals of the paper is to illustrate how theories of mythmaking (Roland Barthes), subculture theory (Dick Hebdige), and post-subculture theory (Sarah Thornton) can operate as guideposts for understanding those Elvis fans who self-identify as working class. In constructing my analysis I chose not to hold up subculture studies as a theoretical straw man that is there only for the kicking, but rather to show which features are appropriate and transformable when studying phenomena that are not indicative of subcultures per se, but instead function as taste cultures with subcultural dimensions.

My analysis is also guided by an understanding of Foucault's work on power, in that class is not viewed as a supercategory under which all other identities are subsumed, nor is power considered in every instance to be a direct and always oppressive force. For example, in reacting to Elvis fans the press and other dominant systems do not function in unilateral ways only to usurp the power of subcultural fans. In fact even those press reports that frame Elvis fans as "deviants" often have liberating effects on fans and the knowledge that circulates among fan groups. At the same time, what we "know" about Elvis, as a result of press reports and numerous other media sources, has a bearing on how we view fans, how we regulate their behaviors, how we censure and castigate them through social means.

To understand Elvis fans, then, one must study how combinations of discourse and power have produced a wide range of concepts regarding Elvis and race, Elvis and class, the activities of Elvis fans, the *ways fans view these activities*, *the way fans perceive* cultural constructions of social class, and so forth, and how the myths that intertwine with these concepts have real effects for fans and observers of fans alike.

Even though I do not dwell at length on the underlying theoretical guideposts of this paper, accustomed readers will realize a model that, while not denying that dominant cultures are often in positions of dominance, shifts attention to localized circuits, tactics, and mechanisms through which power circulates (Foucault, 1977,

p. 27). These points in mind, I describe those structures of meaning that are systemized through the dynamic social processes of those fans who have created and/or interpreted texts relating to Presley (including not only the songs, films, and television clips, but also the books, fanzines, artifacts, shrines, newspaper reports, tabloids, etc. that are appropriate to this kind of analysis).

Elvis Presley and the Development of Fan Cultures

Through interviews and participant observation studies, I have ascertained that Elvis fandom is a highly contested cultural category, one that is rife with contradictions. Moreover, my research suggests that fandom requires a highly charged emotional investment, one that is an empowering feature of everyday life, one that can only be understood in its own terms from within its own contexts.[5] Thus, in drawing on a cultural studies perspective, I want to argue that Elvis Presley and the fan cultures that have embraced him are ripe for cultural analysis because of their intertextuality; they have the ability to generate a potentially infinite range of culturally inscribed meanings. In analyzing Presley and his fans, then, it is the *process* of meaning-construction that must be stressed because there is no final product; no piece of the Presley puzzle contains an independently available set of codes that we can consult at our own convenience; even the myths surrounding Elvis connect in context-specific and contingent ways.

In giving consideration to the implications that subcultural theory (Cagle, 1995) has for an analysis of Presley and his fans, I want to argue, first, that Presley is to be viewed as a cultural politician whose personal forms of bricolage and explicit celebration(s) of class derivations positioned him as a threat to exclusionary class-cultural policies that dominated the United States between 1955 and his death in 1977. Second, his fans, although dispersed across age groups, geographical areas, and contextual boundaries, can be viewed as social actors who have—depending on the time frame/year/decade and context under consideration—symbolically confronted the class-cultural systems that operate to restrict their participation in dominant discourses.[6] To be more specific, in a manner that is extremely subcultural, these fans have frequently engaged in the practice of bricolage and at times they have symbolically resisted cultural prescriptions for class subordination.

While Dick Hebdige's (1979) work on British youth subcultures and my own retheorizing of his work (Cagle, 1995) serves as a basis for fan analysis in this study, "subcultural fandom" refers to the methodical practices of lay theorists (members of fan cultures) who utilize commerce (Elvis paraphernalia, commercial styles) to solidify group identity. The fans that I examine represent subcultural taste cultures that are underpinned by social class and heavily marked by overindulgence in con-

sumerism. For example, Elvis fans replace traditional apparel with uniforms that, while directly or indirectly supporting the profit motives of institutions such as Elvis Presley Enterprises, announce a sense of self-affirmation; their visual styles proudly "out" their social status. Subcultural fans have little concern for what others might think; they "wear their fandom" on their shirtsleeves. Seen in these ways, Elvis fans do not mark the politics of fandom per se, but the aestheticization of politics.[7]

Through hybridizing styles out of images of Elvis and the material culture available to them, fans construct identities that grant them some sense of relative autonomy outside of the restraints of social class and education. Elvis-based styles represent to the press and the general public a kind of doubly ironic "cultural tarnish": not only do fans explicitly announce connections to the hillbilly Elvis, but they also demonstrate that *all* manifestations of Elvis are to be taken seriously. In a number of ways, fans commit cultural treason.

In giving further consideration to the social construction of Elvis fandom, I will first examine some of the myths that Elvis encompasses, keeping in mind Gilbert Rodman's argument that "Elvis is not (and never has been) a completely blank slate on to which fans and critics can simply write their own stories" (1994, p. 458). Likewise, as Dave Marsh contends, "no one myth is large enough to contain Elvis" (1982, p. xiii).

Elvis and Myths

Elvis as mythologist represents an amalgamation of socio cultural paradoxes. He emerged from a position of class subordination that allowed him to draw on black and white working class subcultural styles of the 1940s and 1950s. In turn, he came to represent a composite of subcultural signifiers: black blues, black rhythm and blues, white country and western, and gospel. In the process of developing densely interdependent relations between these musical forms, his style challenged and thereby transformed *cultural conversations* regarding what was and wasn't acceptable to 1950s mainstream-taste publics. (Country music was not a staple of 1950s variety television, and when artists such as Eddie Arnold did make the occasional television appearance, they were rarely considered "threatening." In race-conscious America however, the combination of country, rhythm and blues, blues, and gospel represented cultural defilement, even as this combination had been common in non-mainstream, Southern working class black and white music cultures of the 1930s, 1940s, and 1950s.)

In a corresponding manner, Presley acted as stylistic bricoleur and subcultural provocateur by recontextualizing various clothing styles. For example, he wore suits (the trademark of pop singers), but he combined oversized and often flamboy-

ant country and western jackets with the kind of open-necked, bold-colored shirts and slim-fitted, peg-legged trousers that were associated with rhythm and blues singers. In addition, Presley recontextualized certain body movements by combining the fervent "moves" that were customary to Church of God ministers with a dance style that many perceived as being "sexual." However, he publicly admitted that his visual representations were based on inspiration that simply "came to him" as a result of having grown up in Pentecostal churches; and when questioned about the sexual prowess of his gyrations, he always replied that this was simply the "way he danced ." (Here we find a number of loaded reasons to disdain Presley, if based on class bigotry alone.) In other words, Presley was not "contriving" his dance style or "gyrations," and he was noticeably perplexed when interviewers (again, in the context of the 1950s) perceived him as being "sexual."

Operating from the position of popular subcultural bricoleur, Presley made some rather harsh demands on the straight world by forcing it to acknowledge the class-conscious contradictions that were not integral to popular cultural discourses during the "upwardly mobile" 1950s. It was not so much that Presley's class affiliation was a direct challenge to cultural hegemony; instead, the confrontation arose when he sneered at the straight world by infusing his working-class sensibilities with what can be described as satirical upper-class pretensions (e.g., Graceland's "trailer park" decor, pink Cadillacs, oversized diamond rings). Likewise, it was not so much that he used "improper English," but that he brought working-class black and white vernaculars to the forefront of American popular culture. It was not so much that Elvis was performing rhythm and blues songs, but that he combined elements from two highly demarcated racial cultures, both of which were ostracized from the dominant cultural milieu of the early–mid 1950s. It was not so much that Elvis's jackets were gaudy or loud or that he wore mascara and pink pants, but that given the prevailing cultural standards of the decade, he represented a confusing integration of gender signifiers: the masculine male as feminized star, the feminized "body conscious" male performer whose erotic (and "exotic") dance moves and narcissistic obsessions with appearance questioned the very naturalness of bipolar gender logics. (Likewise, few male performers in the 1950s would have dared to defend a pair of blue suede shoes, much less sing and choreograph a song that revealed a man's desire to dance with another man in a prison environment, as in "Jailhouse Rock.") It was not so much that he had a sexually aggressive image, but that this image was further confounded by song lyrics that suggested a non-hypermasculine approach to romance (e.g. "Teddy Bear," "Good Luck Charm," "Treat Me Nice"). It was not so much that both young women and men reacted in a fanatical manner to his moves; instead, bans on Presley were issued because these young people represented the triumph of choice over constraint. It was not so much that Presley sneered at the straight world when onstage; what was baffling

was the fact that he was so polite offstage. It was not so much that Presley intimated sex, but that he caused people to connect his performance with their own private feelings. As a result, the public had to handle feelings that were usually delegated to the private sphere of everyday life. In general, the issue was not that Presley was good or bad, but that he meshed the categories of good and bad, normal and abnormal, moral and immoral, ordinary and spectacular.

In these ways Presley recontextualized subordinate and dominant cultural codes of the 1950s by resisting and challenging normalizing categories of sex, gender, class, and race. In addition, he simultaneously transgressed, yet slyly celebrated, the hierarchical divisions between classes. He responded to the world around him by remapping musical and stylistic meanings that, up until this point, had not strayed too far from the property lines of the poor and the working class, meanings that—when transformed—allowed him and his fans to construct public identities that pushed against the restraints of social class, thus placing them in symbolic opposition to middle-, upper-middle-, and upper-class ideologies.

If dominant cultures required a sharp division of classes, Presley's middle-class fans suggested the possibility that working-class culture was empowering. If dominant cultures of the 1950s demanded racial segregation, Presley's fans rejected the control and normalcy of this world. If dominant cultures demanded the repression of sexual urges, Presley's fans acknowledged that sexuality could be expressed in the highly visible arena of everyday life: the dance hall, the concert hall, the street. If dominant cultures dictated the styles of youth culture, Presley's fans demonstrated that they could determine their own styles by appropriating fashions that emulated those of black and white subcultures. And into this mix came the appropriation of "improper" vernacular and the stylistic use and glorification of the color pink (an "abnormal" color, a "crass" color, and, in the context of the mid-1950s, a marker of femininity for women and an explicit marker of non-heteronormativity for men). Add to these items Presley's ability to turn exaggerated truck driver haircuts into the fan-style of the moment.

It is important to point out, however, that Elvis did not express a coherent ideological critique of racism, sexism, sexuality, and social class. He provided no overtly radical statements of political resistance. His threat was of the symbolic order. Still, his symbolic challenges and those of his fans were powerful enough to elicit contemptuous attacks by the media.

Here I need not recite all of the newspaper stories of those times, as most readers are already familiar with such accounts. Suffice it to say, however, that according to Strausbaugh:

[The media] attacked Elvis with a savagery that has not been equaled since. *The San Francisco Chronicle* wrote him off as being in appalling taste. *Miami News* columnist Jerb Rau

blasted Elvis as the "biggest freak in show business history". . . . Rau was scandalized by the way Elvis "shakes his pelvis like any striptease babe," and he scorned the fans as "idiots." (1994, p. 26)

Similarly, Elvis fans were also represented as insubordinates, enemies, buffoons, cultural dopes, threats, hooligans, uncontrollable youth, pathological maniacs, delinquents, and finally, simply as crazy kids.

However, in the long run such criticisms were short-lived. By the late 1950s it was difficult to sustain the image of the monstrous Elvis because, after all, he had joined the army and had recorded several lush ballads. In turn, reporters and other journalists reacted in a manner so as to alleviate many of the alarmist attitudes that they had generated. In particular, from 1958 to 1961 the denigration of both Elvis and his fans diminished as the press revealed him to be an all-American soldier, a patriot, the boy next door, the star of lightweight movies, the charming bachelor, the charitable star. Meanwhile, in order to keep the bank rolling while Presley was serving in the army, Colonel Tom had Elvis record a number of sentimental love songs, thus adding fuel to this increasingly "safe" image. In addition, the "safe Elvis" was uniquely charged by the music industry's embracement of performers such as Dion and Fabian, mild-mannered vocalists who were markedly similar to Elvis in terms of hair and clothing styles, but who possessed none of the onstage pizzazz and sexual munitions. Hence by the early 1960s, as these trends multiplied, Presley was incorporated even further into mainstream culture, mostly as a result of the kind of treatment he had received by his management and the press, but also due to the changing sociocultural climate and his contractual willingness to continue performing in B-movies (with the underlying hope of landing a serious role).[8]

Even so, incorporation was not one dimensional, so to speak, for throughout the 1960s Presley was disdained for being the highest-paid star in Hollywood, he was chided by Hollywood's elite, and the fact that he "never put on airs" remained an issue, especially for those who thought of Graceland as nothing more than a glorified trailer with Wal-Mart décor. His continued infatuation with gaudy jewelry and Cadillacs also didn't help matters.

During the 1960s, however, Presley's U.S. fans were not subjected to contemptuous treatments in the press.[9] In fact only *since Elvis's death* have we seen the resurgence in media reports of similar kinds of derisive definitional frameworks as those that were constructed during the 1950s. Does this seem odd? On the surface, one could easily argue, yes.

During the past twenty-five years U.S. Elvis fans have increasingly tended toward absolving many of the most blatant cultural contradictions posed by Presley. Indeed the majority of U.S. fans that I have interviewed and studied, no matter their age or geographic location, make reference to the "real Elvis" and to the

notion that they can only come to know this Elvis by scouring *all* sources relating to Presley and selectively pulling together particular "facts" that justify a certain kind of "positive image." Opinions, observations, and claims that stand in opposition to this mythological image are viewed with suspicion and are therefore denounced. (For example, Elvis's addiction to pharmaceutical drugs indicated that he was vulnerable to external sources and thus "human.")

Unquestionably, my observations at Elvis conventions and during Elvis Week suggest that out of all the possible "Elvises" to choose from, U.S. fans embrace the Vegas Elvis/1970s Elvis above all others. For example, among eighty-eight responses that I received from fans, seventy-six stated that the "Vegas era" is the period of Elvis's career that they identify with the most (nine referenced the Sun years, and three referenced the 1950s RCA years). This data is supported, albeit loosely, by a 1989 *Elvis International Forum* questionnaire that asked the question, "What time in Elvis's career appealed to you the most?" Of all twenty-four printed responses, twenty-three revealed that the concert years of the 1970s were most appealing.

Furthermore, in contemporary times, many U.S. fans have *de*-emphasized Presley's black musical heritage, his flamboyant visual incorporation of "black style," his cultural vulgarism, and his outrageous assaults on the boredom and repression of the 1950s. As most U.S. fan journals will attest, Presley is to be viewed as sexual but not explicit, handsome, altruistic, a good Southern boy, godlike, religious, the greatest singer of all time, and a gentleman. What is most interesting about my findings is that while cultural critics have often forwarded the argument that Presley represents a kind of contradictory embodiment of the American Dream, what has not been addressed is that in recent times U.S. fans often subtly disregard some of the most glaring contradictions posed by Presley. However, at the same time, such sublimation must be understood as a paradox with roots in mythic affirmation, one that relates not to willful ignorance but to fans' reactions to the very images in media that they consider so unpardonable. In fact, along these lines, Lynn Speigal has made the interesting point that:

> [Fans'] knowledge is dependant upon the very media images they deplore—the pulp biographies, magazine articles and tabloid rumors that circulate about Presley. . . . But even if the fans often rely on mass media to make their own histories of the King, they still argue that their memories of Elvis are more authentic than the stories told in the sources they use. (1990, p. 183–184)

Several years after Presley's death, Greil Marcus reminded me that "Presley represents the same range of rebelliousness and conformity, brilliance and drabness, that encompasses all of American popular culture. Presley *was* contradictory, but fans

are always selective" (Personal communication, August 7, 1982, "Elvis Experience '82," Memphis, TN).

For our purposes then, given these observations, the question becomes: if U.S. fans, in particular those in the Midwest, have tended toward "normalizing" the radical Elvis then why do they continue to receive the same kind of contemptuous treatment that fans were victim to during the 1950s? Why are Elvis fans *still* interpreted as hooligans and as harmless buffoons by the media? What's so unusual or threatening about celebrating a man who represents freedom, Christianity, decency, and democracy? As I will demonstrate, although the meanings that are integral to fandom have shifted greatly since the 1950s, fans' disconcerting style(s) still mark them as threats, if not menaces, to public order.

U.S. Style at Fan Gatherings and During "Elvis Week"

It is important to understand that even though U.S. fans have gravitated toward the "philanthropic Elvis," for the most part they are self-conscious about connecting their visual styles to a particular version of what is perceived to be "Elvis's class consciousness." When examining fanzines, for example, on page after page, one will note that fans write about Presley's refusal to abandon the tastes and values associated with his upbringing. In particular, the Vegas Elvis is considered extraordinary because his jumpsuits, oversized rings and necklaces, pink-tinted aviator glasses, and cheap satin scarves are considered a reflection of his rejection of mainstream standards regarding conventional show-biz attire. For fans *his* jumpsuits represent *gussied up* jumpsuits, but *jumpsuits* nonetheless. Again, we are reminded of the earlier remark, "Elvis never put on airs."

The embracement of this particular mythic form of the roots-based Elvis spills over into U.S. fan styles, which demonstrate through explicit means identification with the "gaudiness" of Elvis. For many U.S. Elvis fans, "tackiness" translates as a method for coherency: fans overindulge in styles that reflect "the gaudy" because these offer material means for acknowledging Elvis's ideological refusal to concede to middle-class norms regarding "correct" dress styles. In fact, a majority of the fans that I have interviewed demonstrate no shame when reflecting on the ways in which media and the general public perceive their styles and attitudes as being indicative of *bad taste*. (To be sure, it also doesn't take a sociological interpreter to explain the taunts of those Memphis citizens who drive by Graceland during Elvis Week, gawking at fans' outfits, and then screaming: "Losers!" "Freaks!" "Hillbillies!" "Crackers!" Also, as we will see, a primary focus of media is fans' [lack of] "taste.")

However, unlike the British, who explicitly announce a direct correlation between the 1950s Elvis and their class-oriented styles and rituals, U.S. fans do not

offer the same kinds of analytical connections. U.S. fans *are* self-reflective, but their focus is on a surface approach to visuals that indicates admiration for a star that always remained true to grassroots principles.[10] As I will explain, U.S. fans reveal their "lapse of taste" by decorating themselves and their surroundings with "too many" Elvis objects. In this regard, they are proud of the ways in which they exploit the boundaries of class bigotry.

While U.S. fans do not demonstrate the kind of relation to rock and roll–oriented style that the British do, U.S. fans do reveal a sense of stylistic unity that is unrestrained by the ideological restrictions of the middle classes. U.S. fans combine items that otherwise "oughtn't" go together and in so doing they challenge prevailing conceptions of taste. Particular fan clubs wear self-styled matching T-shirts that display photographs of the Vegas Elvis or the name of their fan club. They value the possession of Elvis-related objects and they cherish mass-produced objects such as posters, lighters, and Elvis clocks. In addition, they often recontextualize commercial, Elvis-signified objects by wearing "too many" Elvis buttons or by draping Elvis-styled jewelry around their necks and arms. Along similar lines, many of them reinvent their automobiles and vans by painting Elvis murals on the doors and trunks, and by attaching license plates that announce allegiance to the King. Some automobiles present declarations, such as "On the seventh day, God created Elvis."

The most dedicated also engage in other kinds of bricologic activities. They take the raw materials provided by Elvis Presley Enterprises and they construct "Elvis rooms" and shrines that contain an abundance of posters, paintings, statues, books, records, and other Presley paraphernalia. They exchange and sell objects that *they* have determined as valuable: Elvis-related board games from the 1950s, personal photos, clothes that *they* wore to Elvis's concerts, pieces of Elvis's clothing, locks of Elvis's hair, and carpet from Graceland. As Elvis researcher, Mark Fenster explains:

> To wear an Elvis t-shirt, to fashion one's bedroom walls with a particular Elvis poster, to wear long, Elvis-like sideburns is to make a statement defining one's self, to construct a meaning out of the object beyond its material, commodified composition. Purchased commodities, self-produced objects (drawings, photographs, appearance, etc.), attendance at conventions, visits to Memphis and Tupelo, and other ways of expressing this self-identification, together form a method of self-identification similar to the activities of most subcultural groups. (1989, p. 14)

Like participants in any regimented organization, U.S. fans also engage in group-based social rituals.[11] They host and attend Elvis sock hops. They sponsor Elvis-related picnics. They raise funds that allow them to place flowers on Elvis's grave. U.S. fans are typically first in line at yearly candlelight vigils.

In a related manner, fans produce, write, and design their own publications that reflect their subcultural sensibilities. In particular, I examined sixty issues of *We Remember Elvis*, a mimeographed, conversational fan publication that is produced by a Pennsylvania club. In these issues, several themes are apparent: fan poems often depict Elvis as a healer, a righteous man, a religious icon, a class martyr who never denounced his Tupelo roots. Advice is given as to which books and records are worthwhile and which are to be dismissed. Monthly business is addressed, including news about charities, tributes, flower funds, picnics, Presley collectibles, and so on. Articles by fans provide informative accounts of Elvis Week in Memphis. Items are advertised. General news of Elvis is distributed and media watch reports frequently crop up. In essence, this U.S. fanzine, like many others, serves essentially as a newsletter version of "star" magazines. It is intentionally plebeian, making no attempt to be analytical or intellectual.

In addition to publishing their own journals, U.S. fans also engage in certain physical and verbal behaviors that indicate "secret codes." For example, head bobbing, a simple up-and-down head motion that emulates the one that Presley employed on stage, is a tradition that began at Elvis's Vegas concerts and is still engaged in today. In a related manner, among die-hard fans the question "Are you a fan?" does not mean, "Do you like Elvis?" but instead means, "Have you fought in the Elvis Army? Are you 'taking care of 'E'?"[12]

Quite clearly, on the most general level, U.S. Elvis fans indicate a kind of out-there subcultural expression (Cagle, 1995). They recontextualize already commercial objects; they engage in expressive forms and rituals; they have developed a specialized argot. At the same time, while many U.S. fans espouse some of the most common traits of subcultures, they differ dramatically from British fans, whose relations to a more explicit version of the class-cultural Elvis warrant a comparison between their styles and those of British youth subcultures.

British Fans and Style Rituals

During the summers between 1990 and 2001 I interacted with many of the British fans that come to the United States by way of tours that are organized by Todd Slaughter and the Official Elvis Presley Organization of Great Britain and the Commonwealth. The most significant features of these fans were their subcultural clothing styles and attitudes, their age range (25% of any group of 1,000 typically range between 18 and 29) and their explicit identification with myths regarding Elvis as "working-class provocateur." Through observing and interviewing these fans I noted distinct similarities between their styles and attitudes and those of other British youth subcultures, in particular the Teds and the Mods.

Young, 18–29-year-old British Elvis fans have an immaculate sense of early-to mid-1950s Elvisan/rockabilly style in that they wear pink and black shirts, sharp shiny suits, tight black levis, white socks, pointed boots and shoes, and almost all the men (and some of the women) sport perfectly styled d.a./quiff hairstyles. Not only are British fans infatuated with the Sun rockabilly look, they pay obsessive attention to detail: pink and silver shirt collars are pressed upward; white tube socks are rolled an inch from the top; sunglasses are perched aloofly on their faces; magnificent sideburns are perfectly trimmed to point outward; hair is often dyed a bluish-black color and slicked on the sides, in summer shirtsleeves are rolled up to reveal tattoos of the young Elvis or the Sun Studios logo. Even the body movements suggest careful thought: many of the British fans stand fully erect with their feet close together, their heads perched forward, as if they are awaiting an announcement that they are about to perform. In many ways, British Elvisans, like the Mods, are almost too neat, too precise, too studied (in their approach to fashion), and too controlled to be "Elvis fans." And these qualities of being "on" are among the distinguishing characteristics that mark these fans as subcultural and "different."

Upon interviewing and corresponding with these fans I found that all listed their jobs in categories that reflect working-class positions. Thirty-three identified as having C1 nonmanual jobs such as publicans, receptionists, and library clerks. Twenty-two identified as C2, thus having jobs such as welders and shop assistants; and three identified as semiskilled, thus having jobs such as bus drivers and postal deliverers. A majority of these fans save a portion of their earnings in order to make the requisite trip to the United States during Elvis Week.

In a manner that is strikingly similar to that of British youth subcultures, these fans place great emphasis on the kinds of appearances that target them as being spectacularly different. But why do they choose the mid-1950s rockabilly-inspired look, as opposed to the other styles that are available? For one, this "look," as I have suggested, was a flamboyant indicator of class contradictions for Presley, and these British fans are nothing if not class conscious. As Ted, a 25-year-old retail clerk put it, "I admire Elvis because he came from the same class I do. All those Sun guys . . . Jerry Lee Lewis, all of them. They were proud to be working class. They flaunted it. Especially Elvis" (Personal communication, August 1997). Dylan, a 22-year-old library clerk claims, "Elvis was so cool. He took what he had and made something out of it. I can't tell you how much I like him. He represents everything I *want* to be. . . . He *talked* with his clothes and his haircut" (Personal communication, August 1997). Mariam, 28-year-old retail cashier, stated,

If I lived in Tupelo I'd want a house in East Tupelo (the poorest section of the town), as close to Elvis's house as possible. Given my own background and my love of Elvis that's where I

dream of living. But I'd also like to just live near where he was born. It must be fabulous to live there. (Personal communication, August 2000)

Joan, a 23-year-old office secretary, states,

No one understands us. Our parents don't. Our friends don't. No one. They can't understand why we like Elvis and American country culture, when there are so many things British to enjoy. I myself am stuck in a time warp. I don't like much, unless Elvis recorded it! I have no interest in British pop culture. Bowie was alright, but . . . it's all so synthetic. There's something about "E" . . . he was just so real. (Personal communication, August 2000)

In a letter she elaborated further,

In Memphis and Tupelo working class people are so friendly, especially shop assistants. So different from the people at home. Memphis. What can I say? Fantastic. Seeing and going inside Graceland was like a dream come true. Something that we didn't think we'd have the chance to do. Standing outside and just looking at the house was very emotional, let alone walking through the same areas that the King had once walked through. (Personal communication, October 2000)

Along even more striking lines, Jimmy, a 22-year-old welder, who dresses in full rockabilly regalia, states:

The America I see when I'm here is just like what I've dreamed it would be. To know that Elvis lived here, it's amazing. No one hassles me here. No one cares. I'm also a fan of Nick Cave—I want to just take off, get in an old heap, live on the road and fly into every Southern small town on the map. Nashville fascinates me. All those country cats there. Elvis is just "me"—he was like me. That song, "Elvis is Everywhere;" its true, but he's in me. I relate to him because he represents everything that is cool about the South. He just wore diamond rings and bought those fleets of Caddies, all pink. He just threw it all right back in their faces. That's cool. This is a place where I could feel comfortable. (Personal communication, August 1994)

Tim, a 28-year-old postal deliverer states, "There's nothing in British culture to compare to Elvis. He showed me how it could be. I listen to him and think, 'that's how it could be for me'" (Personal communication, August 2000). Jen, a 21-year-old fan states,

My mother listens to current music, but I don't. I listen to Elvis at night. I wish I could explain it. He's almost like a counselor. I know this sounds crazy. Everyone thinks it's insane. But he takes me "somewhere." I can escape for a while. But it's not just escape. I think about him as a person. I've read a lot of books about him. It's not something I can easily explain. (Personal communication, August 2001)

What is perhaps most striking about this representative sample of descriptions is the importance that these young fans place on *class*, and in most cases a roman-

ticization of it. British Elvis fans' symbolic dislocation from dominant cultural values and practices suggests that their spectacular styles and rituals imply a kind of "magical" resolution of class-cultural tensions. However, to draw on Sarah Thornton's work, the politics of resistance in a case such as this one is perhaps more appropriately cast as the politics of distinction (1995, p. 166). Fan cultures, are, after all, taste cultures with subcultural dimensions. As such, young British fans do not politicize fandom as resistance *par excellance*, but rather they aestheticize politics via fan styles. They do not represent chaotic outrage or a profane articulation, but British Elvisan style does perform a kind of transgression within the boundaries of appropriate social codes. Fans violate codes of "appropriate" behavior—they are 18–29 and dramatizing relations to Elvis's class heritage—even as defiance is expressed in a less dramatic manner than, say, British punk. In other words, British Elvisan style is not simply a case of "difference as a good thing, solely because it is difference."

Seen in these ways, young British fans do not, in any singular way, echo the death of subculture, in that it is apparent that they view themselves in opposition to dominant culture(s), their parent culture, and even to youthful members of their own working-class culture. In giving further consideration to these points, I will examine in greater detail particular versions of (the authentic) Elvis that appeal to British fans and the ways in which dancing functions to express allegiance to these variations. As I will explain, while the young, sexual Elvis ruminates throughout the wardrobes of British fans, a combination of the young Elvis and the spiritual Elvis hold precedence at their dances and fan gatherings. These gatherings also provide further evidence of the fans' identification with Elvis's class-cultural contradictions.

Dance Rituals

For British Elvis fans, dancing is a very affective and powerful medium. In many cases each particular Elvis song requires its own elaborate dance, which sometimes includes rather intricate and rapidly produced movements that have been choreographed through group practices. Here again, details are what count. For example when "Joshua Fit the Battle" is played fans engage in a hurried series of hand and leg movements that often change with each chord. During "So High," fans collectively move their bodies in the same directions, hands quickly pointing upward, then downward. Some dances also involve the formation of "trains." "Blue Hawaii" requires that fans act as if they are paddling canoes in a rigid, almost robotic fashion.

In the midst of this frantic activity, the Southern (working class) Elvis is a constant, serving symbolically as a passage into a deeper and darker romanticization

of class, especially as the evening's events reach a crescendo. This is evidenced by the concluding minutes of these parties, when the exhausted fans form a circle, embrace one another, and collectively sing the "American Trilogy" (a famous Elvis song that combines the lyrics from "Dixie" with those from "Battle Hymn of the Republic" and "All My Trials"). While doing so a fifty-foot Confederate flag displaying Elvis's (snarling) face in the center is lowered from the side of the dance hall, in full view of the fans. In British terms, however, the Confederate flag bears no relation to the Civil War per se; nor is it indicative of highly charged racial connotations. Instead the flag is a symbolic indication of Elvis's working class Southerness and Elvis's sneer connotes the weird, mysterious, sexual South that these fans have both identified with and mythologized.

From a subcultural perspective, it is apparent that the fans' class revelry via style indicates a strong similarity to the attitudes and styles of other flamboyant British working-class youth subcultures. Young British Elvis fans engage in ritualistic behaviors that are comparable to those of subcultures such as the Mods and Teds. They look like a subculture and *act* like a subculture. They have organized meanings around the contradictions of class in that they too are deviant lay semioticians (even as they have recontextualized already incorporated items/ideas).

But what about other pieces of the British Elvis fan puzzle? Are there other features (i.e., cultural indicators) that provide a more multidimensional picture of fandom? An important clue to these questions is provided by the premiere British fanzine, *Elvis Monthly*.

Whereas the young British fans' sense of visual style stems from class affiliation/identification, their fan journal contains a combination of extremely serious (high-cultural) musicological explanations and analytical arguments that revolve around Presley's cultural impact. If it were not for the self-effacing defenses of Elvis fandom, the journal would otherwise read as a high-cultural publication. The articles are methodical, informative, precise, and their analyses of Presley's music are extremely detailed.

In *Elvis Monthly*,[13] the majority of serious pieces focus on Elvis's religious or folk-based music, since his musical selections within these categories can be compared to "definitive texts" (i.e., sheet music). Thus, the central, guiding questions are: How did Elvis inscribe his style on the (gospel or folk) songs that he recorded? What is "original" about Presley's method that allows the interpreter to analyze Elvis as a serious stylist, a kind of vocal auteur? (These two questions are also central to more traditional musicological analyses of classical auteurs.) For example, in *Elvis Monthly* issue 391, David G. Hall, meticulously chronicles the musicological details of Elvis's rendition of Tommy Dorsey's "Take My Hand, Precious Lord." He states:

Elvis switched from the original key of A♭ down to G Major, but for convenience I'll cover the changes using the original notation. On the first line of the chorus we find a change on "Take my hand" with "take my" sung on the E♭ rather than that A♭. On the phrase "I am tired" in the chorus, and "when my life" in the verse, Elvis uses the same run of F, E natural and E♭, whereas the score comes down through A♭, F and E♭ on the chorus and C♭, A♭ and F on the verse. . . . On the line "I am tired, I am weak, I am worn," Elvis sings "and worn" and possibly "I'm weak" just beforehand.

In issue 392, Brian Farmer (1992) compares the original 1812 composition of the folk song "Frankie and Johnny" with Elvis's film version. In the comparison he notes that Elvis changes particular words in the film version and his key changes don't correspond with those that are notated on an early copy of the sheet music. In another article, a fan explains that Elvis's version of "Amen" was a much more musically complex version than the original, due once again to the kinds of structural (musicological) changes that Elvis utilized (Slaughter, 1992). Yet another piece details the history of the song "What a Friend We Have in Jesus." These analyses remind the reader of the self-indulgence of classical musicological studies where "serious" analyzes and critiques are provided only for those who are able to speak and understand the same specialized language.[14] These kinds of articles thus serve as a kind of validation for the British fan community, the only group that would probably be interested in these kinds of analyses of these particular Elvis songs.

Other articles in the journal take a less serious approach, such as one piece that lists all of the actors and actresses that appeared in more than one Elvis film, an article that questions why the master for "I Don't Care" cannot be located, and an article that analyses Cinemascope, Vistavision, Panavision, and Techniscope, all filmic techniques used in Elvis's 1960s films. On an even less serious note, these fanzines contain, for example, an analysis of how Bill Clinton's "connection" to Elvis won him the presidency, innumerable criticisms of RCA and their poor decisions and improper promotion techniques, articles on Elvis's film directors, record reviews, book reviews, historical reminiscences about the fan club, and numerous defenses of fandom.

To summarize, if we reconsider the particular group of British Elvis fans that I have described in light of my characterization of the fanzine that they both compose and read, an interesting assessment is revealed. Dick Hebdige (1979) explains that "any particular subculture is characterized by an extreme orderliness: each part is organically related to the other parts and it is through the fit that the subcultural member makes sense of the world" (p. 113). Thus, in accordance with this claim, the serious tone of much of these fanzines and the explicit musicological analyses must resonate with other aspects of the group life of subcultural members. In many ways, given the chief focus of this group, it is understandable that their

wardrobes, body movements, and dances would make reference to Presley's Southerness/class while the fanzines that they enjoy are often aligned with the principles of traditional high art. For if we recall, Presley was the master of subordinate/dominant contradictions.

His monetary earnings qualified him as wealthy and as a member of the "dominant class," but his cultural tastes forever marked him as "white trash" in the eyes of many observers. His shocking stage display was labeled vulgar and plebeian, but his manners suggested a reverence for Emily Post. The music he chose was popular, but it was recorded and performed with the precision of a classicist. I could continue with this line of thinking, but believe that the point has been made. It makes sense that the British fanzines contain an odd mix of musicology, serious analyses, and typical fan banter. In the world of Preselyana, where contradictions mix freely (but in a coherent manner), subcultural British fans have constructed a homology that is similar to the one constructed by Elvis. There is an organic "fit" between their employment of high-culture prose and their employment of fantastic, subversive, popular visual styles. Indeed, as Stuart Hall and John Clarke have stated, "it is this reciprocal effect, between the things a group uses and the *outlooks* and *activities* which structure and define their use, which is the generative principle of stylistic creation in subcultures" (Clarke, 1976, p. 56).

These points in mind, we can now arrive at a more solid distinction between the subset of British fans I have focused on and the broad category of U.S. fans I have described. Whereas we have noted some of the main differences and similarities between particular groups of U.S./British Elvis fans, and whereas it is difficult to arrive at generalizations about all fans, I offer the following interpretation: If subculture theory (Hebdige, 1979) and "post-subculture theory" (Cagle, 1995; Thornton, 1995) illuminate the nature of fandom by offering theoretical conversational partners, then we can suggest that one particular group of British Elvis fans tend to correspond in many ways with other more "typical" British youth subcultures. Young British fans have developed expressive forms and rituals that announce their class heritage and distinguish them from more traditional groups of Elvis fans. In a manner similar to that of British working-class subcultures, this group has marked itself off from peers, the parent culture, and dominant groups. It has engaged in the process of bricolage as a way of announcing its *indifference* toward mainstream culture. In other words, this group of Elvis fans, while not explicitly "oppositional," is simply unconcerned with the attitudes and options that mainstream culture holds in regard to the group's embracement of Presleyana, and group members "flaunt" their visual style as a way of enforcing mainstream/fan divisions. In this manner, the group can be said to be oppositional, yet the habits, styles, and attitudes are not such that the group is viewed as a "threat to the moral order" of mainstream culture.

In considering a more direct comparison to U.S. fans, it is apparent that U.S. fans are representative of a kind of star-culture version of subcultural fandom. While these fans do not allow for a specific comparison due to the fact that a majority range in age from 25 to 50, it is significant that they make explicit references to a particular star-based version of class in their fanzines (Vegas Elvis), and their styles indicate a method for replicating the "gaudiness" that is associated with Elvis. While not as candid as the British, their behaviors, rituals, and bricologic dress styles do suggest a kind of subcultural being-in-the-world, a subcultural sensibility.

As Hebdige (1979) has suggested in his deeply contextual analysis of British subcultural style, one of the qualifying features of resistant subcultures is the way in which the use of objects constructs a sense of group solidarity by suggesting that subcultural codes are not "available" to the general public. Hebdige points out that the subculture's style is not created for mass consumption and is therefore made doubly resistant/significant due to the ways in which it leaves a semiotic smear on everyday objects. The "tainted" objects are readily available, but the "tainted" connotations of style are what marks it from the mainstream and makes it so incomprehensible to onlookers.

While neither British nor U.S. Elvis fans construct this kind of subcultural expression *par excellence*, I would like to propose that the stylistic manner in which fans utilize Elvis-related paraphernalia qualifies as an oppositional act since it is done in such a way so as to "mark" fans as social "others," in this case as "fanatics." Fan-based, subcultural expressions in the forms I have described are self-conscious and self-referential; they represent a denouncement of taken-for-granted modes of fashion discourse. Thus the rearrangement of already commercial objects suggests a subcultural dimension to fandom. In this manner, Elvis-related bricolage has the effect of displacing the onlooker. It suggests the presence of "difference"; it encompasses the signs of forbidden identity (Hebdige, 1979).

In giving these points further consideration I want to suggest that even though British fans and U.S. fans tend to present dissimilar stylistic forms, one common effect unites them as well as *all* Elvis fans. The press exploits their acts of semiotic defiance (behaviors and fashions), and in doing so, demonstrates that the act of stylization is one of the central, guiding forces behind negative media assessments.

Just as the British dailies have traditionally spewed forth venomous accounts of British subcultural styles, U.S. dailies that cover Elvis Week tend to provide similar explanations, no matter the cultural/social/geographical/economic background of fans. In fact the press tends to treat all Elvis fans in a like manner by using the classic ploy of focusing on the behavior/styles of a few in order to construct generalities about *all* fans. The fans' "otherness" is therefore framed through portrayals of fans as obsessed loners or through accounts that position fans as those who possess an irrational crowd mentality.[15]

For example, in the most dramatic accounts, fans are presented as being so consumed with Elvis that they are willing to make permanent changes to their bodies. In the August 13, 1998, edition of Memphis's *The Commercial Appeal*, Geromel Patrick of France displays a six-inch colorized image of Elvis that has been tattooed onto his forearm. The August 9, 1999, edition of Tupelo's *The Daily Journal* reveals a young woman with a tattoo of Elvis's face on her upper-right shoulder.[16] The January 8, 1993, edition of *The Commercial Appeal* provides a photo of Lavera Chapel, who has tattooed an image of the Elvis stamp on her arm. Like many other fans often on display, she wears Elvis earrings, bracelets, a pink and black shirt, and heavy makeup. This is an image of the fan as hard-core narcissist; the body as a permanent canvas for the display of hypnotic effects.

In another telling account, the August 3, 1987 edition of *Newsweek* portrays the archetype of the classic loner. An overweight single woman with a poor imitation of a Priscilla-like hairstyle lies across a bed and poses a sly grin toward the camera. She is surrounded, literally surrounded, by the objects of her Elvis shrine. In the Wednesday, August 15, 1990, edition of *The Clarion Ledger* the story is told of a woman who worked two shifts in order to come to Elvis Week. In addition, she is also in poor health and close to death. And as a person who has disregarded her family's wishes about the trip, she, the obsessed loner, has made it to her spiritual destination of Graceland (Lucas, p. 1D). In the August 17, 1988, edition of *The Commercial Appeal* we see another version of this theme. Two lonely women, one from Arizona and one from Michigan, have moved to Memphis so they can "be near Graceland" (Piper p. C 1–2). Along similar lines, each year the press is repeatedly preoccupied with "Buttons," the obsessed loner who left her husband and family and moved to the Howard Johnson's near Graceland. Not only does she don two hundred Elvis buttons, and not only does she belong to forty-seven Elvis clubs, but she constantly hints that she had sexual relations with the King.

In particular, in these accounts we are provided with representations of what happens to those who obsess *too much*. They grow old and lonely, and they cling to unrequited dreams. They are pathetic characters; they are pathological liars; we do not want to be like *them*.[17]

In other accounts, photos and stories depict a version of the fan as a victim of individual or crowd pathology.[18] For example, in the Friday, August 19, 1988, edition of *The Commercial Appeal*, a male Elvis fan lies on a hotel bed with a life-size Elvis doll beside him. Both the man and the doll recline and watch television. In the August 19, 1988, edition of *The Daily Journal* two male fans who are friends pose in ruffled black shirts and tight white polyester pants. They are Elvis-look-alikes, not impersonators, and they dress this way as often as possible. The fan as one who "takes things too far," the fan as crazy kid or harmless buffoon.

In another version of the crowd mind, fans desire the tackiest objects available. For example, in the August 12, 1988, edition of *The Commercial Appeal Playbook* an article explains how Graceland Enterprises has attempted to "class up" the merchandise. However, the fans interviewed by the writer are profoundly disappointed. They had come to Memphis looking for Elvis shoe slippers, viles of sweat, pieces of hair, velvet paintings, Elvis underwear, garters, and drink tumblers (Smith p. E12). The fan as other, the fan as obsessive, the fan as oddity, the fan as "insane," the fan as fool, the fan as the bearer of irrationality, the fan who has fallen prey to a number of external sources (especially Elvis Presley Enterprises).

In other accounts, fans "announce" themselves in equally disruptive and bizarre ways. Some fans decorate their motorbikes with Elvis items and travel cross-country to Graceland. A number of male fans have exaggerated Elvis hairstyles and they sport TCB rings and pendants. Usually in the photographs, they are sobbing. Obese, middle-aged impersonators (some of whom have had plastic surgery) dominate some photo spreads; whereas overweight women wearing Elvis T-shirts dominate others.

In additional versions of the fan as pathological crowd member, people trek to Elvis's ranch to sing near a cross. Fans weep at the candlelight vigil. Fans decorate hotel rooms and compete in room-decorating contests. They battle it out in trivial trivia games. They collect strange objects such as tiles from Meditation Gardens. They repeatedly reinforce the notion of Elvis-as-healer. They have "Elvis fever," and they are compared to Muslims who journey to Mecca. They leave bizarre messages to their healer on the stone walls surrounding Graceland. The fan as cult member, the fan as blind believer, the fan as unstable individual.[19]

In reviewing U.K. news sources that have indexed articles on Elvis fans, including *The Guardian* (1995–2002), *The Observer* (2002), *The Informer* (1995–2002), and *The Northerner* (1995–2002), I found that a majority of reports framed Elvis fans in a manner that correlated strongly with those presented in U.S. media. For example, in an article published during the week of August 16, 2002, the twenty-fifth anniversary of Elvis's death, a writer offers reasons why fans should be ridiculed for their idolatry (Engel, 2002). During that same week, accounts described fans that have named their dogs after Elvis, fans that have said "Elvis wedding vows" (Oliver, 2002) and fans that are victimized by white-trash U.S. Southern culture. One reporter refers to Elvis as a redneck, another as a fat person, another as a thief, while another describes fan behavior as a definite way to "lose friends and alienate people" (Odell, 2002). Again we are offered a blatant reminder of the reasons John Strausbaugh is often asked the question, "You aren't going to mock us, are you?"

Here we might ask, in what ways do the fans perceive the kinds of depictions I have described? Occasionally, a newspaper reporter will ask fans' opinions of media

representations, and in such cases fans typically denounce the formulaic represen-
tations as being defamatory. In other sources, such as fanzines, fans often write about
how they are misrepresented and misunderstood. They comment frequently on how
their styles reflect devotion to a man who made their dreams possible. They often
engage in tirades about the media's "mishandling" of their styles, and the fact that
many fan clubs are actively involved in charity work, something that is rarely men-
tioned in exploitative accounts. Elvis fans, like most subcultural participants, are
a protective lot, quick to point out misrepresentation and places where the media
simply "get it wrong." In fact at fan gatherings a common ritual is the reading of
press reports, an act that allows fans to offer criticisms, while acknowledging that
they do not belong to the very world that seems to gain gratification from such
reports. In fact, fans usually laugh when reports are read.

In giving consideration to this point, I would like to argue that British and
American Elvis fans, while different in their approaches to subcultural style, elic-
it the same range of responses in the press. In fact what was most interesting about
my newspaper survey was the diversity of fans represented: British fans, U.S. fans,
German fans, African fans—they were all there. Indeed the press treats all Elvis
fans as if they are a bona fide subculture (in the traditional sense), even though such
fans seem—on the surface—to be nonthreatening to mainstream culture.
Nonetheless, it is the fans' excessive recontextualization of objects and their
expressive, creative group style(s) that "warrant" negative representations in the
press.

In conclusion, while Elvis fans do not represent radical, overt affronts to dom-
inant cultures, their behaviors and styles are indicative of a kind of low-level
"moral panic," as demonstrated by newspaper accounts that depict these fans as
compulsive, irrational, unintelligent, and insane. Given the styles of fans, it comes
as no surprise then that the press ignores the contradictions posed by fans (and the
diversity of Elvis fandom), while presenting *all fans* as consisting of a unified group
of pathologists: pathetic people who have turned a man into a god. Consequently,
since fan-based bricolage typically displaces the position of the interpreter and
results in confusion, and since class plays a role in the production of negatively
inspired press reports, one can only expect the continuance of media coverage along
these same lines.

According to biographer Peter Guralnik, from the mid 1950s until his death,
Elvis demonstrated an "extraordinary sense of identification with the fans. He had
an almost mystical belief that all of his strength—and his very legitimacy—came
from his fans" (Allen,1999). This "real life" identificatory relation continues today,
through posthumous relations; fans continue to believe that Elvis identifies with
them, just as they identify with Elvis. In this capacity, fan-groups pick and choose
images of the mythical Elvis that best fit their own sense of dislocation within a

system that often seeks to deny, ignore, and discredit aspects of their identities that are the closest to those of Elvis's own "human flesh."

In the twenty-first century, as Presley continues to represent not only the paradoxes of fandom, but a token symbol of hip-kitsch and a signifier of coolness among the "coolest" of writers and artists, and as he continues to find his way into television comedies, tabloids, and Quentin Tarantino films, fans will no doubt be forced to realize new and interesting ways to signify their *difference*.

Notes

Many thanks to Norman Denzin and Larry Grossberg for their invaluable support. Thanks also to my parents, Marion and Betty Cagle, who raised me in Elvis's hometown of Tupelo, Mississippi, and who continue to be proud members of the "E Club."

1. This is not to say that the fan rituals described in the paper have only existed since August 16, 1977. In fact, the Official Elvis Presley Fan Club of Great Britain has been in operation since, coincidentally, August 16, 1967. (Elvis died, ten years later, on August 16, 1977.)
2. See reference: Marsh (1982). Public Lecture. University of Memphis.
3. See reference: Phillips (1982). Public Lecture. University of Memphis.
4. The fanzine is no longer being published.
5. See also Grossberg, 1992a.
6. At other times, and in varying ways, they have also willfully indicated their symbolic alliance with such discourses.
7. This claim was inspired by Sarah Thornton's work on club cultures and Chris Barker's explanation of her work.
8. I want to suggest that the production of Elvis fandom in the 1950s is oddly dissimilar to the production of "authentic" British youth subcultures. The press however treated fans as if they were a bona fide, grassroots subculture along the lines of rockers or punks. In turn, the incorporation of Elvis wouldn't have been nearly as effective had he and his fans not been treated as cultural deviants by the media. The "alarm" had to be quelled.
9. I use the term "U.S. fans" because Elvis did not perform outside of North America and Hawaii, and fans in other countries were never the focus of contemptuous media reports, as most published reports focused solely on public displays of fandom.
10. U.S. fans do not go into great detail when describing their social class and its relation to Presley.
12. See, also, Stern and Stern (1987, p. 163).
13. *Elvis Monthly* has been replaced by other fanzines, but it was the reigning British 'zine from the late 1960s through the late 1990s.
14. These analyses also bear a strong correlation to Barthes's work on the grain of the voice. Barthes argues that what is significant is the way in which the diction of particular singers has the ability to sway us to jouissance.
15. See Jensen (1992, p. 13).
16. In surveying ten years of coverage of Elvis Week, I focused mainly on *The Commercial Appeal* and *The Daily Journal*. These regional papers included Associated Press stories due to the fact that national and international reporters are sent to cover Elvis Week. Also, many national sources

seek photographs and news stories from the two main regional sources, located in Memphis and Tupelo. Along related lines I also was concerned with the two sources because they contain primary information for fans during Elvis Week; fans purchase the papers to find out about local happenings and to see themselves represented in print.

17. See Jensen (1992, pp. 9–29).

18. This depiction is exemplary of fan descriptions in media, as Jenson (1992) has chronicled in "Fandom as pathology."

19. These are the depictions that I have found in surveying ten years of coverage on Elvis Week.

References

Allen, P. (1999, January 22). Elvis: Through a glass darkly. *CNN.Com*. Retrieved February 8, 2003, from http://www.cnn.com/books/news/9901/22/careless.love/

Barker, C. (2000). *Cultural studies: Theory and practice*. London: Sage Publications.

———. (2002). *Making sense of cultural studies*. London: Sage Publications.

Barthes, R. (1977). *Image, music, text*. Glasgow: CollinsFontana.

Bruyn, S. T. (1966). *The human perspective in sociology: The methodology of participant observation*. Englewood Cliffs, NJ: Prentice Hall.

Cagle, V. M. (1995). *Reconstructing pop/subculture: Art, rock, and Andy Warhol*. London: Sage.

Clarke, J., Jefferson, T., Hall, S., and Roberts, B. (1976). Subcultures, cultures and class. In *Resistance through rituals: Youth subcultures in post-war Britain* (pp. 9–79). London: HarperCollins.

Cohen, J. R. (1991). The 'relevance' of cultural identity in audiences' interpretations of mass media. *Critical Studies in Media Communication*, 8, 442–454.

Denzin, N. K. (1970). *The research act: A theoretical introduction to sociological methods* (3rd ed.). Englewood Cliffs, NJ: Prentice Hall.

Engel, M. (2002, August). Still stuck on Elvis, fans exalt the King. *The Guardian*. Retrieved February 8, 2003, from http://www.guardian.co.uk/international/story/0,3604,776114,00.html

Farmer, B. (1992, September). Words and music part 15. *Elvis Monthly*, 392.

Fenster, M. (1989). *Elvis: The consumption and use of the popular figure*. Paper presented at the annual conference of the International Communication Association, New Orleans, LA.

Foucault, M. (1977). *Discipline and punish*. London: Tavistock.

Grossberg, L. (1992a). Is there a fan in the house?: The affective sensibility of fandom. In L. A. Lewis (Ed.), *The adoring audience* (pp. 50–65). New York: Routledge.

Hall, D. G. (1992, August). Elvis is alive and well. *Elvis Monthly*, 391.

Hebdige, D. (1979). *Subculture: The meaning of style*. London: Methuen.

Jensen, J. (1992). Fandom as pathology: The consequences of characterization. In L.A. Lewis (Ed.), *The adoring audience* (pp. 9–29). New York: Routledge.

Lucas, S. (1990, August 15). Like Moslems to Mecca, EP fans head south. *The Clarion Ledger*, p. 1D.

Marsh, D. (1982). *Elvis*. London: Rolling Stone Press.

———. (1982, August 16). Public lecture presented at the University of Memphis, Elvis Tribute. Memphis, TN.

Odell, M. (2002, August 11). How to lose friends and alienate people. *The Guardian*. Retrieved February 8, 2003, from http://www.observer.co.uk/magazine/story/0,11913,772034,00.html

Oliver, M. (2002, August 16). Fans around the world remember Elvis. *The Guardian*. Retrieved February 8, 2003, from http://www.guardian.co.uk/arts/elvis/story/0,12333,775817,00.html

Phillips, S. (1982, August 16). Public lecture. Presented at the University of Memphis Elvis Tribute, Memphis, TN.

Piper, J. (1988, August 17). Fans hard to find in his hometown. *The Commercial Appeal*, pp. C1–2.

Rodman, G. (1994). A hero to most?: Elvis, myth, and the politics of race. *Cultural Studies*, 8(3), 457–483.

Slaughter, T. (Ed.). (1992, September). *Elvis Monthly*, 392.

Smith, W. (1988, August 12). Tacky tributes to Elvis remain popular with fans. *Commercial Appeal Playbook*, p. E12.

Spiegel, L. (1990). Communicating with the dead: Elvis as medium. *Film Quarterly*, 11(13), 177–204.

Stern, M., and Stern, J. (1987). *Elvis world*. New York: Alfred A. Knopf.

Strausbaugh, J. (1994). *Reflections on the birth of the Elvis faith*. New York: Blast Books.

Thornton, S. (1995). *Club cultures: Music, media, and subcultural capital*. Cambridge: Polity Press.

"Elvis Forever"

Erika Doss

In the Fall of 2002, Elvis Presley had a chart-topping album. Released on September 24, *Elv1s 30 #1 Hits* sold nearly six million units in three weeks, debuting as *Billboard*'s number one album in the United States and likewise reaching the top spot in the U.K., Canada, Australia, France, Brazil, and nineteen other countries ("The King Rules," 2002). Accompanying Elvis hits such as "Heartbreak Hotel" and "Are You Lonesome Tonight" was the bonus single "A Little Less Conversation," a techno remix by the Dutch DJ Junkie XL of a song Elvis originally recorded for the B-movie *Live a Little, Love a Little*, in which he played a randy photographer. Featuring the line "a little less conversation, a little more action," the song was a fluke hit in European dance clubs and the upbeat hook in Nike's "Secret Tournament" ads, a £10 million television campaign directed by Terry Gilliam that highlighted twenty-four of the world's top soccer players in a "secret" match and helped promote Nike World Cup Soccer in summer 2002.[1] Becoming a number-one hit in the U.K. (and later in the United States), "A Little Less Conversation" helped Elvis beat The Beatles on the British singles chart for all-time number one career hits (Elvis: 18; The Beatles: 17). All this almost fifty years after Elvis cut his first single at Sam Phillip's Memphis Recording Service (the precursor of Sun Records) in 1953 and more importantly for the purposes of this book, twenty-five years after Elvis's death, at the age of 42, on August 16, 1977.

What accounts for Elvis's posthumous popularity? Marketing plays a big role: sales of *Elv1s 30 #1 Hits* certainly benefited from a massive campaign spearheaded by RCA Records and its parent company BMG, the global music division of Bertelsmann AG, one of the world's leading media companies with annual revenues of $17.86 billion. Print and television advertisements with the tag line "Before Anyone Did Anything, Elvis Did Everything" helped both promote the album and reaffirm Elvis's iconic status in contemporary popular culture as "The King" of rock and roll. As RCA Music Group chairman Bob Jamieson remarked,

> RCA is thrilled and truly proud to be giving renewed life to the musical legacy of one of the greatest musical artists of all time. The debut of *Elv1s 30 #1 Hits* at the top of the charts speaks as much to Elvis' future as it does his past.[2] (BMG/RCA Records, 2002)

"Renewed life" indeed. Even before it released *Elv1s 30 #1 Hits*, RCA issued *Elvis: Today, Tomorrow, and Forever*, a four-CD box set of 100 previously unreleased recordings (mostly studio and concert outtakes) that was produced in conjunction with the twenty-fifth anniversary of Elvis's death. In June 2002, Disney released *Lilo and Stitch*, an animated feature film about Lilo, a plucky young Elvis fan mourning the deaths of her parents, and Stitch, an alien from outer space who learns how to become a "model citizen" on earth by impersonating Elvis. In August, *Forbes* magazine listed Elvis as the "top-earning dead celebrity," netting his estate $37 million annually from record sales (including $4 million from the single "A Little Less Conversation"), from tours at Graceland (his Memphis home and burial spot, which garners about $15 million a year in admission fees alone), and from earnings on various Elvis products and product endorsements (Baird, 2002; Schiffman, 2002). Also in August, a fifty-three-foot truck called "Mobile Graceland" hit the road, a sort of rock and roll bookmobile that visited thirty-one cities and drew large crowds to its traveling exhibition of Elvis memorabilia such as guitars, jumpsuits, photographs, letters, pistols, and jewelry (Wilson, 2002). In November, NBC and RCA/BMG joined forces to air "Elvis Lives," a one-hour prime-time special featuring Elvis songs performed by Bono, Sheryl Crow, Tom Petty, Dave Matthews, No Doubt, and Britney Spears. Future marketing plans by Elvis Presley Enterprises, Inc. (Elvis Inc., or EPE, the corporate outfit that owns Graceland and claims copyright on Elvis's name, face, voice, and signature) include a musical based on Elvis's courtship of Priscilla Beaulieu Presley. Priscilla, who runs Elvis's estate along with chief executive officer Jack Soden, remarked in 1995 that EPE aims "to bring Elvis into the twenty-first century" (as cited in Baumgold, 1995, p. 99). It won't be that hard: already, folklore has it that the three most recognized words around the world are "Jesus," "Coca-Cola," and "Elvis."

Why Elvis?

Still, marketing alone doesn't account for why Elvis Presley is consistently deified by many as *the quintessential* American icon. Why Elvis—why not some other popular culture music martyr who died young, like John Lennon or Buddy Holly or Janis Joplin or Jimi Hendrix or, more recently, Kurt Cobain or Selena? Why Elvis, more so than equally iconic American political leaders such as Malcolm X, the Reverend Martin Luther King, Jr., or J.F.K.? Why, in a culture where images dominate (some estimate we receive three-quarters of our knowledge from visual sources), does Elvis's image seem to dominate most of all in and on all sorts of Elvis "stuff": black velvet paintings, ceramic statuettes, laminated clocks, liquor decanters, T-shirts, address books, earrings, lottery tickets, key rings, oven mitts, and cell-phone covers? Why does Elvis seem to have more fans, fan clubs, fanzines, annual conventions, merchandise, and memorabilia than any other performer, live or dead? During Elvis Week, a Memphis phenomenon that occurs each August on the anniversary of Elvis's death, the city swells with tens of thousands of fans displaying a kind of emotional intensity and reverence that intimates Elvis's popular culture canonization

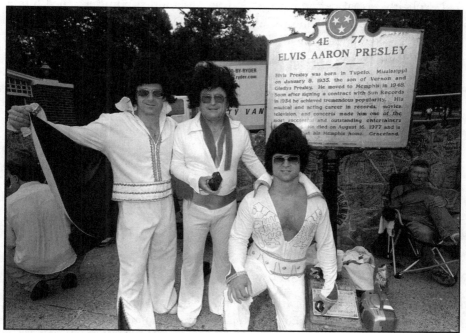

Figure 4.1. Elvis fans at Graceland, Memphis, Tennessee, during Elvis Week, August 2002. Photo by Rodney Harrison.

Other fans belong to one or more of the 500 or so official Elvis Fan Clubs registered with Elvis Inc. At the time of his death, there were fewer than 65 Elvis fan clubs; today, about 50 new clubs are formed each year, with the fastest growth taking place in the United States, which has around 280 clubs (Doss, 1999, p. 54).[3]

Yet, like the frenzied marketing that accompanied the twenty-fifth anniversary of his death, such data begs the question of Elvis's posthumous popularity—his afterlife and afterimage. More significant answers to the resonance of Elvis's reputation lie in the ubiquity and multivalence of his image, and in the complexities and contradictions of fandom. Understanding Elvis's abiding cultural symbolism, particularly in the United States, relates to how celebrity is constructed in contemporary America, to the links between popular visual culture and audiences, and especially, to how Elvis satisfies individual and national cravings for identity and definition.

While Elvis's image has been fixed in national popular culture for over forty-five years—ever since millions watched him gyrate on *The Ed Sullivan Show* in 1956 and 1957—there is no particular agreement about what his image really means.[4] There are many different Elvis's, beginning with the rockabilly rebel of the mid-1950s who soared to teen culture adoration and critical rebuke with an explosive and explicitly sexual performance style (one disgruntled minister called him a "whirling dervish of sex") and with hits such as "Don't Be Cruel" and "Love Me Tender" ("Presley Termed," 1956). Elvis was also post–World War II America's most obvious "white Negro," a teen version of the white hipsters that writer Norman Mailer portrayed as being infatuated with the sights, sounds, and styles of urban black culture (Mailer, 1959, pp. 311–31).[5] Indeed, much of Elvis's earliest popularity, and the media attention he then received, can be ascribed to his cross-race stylistics: to the ways that he mixed black and white music and black and white performance styles into the emergent hybrid of rock and roll, thereby negotiating the 1950s terrain of the nascent Civil Rights movement to participate in the creation of a more democratic American popular culture.

Yet Elvis's image as a rebellious race-mixer is complicated by his image as a working-class success story: a "blue-collar guy in blue-suede shoes"; a poor white kid who grew up in the projects but worked hard, followed his dream, and became "The King" of rock and roll. Labor historian David Roediger (1991) argues that the terms "work" and "working class" are deeply imbricated with whiteness, as the formation of American working-class identity in the nineteenth century was anchored to assertions of white racial superiority over nonwhites. Further, crowning Elvis king (which he, apparently, disliked and which many black musicians and critics, not surprisingly, despise) relegates everyone else in the rock and roll pantheon as lesser figures, including the many black musicians who influenced Elvis and whom *he* credited with inventing rock and roll, such as Fats Waller, B. B. King, and Muddy

Waters. As Vernon Reid, guitarist with Living Colour and cofounder of the Black Rock Coalition, protested in 1990,

> It's not enough for the powers that be to love Elvis, for him to be *their* king of rock and roll. [But] Elvis has to be the king of rock and roll for everybody. And that is something I cannot swallow.[6] (Fricke, 1990, pp. 50–51)

These conflicted images of Elvis are accompanied by many others: Elvis the army private (Elvis was drafted in 1958 and spent two years as a tank driver in Friedberg, West Germany); Elvis the B-movie idol (Elvis made over thirty mostly forgettable movies, including *Tickle Me* [1965] and *Clambake* [1967]); Elvis the Southern gentleman (Elvis bought Graceland, a Tara-like mansion in Memphis, in 1957 and died there twenty years later in an upstairs bathroom); Elvis the family man (Elvis and Priscilla married in 1967 and their daughter, Lisa Marie Presley, was born nine months later); Elvis the Las Vegas superstar (wearing bejewled jumpsuits with Cadillac fin collars and oversize silver cummerbunds, Elvis played 1,126 shows in eight years in Las Vegas, from 1969–1977, and did hundreds of other concerts in sports arenas across America); Elvis the philanthropist (Elvis rather impulsively liked to give diamond rings and Cadillac Eldorados to total strangers, and checks to Memphis hospitals and police departments); Elvis the Nixon admirer (Elvis visited the White House in December 1970 and offered President Richard Nixon his services as an honorary "Federal Agent at Large" in order to rid the United States of "drug abuse and Communist brainwashing"); and finally, Elvis the drug addict (Elvis consumed hundreds of pills a week and autopsy evidence showed a body stuffed with Dialaudid, Placidyl, Valium, Quaaludes, Percodan, Demerol, Seconal, Nembutal, Phenobarbital, morphine, codeine, cortisone, and lots of other uppers, downers, and painkillers). Elvis's image was, and remains, ambiguous and contradictory, solid but unstable. American popular culture has always been an unstable "site of conflicting interests, appropriations, impersonations" remarks historian Eric Lott (1993, p. 92). Since the mid 1950s, Elvis's image has been continually renegotiated and remade in order to mesh with individual, and institutional, preferences.

It is interesting that the twenty-fifth anniversary of Elvis's death was accompanied by such a concerted effort by RCA/BMG and EPE to market, and remarket, his music. In fact, Elvis's musical reputation, with the exception of his revolutionary subversion of mid-1950s American pop music, is almost inconsequential; his albums are never included on VH-1's "Top 100" lists and few contemporary performers cite Elvis as a primary influence on their own work. "There was so little of it that was actually good," rock musician David Bowie remarks. "Those first two or three years, and then he lost me completely" (Patterson, 2002, p. M-13). Indeed, Elvis's role as America's premiere popular culture icon has less to do with

his music than with his multifaceted image—and especially, what these diverse and conflicted images mean to the people who look at them, make them, and collect them: his fans. Their cultural production of Elvis's meaning, which is hardly monolithic and is, in fact, layered in contradiction, is key to his posthumous celebrity. By extension, the narrative instability of Elvis's image corresponds to certain tensions evident in the larger public sphere of post–World War II America, most notably those of race and sex (Doss, 1999).[7] The complexity of his image is especially apparent in a consideration of Elvis's iconic, religious, meaning, and how Elvis fans have made him a figure of popular culture canonization.[8]

Elvis Religion

One fan, a former language and psychology teacher who emigrated from Greece to Memphis in order to "be closer" to Elvis, spends every spare moment at Elvis's grave, tending it and honoring him with small shrines and hand-made offerings, engrossed in vigils of prayer and remembrance. Sometimes she stays all night in Graceland's Meditation Gardens, the small plot of land near the mansion where Elvis, his parents, and his paternal grandmother are buried, and where his still-born twin (Jesse Garon Presley) is memorialized with a bronze plaque. A devout Catholic (raised Greek Orthodox), this fan does not worship Elvis but sees him as a mediator, or an intercessor between herself and God. As she says, "There is a distance between human beings and God. That is why we are close to Elvis. He is like a bridge between us and God" (K. Apostolakos quoted in Harrison, 1992, pp. 68, 53). If she imagines Elvis as a saint, she also sees him as a redemptive figure. "I believe in Jesus Christ and I believe in God," she remarks, "but Elvis was special. Elvis was in our times, he was given to us to remind us to be good." Servant of God and Christ-like savior, Elvis brings this fan joy, intensity, pleasure, and purpose (K. Apostolakos, personal communication, August 14, 1995).[9]

Consider, too, Elayne Goodman's 1990 *Altar to Elvis*. Every inch of this six-foot-tall shrine is covered with images of Elvis, many bordered by beads, buttons, or bric-a-brac, some glued on to frilly valentines or mounted in elaborate gold and silver frames, still others revealed on the altar's wings and secret niches. Elvis pictures are accompanied by busts and statues, and by what Goodman calls "Genuine Fake Relics," simulated bits and pieces of Elvis's hair and fingernails displayed in tiny vials and little boxes. The entire altar features reds, blacks, and golds—the high holy colors of religious cultures from Byzantine to Buddhist. A "self-taught" artist who has lived most of her life in Columbus, Mississippi, Goodman has made Elvis shrines and altars for the past two decades, all fashioned from stuff she finds in flea markets and garage sales. Encrusted in pictures of Elvis, Goodman's altar draws atten-

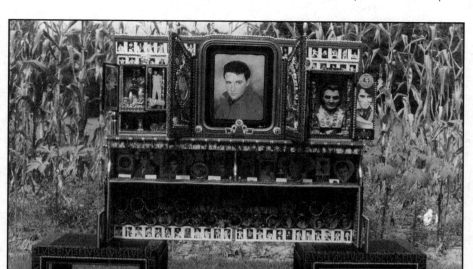

Figure 4.2. Elayne Goodman, *Altar to Elvis*, 1990. Photo from collection of the artist.

tion to the vast number of Elvis images that exist in everyday popular American culture. But it also cleverly points out how Elvis's image is frequently received and experienced, poking fun at his contemporary iconic status and at those who put Elvis's image, his body, and even his body parts, on such a holy pedestal. With the use of recycling rituals and shrine-making practices common to religions all over the globe, these fans invest the secular Elvis with sacred importance. Their practices and rituals highlight how Elvis is increasingly perceived, desired, and constructed on religious terms.

In fact, comments like "it's a religious thing" from journalists and critics tend to dominate the discourse surrounding Elvis's steadfast cultural presence in contemporary America. "The worship, adoration and the perpetuation of the memory of Elvis today, closely resembles a religious cult," stated former BBC Religious Affairs Correspondent Ted Harrison (1992, p. 9). Elvis's posthumous popularity has "transcended the familiar contours of a dead celebrity cult and has begun to assume the dimensions of a redemptive faith," asserted writer Ron Rosenbaum (1995, p. 50). Multiple scholars have probed the Celtic, Gnostic, Hindi, and Vodun derivations of Elvis's cult-like status, and contemplated Graceland's manifestation as "sacred space" (e.g., Alderman, 2002; Beckham, 1987; Ebersole, 1994; Fiske, 1993; King, 1992; Lardas, 1995; Stromberg, 1990; Vikan, 1994). Some cynically attribute the entire phenomenon to Elvis Inc.'s incredibly successful mass marketing techniques,

and to the susceptibility of an apparently passive public bent on real-world escapism through, especially, the "transformative" ideology of consumerism. "Explicit manifestations of 'Elvis Christ' did not exactly evolve," carps British journalist John Windsor (1992). "They were cunningly contrived for a mass market" (p. 33).

Eager to explain, and debunk, the preponderance of Elvis imagery and the emotional and collective behavior of his fans, many of the journalists and critics who analyze Elvis culture relate how "culture" has become "cult." Some point out that Elvis's rags-to-riches life story and tragic death neatly parallel the secular/sacred narrative of Jesus Christ, and hint at the contemporary possibility of Elvis's own eponymous cult foundation. Several funny spoofs of these "Elvis as Messiah" analogies have emerged in recent years, including *The Two Kings* (Jacobs, 1994), which draws contrasts and "bizarre parallels and strange similarities" between Jesus and Elvis ("Jesus was baptized in the River Jordan," "Elvis's backup group was the Jordanaires"), and the *Gospel of Elvis* (Ludwig, 1996), which tells how "a boy from the poorest village of the land of Plenty became the Priest-King of the Whole World."

Some cynically list the quasi-religious conditions that seem to confirm Elvis's contemporary deification: how in the years since his death a veritable Elvis religion has emerged, replete with prophets (Elvis impersonators), sacred texts (Elvis records), disciples (Elvis fans), relics (Elvis memorabilia), pilgrimages (to Graceland and Tupelo, Mississippi, where Elvis was born in 1935), shrines (such as his gravesite at Graceland), temples (such as the 24-Hour Church of Elvis in Portland, Oregon), and all the appearances of a resurrection (with reported Elvis sightings at, among other places, a Burger King in Kalamazoo, Michigan). Ritual activities that occur in Memphis each August during Elvis Week (nicknamed "Death Week" by more sarcastic observers) are cited as further evidence of Elvis's cult status.

Yet easy explanations that Elvis's omnipresence and the devotion of his fans embody a cult or a religion raise all sorts of questions, including the issue of religious essentialism. That is, what is it about the revered images, ritual practices, and devotional behaviors among Elvis fans that is essentially religious? Do these images and practices constitute the making of a religion? Why is it that *images* of Elvis have taken on the dimensions of faith and devotion, viewed by many fans as links between themselves and God, as ex-votos for expressing and giving thanks, or as empowered objects that can fulfill wishes and desires?

Most fans quickly dismiss the idea that Elvis is a religious figure or that Elvis images and Elvis-centered practices constitute any sort of Elvis religion. "It's only the media who seem to be obsessed with turning Elvis into a religion, you don't hear normal fans discuss it," says one fan. Fans worry, and with good reasons, about being ridiculed as religious fanatics. Others object to how they are repeatedly represented as lower-class, uneducated, and irrational worshippers of a "fat, pill-filled Vegas

singer," as Elvis was described in a *New York Times Magazine* article (Rosenbaum, 1995, p. 51). Unflattering pictures in this article included photos of older Elvis fans wearing Elvis T-shirts, Elvis buttons, and Elvis rings, and basically being caricatured as the delusional devoted. Canny to such media marginalization, it isn't surprising that many Elvis fans hotly deny fidelity to any sort of Elvis cult or religion.

Without discounting their objections, however, it is important to recognize, following from its "city on the hill" creation myth to the present day proliferation of New Age spirituality and the growth of fundamentalism, that religious expression—mainstream and fringe—remains central to American self-identity and national experience. As a profoundly religious people, Americans tend to treat things on religious terms, apply religious categories, and generally make a religion out of much of what is touched and understood. According to a 1980 Gallup Poll, Americans "value religion" and maintain "strong religious beliefs" to far greater degrees than the citizens of any other Western industrial nation (as cited in Hatch, 1989, p. 210). In 1999, the Gallup Poll found that 96% of Americans interviewed "believed in God" (Gallop, 2001; Siemon-Netto, 2001). Yet, Americans tend to be predominantly private and diverse in their religious beliefs and practices. Indeed, historian Nathan Hatch (1989) observes that much of America's "ongoing religious vitality" can be attributed to the longstanding democratic, or populist, orientation of American Christianity: as "custodians of their own beliefs," Americans have traditionally shaped their religious practices to mesh with individual, rather than strictly institutional, desires (pp. 212, 218; see also Bellah, et al., 1985; Roof, 1993).[10] It may be that when Elvis fans protest that their devotion to Elvis is not "religious," they are really objecting to an institutional definition of the term. In fact, their privatizing veneration of Elvis is one strong historical form of American religiosity.

My references here to "religion" are not meant as metaphorical or rhetorical flourishes; nor do I want to mitigate the reverence that many fans have for Elvis as a "kind of" religion. Religion constitutes those practices and attitudes that imbue a person's life with meaning by linking him or her to a transcendent reality: that which is beyond purely immanent, or secular, experience and understanding. Collecting Elvis stuff, creating Elvis shrines, and going to Graceland are not, in and of themselves, religious acts and practices. But they can become religious if they affect a transcendent and all-powerful order that can influence human affairs and is not inherently apprehensible.

Elvis was and remains a profoundly charismatic figure, which clearly contributes to his posthumous reputation. Mainstream religions tend to be fronted by charismatic types (Jesus, Confucius, Buddha, Muhammed, Joseph Smith), as do their cult counterparts (most recently, Jim Jones, David Koresh, Shoko Ashahara). But being charismatic does not automatically translate into reverential status:

plenty of contemporary rock stars and sports figures are objects of adoration, but few sustain religious veneration. Contrary to presumptions about "the religion of the stars," the cult of celebrity and the religious beliefs and practices cultivated by Elvis fans are not exactly the same. Rather, Elvis's religious import hinges on his multifaceted image, which for many fans is imbued with a certain mystical greatness and looked upon for access to a transcendent reality. It is longstanding, too: as early as 1957, some fans were trying to start an "Elvis Presley Church" (Pierce, 1994, p. 136); as recently as 1995, a Saint Louis group (The Congregation for Causes of Saints) sought his canonization (Morin, 1960). Most fans, however, prefer to commune with Elvis privately, in their homes, or during Elvis Week, in Memphis.

Elvis at Home

Whether or not they believe Elvis is a "religion," fans do believe in Elvis and they often express this belief most tellingly in their homes. The domestic sphere is a safe haven far and away from an unfriendly outside world, a sanctuary where fans can be with Elvis without drawing attention. Many fans have special rooms or areas in their homes especially dedicated to Elvis. "I like to go to my Elvis Room, down in the basement, after supper," remarks a fan in Roanoke. "It's a quiet space and time for me." Filled with Elvis stuff that she has collected since the 1950s, she says her room "helps to keep memories of Elvis alive." As places where secular thoughts and tasks are suspended, Elvis rooms allow private moments of contemplation and solitude. As places where fans spotlight their collections of Elvis stuff, they also speak to the ways in which material culture plays a major role in sanctifying and legitimizing Elvis as a special, important entity.

This combination of religious and commercial sensibilities in the American home is nothing new: in the nineteenth century, Protestants and Catholics alike linked religiosity with domesticity, creating a more sanctified home front with parlor organs, Bibles, and religious pictures and statues (McDannell, 1986, 1995; Morgan, 1998). Filling special rooms, and sometimes whole houses, with Elvis paintings, collector's plates, trading cards, limited edition lithographs, watches, dolls, framed needlepoint projects, and all sorts of other mass-produced and homemade items, Elvis fans similarly sacralize their contemporary American homes, using images and objects to declare their deep-felt devotion to Elvis.

Fidelity is best expressed, in fact, in terms of material culture. One fan observes that "real fans do need Elvis items around their house," implying that fans who don't purchase and display Elvis memorabilia aren't "true" fans (quoted in Harrison, 1992, p. 160). Loyalty is further construed in terms of sacrifice, as fans assess their personal commitment to Elvis (and that of other fans) on the basis of how much time,

space, and money they are willing to devote to Elvis. Associating material culture abundance with Elvis piety is not only a sign of being a true fan, but of being true to Elvis: fans repeatedly say that by collecting and displaying Elvis memorabilia they are "taking care" of Elvis, keeping his memory alive and rescuing him from historical oblivion. Such explanations might seem to simply justify conspicuous consumption, allowing Elvis fans to indulge and even wallow in the crass materialism of Elvis culture. But these collections "transcend mere accumulation" because of Elvis's absence (Baudrillard, 1994, p. 23). Most fans believe Elvis is dead, but by collecting and displaying his image, they construct his immortality. The images and objects in these rooms are highly charged and passionately loved, antidotes to Elvis's absence, fetishistic substitutes for Elvis himself.

Seen by outsiders simply as Elvis rooms packed full of Elvis stuff, these spaces have their own secret meanings among Elvis fans: they provide a common language and something to talk about, they allow private moments of solitude and communion with Elvis, and they are highly intensified physical settings where fans make Elvis into a passionately loved and revered figure. Certainly for many Elvis fans, Elvis rooms are spiritual sanctuaries in which they freely express the devotional nature of their relationship with Elvis. They also suggest how Americans continue to adapt and reorder various religious practices in order to accommodate personal spiritual beliefs. Elvis rooms are places where Elvis fans subvert and appropriate religious styles and sensibilities to construct special private spaces where Elvis holds center stage.

Elvis rooms are also places where fans rehearse public expressions of devotion. The home, after all, mediates between the private and public sphere. Likewise, the home shrines of Elvis fans, while separate from the outside world, help permeate that world with Elvis's presence. Shrines, as religious studies scholar William Christian (1989) comments in his study of relationships to the divine between communities and individuals in a small Spanish village, "are energy transformation stations—the loci for the transformation of divine energy for human purposes and the transformation of human energy for divine purposes" (p.101). Many of the images, effects, and rituals that fans use in their homes to articulate their devotion to Elvis are repeated in the public sphere, especially in Memphis each August, during Elvis Week.

Graceland as Pilgrimage

Religious terms like "pilgrimage" and "shrine" are not part of the average Graceland visitor's vocabulary when they describe their feelings about Elvis, and many of the estimated 750,000 people who tour the mansion each year might be offended if they

heard these words used to describe them. Still, Elvis's estate has become the object of veneration for thousands of fans; as one remarks, "Graceland is like the worshipping ground for all Elvis fans." Set back on a hill, a hundred or so yards from a four-lane highway, and completely surrounded by fieldstone walls and white fences, Graceland is conceptualized by many Elvis fans as an especially hallowed place. Fans go to Graceland to walk in Elvis's house, to gaze at his things, to mourn at his gravesite, and to be that much closer to the man they adore. Some leave things for Elvis: slips of paper tucked under vases or hidden behind curtains have messages like "Elvis, we miss you. Love, Bob and Marge." Others can't resist the temptation to take a little piece of Graceland home with them, pocketing leaves, pebbles, sticks, and pinches of dirt as tokens of their pilgrimage and their brush with Elvis. Once again, it is the stuff of material culture that is pivotal to the devotional practices and beliefs of Elvis's fans, and to his posthumous sustenance.

Graceland itself isn't that remarkable: a pseudo-Georgian structure of about 4,500 square feet with a small guitar-shaped pool. If it is ironic that this mundane mansion has now become a very popular house-shrine (the second most popular house-tour in the United States, after the White House) the fact that Elvis died and is buried there has a lot to do with it. Contemporary Americans are increasingly drawn to the sites of tragic death: placing teddy bears and toys at the South Carolina lake where Susan Smith drowned her two young sons in 1994; pinning mementoes to the steel fence (called "Memory Fence") that originally surrounded the bombed remains of the Murrah Federal Building in Oklahoma City in 1995; building makeshift shrines to students murdered at Columbine High School in Littleton, Colorado, in 1999, or to those who died in the attacks on the World Trade Center in September 2001 (Doss, 2002). People often go to these sites to see and touch real-life tragedy, to weep and mourn and *feel* in public, socially acceptable situations. As shrines to tragedy and trauma, these sites memorialize the horrible events that occurred there and also the grief of visitors who feel kinship with those who died. Ghoulish fascination with inexplicable death, with the death of innocents and unfortunates, is accompanied by feelings of guilt and gratitude: with worries about personal responsibility, with thanks that we were not inside that federal building or that high school. Similarly, Elvis fans go to Graceland to emotionally indulge themselves and become overwhelmed by feelings of love, loss, and loneliness for Elvis.

Of course, not everyone who goes to Graceland is an Elvis fan. As with any shrine, Graceland attracts a mixed audience of devotees and casual tourists: families on vacation, RV retirees, on-the-road college students. Still, however diverse this crowd might be, it is safe to say that most are drawn to Graceland, and drawn together, to try to come to terms with Elvis's continuing popularity. Their presence feeds his posthumous reputation: even the most ambivalent tourist, who goes to

Graceland simply to see why everyone else has gone to Graceland, adds to Elvis's popular culture canonization.

Elvis Week

Graceland's shrine-like sensibility is particularly evident during Elvis Week, when the number of fans swells: in 1997, on the twentieth anniversary of his death, some 60,000 fans (and a huge number of journalists and photographers) descended on Graceland; in 2002, despite pouring rain, about 30,000 fans attended evening ceremonies at the mansion. In addition to touring Graceland, fans typically spend Elvis Week at fan festivals and auctions, vying for Elvis collectibles. They go to benefit concerts for area hospitals; donate blood to the Elvis Presley Trauma Center; attend talks and memorial services; watch Elvis impersonators; visit his birthplace, high school, and karate studio; tour Sun Studios; and tag their names on the fieldstone wall in front of Graceland. They spend a lot of their time buying Elvis stuff at area gift shops. Fans at area motels participate in elaborate window decorating competitions; others submit handmade pictures and crafts to the annual Elvis Art Exhibit held inside Graceland's Visitor Center. Ordinary spaces such as motel rooms and fast-food restaurants become sacred spaces during Elvis Week, because Elvis fans occupy them and fill them with images and objects that they deem to have special significance. Simultaneously a shrine and a shopping mall, Graceland's multi-acre complex is no different than other pilgrimage sites: from Lourdes to the Basilica of the Virgin of Guadalupe in Mexico City, devotional practices, material culture, and commercialism are commonly mixed.

Elvis Week culminates in the all-night Candlelight Vigil, held on the anniversary of Elvis's death. Beginning on the afternoon of August 15, fans gather at the gates of Graceland. A ceremony with prayers, poems, and Elvis songs starts around 9 P.M., and shortly thereafter, fans slowly snake their way up the mansion's steep driveway to the Meditation Gardens for a brief, private, tribute to Elvis. The procession goes on all night, until every fan has had a chance to visit Elvis's grave. Each solemnly holds a glowing candle, lit from a torch at the start of the procession (which itself is lit from the eternal flame at Elvis's grave); once back down the driveway and outside of Graceland's gates, they snuff it out. The tone of this ritual is clearly borrowed from traditional religious practices, such as midnight mass. It also resembles secular-realm rituals such as the Bic-flicking encore summons at rock concerts to the lighting of the Olympic Torch.

For most Elvis fans, the Candlelight Vigil is a hushed and somber ceremony, the cathartic moment of a highly emotional week. Rituals have special meaning because of their sensuality, and this one is particularly sensual. The sounds of cicadas, low murmurs, hushed cries, and Elvis's music, broadcast over strategical-

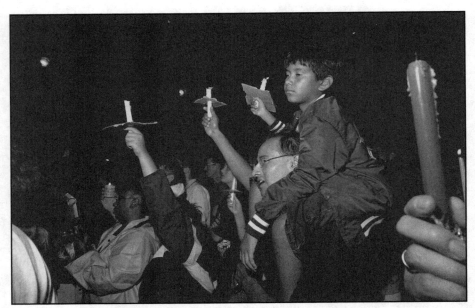

Figure 4.3. Elvis fans at Candlelight Vigil, Memphis, on 25th anniversary of Elvis's death, August 16, 2002. Photo by Rodney Harrison.

ly placed loudspeakers all over the mansion grounds; the visual spectacle of Graceland lit up at night, of flickering candles, the lines of fans; the smells of wax, perfume, flowering magnolias, mounds of roses, and sweat; and, of course, the damp and steamy heat, made even more oppressive from standing in line pressed against thousands of other fans for hours on end, all combine to make the Candlelight Vigil an especially physical, powerful, and spectacular ritual.

Its special character is enhanced by the offerings—flowers, photographs, pictures, dolls, toys, records, handwritten messages, and occasionally, crutches and women's panties—that fans leave at Elvis's tomb. Some offerings specifically request Elvis's intervention: a gift left at his grave during Elvis Week 1996, for example, featured a photo and a hand-printed letter that read: "Dear Elvis: Miss Yoko was here at Graceland last summer but can't make it this time because she died in a car accident in September last year. You don't know how much she loved you but we hope she is with you in the heaven. Her friends from Japan." Other offerings are the physically and visually expressive focal points of fan tribute to Elvis's greatness and absence. Oddly enough, the teddy bear has become *the* ubiquitous symbol of contemporary grief and mourning: found in front of the Vietnam Veterans Memorial in Washington D.C., at many other permanent and spontaneous shrine sites, and especially, at Elvis's tomb. Teddy bears by the hundreds blanket Elvis's grave on the anniversary of his death, simultaneously evoking his 1957 hit single

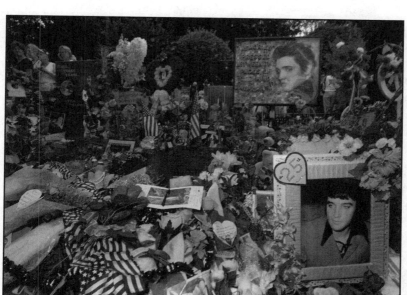

Figure 4.4. Elvis's gravesite on 25th anniversary of his death, August 16, 2002. Photo by Rodney Harrison.

"Teddy Bear" and the lost intimacy of a beloved companion.

As much as fans find pleasure in Elvis's image, it is pain and sorrow that is most evident during Elvis Week. Aside from assassinated political figures such as Abraham Lincoln, John F. Kennedy, and the Reverend Martin Luther King, Jr., Americans have historically embraced few secular-realm martyrs. Elvis's pain and suffering, his drug-addict death in a Graceland bathroom, his failure to find happiness *despite* achieving the American Dream, may be what attracts so many of his fans, who are likewise caught up in pursuing the myth of the American dream. Fans often identify Elvis as a fellow sufferer, which may explain that the image of Elvis most loved by contemporary American fans, and most frequently evoked by his impersonators, is that of the Vegas Elvis, the "Late, Fat, Pain-Racked, Self-Destructive Elvis" (Gottdiener, 1997; Rosenbaum, 1995, pp. 62, 64). This image of Elvis embodies the pleasure *and* the pain of his fans, and plays an important role in his posthumous reputation.

Faith in Elvis

People build shrines and make pilgrimages for religious reasons, because of deeply felt needs for meaning and enlightenment, in hopes of salvation or expectations of spiritual satisfaction, and as tributes to special, sacred figures, things, or places.

The burgeoning of Elvis shrines and Elvis Week rituals suggests that Elvis's after-life has a lot to do with the faith of his fans, which hinges on the ways they see him as a special, wondrous, and even miraculous figure. There is the "identification of the *seen* with what is to be *believed*" Michel de Certeau (1984, p.187) argues; indeed, looking plays a pivotal role in the formation and practice of religious belief.

The ways that fans *see* Elvis's image suggest that he is often perceived as a saint and a savior—not as a God, they emphasize—but as a mystical figure looked upon for access to a transcendent reality, a spiritual intercessor whom they reproduce and personalize in art and in ritual as an instrument of therapeutic relief. In an especially poignant memoir, one fan from Duluth wrote that her mother's long and painful bout with cancer was eased by her vast collection of Elvis memorabilia: "The velvet Elvis was in her bedroom. The bronze plaque was hanging above the stove in the kitchen. The 26-inch statue that could play Elvis songs on mini cassettes was on the TV set. There was even a painting in the bathroom. In the final stages of illness, when she was heavily medicated on morphine, she often commented that the various Elvis's around the house were talking to her, comforting her."

For most fans, the authority of Elvis's image lies in its iconic ability to satisfy spiritual needs and respond to *personal* notions of contemporary piety. Many critics lump these essentially private constellations of belief and practice together to construct cultish apparitions of some sort of an "Elvis Religion." But there is no totalizing institutional religious paradigm that accounts for Elvis's afterlife. Instead, Elvis fans themselves construct a series of cultural and social practices that foster a sense of belonging (which is largely what the numerous Elvis fan clubs are all about) and which also allow room for individual beliefs. Faith in Elvis corresponds to American needs for spiritual community and spiritual solitude, which makes Elvis a profoundly democratic American icon.

Notes

1. "The Secret Tournament: The Nike world Cup 2002 Advertisement," at http://www.bbc.co.uk/dna/h2g2/A776009
2. "The King Still Alive," Press Release, October 16, 2002, BMG/RCA Records, at <www.elvis-numberones.com> For one advertisement see *Vanity Fair* (November 2002, p. 145).
3. See also Elvis Inc.'s Official Fan Clubs' web site at: http://www.elvis.com/fan-relations/default.asp
4. Elvis appeared three times on *The Ed Sullivan Show*: September 9, 1956, October 28, 1956, and January 6, 1957. His first appearance drew the highest ratings in then-TV history, with over 82% of the American viewing public (54 million people) tuning in.
5. Norman Mailer's "The White Negro" was originally published in *Dissent* in 1957.
6. From the start of his career, Elvis publicly acknowledged his borrowings from black culture; see Doss (1999, pp. 170–73).

7. On the sexual and racial dimensions of Elvis's image see especially the chapters "Sexing Elvis" and "All-White Elvis," pp. 115–161 and 163–211, respectively in Doss (1999).
8. The following remarks are condensed from the chapter "Saint Elvis" in Doss (1999, pp. 69–113).
9. Unless otherwise noted, all quotes from Elvis fans in this chapter stem from interviews conducted in Memphis and elsewhere between 1993 and 1996, or from surveys of Elvis fans during 1996.
10. Ideas of personal religious pluralism in complex industrial societies were first advanced in the works of Peter L. Berger and Thomas Luckmann; see, for example, Berger's *The Sacred Canopy* (1967), and Luckmann's *The Invisible Religion* (1967).

References

Alderman, D. H. (2002). Writing on the Graceland wall: On the importance of authorship in pilgrimage landscapes. *Tourism Recreation Research, 27*(2), 27–33.

Baird, W. (2002, August 14). Presley's home earns millions for estate. *The San Diego Union Tribune*, p. M–22.

Baudrillard, J. (1994). The system of collecting. In J. Elsner and R. Cardinal (Eds.), *The cultures of collecting* (p. 21–45). Melbourne: Melbourne University Press.

Baumgold, J. (1995, March). Midnight in the garden of good and Elvis. *Esquire*, 99.

Beckham, S. B. (1987). Death, resurrection and transfiguration: The religious folklore in Elvis Presley shrines and souvenirs. *International Folklore Review, 5*, 88–95.

Bellah, R. N., Madsen, R., Sullivan, W. M., Swidler, A., and Tipton, S. M. (1985). *Habits of the heart: Individualism and commitment in American life*. Berkeley: University of California Press.

BMG/RCA Records. (2002, October 16). *The King still alive* (Press Release). Retrieved October 26, 2002 from www.elvisnumberones.com

Certeau, M. de. (1984). *The practice of everyday life*. (S. Randall, Trans.). Berkeley: University of California Press.

Christian, W. A., Jr. (1989). *Person and God in a Spanish valley* (Rev. ed.). Princeton, NJ: Princeton University Press

Doss, E. (1999). *Elvis culture: Fans, faith, and image*. Lawrence: University Press of Kansas.

———. (2002). Death, art, and memory in the public sphere: The visual and material culture of grief in contemporary America. *Mortality, 7*(1), 63–82.

Ebersole, L. (1994). The god and goddess of the written word. In G. DePaoli (Ed.), *Elvis + Marilyn 2 x immortal* (pp. 136–145). New York: Rizzoli.

Fiske, J. (1993). *Power plays power works*. New York: Verso.

Fricke, D. (1990, November 1). Living Colour's time is now. *Rolling Stone*, 50–51.

The Gallop Organization. (2001, April 13). *Poll analyses: Easter season finds a religious nation*. Retrieved October 26, 2002, from http://www.gallup.com/poll/releases/pr010413.asp

Gottdiener, M. (1997). Dead Elvis as other Jesus. In V. Chadwick (Ed.), *In search of Elvis: Music, race, art, religion* (pp. 189–200). Boulder, CO: Westview Press.

Harrison, T. (1992). *Elvis people: The cult of the King*. New York: Harper Collins.

Hatch, N. O. (1989). *The democratization of American Christianity*. New Haven, CT: Yale University Press, 1989.

Jacobs, A.J. (1994). *The two Kings*. New York: Bantam Books.

King, C. (1992). His truth goes marching on: Elvis Presley and the pilgrimage to Graceland. In I. Reader and T. Walter (Eds.), *Pilgrimage in popular culture* (pp. 92–104). New York: Macmillan.

The King rules again. (2002, October 3). *USA Today*, p. D-1.

Lardas, J. H. (1995). *Graceland: An analysis of sacred space on the American religious landscape*. Paper presented at the American Academy of Religion annual conference. November, 1995.

Lott, E. (1993). *Love and theft: Blackface minstrelsy and the American working class*. New York: Oxford University Press.

Ludwig, L. (1996). *The gospel of Elvis*. New Orleans: Summit.

Mailer, N. (1959). *Advertisements for myself*. New York: G. P. Putnam.

McDannell, C. (1986). *The Christian home in Victorian America, 1840–1900*. Bloomington: Indiana University Press.

———. (1995). *Material Christianity: Religion and popular culture in America*. New Haven, CT: Yale University Press.

Morgan, D. (1998). *Visual piety: A history and theory of popular religious images*. Berkeley: University of California Press.

Morin, E. (1960). *The stars*. (R. Howard, Trans.). New York: Grove Press, Inc.

Patterson, J. (2002, August 15). A new generation keeps Elvis a pop-culture icon, 25 years after his death. *The San Diego Union-Tribune*, p. M-13.

Pierce, P. J. (1994). *The ultimate Elvis: Elvis Presley day by day*. New York: Simon and Schuster, 1994.

Presley termed a passing fancy. (1956, December 17). *New York Times*, p. 28.

Roediger, D. (1991). *The wages of Whiteness: Race and the making of the American working class*. New York: Verso.

Roof, W. C. (1993). *A generation of seekers: The spiritual journeys of the Baby Boom generation*. New York: Harper.

Rosenbaum, R. (1995, September 24). Among the believers. *New York Times Magazine*, pp. 50–57, 62, 64.

Schiffman, B. (2002, August). Top-earning dead celebrities. *Forbes, 147*.

Siemon-Netto, U. (2001, June 28). *Barna poll on U.S. religious belief-2001*. Retrieved October 26, 2002, from http://www.adherents.com/misc/BarnaPoll.html

Stromberg, P. (1990, Winter). Elvis alive? The ideology of American consumerism. *Journal of Popular Culture, 24*(3), 11–19.

Vikan, G. (1994). Graceland as *locus santos*. In G. DePaoli (Ed.), *Elvis + Marilyn 2 x immortal* (pp. 150–166). New York: Rizzoli.

Wilson, M. (2002, September 25). Elvis fans say it rocks. Without a doubt, it rolls. *New York Times*, p. A-22.

Windsor, J. (1992, August 15). Faith and the state of Graceland Enterprises. *The Independent, 33*.

Mediating Meanings

Case Studies in Posthumous Celebrity

Commemoration as Crossover

"Remembering" Selena

MARY C. BELTRÁN

In 1995, acclaimed Tejano singer Selena Quintanilla Perez, known professionally as Selena, "crossed over" from Latino-specific to mainstream U.S. popularity, becoming a larger-than-life icon and top-selling musical artist in the Latin music *and* pop markets and touching off a wave of corporate interest in Latino and Latina performers that continues today. She achieved such widespread stardom only after her death, however, with her posthumous fame spurred in large part by the media coverage that followed her tragic murder.

When Selena was shot by her former employee, Yolanda Saldívar, on March 31, 1995, news of the shooting was omnipresent in the Spanish-language news media. Updates of Selena's death and Saldivar's standoff with the police were reported around the clock by the television networks Univisión and Telemundo, while Latin-format radio stations were deluged with requests for her music from grief-stricken fans. Although the 23-year-old singer was virtually unheard of by most non-Latinos at the time, she was beloved among the mostly working-class, Mexican American fans of Tejano and conjunto music, and a prominent celebrity within the broader Latino community. The dramatic outpouring of grief among her fan community—as many as 60,000 mourners made the trip to Corpus Christi, Texas, to pay their final respects—alerted the English-language media to a celebrity icon that they had not previously been aware of, and they quickly attempted to fill the vacuum with information on this "new" star.[1] In the print media, report-

ing was led by *The New York Times*, which ran the story of the singer's death on its front page.

Selena thus was not merely promoted but in fact introduced as an American star through the various media texts that commemorated her life and passing in the English-language broadcast and print media. This process involved a sometimes-bumpy negotiation, however, as my analysis of tribute articles that appeared in English-language magazines and of the reviews of the 1997 narrative film about Selena's life documents. The image of Selena as a cross-cultural icon was created in large part by reporters who were previously unfamiliar with the singer and the social context of her fan community. These journalists served to translate Selena's life story for non-Latinos, constructing a star image that reflected cultural schisms that still placed Mexican Americans outside the borders of American popular culture. Despite this subtle marginalization, Selena's rags-to-riches life narrative and an emphasis on her family's mourning process served to position her as a romantic icon for non-Latino audiences. This construction of Selena as a posthumous icon also signaled a new acknowledgment, if not central positioning, of Mexican American culture and performers in the broader U.S. imagination.

Selena's Posthumous Stardom and Latino "Crossover"

As José Behar, President of EMI Latin, has claimed in recent years, the mass appeal that Selena garnered posthumously was instrumental in drawing attention to the potential profitability of Latino/a performers and culture. The subsequent success of such performers as Ricky Martin and Jennifer Lopez has been due in large part to how Selena "blew [the door to mainstream stardom for Latinos] wide open" posthumously, as Behar states (as cited in Cortina, 1999).[2] It must be underscored that this was not the same reception that the singer faced in the pop music market while she was alive, though she was preparing to release an English-language album at the time.[3] For despite the increasingly multicultural makeup of U.S. society, the media industries in 1995 still tended (as they often still tend) to reinforce a white-dominant popular culture, as such scholars as Dyer (1997), Lipsitz (1998), and Shohat and Stam (1994) document. With respect to Latino/a performers wanting to gain an audience outside the Latino community, Hollywood tradition has long necessitated pushing through preconceptions of insufficient audience appeal in order to garner substantial promotion and positioning within the realm of mainstream entertainment. A handful of Latino/a performers can be said to have achieved such a "crossover" in their careers, among them film stars Ramón Novarro and Dolores Del Rio in the 1920s, Anthony Quinn in studio-era Hollywood, and Jennifer Lopez today. Selena is notable as the first Mexican American young

woman, aside from perhaps Vicki Carr, [4] to achieve stardom that could be described in this manner in the realm of American music.

"Crossover" stardom, a term often bandied about in the popular press, can be defined most simply as a performer being marketed to and becoming popular with more than one audience, or in more than one musical genre, as such scholars as Garofalo (1994) and Perry (1988) have documented. In popular usage, however, the term typically has been used to describe non-white and particularly Latino performers who become popular with white audiences, rather than vice versa—a reminder of the racially hegemonic nature of the U.S. star system, even in 1995. Such was the fairly monochrome view of popular culture that Selena attempted to challenge prior to her death. In a time when Latina performers still were seen mainly as sexualized exotics or as of interest only to Latino audiences, the singer was actively working to be launched into and become popular with a broader cross section of the American public.

Such a process is not without its pitfalls. Scholars such as Dyer (1986), hooks (1992), and Kirihara (1996) point to contradictions, through the simultaneous celebration and objectification of difference, traditionally embedded in media representations of non-white celebrities meant for consumption by white audiences. In such a process there also can be a watering down of authenticity or other compromise expected of performers, dynamics that have been described alternately as containment, deactivation (Dyer, 1986), or neutralization (hooks, 1992). The shaping of Selena's posthumous star image, formed through commemoration coverage in the print and broadcast media, illustrates such processes of containment and neutralization, even while this media discourse ultimately helped to expand the boundaries of mainstream popular culture, as I describe further below.

"Remembering" a New Star: The Selena Tributes

To explore the nature of the media commemoration of Selena in the English-language print media, I analyzed the coverage of her passing in the months following her death. Magazines were emphasized on the understanding that producers of such wide-circulation media most clearly serve as gatekeepers of national celebrity. Using the Reader's Periodical Index and Academic Index, articles were found in the entertainment and news magazines *People*, *Entertainment Weekly*, *Time*, and *Newsweek*; in the women's magazines *Ladies Home Journal* and *Good Housekeeping*; and in the progressive intellectual magazines *New Republic*, *New Yorker*, and *The Nation*. These articles fell into two main categories: The first were articles that eulogized Selena's life in the months after her death, while the second grouping consisted of stories about and reviews of the feature film *Selena*, which was based on the posthumous star's life and released by Warner Bros. in the spring of 1997. In

the case of these reviews, I expanded my search to include large-circulation newspapers such as the *Los Angeles Times* and *New York Times*.

I found a variety of often-contradictory themes in the overall commemoration discourse. The articles, while generally providing an educational introduction to Selena's career, to Tejano music, and to other aspects of Mexican American culture, also often exhibited a more ambivalent undercurrent that was less than celebratory. Particularly, a subtle distancing from Latino culture and community and at times a downplaying of Selena's status and popularity was discerned in many articles.

Most immediately remarkable was simply how few articles were published about Selena in English-language magazines in the months following her death in 1995. In the Spanish-language press, seemingly every media outlet headlined with stories eulogizing Selena and underscoring her importance to the Latino community. In the English-language print media, however, as is apparent from the above listing, only a handful of articles were found, even while magazines that did choose to feature Selena tended to sell record numbers of copies. For instance, when *People Weekly* put a picture of the slain singer on their cover in the Southwest U.S., the run of 450,000 copies promptly sold out, as did a subsequent special tribute issue that was later published ("Her Life in Pictures: Selena 1971–1995," 1995). *People* eventually launched *People En Español* as a result of discovering this untapped audience.

Also of note are the magazines in which tribute articles appeared. Aside from *People* and *Entertainment Weekly*, articles on Selena were found mainly in news-oriented magazines and in tabloids such as *The National Enquirer* and *The Globe* (which are unavailable at this time through on-line databases). Only a few articles were published in women's magazines, while no articles were found in magazines catering to young people—a striking finding considering Selena's age and the possible appeal of her story to young female readers in particular.

In addition, a few "think pieces" about the star's passing were published in magazines positioned as high-brow news and culture forums: *New Republic*, *The Nation*, and *New Yorker*. What to make of the focus on Selena in this media niche, while she often was ignored elsewhere? Apparently while many entertainment news media gatekeepers did not consider the passing of a Latina who sang Tejano music newsworthy in 1995, she was considered a particularly interesting enigma for intellectuals to grapple with, underscoring the fascination of both deceased celebrity icons and crossover stars for a general public in a state of flux with respect to ethnic identity. As Castillo (1995) notes in *The Nation*, Selena could be viewed as "an exotic enterprise, testing the waters" of popular culture (p. 764). These articles, in addition to paying tribute to the star, explore the nature of fan and commercial response to her death. They also were often written by Latino/a writers, who like-

ly were commissioned by their respective magazines to "make sense" of the Selena Phenomenon for readers. These included the above-mentioned author Ana Castillo of *The Nation*, who identifies as Chicana, and *New Republic*'s Ilan Stavans, of Eastern European descent and Mexican upbringing. Arguably, these more critical and culturally grounded articles were read by a much smaller audience than the other tribute pieces in the English-language press, however, given the circulation of these magazines.

Differences between the more widely read tribute articles and the film-related articles and reviews in 1997 also highlight some of the common elements of the phenomenon of media commemoration. Despite many journalists' apparent or declared initial ignorance of Selena and her culture, the resulting tribute articles cast the singer, her family, and her fan community in a positive and respectful light, at least upon superficial examination. As was the case in the Spanish-language media, such coverage often could be described more as hagiography than historiography, constructing a larger-than-life mythos around the life of Selena Quintanilla Perez. Care was no doubt taken to describe the deceased star's background and community respectfully, while the creation of a saint-like icon also provided dramatic interest to the articles.

The ethnicity of the tribute article authors also appeared to strongly influence the manner in which Selena was described, a commentary on the import of cultural diversity among media gatekeepers—although not always in the stereotypical manner one would expect. As far as could be discerned, there were only a few Latinos among the writers; only Castillo and Stavans described Selena's passing in relation to the Mexican American perspective.

Most of the other tribute writers appeared to assume a non-Latino readership with no prior knowledge of Selena or of Mexican American culture—overall, a discerning feature of Selena's media commemoration in the English-language press. As such, these provided a primer to Tejano music and its fans while also maintaining a tourist stance with respect to the Mexican American community. Notably, journalists had to seek out members of the Latino entertainment community, seldom given voice in the mainstream media, to share their expertise on Tejano music and culture. As Leland (1995) reported in *Newsweek*:

> Literally, "Tejano" means Texan, not just the music but the people as well. It is the soundtrack of MexAmerica. "Tejano," says Abraham Quintanilla Jr., Selena's father . . . "is a fusion, with all these influences, rock and roll, pop, country jazz. We're Americans who happen to be of Mexican descent." (p. 80)

While a crude introduction to Tejano music and culture, this process brought Tejano music in from the margins with respect to the radar of the mainstream news media.

In addition, the tribute articles served to educate readers unfamiliar with Selena before her death with the singer's talent and stardom from when she was still alive. She is described alternately as "one of Latin music's brightest stars" (Sanz and Cortina, 1995, pp. 36–41), the "Queen of Tejano music" by several authors (Sanz and Cortina, 1995, pp. 36–41; Hewitt, Harmes, and Stewart, 1995, p. 48; *Texas Monthly* on its December 1995 cover), and "the Tejana diva" (Castillo, 1995, p. 764). The articles also point to various highlights from Selena's career, including her 1994 Grammy for best Mexican American album for *Selena Live*, her concerts in the Southwest and Latin America, which drew crowds of upwards of 80,000, and her appearances on Spanish-language telenovelas and in the Hollywood film *Don Juan de Marco*. Occasionally attempts at education falter, however, as in the case of inaccuracies inadvertently reported. For example, *Time* and *New Republic* refer to Selena as a child as Selena Quintanilla Perez, when in fact Perez was Selena's married name.

The descriptions of Selena are notable in their similarity and particularly in their worshipful tone. For the most part the posthumous singer is depicted in glowing, even saint-like terms, as in this excerpt from *People Weekly*: "For Latin music enthusiasts, the most apt comparison was with the death of John Lennon. Selena was vastly talented, deeply adored" (Hewitt, Harmes and Stewart, 1995, p. 49). Only the subsequent commentaries in *New Republic* and *The Nation* critique Selena's posthumous popularity as a phenomenon as well as celebrating her life and achievements. For example, Stavans (1995) comments in *New Republic*, "Selena was a symbol, not a genius" (p. 24).

In addition, Selena is both mourned and constructed as an American icon in the tribute articles through a number of discursive thrusts. First, Selena is introduced to the non-Latino American public as a family member, a wife, and a woman. In all of the tribute articles, Selena is described as an amiable, hard worker who identified strongly as part of a tightly knit family that worked together on their music and backed her singing career. As the following excerpts illustrate, this is generally accomplished through emphasis on Selena's humble origins and hard-scrabble climb to success—a narrative of a young woman and her family's achievement through talent, hard work, and mutual love and support.

> "If we got 10 people in one place, that was great," said Selena, who was 9 when she hit the road. "We ate a lot of hamburgers and shared everything." They traveled to gigs in the banged-up family van. (Hewitt, Harmes, and Stewart, p. 50)

> Selena was "a genuinely good person—she was clean, she stood for family." (Selena's father, Abraham Quintanilla, cited in Powell, 1995, p. 26)

Telltale details of her life, such as the fact that she and her husband, Chris Perez, lived in a house next door to Selena's parents, also are shared in many of the tribute pieces in support of this public picture of the slain singer.

Selena also was often described as being *del pueblo*—of the people—with respect to her strong ties with her working-class community, despite her fame and financial success. A number of stories related that she had not moved from her modest neighborhood, and that she still liked to shop at the local mall. Such discursive constructions emphasized aspects of family and community involvement coded in the public imagination as uniquely American and particularly as connected to the mythical American Dream. It also emphasized Selena's ethnic pride, a phenomenon that many Americans of all ethnic backgrounds now identify with, as Halter (2000) has documented in her study of recent trends in American marketing. Despite earning platinum records, Selena was "Texan through and through . . ." Castillo (1995) reassured (p. 764), while Sanz and Cortina (1995) asserted that "[o]ffstage, [Selena's] unpretentious charm and obvious pride in her heritage endeared her to her fans" (p. 36).

Through highlighting such details of Selena's life, she was promoted as an unpretentious and clean-living American role model. Ironically, this image of Selena as a posthumous star likely would not have been considered a worthwhile image to promote to non-Latinos, were she alive. As Castillo (1995) points out, "perhaps Selena was not a household word yet because of her clean-cut, married image" (p. 764).

Aside from sensationalized coverage in the tabloids, including speculation on Selena's relationships with Saldívar, her husband, and her family (the high point of sensationalism being *The Globe*'s unauthorized publication of Selena's autopsy photos), and the more sedate coverage of Saldívar's trial in the news media, non-Latinos also were encouraged to adopt Selena as an American icon through news of her family and her husband's mourning process. In this manner, a window was created into the Quintantilla family's personal world that encouraged and enabled readers to identify with Selena's memory, even if they had been unfamiliar with her when she was alive. The excerpts below illustrate the emotional tone of this discourse:

> "The ultimate sorrow a human can feel is when someone dies," [Selena's] father, Abraham Quintanilla Jr., told *People*. "I felt like this was all a dream." (Hewitt, Harmes and Stewart, 1995, p. 49)

> As fans pay tribute to a fallen star, Chris Perez mourns the woman he loved. (Sanz and Cortina, 1995, p. 40)

This element of the media commemoration of Selena has continued in articles published in subsequent years. For example, *Los Angeles Times* readers were updated on the mourning process of Selena's family in 1999 in "The Resonance of Selena" (Valdes-Rodriguez, 1999, p. F1), four years after Selena's murder.

At the other extreme, the commemoration discourse also included occasional, quasi-negative asides that appear to be related to cultural stereotypes. Notably, Selena's skin-baring but ultimately wholesome costumes are given more attention than her music in a few of the tribute pieces, and even more so in the news coverage of the singer's slaying that preceded them. Selena was often referred to in these initial news stories as the "Latin Madonna" or "Tex-Mex Madonna," presumably to provide a vivid referent to non-Latinos. Similarly, the image of Selena's bare midriff at times overpowers all other description in the tribute articles, as in *Entertainment Weekly's* introduction to the deceased star: "In concert, Selena's sexy bustiers and taunting, pouty smiles earned her the nickname, 'the Tex-Mex Madonna'" (Seidenberg, 1995, p. 20). While such comments do not prevent Selena from appealing to non-Latinos, they work to contain such stardom in that they focus attention primarily on aspects of her appeal that are exoticized in the U.S. mainstream. As Willis (1997) argues, through such dynamics Selena's appearance is interpreted strictly from an Anglo American perspective, which tends to sexualize female dress more intensely than is generally the case in the Latino or Latin American context.

Despite a general tone of respectful adulation for Selena in the media eulogies, other cultural schisms are evident on closer examination. For one, contradictions are evident in the emphasis on Selena's crossover potential and almost-completed English-language CD at the time of her death, to the extent that her considerable achievements in the realms of Tejano and Latin music are often downplayed. Selena's fan community also is indirectly devalued in this construction; it is a non-Latino fan base that "really" matters and that Selena almost achieved during her lifetime, as many of the tribute articles appear to express.

Ambivalent attitudes also can be detected with respect to the reporting of the overwhelming tide of "Selenamania" among the star's primarily Mexican American and Mexican fans after her death. As Coronado (2001) asserts, "across the nation, non-Latino USA was caught off guard by the massive Latino response to Selena's death" (p. 60). Mixed reactions can be discerned in the Selena tribute articles in the English-language media. On the one hand, her fans are described as strongly and eternally devoted to their beloved icon:

As many as 1,200 mourners still visit the grave each weekend. Some of them bring gifts and letters; a few assuage their grief by carving messages like "Now you can sing with the angels" in the sappling's thin, soft bark. "There are always people here," says a cemetery security guard. "She will always have fresh flowers." (Sanz and Cortina, 1995, p. 36)

For five days they lined up by the thousands, weeping, leaving flowers, spray-painting messages, even scraping blood from the concrete outside of room 158 at a nondescript Days Inn in Corpus Christi, Tex. [where the singer was shot by Saldivar]. (Seidenberg, 1995, p. 20)

Such commentary tended to describe the posthumous star's fan community from a distance, however, through never allowing the fans to speak for themselves. Stavan's (1995) tribute article in *New Republic* in fact was the only exception. More often, Selena devotees were positioned at the fringes of American popular culture and marked as distinct from other fans—in the words of Kerr (1995) in *New Yorker*, with regard to their "fever of adulation and grief in a low-profile corner of the country" (p. 34).

Similarly, it was hinted in some descriptions that perhaps Selena's fans were extreme in their adoration, pathological to the point of "loving [Selena] to death" (Castillo, 1995, p. 766). That Selena died at the hands of the former president of her fan club likely influenced this construction. This negativity can also be interpreted, however, as indicative of an ongoing lack of familiarity or comfort with Latino culture in the United States As Coronado (2001) asserts in his insightful explication of the marketing of Selena products to Latino consumers after her death, the mainstream media discourse generally failed to understand the importance of Selena to the Mexican American community as a "*morena*, a dark-skinned woman of working class origins who represented, for so many Texas Americans, their own families and the long dream to not only make it but to overcome the historical denigration of their culture and origins" (p. 83).

Commemoration on the Rewind: *Selena* and Its Reception

In this period in 1995, fan response to Selena's death and particularly the heavy sale of her albums alerted industry professionals to a dramatic interest on the part of the general public in the deceased singer's music and products branded with the star's name or image. Selena's first posthumous album, *Dreaming of You*, sold 175,000 copies in one day after its release in July 1995, becoming the second-fastest-moving album ever by a female performer (Lannert, 1995, p. 8). The singer subsequently had five albums on the Billboard 200 in April 1995 and topped 10 categories of the 1995 year-end charts. These figures served to underscore Selena's posthumous crossover appeal, as well as the size and spending power of the previously neglected Latino market.

In addition, bootleg products stamped with Selena's name or image or showcasing her music sprang up around the world, to the extent that the Quintanilla family filed over 100 copyright lawsuits (Cantu, 1996, p. 18). Unauthorized biographies began to be published, including Clint Richmond's early entry, *Selena: The Phenomenal Life and Tragic Death of the Tejano Music Queen*, with Joe Nick Patoski's *Selena: Como La Flor* soon following on its heels. Both biographies were extreme-

ly successful. Talk of a film based on Selena's life quickly sprouted up in response to this outpouring of demonstrated commercial interest. Abraham Quintanilla came to an agreement with Esparza-Katz Productions in November 1995 that enabled them to produce a film based on his daughter's life and career, which was to focus only marginally on the circumstances of her death. *Selena* was released in April 1997. Directed by Gregory Nava, executive produced by Quintanilla, and starring Jennifer Lopez as Selena, the film provides a non-controversial, upbeat presentation of Selena's life story. The film was hyped in the mainstream press prior to its release, particularly through a massive, *Gone with the Wind*-type search for the actresses who would play the child and adult Selena. More than 22,000 women and girls vied for the roles, Menard (1997) reported (p. 32). While a less hyped documentary on the star, *Selena Remembered*, was released the same year, *Selena* arguably served most effectively as a crossover text with respect to introducing the posthumous star to a broader American audience. With respect to its role in Selena's ongoing media commemoration, it provided a quasi-memorial document of the singer's life that viewers could watch as often as they cared to press "rewind."

With respect to articles on the making of the film, similar entry points for fan identification to those found in the tribute articles can be discerned. For one, non-Latino readers and Latinos unfamiliar with Tejano music were once again introduced to Selena and Mexican American culture. In the case of one author, this was achieved through emphasizing the perspective of the film's Californian production team:

> As Californians, most of the cast and much of the crew, including [director Gregory] Nava, were not well acquainted with the subject of their movie. "We were proud of her as a Chicana, but we weren't that familiar with her music," asserts the director. Spending time with the Quintanillas, especially in their hometown of Corpus Christi, revealed to the actors how important Selena was to her family as well as her fans. (Menard, 1997, p. 36)

Articles on the production also often described the film as a labor of love for Selena's family. In the process, writers provided an indirect update on how her family and friends were coping with their loss. Such commentary again promoted Selena as a romantic icon to fans and would-be fans. For example, Gregory Nava is quoted as saying, "I feel [Selena's] spirit is with us," (Lambert and Cortina, 1997, p. 160), while Jennifer Lopez commented to reporters that "it's common to be walking around and find people crying" [on the film set] (p. 161).

The reviews of the film in the English-language print media provide an interesting counterpoint to the earlier analysis of the Selena tribute articles in 1995. For one thing, some magazines that didn't bother to mark Selena's death chose to review the film. These magazines tended to be younger-demographic pop culture magazines, among them, *Rolling Stone* and the women's magazine *Glamour*. Film

critics, as would be expected, also presumably were under no obligation to put a positive or respectful spin on the reviews. As a result, a wider range of attitudes is expressed toward both the movie and Selena-as-icon.

Several critics also expressed ambivalence or disbelief regarding the appeal of Selena, a Latina star, to mainstream audiences. Perhaps such a "crossover" can only be possible if Selena is exoticized or otherwise contained, as Beltrán (2002), Dyer (1986), and Hooks (1992) describe in relation to patterns experienced by previous Latina and other non-white stars. Such a dynamic is illustrated in the almost constant emphasis on Selena's purported exotic visual image in the reviews. She is often described in reference to her stage costumes, in such terms as a "saint in spandex" and "bare-midriffed." As Lisa Schwarzbaum (1997) noted in *Entertainment Weekly*: "When the graceful Jennifer Lopez shakes her booty in the star's signature sequined bustiers, Gregory Nava's celebratory biopic about the slain Tejano singer becomes a nice enough concert film" (para. 1).

In addition, it should be noted that, as in the above example, critics were in fact responding to Jennifer Lopez as Selena as opposed to film footage of the posthumous star. The complex dynamics involved in this star construction bring up a new twist to understanding Selena's media commemoration and posthumous stardom. Selena's symbolic replacement by Lopez in *Selena* arguably offered the general public a physical image of the slain singer that was more "Hollywood-friendly" than the star herself. Even a cursory comparison of pictures of the posthumous singer with those of the now-multi-media star who portrayed her reveals that Mexican-American Selena possessed more indigenous features and darker skin than Lopez, a Puerto Rican of partial European ancestry (her more recent dark skin tones achieved through makeup artists' strategic use of bronzers notwithstanding). This makes the recurring comment in reviews that Lopez looked remarkably like Selena in the film all the more curious. The critique of the *Los Angeles Times'* Kenneth Turan (1997) that "Lopez so much resembles [Selena] that for an instant you can't tell one from the other" (p. F1) was echoed by several other critics without discussion of the implications of Lopez serving as an aesthetic stand-in for the *morena* star.

Similarly striking are complaints by critics that the film did not provide enough private information about the star. Such discussion illustrates a desire to critique the "good girl from a loving family" narrative constructed in the earlier media eulogies. Among these comments, Travers (1997) complained in *Rolling Stone* that "missing is a sense of the interior life behind the smiling face that Selena showed the world. What of the drive that led her to music? What comfort did she find in it? What pain?" (p. 86). McLane (1997), similarly, comments in *The Village Voice* that the film provides only "a sense of what a fascinating character this impulsive, determined young woman must have been. Maybe someday someone will make a movie about her" (p. 70).

In this context, a few of the reviewers also problematize the previously constructed image of Selena's close-knit, perfect family. Several critics also question the motives of the Quintanilla family in making money from the film and Selena's music and image since her death—in a sense providing the conflict that they may have felt was missing from the film. Differing opinions of how Selena's posthumous star image should respectfully be handled and/or marketed become central to these critiques. As one commentator presented the debate in *Time* magazine:

> "I didn't do the movie to exploit my daughter," insists Abraham Quintanilla, Jr., 57, who formed the group Selena y Los Dinos when the girl was nine and served as its manager and goading spirit. "I did it because there's an insatiable desire from the public to know more about her." *Selena* is the latest, largest artifact in the kind of postmortem career maintenance that not only honors but also profits from a slain celebrity. (Corliss, 1997, p. 86)

This discourse and other commentary in the film reviews can also be critiqued as expressing negativity in regard to whether Selena "deserved" her popularity. In contrast to a general tone of respect for the dead in the tribute articles, some of the commentary in the reviews discloses thinly veiled contempt, whether in response to the film, the late singer, Tejano music, or some combination of the three is difficult to determine. The following excerpts illustrate such attitudes expressed by film reviewers:

> I must stress that no type of today's pop music pleases me, and it may be that Selena Quintanilla Perez, the queen of tejano music had genuine merit for others. . . . What accounted for the popularity of the Mexican-American singer Selena, killed at age 23 by a crazy woman who had worked for her, is less easy to fathom [than that of Howard Stern, whose *Private Parts* was reviewed in the same article] . . . For a while, I considered titling this review 'Ta-Ra-Ra Bustier.' (Simon, 1997, p. 77)

> What can you say about a 23-year-old, mono-monikered, Tejano superstar who died? Not enough, the moviemakers seem to think. This worshipful two-hour-plus movie traces in excessive detail the brief but bright career of Selena Quintanilla Perez. (Rozen, 1997, p. 47)

> . . . the story of Selena's climb from the rickety stages of Texas state fairs to the Grammys and stardom has all the showbiz grit of a Partridge Family episode. (McLane, 1997, p. 42)

In contrast, a number of reviewers praised the film, with Jennifer Lopez's performance in particular garnering kudos from critics. Those with more positive reactions to the film often cited its importance as an educational tool, as well as a primer to the life and career of Selena:

> On its own good-natured terms, *Selena* is both pleasant to watch and instructive in familiarizing a movie audience with the Texan-Mexican borderland music known as Tejano. (Holden, 1997, p. C16)

Selena brings freshness and heart to the life story of a little girl from Corpus Christi, Texas, who had big dreams and was lucky enough to realize almost all of them before her life was cut short . . . like Nava's *My Family*, it's insightful in portraying Mexican-American culture as a rich resource with its own flavor and culture. (Ebert, 1997, p. 16)

Because of the 2,000 theater-wide *Selena* exposure, Tejanos, their music, and their accompanying *onda* [vibe] will now be seen as its own unique synthesis of Mexican and American elements. . . . It's all there in the movie—on the fringes, in the crowd scenes—like all secrets ready to reveal themselves. (Mendiola, 1997, para. 3)

Ultimately, reviewers appear evenly divided in their attitudes toward the film and its subject. While many were not impressed with the film, the posthumous star Selena, particularly as portrayed by Lopez, again was brought to center stage in popular culture discourses. As a result of the film's release, a process of active commemoration continued in the mainstream media, further fueling Selena's posthumous celebrity and the marketing of her music and image.

Conclusions

Despite the ambivalence embedded in the media commemoration of Selena's life in English-language magazines after her death, through it Selena became a household name and American star. Album sales, in particular, indicated that a substantial number of Anglo-Americans were listening to Selena's music for the first time. Selena had crossed *al otro lado*, into the media mainstream. For her most devoted fans, her memory continues to be maintained in the music world, on personal internet sites, and in countless other popular culture sites, including clothing stores that sell a Selena clothes line and a public memorial site and Selena museum in Corpus Christi, Texas. Alongside the Selena documentaries and the feature film *Selena*, her life inspired a musical, *Selena Forever*, that was launched in late 1999 with highly publicized auditions in San Antonio, Houston, Corpus Christi, New York, Las Vegas, and Los Angeles (Navarro, 1999). In 2000, the musical began a successful 30-city tour—a milestone project with respect to its focus on a Latina musical star and 95% Latino cast.

Most critics agree, however, that it was only with her death that Selena achieved mainstream stardom. Disheartening as it is to consider, Selena's "crossover" perhaps was only possible because she was deceased, and so would never mature to further threaten the racial hegemony of the media mainstream. Rather, with her death, the singer remains forever static, always bare-midriffed in the popular imagination. Selena's death and the subsequent process of media memorialization provided the containment necessary for her image and performance artifacts to be palatable cross-cultural media texts to market to Anglo Americans, even while

the tragedy of her death supplied a compelling sense of romance and tragedy to her posthumous figure. The inclusion of Jennifer Lopez's more palatable visage—in the eyes of Hollywood entertainment producers—to the iconography of Selena further fueled this crossover construction.

The resonance and continuing popularity of Selena's star image within American popular culture since her posthumous crossover, however, does speak to cultural shifts and changes in the U.S. that have prompted an increasing broadening of the pop culture mainstream with respect to ethnic diversity. As cultural critic Coco Fusco (1995) attests, icons and other media images often serve to express questions of identity as cultural borders shift and change. As an "authentic Hispanic and authentic American," as José Behar (1995) described the singer (p. L14), Selena personified the cultural blending that characterized not just the New Latina but also the New American, hybrid identity—contradictions, shifting borders, and all. And while the tributes to Selena in the English-language press expressed ambivalence and at times negativity toward Mexican American performers, cultural forms, and fans, they also demonstrated a growing acknowledgment and inclusion of Latinos in an overall vision of "America." Both symptom and catalyst of such cultural shifts, the media memorials prompted by Selena's death challenged racialized paradigms in Hollywood, creating an opening that would accommodate living Latino and Latina performers in subsequent years.

Notes

1 The number of mourners who made the pilgrimage to view Selena's casket at the Bayfront Convention Center in Corpus Christi, Texas, was in fact disputed greatly, with obvious tensions apparent with respect to the figures preferred by Latino-oriented and mainstream news outlets. Latino-oriented media outlets tended to estimate the number of mourners who lined up to pay their respects at 60,000. In contrast, *Newsweek* and *Entertainment Weekly* reported a more conservative 30,000, while *People Weekly* estimated that the numbers were "as high as 50,000."
2 Lopez portrayed Selena on the big screen in 1997, with her starring role in *Selena* widely considered the part that catapulted the actress to American stardom.
3 English was in fact the first language of Selena Quintanilla, who grew up in a primarily white neighborhood—facts which underscore the false cultural boundaries that the "crossover" marketing of Latina and Latino performers can construct and emphasize.
4 Vicki Carr, born Florencia Bisenta de Casillas Marinez Cardona in El Paso, Texas, launched her career in 1961 with the hit song "He's a Rebel." Carr is now a three-time Grammy winner who has recorded in both English and Spanish (Community Television of Southern California, 2001, para. 1).

References

Behar, J. (1995, June 10). Thoughts from José Behar. *Billboard, 107,* L14.
Beltrán, M. C. (2002). *Bronze seduction: The shaping of Latina stardom in Hollywood film and star publicity.* Unpublished doctoral dissertation, University of Texas, Austin.

Cantu, T. (1996, June). Cashing in on Selena: How the Tejano queen's murder caused an economic phenomenon. *Hispanic*, 18–24.

Castillo, A. (1995). Selena aside. *The Nation*, 260, 764–766.

Community Television of Southern California. (2001, March). *Vicki Carr: Memories y Memorias*. Retrieved November 15, 2001, from http://www.kcet.org/vikkicarr/talent/index.htm

Corliss, R. (1997, March 24). Viva Selena! *Time*, 149, 86–87.

Coronado, R. Jr. (2001, Spring). Selena's good buy: Texas Mexicans, history, and Selena meet transnational capitalism. *Aztlán*, 26, 59–100.

Cortina, B. (1999, March 26). A sad note: Selena's death in 1995 cut short a bright career and introduced the world to her music [electronic version]. *Entertainment Weekly*. Retrieved January 20, 2003, from EW.com: http://www.ew.com /ew/report/ 0,6115,274898~7~~,00.html

Dyer, R. (1986). *Heavenly bodies: Film stars and society*. Hampshire, England: MacMillan Press.

———. (1997). *White*. London: Routledge.

Ebert, R. (1997, March 21). Selena. [Film review]. *Chicago Sun-Times*, p. 16.

Fusco, C. (1995). *English is broken here: Notes on cultural fusion in the Americas*. New York: New Press.

Garofalo, R. (1994). Culture versus commerce: The marketing of black popular music. *Public Culture*, 7, 275–287.

Halter, M. (2000). *Shopping for identity: The marketing of ethnicity*. New York: Schocken Press.

Her Life in Pictures: Selena 1971–1995. (1995, Spring). [Commemorative issue]. *People Weekly*.

Hewitt, B., Harmes, J., and Stewart, B. (1995, April 17). Before her time. *People Weekly*, 43, 48–53.

Holden, S. (1997, March 21). A short life remembered with songs and sunshine. *New York Times*, p. C16.

hooks, b. (1992). *Black looks: Race and representation*. Boston: South End.

Kerr, S. (1995, October 30). Selena's siren song. *New Yorker*, 71, 35–36.

Kirihara, D. (1996). The accepted idea displaced: Stereotype and Sesseu Hayakawa. In D. Bernardi (Ed.), *The Birth of Whiteness: Race and the Emergence of U.S. Cinema* (pp. 81–99). New Brunswick, NJ: Rutgers University Press.

Lambert, P., and Cortina, B. (1997, March 24). Viva Selena! *People Weekly*, 47, 160–161.

Lannert, J. (1995, April 22). Selena's albums soar: EMI rushes shipments. *Billboard*, 8.

Leland, J. (1995, October 23). Born on the border. *Newsweek*, 126, 80–83.

Lipsitz, G. (1998). *The possessive investment in whiteness*. Philadelphia: Temple University Press.

McLane, D. (1997, April 1). Selena. [Film review]. *Village Voice*, 42, 70.

Menard, V. (1997, March). The making of Selena. *Hispanic*, 30–32.

Mendiola, J. (1997, March 26). The heart of Tejas [electronic version]. *San Francisco Bay Guardian*. Retrieved January 19, 2003, from SFBG Arts and Entertainment: http://www.sfbg.com/AandE/ 31/26/selena.html

Navarro, M. (1999, Nov. 8). Inspired by Selena, they seek her role; Singer's spell lives on in stage auditions [electronic version]. *New York Times*. Retrieved September 26, 2002, from http://query.nytimes.com/search/ article-page.html?res= 9D06E5D6143AF93BA35752C1A96F 958260.

Perry, S. 1988. Ain't no mountain high enough: The politics of crossover. In Simon Frith (Ed.), *Facing the Music* (pp. 51–87). New York: Pantheon.

Powell, J. (1995, August). The family of murdered music star Selena: Their grief, their memories, and the painful process of healing. *Good Housekeeping*, 26–28.

Rozen, L. (1997, March 31). Selena. [Film review]. *People Weekly*, 44, 21–22.

Sanz, C., and Cortina, B. (1995, July 10). After Selena. *People Weekly*, 44, 36–41.

Schwarzbaum, Lisa. (1997, April 4). *Selena*. [Film review]. [electronic version]. *Entertainment Weekly*. Retrieved January 20, 2003, from EW.com: http://www.ew.com/ew/article/review/movie/0,6115, 287336~1│9096│ │0~,00.html

Seidenberg, R. (1995, April 14). Requiem for a Latin star: Selena's brutal death robs Tejano music of its great young hope. *Entertainment Weekly*, 20.

Shohat, E., and Stam, R. (1994). *Unthinking Eurocentrism: Multiculturalism and the media*. London: Routledge.

Simon, J. (1997, April 21). *Selena*. [Film review]. *National Review*, 49, 77.

Stavans, I. (1995, November 20). Dreaming of you. *New Republic*, 213, 24–25.

Travers, P. (1997, April 17). *Selena*. [Film review]. *Rolling Stone*, 758, 86.

Turan, K. (1997, March 21). In the authorized *Selena*, She's seen in the best light. [Film review]. *Los Angeles Times*, pp. F1, F3.

Valdes-Rodríguez, A. (1999, April 9). The resonance of Selena. *Los Angeles Times*, p. F1.

Willis, J. L. (1997, Spring). Reconceptualizing gender through dialogue: The case of the Tex-Mex Madonna. *Women and Language*, 20, 9–12.

chapter 6

Karen

The Hagiographic Impulse
in the Public Memory of a Pop Star

PEGGY J. BOWERS AND STEPHANIE HOUSTON GREY

I know I ask perfection of a quite imperfect world
And fool enough to think that's what I'll find
—KAREN CARPENTER'S FAVORITE CARPENTERS RECORDING,

"I NEED TO BE IN LOVE" (CARPENTER AND BETTIS, 1976)

Popular singers often loom larger in death than in life. It is not surprising then that their gravesites often become destinations for pilgrimage. For example, the resting place of Jim Morrison in Paris has become a favored tourist destination, attracting numerous fans who express their respect and affection by leaving gifts and graffiti to honor the gifted singer and songwriter. Perhaps the most important lesson of these rituals is that, for some popular performers, the meanings inscribed in their public image often are derived from their fans' tendency to read their lives and music through the manner in which they gave their lives for the sake of their art. Carole Blair et al. (1994) note that gravesites and memorials are often places where readings of history are shaped and solidified in the public mind by ensconcing celebrated individuals within a framework that makes them legible for future generations as well as creating a space in which mourning can take place. One very striking shrine in the world of popular music is the mausoleum owned and maintained by the family of Karen Carpenter at Forest Lawn Cemetery in Downey, California. With its romantic and ecclesiastical imagery, few other rock and roll

memorials so vividly encapsulate the ethical and ideological vocabularies that so often constrain the memory of popular musicians.

Karen Carpenter, along with her brother Richard, formed one of the most prolific and successful pop acts of the 1970s. The group was notable for a series of popular love ballads that featured Karen's striking voice and lyrics (many written by her brother and John Bettis) that were characterized by an ever-innocent romanticism. Thirty-three years after their debut, the Carpenters have sold over 100 million albums worldwide (20 million posthumously) while accruing three Grammys, an Academy Award, and a star on the Hollywood Walk of Fame. During the late seventies, fans of the group watched as Karen Carpenter struggled with Anorexia Nervosa. On February 4, 1983, at 32 years of age, she finally succumbed to heart damage and possible complications from the drug Ipecac, which she was using to induce vomiting after meals. Karen had spent the night before with her parents, who had encouraged her to stay rather than going out with friends. The next morning, her mother, Agnes, found her daughter lying on the floor dead. During her autopsy coroner Ronald Kornblum noted the emaciation and dehydration common to anorexics who make frequent use of laxatives. For both her fans and the general public, Karen's image is now inextricably bound to the manner in which she died and the ethical persona of the anorexic that was evolving in the popular imagination during the 1970s and '80s.

During the early seventies in particular, when the popular culture was becoming much thinner and models such as Twiggy and singers such as Cher became the norm, popular myth has it that Karen became increasingly weight conscious when music critics began commenting on her weight. Richard, too, was quoted as asking whether the art direction staff could "do something about those hips" after he saw the photos of Karen from an album shoot early in their career. It is important to note that Karen was never intended to be a sex symbol in the erotic sense, as the Carpenters came to represent a more innocent America that so many sought to preserve during turbulent times. Indeed, they were one of the few popular music acts to perform in the Nixon White House because they so well represented that American ideal challenged by political and social adversities such as the hippie culture and the Vietnam War. It is important to remember that with the British Invasion of the mid 1960s, rock and roll became increasingly harder and more associated with youth rebellion, drug use, sexual miscreants, and social upheaval. By the late 1960s, rock music was essentially the soundtrack to Vietnam War protests, Black Power, and a rejection of traditional sexual mores and societal values. In 1970, the drug-related deaths of Janis Joplin and Jimi Hendrix and the announcement that the Beatles had disbanded sent the rock world reeling, and opened the door to a cultural backlash. While the early 1970s saw groups such as the Rolling Stones pushing for increasingly harder rock forms that appealed to middle-class

white male teens, folk musicians from the 1960s as well as new artists such as the Osmonds, the Jackson Five, the Captain and Tenille, Gladys Knight and the Pips, Olivia Newton-John and the Carpenters popularized a "softer" sound that bridged the gap between the older generation and American youth. Artists such as James Taylor, Carly Simon and Carole King wrote ballads—poetry set to music, really—that emotionally allowed the country to heal from the turbulent 1960s. Around the middle of the 1970s, however, the American palate tired of this musical trend that hearkened back to the simpler tunes of the1950s. With their wholesome family image, Karen and Richard were able to tap into this cultural ethic, with Karen in particular playing the role of star-struck female innocence—an image that was quickly subsumed by the ethical mandates of the pathology that eventually killed her.[1]

The Carpenter mausoleum is therefore more than a resting place for Karen's body; it is a temple to this lost innocence where guests go to pay their respects to their fallen icon. Karen rests in a tomb whose carved epitaph reads, "A star on earth. A star in heaven."[2] This is a refrain that is often heard in texts that remember and celebrate her musical career, such as Tom Stockdale's eulogy (2000) depicting Karen Carpenter as an innocent young woman struck down in her prime and at the height of her creative potential. Above her tomb one sees an El Greco painting entitled *Madonna and Child with Saint Agnes and Saint Martin* (see figure 6.1). For the family members who have continued to take an active role in managing Karen Carpenter's public identity, particularly her brother Richard, these images are not accidental. Saint Agnes, with her characteristic lamb, is considered the patron saint of virgins, and was in fact considered the first of the martyred virgins (Hall, 1979, pp.10–11).[3] Given the Carpenters' outward persona of sexual innocence and naïveté, particularly the group's reliance on Karen's girl-next-door image to create consumer appeal, the selection of the virgin—the woman untainted by sin or the desires of the flesh—in many ways embodies the cultural legacy of the Carpenter myth. Yet, as Gillian Garr (1992) notes, the public memory surrounding Karen Carpenter has linked her ethical purity to the tragic nature of her death. In as much as she desperately tried to please her intensely controlling parents and brother, she remained forever locked in a pre-adolescent state. Rather than providing an image of feminine strength or self-reliance, Karen's story is one of a desperate little girl, bereft of any control of her own life, ultimately succumbing to the premier feminine pathology that would claim the lives of so many like her.

Around the turn of the twentieth century, the public began to consume celebrities in a manner that demanded access to the private lives of these figures (Flanagan, 1999). No longer satisfied with merely witnessing the performer in the act of performance, trade publications and gossip magazines began to integrate elements of the private lives of famous individuals to supplement their public person-

Fig 6.1. Karen Carpenter's former grave in Downey, California.

ae, giving birth to the modern cult of the star. Karen Carpenter was no exception. As early as 1975, her fans became aware of the fact that she suffered from an acute eating disorder and, over the next several years, watched as she slowly died in front of their eyes. With the finality of her death, Karen's memory would be eternally linked to the illness that killed her. Kim Chernin (1986) writes, "with the life and

death of Karen Carpenter, a generation of young women found in her a symbol for their lives" (p. 12). In many ways she would come to embody the tension between beauty and moral purity with which many female listeners could identify. Eating disorder expert Joan Brumberg (1988) further notes that Karen's "death made anorexia nervosa a household term and underscored the serious consequences of the disorder" (p. 92). Often, for diseases to capture the public imagination, they require a personification, much as the famed baseball player Lou Gehrig would become associated with Anterior Lateral Sclerosis (ALS). The irony of Gehrig's illness was of course that the player who had played in more consecutive games than any other before him (a record that would stand for many decades) would suffer rapid muscular degeneration. For Karen, the irony was that she did not engage in the lifestyle and drug use that had taken so many rock stars before her such as Jim Morrison, Janis Joplin, Jimi Hendrix, and a host of others whose hedonic practices led, almost inevitably, to tragic conclusions. In a perverse reversal of this narrative, it would be Karen's austerity that would kill her. By trying so hard to please her family and fans, she would become locked in a self-destructive attempt to become that perfect little girl that they desired. Rather than dying from her perceived hedonic excesses, she would literally die from the aesthetic practices of self-starvation designed to purify both mind and body. In a *New York Times* article about her death, one writer summarized that "Anorexia, in the end, claimed victory over her body and her name, which became practically synonymous with the affliction" (Hoerburger, 1996, p. 53). In other words, the image of Karen Carpenter, the iconography that she represented, became interchangeable with the public's understanding of eating disorders in the late 1970s and early 1980s. Karen Carpenter became "that pop star who died of anorexia," and anorexia the illness "that killed Karen Carpenter." One cannot understand one semiotic without understanding the other.

Living at home until her mid-20s in the midst of a controlling family, Carpenter ultimately became what Lidia Curti (1992) has termed a "female fabulation," or cautionary tale for young women. As a singer whose public persona relied on a myth of retarded sexuality, Karen's handlers were quick to use her infantile nature as a marketing tool. In an era when women were beginning to express greater autonomy, Karen was distinctly traditional and nonthreatening—a throwback to what was rapidly becoming an outdated image. Henry Krips (1999) notes that often the association of a desired image or individual with religious iconography in the cultural marketplace can lead beyond mere association, conflating the allegorical and the material to create secular saints (p. 77). These saints become themselves objects of desire capable of transmuting mere sexual attraction into more resonant compulsions. In the present case Karen Carpenter would become symbolic of the quest to purge the flesh of its sins by denying the appetite—a story that would repeat

itself in the lives of tens of thousands of young women who would come to regard the emaciation of anorexia as a quest for ethical perfection. As biographer Ray Coleman (1994) notes, her "exhilarating journey to a summit in show business has its shocking end with the price a young woman paid for hating what she saw in the mirror" (p. xiii). In essence, the life of Karen Carpenter has become a fable or cautionary tale about the psychological threats that confront women in the modern world.

In recent years, a number of musicologists and cultural critics have begun to explore the impact that popular female performers have on their audiences—particularly how they shape the contours of modern femininity. Lori Burns and Melisse Lafrance (2002) provide one of the most recent analyses of this sort, examining how the private lives of performers such as Tori Amos shape the music that they create and the female image they market. Strong female performers, operating in a male-dominated industry, often struggle against the ideological codes of the marketplace to create an image that is at once authentic and their own (Whitely, 2000). In the contemporary world of pop stars such as K. D. Lang, the Indigo Girls, and Madonna, Carpenter's memory reads as the antithesis of the current artists, with her childlike qualities and failure to control her own image. This modern perception of the independent female artist has deep roots. While rock music was for the most part male dominated in the 1960s, novelty all-girl bands such as record producer Phil Spector's Crystals or the Ronettes were modestly successful. In the last half of the decade, Janis Joplin of Big Brother and the Holding Company and Grace Slick of Jefferson Airplane pioneered a role for women rock stars. The "folk rock" movement provided an outlet as well. The public personae of singers such as Carole King and Carly Simon's public persona asserted women to be prominent as artists as well as social activists, drawing on the achievements of the Women's Movement in the 1970s. This set the stage for the Lilith Fair generation in the 1990s. Although many female musical artists suffered personal pain, even tragic ends, the dominant image shown the public is often that of a woman who can stand apart by drawing on an inner strength.

In order to more fully understand how Karen would emerge as an icon for female passivity, the following exploration will first examine the way that she, through both marketing and her song lyrics, came to embody the anorexic saint. Since anorexia was coming under increasing public scrutiny during Carpenter's rise to fame, her image and the evolving vocabulary of this mental illness were interpenetrating and thus shaping the public's perceptions of both. After her death, the Carpenter family attempted to maintain Karen's marketability by reinforcing images of Karen's virginal sainthood (as seen in her mausoleum), thus unconsciously promoting both anorexic stereotypes and the myth of her martyrdom. The second portion of this analysis will examine the challenges to this narrative through

films such as Todd Haynes's *Superstar* as well as the suppression of song lyrics on later albums that the family deemed inappropriate for the Carpenter image. Commentators such as Haynes have attempted to appropriate Karen Carpenter as an allegory that can be used to critique the idealization of submissive, innocent femininity that she would come to embody. Whatever efforts the Carpenter family made to insulate Karen's name and reputation from what they felt would be the irreparable stigma of anorexia, Karen's death from anorexia irrevocably sealed her fate as forever associated with the disease in the public mind.[4] The subsequent analysis explores the public representations of Karen's life, death, and the feminine stereotype with which she remains associated. By examining the manner in which she has been eulogized throughout the popular media, one is afforded a unique glimpse into the manner in which public memory binds fans together amid the mythic terrain of martyrdom, ethics, and disease.

Marketing the Hagiography

David Blake (2001) notes that a celebrity is a fiction—a collection of myths designed to market the texts with which they are associated. They are, in essence, walking, breathing commercials for music, books, and films. Popular shows such as *Behind the Music*, *The Osbournes*, and *MTV Cribs*, are just a few modern manifestations of the attempt to use a celebrity's private life to reinforce the marketability of their music. Karen Carpenter was no exception, as her handlers, particularly her brother Richard, were able to promote an ambience of suspended, happy adolescence around her. Indeed, one of the things that made her suffering seem so pathological was the fact that she seemed to have everything. To the public, she seemed to come from the ideal nuclear family and possess talent, beauty, and wealth along with sound middle-class American values. So why would a young woman who came so close to these cultural ideals literally starve herself to death in front of the American public over the course of a decade?

Examining the traditional anorexic ideology, one can see that this practice should not be surprising, as it fits seamlessly with dominant ethical imperatives within Western culture. Take for example the Miracle Maidens who would sporadically appear throughout medieval culture, starving themselves to demonstrate their devotion to Christ and their capacity to subsist on pure spiritual energy. If this early anorexic ethic is combined with the hagiography of virginal martyrdom through images like that of St. Agnes, young women such as Karen Carpenter, by denying themselves the consumptive and sexual pleasures of the flesh, are in one sense atoning for the sins of an entire culture that has grown soft and gluttonous in its own material excess. At the same time that Karen and Richard Carpenter were visit-

ing with the record producers at A&M records, eating disorder therapist Hilde Bruch was interviewing young women with a bizarre new illness that led them to diet themselves into a state of emaciation. Bruch (1978) eventually came to the conclusion that these individuals had an unnatural desire for perfection and attempted to attain it by rejecting the role of adult femininity—the fuller body, sexual activity, and the role as mother that it entailed. These girls were often overachievers who were hypersensitive to criticism. The anorexic's starvation produced a visual tableau for demonstrating a virtuous interior and, because her body was beyond criticism, so was her mind. Add to this mix the increasingly thin models found in the fashion magazines at this time and the recipe for wide-scale anorexic practice was firmly ensconced in the public imagination. Karen's mother would often recall that Karen's anorexia began when she was reading a review of one of her concerts where the writer referred to her as possessing "baby fat." At that point she entered into what Susan Bordo (1993) has called a state of consumptive asceticism where, in the process of obtaining ideal beauty, the sufferer ends up disciplining her body as a moral imperative. Given the aesthetic qualities of Carpenter's music and public image, she would tell the tragedy of the victimized young girl in an extremely compelling fashion.

In 1970, the Carpenters would revive the little-known Burt Bacharach song "Close to You," a lyrical melody that would remain one of their signature songs. The tension that would define the Carpenters' work was that Karen, still an innocent 19-year-old girl, was to perform a repertoire of love songs that often expressed adult desire. In contrast to the current age, where singers such as Britney Spears and Christina Aguilera market themselves as sexual commodities at a very young age, Karen would remain the goofy teenager admiring her object of desire in terms that were distinctly less erotic and nonsexual. The lyrics to this classic demonstrate the way that this tension was negotiated:

> On the day that you were born
> The angels got together
> And decided to create a dream come true
> So they sprinkled moondust in your hair of gold
> And starlight in your eyes of blue
>
> —"CLOSE TO YOU" (BACHARACH AND DAVID, 1963)

In this context, Karen is allowed to express her admiration and desire without explicit reference to her own body or desires. In many ways the love expressed in these lyrics is somewhat spiritual in nature. Music producer Herb Alpert notes that Karen "was a little girl woman who was always looking for something or someone to fill her life beyond hit records, and seemed very lonely and very innocent in her pursuit" (Coleman, 1994, p. xv). In retrospect, many fans have returned to songs

such as "Close to You" and reread them through this lens of unattainable perfection—forever close but never realized. In his comprehensive history of asceticism in Western culture, Geoffrey Harpham (1987) writes, "while asceticism recognized that desire stands between human life and perfection, it also understands that desire is the only means of achieving perfection" (p. 3). In order to move into the hagiographic realm, one does not eliminate desire, but one rechannels it toward spiritual ends in order to transmute it to something less reliant on the flesh. Karen was therefore able to express desire in a fashion that seems so idealized and naïve that her own purity remains intact. In fact, one of the composers for her solo album remarked, "(she) had this very sexy voice, but she wasn't a sexy person at all" (Hoerburger, 1996, p. 54). Yet, what might appear to be a contradiction was quite possibly the crux of her appeal—the ability to express profound desire without retreating to gross sensuality.

Photographed for the *Rolling Stone* interview,
May 22, 1974.

Fig 6.2. Karen's childlike public persona was an important part of the Carpenter's image.

Central to the Carpenters' marketing narrative was the idea that Karen had emerged from the ideal family who had a vested interest in insuring that her sexual growth remained somewhat stunted. In the photograph for the cover story in *Rolling Stone Magazine* (figure 6.2), we see Karen looking characteristically happy and making a childlike face into the camera. In the accompanying 1974 article setting the stage for the group's new tour, Tom Nolan (1974) writes that "Karen is in some ways like a child, which is not surprising. A star since 19, she probably missed out on one or two normal stages of adaptation to the real world" (p. 63). It is indeed interesting to note that even at her graveside eulogy, Karen would continue to be referred to as a child despite the fact that she was 32 years old. This imprisonment in a state of eternal adolescence is central to the anorexic allegory for young women. When Karen Carpenter finally admitted publicly to having anorexia after she collapsed on stage, she sought out Cherry Boone (daughter of singer Pat Boone), who advised her to visit the psychiatrist Steven Levenkron. Although her illness was not publicized as widely, Boone's struggle with anorexia mirrored many of Karen's experiences. She came from a traditional family who expressed dismay and resentment when their daughter went public with her illness, thus tarnishing the myth that they were indeed the perfect nuclear family. In one scenario described by her biographer, Karen, who entered treatment against the wishes of her family, was finally able to convince her mother and father to attend a session where she broke down and expressed " . . . how badly she felt about herself; how much she wanted to apologize for ruining her family's life and causing distress to her friends; how her feelings of degradation had threatened her career and ruined her personal life" (Coleman, 1994, p. 3). Levenkron had just authored his now classic text *The Best Little Girl in the World* (1978) that has become a staple in the library of many young adults, and with which Karen was reputedly secretly enamored. In this text he created the classic anorexic template where a young woman, consumed with the desire for perfection, used her interest in dancing to resist her parents' authority, starving herself as an act of rebellion. Levenkron's conclusion was that, since these anorexic girls are engaging in a form of rebellion, they simply needed to be chastised by a paternal authority figure to stop dieting—a role that Levenkron would often play with his patients. It is important to note that in this model, the young woman remains a somewhat powerless and passive entity in her own recovery—a role that Karen, now a legal adult, played all too well.[5]

One of the most disturbing questions for many fans has been whether one can see the signs of her mental turmoil in her work, outside of which she and her handlers were so careful to mask it. This follows from the general notion that mental illness will often express itself unconsciously through particular cultural productions. In another one of her standards, "Rainy Days and Mondays," one can see that

depression often played a role in her song texts. Take for example the following lyrics that seem to identify a kind of general malaise:

> Sometimes I'd like to quit
> Nothin' ever seems to fit
> Hangin' around
> Nothin' to do but frown
> Rainy days and Mondays always get me down
>
> —"RAINY DAYS AND MONDAYS" (WILLIAMS AND NICHOLS, 1970)

There is perhaps little that is unusual about tragic plots in popular youth music from the 1950s onward, particularly stories of loss and early death (Cooper 1991). However, the Carpenters focused a bit more overtly on the psychological manifestations of loss such as sadness and ennui, although in this case something as simple as rainfall can produce the depression. Notably, in this song, it is not necessarily a particular event that has produced the sadness, but it exists as a more or less general state of being. An even more compelling image of alienation emerges later in the song "When It's Gone":

> There's no word for the sadness
> There's no poetry in the pain
> There's no color in the stain where the tears have fallen
> Well, it's gone, it's just gone
>
> —"WHEN IT'S GONE" (HANDLEY, 1980)

After Karen's death, songs such as this were often reread in a much more complex and sympathetic light. Rather than a little girl fumbling for the words to express her loss, she became instead a deeply introspective and psychologically complex artist. David Sanjek (2001) notes that as a musician's popularity increases, often their artistic talents fall under some suspicion—that perhaps their music lacks an authenticity that would immunize it against the marketplace. This balance between the need to sell records and the artistic integrity of a work is sometimes called creative conservatism (Street, 1986, p. 193). Artists and producers must create a product that appears creative, but does not challenge standards in a way that would alienate those who buy records. In the case of the Carpenters, interest in their music had begun to decline in the 1970s as the age of bubble-gum pop music came to a close. Yet after Karen's death, much of the Carpenters' work was revived within the cultural memory because suddenly Karen had an artistic depth not attributed to her in life. Neil Nehring (1997) has traced a similar phenomenon in the work of the rock band Nirvana after the death of its lead singer Kurt Cobain, one of the most influential singers of the past twenty years, who went from a pop-grunge rocker to a symbol of repressed male anger (p. 99). For Karen Carpenter this

"deepening" largely revolved around the recognition that she was experiencing pain and suffering and that the smile she showed to the public was little more than a façade. Ray Coleman (1994) perhaps puts it best when he writes that for many of these fans Karen's "art must have been to a large degree the product of her soul, [and] many interviewees have remarked on her psyche and the quality of her voice which evoked loneliness" (p. xi). In some ways, anorexia gave Karen Carpenter a psychological depth that hitherto she had been denied by mainstream audiences.

It should not be overlooked that Karen Carpenter's death may have provoked a certain amount of cultural guilt among those in her audience. If the very music that she had produced and that so many had enjoyed could be seen as having drawn the life from her, then what did that say about the audiences who attended concerts and commented freely on her appearance? In one sense, this collective guilt has done nothing but enhance Karen's image as the holy anorexic and virginal martyr. In the following lyrics from 1976, one can begin to see this gradual recognition in Karen's recording:

> It took a while for me to learn
> That nothing comes for free
> The price I've paid is high enough for me
> —"I NEED TO BE IN LOVE"[6] (CARPENTER AND BETTIS, 1976)

Of course the idea that one pays a price for one's desires, particularly a psychological price, is a notion that is extremely resonant with the dynamics of sacrifice. As Rudolph Bell notes (1989), "the holy anorexic never gives in, and ultimately she may die from her austerities. She rejects the passive, dependent, Catholic religion of meditation through priests and intercession by saints, and so herself becomes a saint" (p. 19). In the numerous tributes that one sees to Karen Carpenter in both print and on the Web, they share the common characteristic of profound sadness at her tragic death while celebrating the purity of her legacy. Like St. Agnes she remained pure and devout, devoting herself to a higher calling that sprung from a childlike innocence. Given the nature of her marketing along with the manner of her death, Karen Carpenter would indeed come to embody the ultimate feminine victim caught between two worlds—one of purity and the other of beauty. After starving herself to death, she became the ideal type or living embodiment of the anorexic subject—female, sexually underdeveloped, and obsessed with perfection. With these attributes the stereotypes of the eating disordered subject would become firmly entrenched in the American mind and acquire their most resonant personification. Karen would thus become both patron saint of anorexia as well as its most resonant cautionary tale.

Living Memory and the Struggle for Meaning

In 1998 the board of directors for the Richard and Karen Carpenter Performing Arts Center elected to create a walking exhibit in the lobby—this in response to numerous requests on the part of visitors who wondered why representations of Karen Carpenter seemed to be at a minimum. The directors, in conjunction with Richard Carpenter, created an exhibit that detailed the Carpenters' "creative process" along with their instruments and gold and platinum records. Karen's battle with anorexia is mentioned only briefly in the exhibit, an omission that seems somewhat remarkable given the amount of attention it has received over the years. It should be noted at this point that while Karen's illness remains a crucial part of her story, her family has often expressed embarrassment about the nature of her death, perhaps as a result of the stigma often attached to mental illness in the popular culture. Indeed, despite the autopsy results, Karen's family continues to deny that she was taking Ipecac, contrary to the testimony of friends and its consequences in her body. In his classic treatise on insanity in the age of reason, Michel Foucault (1966) notes that madness was often constructed as a polluted site of cultural impurity as society entered the Age of Enlightenment, leading to profound moral stigma regarding the behaviors of the insane. The cultural response to those with mental pathologies was to contain and control them. Phyllis Chesler (1972) would extend Foucault's observations to the sphere of mass representation, arguing that women were often the subjects of art and literature regarding mental illness, a dynamic that led to a feminization of madness within the medical and popular cultures. By coding femininity as a state of mental illness, women who were either independent or troublesome could be easily dismissed. As the most prolific "women's disease" of the twentieth century, eating disorders such as anorexia have become the primary vehicles for reasserting this relationship between femininity and madness. Given the fact that Karen quickly became the personification of this illness, the Carpenter family has attempted to downplay the importance of anorexia in Karen's life, while embracing other, more appealing aspects of the virginal, little girl narrative. For example, when Richard was discussing an actress to play Karen in the proposed television movie about their lives, he said, "She never got that thin," although she chronically weighed 79 pounds during the last several years of her life (Rosenfeld, 1985, p. B3). Carpenter family spokesperson Paul Bloch "downplayed the anorexia connection" to *People* magazine just weeks after her death, saying that she was a "vibrant and energetic person" (Levin, 1983, p. 53). The president of A&M Records at the time also told *People*, "Karen was the girl next door, always up even when she was down" (p. 53). What emerges is a cultural exchange where the boundaries of feminine pathology are subject to continual scrutiny.

Immediately following Karen's death, America found itself in a full-blown eating disorder panic. John Springhall (1998) notes that it is not unusual for moral panics to emerge in response to youth culture when a broader society perceives that its ethical fiber is under assault (p. 176). After Karen Carpenter's death, people in the broader culture began to self-identify as anorexic as well as to scrutinize family members who were also potentially affected. In an effort to minimize the damage to the Carpenters' reputation, Richard would participate in the production of *The Karen Carpenter Story*, one of the most highly rated made-for-television movies in history. The movie presents a fairly humane representation of Karen, and even discusses Richard's brief foray into the realm of drug addiction (this against his family's wishes). The result of the first airing of the movie was to spark another cultural panic about anorexia, as eating disorder clinics reported record numbers of phone calls and admissions the following week (i.e., see *Los Angeles Times*, 1989, January 4,). Suddenly, like never before, the beauty and diet industry saw itself under attack for the manner in which it imprisons and deludes young women. Patricia Brennan (1989) would sum up the film's impact by arguing that it used Karen's life as a "cautionary tale" to warn young women about the dangers of dieting (p. 4B). In the film, the ideal family is seen to disintegrate once Karen and Richard leave home and are subjected to the adult stresses of the music business. Note that Richard was very careful to implicate neither himself nor his parents in Karen's death, focusing instead on the pressures of touring and fan expectations. Yet, given the fact that Karen's myth was growing beyond his control, the discourse of mental pathology began to take on a life of its own.

In 1983 the award-winning director Todd Haynes produced his first film, entitled *Superstar*, a black and white horror film depicting the life and madness of Karen Carpenter using Barbie Dolls for actors. With the film's stark framing and violent music, Haynes would demonstrate an acute awareness of the cultural vocabulary of anorexia by using the Barbie Doll, one of the primary culprits in promoting unrealistic expectations about the female body type. In an analysis of the relationship between high art and horror cinema, Joan Hawkins (2000) argues that independent filmmakers use the aesthetics of terror to represent turbulent psychological interiors. In Haynes's film we see the slow degradation of Karen's mind and body coupled with grotesque images of food, vomiting, and even stock footage of mass graves during the Holocaust. In the film, Haynes locates much of the blame for Karen's condition on her perversely overbearing family, who are seen as bizarre shadows hovering around her as she passes in and out of her catatonic states. This would be one of the primary reasons that Richard and the rest of the Carpenter family would repress distribution of Haynes's film by threatening lawsuits due to copyright infringement (Haynes makes extensive use of Carpenters music). The result

was to create a cult classic. As has been pointed out earlier in this chapter, the anorexic subject is written as one who exists in a regressed state of childhood where often the only way that one can exercise control is to regulate food intake. As Avis Rumney (1983) writes, "I adopted the only strategy open to me in order to preserve any sort of identity, however precarious, and in order to believe in myself as an individual being, separate from both family and the school" (p. 56). Haynes, who demonstrates a fairly sophisticated understanding of the causes and symptoms of the eating disorder, is aware of the semiotic that he is creating in *Superstar*, stating that "identity is a fragile and basically an imaginary construct that we pretend to carry around." (Taubin, 1996, p. 33). Here Haynes represents Karen's anorexia as a sort of self-destructive bid for control over her own life in response to her overbearing family, an interpretation that the Carpenters understandably resist. In short, her life becomes a parable for modern femininity in a society where access to power is often denied to women. When asked why he continues to threaten lawsuits against Haynes, Richard replies simply that the movie is "mean" (Kahn, 2002, p. A10). Given its candid portrayal of Karen's sexuality and the unsupportive nature of her family, it is not surprising that the result of such texts is a history war. Despite an unsuccessful marriage (her premarital relationships were kept secret), the Carpenter family had been able to preserve Karen's hagiographic image, and Haynes's suggestion that they played a role in her martyrdom was threatening to the legacy they had constructed for their daughter and themselves.

Perhaps the most egregious form of revision (from Richard's standpoint) that Haynes would engage in was to reread the Carpenters' music through Karen's illness. His frequent use of the more popular Carpenters songs, often warped and played in minor keys, created much of the film's suspense and horror aesthetic. One segment of the film is particularly striking where he uses the song "Top of the World" to depict the mania that often accompanies the dieting impulse in anorexia:

> Everything I want the world to be
> Is now coming true especially for me
> And the reason is clear
> It's because you are here
> You're the nearest thing to heaven that I've seen
> I'm on the top of the world looking down on creation
> —"TOP OF THE WORLD" (CARPENTER AND BETTIS, 1972)

This song is one of the Carpenters' classic "feel good" tunes where Karen is expressing joy at the sensations that love produces. In Haynes's film, however, he uses an ironic juxtaposition where he depicts a series of meager salads with iced tea, con-

certs, and a scale showing progressively lower weights. Here Karen is viewed not in terms of sainthood, but as clearly located in the realm of mental illness. While expressing spiritual joy on stage each night, she is not purifying her thought and body, but obsessively destroying her tissues in a most grotesque fashion. By comparing Karen's body, which her family and record producers attempted to hide during her singing career, to the victims of the Nazis being tossed into mass graves, Haynes draws attention to the fact that there is little spirituality to the anorexic's quest. Instead it is both gory and repetitive and possesses little romanticism. In death there is neither purification nor transcendence, but instead the decay of tissues that in many ways might mirror the decay of the mind. In this appropriation of sound and image, Haynes clearly transmutes hagiography into madness. It is in large part this revision of the Karen Carpenter myth that has made her an icon for underground grunge culture as well as a mainstream pop star.[7] She began to represent not only the good-girl singer, but also an emblem for the excesses and mendacity of the traditional American culture that she had come to embody so well.

During the final years of her life, Karen had initiated a mild resistance to the traditional control that Richard had exercised over her in the creative process and an attempt to ascend into the ranks of independent female artists. In one interview she noted, "He'll always stall when we're due to go into the studios and not let me know the title or the nature of the song until we get there. I keep saying, 'What is the song' and he keeps saying, 'Oh, you'll be OK. It's easy for you.' He doesn't let me know what my work is! And I hate that about him" (Coleman, 1994, p. 224). This anger was compounded by her eventual recognition that her family had manipulated her life by orchestrating the male relationships that she would enter and exit—with her own staff members working alongside Karen's parents in secrecy. The degree of possessiveness can be seen in Richard's anger after her death when he claimed to experience "silent fury at being robbed" and that he "should have been more of a bear on her" (Coleman, 1994). Rather than expressing sorrow or sympathy, he was clearly angry with Karen for depriving him of her talent. Rather than acknowledge the struggle for identity that she underwent on a daily basis, it became easier to simply blame her or attribute her illness to his failure to exercise sufficient control over her.

This battle to control Karen's voice would continue well into the late 1990s. During 1979, Karen had recorded a series of songs with Phil Ramone that would expand her repertoire and image. Karen had been inspired by Olivia Newton-John's transformation from doing Christmas specials to the sexually aware young woman in the movie *Grease*. When she and Phil Ramone played these songs for the executives at A&M records, they scoffed at the idea of Karen Carpenter doing post-disco music. One must recognize that while Karen had certainly performed a number of

love songs, the majority of these did not feature sensuality as a main component.
Take the following sample for example:

> I'm aware
> My heart is a sad affair
> There's much disillusion there
> But I can dream,
> Can't I?
> Can't I adore you
> Although we are oceans apart?
>
> —"I Can Dream Can't I" (Kahal and Fain, 1937)

When Karen expresses her desire, she often describes her ideal mate as a dream,
someone who is almost, by nature of his perfection, an absent lover. In her analy-
sis of sexuality in Western literature, Camille Paglia (1990) writes of Emily
Dickinson, " . . . because her eroticism is visual rather than sensual, Dickinson's love
affairs take the form of adorations and apotheosis" (p. 668). This is very similar if
not identical to the manner in which Karen Carpenter expressed desire in the music
she performed with Richard, and very consistent with virginal desire. The male
other becomes an idealized apotheosis, a spiritual embodiment that is not to be
touched, but only longed for.

This can be seen in perhaps one of the Carpenters' most successful singles, the
classic hit "Superstar" featured on their third album in 1971:

> Long ago and oh so far away
> I fell in love with you before the second show
> Your guitar, it sounds so sweet and clear
> But you're not really here
> It's just the radio
>
> —"Superstar" (Russell and Bramlett, 1970; 1971)

Notice how the idealized lover is present only as a vision or a disembodied
voice. He is not a body that she can touch or experience in an immediate fashion.
Thus while she is singing about love with her adult alto voice, the lover's absence
mediates between her desire and her body. It is where these two spheres meet sym-
bolically—where adult or "womanly" desire can be experienced. Given the fact that
it is one of the primary goals of the anorexic to literally erase her own body and
the sexuality it represents, Karen appeals to the anorexic consciousness by render-
ing her own body mute in her song lyrics.

Perhaps one of the reasons that the Carpenter family actively sought to repress
the Ramone recordings despite public interest after Karen's death was because she
had clearly violated the boundary so clearly established in her prior music. It was

Fig 6.3. The photograph originally planned for the cover of her solo album, revealing a more sexually sophisticated Karen.

only in 1996 after consistent public pressure that Richard finally consented to the songs' release. The title of one cut on the album, "My Body Keeps Changing My Mind," is in many ways self-explanatory:

> But my body keeps changing my mind
> Keeps changing my heart
> When we're dancing
> My body says love you tonight
> You drive me out of my mind
> When we're dancing
>
> —"MY BODY KEEPS CHANGING MY MIND" (PEARL, 1979)

Here we see a sexually mature Carpenter who is no longer pining for the lover who is not there and can never be there, but is instead driven by her body to cling to an imperfect man. Suddenly she had a body that itself could be touched and aroused. This song was augmented by a remake of Paul Simon's "Still Crazy After All These Years" that depicts old lovers getting together to have a few beers, and by songs such as "Making Love in the Afternoon" and "Still in Love with You," including the line, "I remember the first time I laid more than eyes on you" (Javors, 1979). By attempting to reclaim her body, Karen is in many ways attempting to

resist the hagiographic image that had defined her entire career. St. Agnes is no longer stolidly clutching her lamb, but has embraced her roman lover with great zest.

It has been well publicized that the Carpenter family disapproved of Karen's solo career (Hoerburger, 1996). Richard felt betrayed and was sharply critical of the final product, accusing Karen of "stealing" the Carpenters' sound and of a weak performance. When she took her first collection of songs home, Phil Ramone reported that upon her return, he confronted an "eighty-pound Auschwitz victim figure" who left laxatives all over his house (Hoerburger 1996, p. 54). It was clear to the Ramones that Karen had disagreed with her parents and that she was continuing to pursue her solo project against their wishes.[8] Indeed it was when she was emotionally pressured to stay with her parents that Karen finally killed herself. Yet, when she was with the musicians who treated her as an equal and working on her own music, she seemed to recover temporarily. Karen's best friend, Frenda Franklin, said, "She told me that working on this album was the happiest time in her life" (Hoerburger 1996, p. 54). In a conversation with Phil and Itchy Ramone only thirty-six hours before her death, the following exchange took place:

Karen: "Can I use the F-word?"
Phil: "You're a grown woman. Say whatever you want."
Karen: "It's a fucking great album." (Coleman 1994, p. 321; Hoerburger, 1996, p. 53)

Along with these moments of self-assertion, Karen would also express amazement at the press shots for the album cover, remarking that, photographed as an adult in good health, "Look at me, Itch, I'm pretty! I'm really pretty!" (Hoerburger 1996, p. 54). It is interesting to note that Richard would use this photo for a posthumous release of the Carpenters' final but unfinished studio work because Karen did not look so gaunt. The systematic repression of this image of Karen has been an important part of the hagiographic myth, and by extension, to the anorexic subject that she would come to idealize. More importantly, the Carpenter family attempted to manage Karen's legacy in a way that allowed them to celebrate her moral purity while extracting the sources of this purity from the disease that killed her. Despite this effort, a growing discourse has emerged that critiques this seamless narrative, creating a collection of counter myths that overtly point to the psychologically destructive nature of female submission within a material culture.

These detours in the myth of Karen continue to present a more complex and conflicted history of feminine pathology in the twentieth century as the struggle to control the image of the secular saint continues. Commentators such as Todd Haynes and record producers such as Phil Ramone have attempted to revise the Carpenter image—to reread Karen's narrative in such a way that the sources of her pathology are accurately portrayed and a more complex analysis of feminine iden-

tity rendered. From the family's point of view, they would prefer she remain forever their little girl who just happened to make some bad decisions when she entered the world outside their protection. Given the powerful relationship between femininity and popular music, Karen Carpenter remains a resonant template for young women, in particular, struggling for a sense of self in a male-dominated industry. Her failure to author her own voice would in many ways become symbolic for a generation of young women striving for moral perfection by systematically starving themselves to death.

Conclusion

Given the major templates provided by female artists today, whether as independent songwriters or highly erotic pop stars, the images and narratives that they fulfill play a role in defining modern femininity. As Karen became the primary personification of mental illness, to some extent it rendered her girl-next-door image a façade at best, and a recipe for suicide. In many ways Karen has become a symbol of feminine pathology—the woman out of step with her own reality. Ellen Lansky (1998) notes that this narrative is not uncommon within the fabulations surrounding female artists. Using the template of Jeremy Bentham's Panopticon, she argues that the minds of women writers are often placed on display while their male counterparts look on, describing for the audience their gradual degradation due to alcohol or madness. This is not unlike the myths surrounding Karen Carpenter, who ultimately failed to author her own narrative. In death, she has become a pure container for failed feminine resistance. Nancy Love (2002) notes that female musicians have a cultural mandate to use their voices and bodies to challenge dominant ideological codes, creating an activist consciousness. From this standpoint, one would expect that the Carpenters would have long since been relegated to the realm of anachronism. Instead, her story is one that continues to resonate with new generations of fans.

Fig 6.4. The cover of People magazine following Karen's death in 1984, which reveals her form during the most severe portion of her illness.

Three years after the death of Karen Carpenter, the noted eating disorder therapist Susie Orbach (1986) described anorexia as the "metaphor of our age." In an age when women attempted to resist patriarchal representation of their bodies away from the confines of sexual objectification, the eating disorder continues to function as both a symptom and a resistance to the dictates of the beauty culture. Oftentimes the ultimate form of resistance, as demonstrated by Judith Butler's (2000) Antigone, who resists the tyrant to follow the dictates of natural law, provides a symbolic death to demonstrate the capacity to resist oppression no matter the consequences. In some ways the struggle to link Carpenter's body with mind, whether through pathology or through desire, can be seen as an attempt to reread the eating disorder in a more politically complex context. It is interesting to note, for example, that Karen was also bulimic and her autopsy revealed that complications from a drug used to induce vomiting in fact caused her heart failure. Yet, given the gluttonous and sneaky stereotypes of the binging and purging bulimic present in the media, this fact is often conveniently ignored by those who wish to maintain the myth of Karen Carpenter's spiritual purity.

As popular icons, musicians may often come to represent larger ideological constructs rather than individuals. After death, this process of representation can become complex and revisions in their narrative can be viewed as attacks upon the ideals that they represent. From this standpoint, memory becomes a battleground where differing groups may carry ideological agendas to particular readings. Those who wish to believe the moral efficacy of traditional doctrines of spiritual purgation and sainthood remember Karen as a saint.[9] Those who challenge often look to appropriate her for critical means such as exposing the politics of eating disorders or reinvigorating the little girl/victim image as an adult woman making choices and experiencing sensuality. On many websites, the now infamous "Karen's Law of Physics," which states that what "goes down must come up," has become commonplace within the eating disorder community (see for example www.lesion.com). Much as Agnes the virgin sought to maintain her purity in the face of pagan sexual assault, becoming a virgin martyr, Karen would evolve into the resident saint for eating-disordered women caught within the contradictions of religious austerity and beauty culture. In her book, *The Political Lives of Dead Bodies*, Katherine Verdery (1999) notes that the dead function to galvanize the public around both political and cultural regimes, becoming literal embodiments of histories both embraced and rejected. In Karen's death, her body became the literal inscription of martyrdom—a saint killed by a grotesque material culture that continues to assault generations of young women who die for its collective sins. In other words, she remains a resonant symbol with which many young women now identify. The way that Karen's history is told is crucial to the lives of these individuals and to the meaning of her musical legacy.

Notes

1. After dining at a posh restaurant on the famous Melrose Place in Los Angeles, Karen passed John Lennon in the courtyard. When he recognized her, he said, "I just want to tell you, love, that I think you've got a fabulous voice." Karen was ebullient; she said to her dinner companion, "Did you hear what he said? John Lennon!" She had a similarly astonished reaction to Barbra Streisand telling her she had a "marvelous instrument" (Coleman 1994, p. 156).

2. By the Carpenter family's request, Karen's body must always rest in the top position of the family crypt.

3. It is no small irony, or perhaps even coincidence, that Karen's mother, who almost exclusively shaped the Carpenter family ethic and image, is also named Agnes.

4. Her fans, her record company, and her family could only participate in reading Karen as virginal victim, made all the more tragic by the claim that she had overcome the disorder (she was a respectable 108 pounds), was emotionally untroubled, and on the outside resembled the familiar persona that had been so successfully marketable. Thus, if it were inevitable that she embody anorexia, she could at the same time be dissociated with its dark elements. This could explain why the Carpenter family so fiercely protected and promulgated a particular narrative of the circumstances surrounding her death—a narrative that has functioned to swirl her death in controversy. For example, Agnes Carpenter protests vehemently that Karen ate normally the night before her death, and claims to have found her unconscious in a nightgown in the walk-in closet of her bedroom the next morning. In fact, the autopsy report details that Karen was in a red jogging suit in the kitchen, though her stomach was empty. She did have a vial of Ativan, a prescription anti-anxiety medication, in her pocket. Although the autopsy lists cause of death as emetine cardiotoxicity, the Carpenter family stridently rejects the notion that she used Ipecac to throw up after meals. It is well documented that for days preceding her death, Karen complained of an irregular heartbeat, one of the signs that emetine has been absorbed into the liver, heart, and muscles, according to the Los Angeles County coroner. It seems apparent that her last scene was as carefully orchestrated as her stage performances had been.

5. The extreme case of this was Levenkron's order to hospitalize and force feed Karen, who subsequently gained thirty pounds. When she completed treatment with Levenkron, her gift to him was a needlepoint she had made for him in the idle hours in her hotel room. It read, "You win. I gain" (Coleman 1994, p. 316).

6. Much was made of the fact that this was reportedly Karen's favorite recording of all the songs the Carpenters had done.

7. In 1994 several alternative rock artists collaborated on the release of *If I Were a Carpenter*. It included a tribute to Karen ("Tunic—Song for Karen") by Sonic Youth as well as re-recordings of some of her songs by such groups as Cracker and The Cranberries.

8. After playing the finished product for A&M executives and for Richard, and meeting stony silence or disapproval, producer Phil Ramone described the usually stoic Karen like this: "When she was upset, she just wouldn't eat. But when we got out of that meeting and far enough away, she just crumpled in my arms" (Hoerburger 1996, p. 55).

9. Just recently a man claiming he hadn't even been a fan wrote in to a publication with a down-on-his-luck Christmas story in which, in his darkest hour, he felt Karen was singing to him invisibly in a diner. Years later through a psychic, a dead acquaintance sent him this message: "Tell Bob that Karen is here. She's a singer." He wrote that this had affirmed for him his earlier experience that he had been "listening to an angel" (Shortz, 2001).

Songs Cited

Bacharach, B. and David, H. (1963). Close to You. [Recorded by the Carpenters]. On *Close to You* [CD]. Hollywood, CA: A&M. (1970)

Carpenter, R. and Bettis, J. (1972).Top of the World. On *A Song for You* [CD]. Hollywood, CA: A&-M.

———(1976). I Need to be in Love. On *A Kind of Hush* [CD]. Hollywood, CA: A&M.

Cetera, P. (1979). Making Love in the Afternoon [Recorded by Karen Carpenter]. On *Karen Carpenter* [CD]. A&M. (1979)

Handley, R. (1980). When It's Gone (It's Just Gone) [Recorded by the Carpenters]. On *Made in America* [CD]. Hollywood, CA: A&M. (1981)

Javors, R. (1979). Still In Love With You [Recorded by Karen Carpenter]. On *Karen Carpenter* [CD]. Hollywood, CA: A&M. (1979)

Kahal, I. and Fain, S. (1937). I Can Dream Can't I [Recorded by the Carpenters]. On *Horizon* [CD]. Hollywood, CA: A&M. (1975)

Pearl, L. (1979). My Body Keeps Changing my Mind [Recorded by Karen Carpenter]. On *Karen Carpenter* [CD]. Hollywood, CA: A&M.(1979)

Russell, L. (1970). A Song for You [Recorded by the Carpenters]. On *A Song for You* [CD]. Hollywood, CA: A&M. (1972)

Russell, L. and Bramlett, B.[(1970/1971). Superstar [Recorded by the Carpenters]. On *Carpenters* [CD]. Hollywood, CA: A&M. (1971)

Simon, P. (1974/1979). Still Crazy After all these Years [Recorded by Karen Carpenter]. On *Karen Carpenter* [CD]. Hollywood, CA: A&M. (1979)

Williams, P. and Nichols, R. (1970). Rainy Days and Mondays [Recorded by the Carpenters]. On *Carpenters* [CD]. Hollywood, CA: A&M. (1971)

Bibliography

Bell, R. (1989). *Holy anorexia*. Chicago: University of Chicago Press.

Blair, C. (1994). Public memorializing in postmodernity: The Vietnam Veterans Memorial as proto-type. In W. Nothstine, et al. (Eds.), *Critical questions: Invention, creativity, and the criticism of discourse and media* (pp. 344–349). New York: St. Martins.

Blake, D. (2001). Public dreams: Berryman, celebrity, and the culture of confession. *American Literary History*, 13, 716–736.

Bordo, S. (1993). *Unbearable weight: Feminism, Western culture, and the body*. Berkeley: University of California Press.

Brennan, P. (1989, January 1). She'd only just begun. *The Washington Post*, p. 4B.

Bruch, H. (1978). *The golden cage: The enigma of anorexia nervosa*. Cambridge, MA: Harvard University Press.

Brumberg, J. J. (1988). *Fasting Girls: The Emergence of Anorexia Nervosa as a Modern Disease*. Cambridge, MA: Harvard University Press.

Burns, L., and Lafrance, M. (2002). *Disruptive divas: Feminism, identity and popular music*. New York: Routledge.

Butler, J. (2000). *Antigone's claim: Kingship between life and death*. New York: Columbia University Press.

Chernin, K. (1986). *The hungry self: Eating, women, and identity*. New York: Harper.

Chesler, P. (1972). *Women and madness*. San Diego: Harcourt.

Coleman, R. (1994). *The Carpenters: The untold story*. New York: HarperCollins.

Cooper, B. L. (1991). *Popular music perspectives: Ideas, themes, and patterns in contemporary lyrics*. Bowling Green, OH: Bowling Green State University Press.

Curti, L. (1992). What is real and what is not: Female fabulations in cultural analysis. In L. Grossberg, C. Nelson, and P. Treichler (Eds.), *Cultural studies* (pp. 134–153). New York: Routledge.

Fields, S. (1978, March 4). Review of *The golden cage*. *Washington Post*, p. B2.

Flanagan, M. (1999) Mobile identities, digital stars, and post cinematic selves. *Wide Angle*, 21, 77–93.

Foucault, M. (1966). *Madness and civilization. A history of insanity in the age of reason* (R. Howard, Trans.). New York: Vintage.

Garr, G. (1992). *She's a rebel: The history of women in rock and roll*. Seattle: Seal.

Hall, J. (1979). *Dictionary of subjects and symbols in art*. New York: Harper.

Harpham, G. (1987). *The ascetic imperative in culture and criticism*. Chicago: University of Chicago Press.

Hawkins, J. (2000). *Cutting edge: Art-horror and the horrific avant-garde*. Minneapolis: University of Minnesota Press.

Hoerburger, R. (1996, October 6). Karen Carpenter's Second Life. *New York Times Magazine*, 52–55.

Kahn, R. (2002. Nov. 12). Hoping to get 'Superstar" Close to You. New York *Newsday*, p. A10.

Krips, H. (1999). *Fetish: An erotics of culture*. Ithaca, NY: Cornell University Press.

Lansky, E. (1998). Female trouble: Dorothy Parker, Katherine Anne Porter, and alcoholism. *Literature and Medicine*, 17, 212–230.

Levenkron, S. (1978). *The best little girl in the world*. Chicago: Contemporary.

Levin, E. (1983, Feb. 21). A sweet surface hid a troubled soul in the late Karen Carpenter, a victim of anorexia nervosa. *People Weekly*, v. 19, p. 52–55.

Los Angeles Times News Service. (1989, Jan. 4). Morning report: TV and video. *Los Angeles Times*, p. VI2.

Love, N. (2002). Singing for our lives: Women's music and democratic politics. *Hypatia*, 17(4), 71–94.

Nehring, N. (1997). *Popular music, gender, and postmodernism*. New York: Sage.

Nolan, T. (1974, July 4). Up from Downey. *Rolling Stone*, 60–64.

Oliver, P. (1984). *Songsters and saints*. New York: Cambridge University Press.

Orbach, S. (1986). *Hunger strike: The anoretic's struggle as a metaphor for our age*. London: Faber.

Paglia, C. (1990). *Sexual personae: Art and decadence from Nefertiti to Emily Dickinson*. New York: Vintage.

Rosenfeld, M. (1985, June 19). Life after Karen going solo: Richard Carpenter pays tribute to his sister. Washington *Post*, B3.

Rumney, A. (1983). *Dying to please: Anorexia nervosa and its cure*. London: McFarland.

Sanjek, D. (2001). They work hard for their money: The business of popular music. In R. Rubin and J. Melnick (Eds.), *American popular music* (pp. 9–29). Amherst: University of Massachusetts Press.

Springhall, J. (1998). *Youth, popular culture and moral panics*. New York: St. Martins.

Stockdale, T. (2000). *They died too young: The Karen Carpenter story*. Philadelphia: Chelsea.

Street, J. (1986). *Rebel rock: The politics of popular music*. Oxford: Basil Blackwell.

Taubin, M. (1996). Nowhere to hide. *Sight and Sound*, 6, 32–34.

Verdery, K. (1999). *The political lives of dead bodies: Reburial and postsocialist change*. New York: Columbia University Press.

Whitely, S. (2000). *Women and popular music: Sexuality, identity and subjectivity*. New York: Routledge.

chapter 7

Posthumous Patsy Clines

Constructions of Identity in Hillbilly Heaven

JOLI JENSEN

In the fall of 1978, I discovered Patsy Cline through listening to a battered LP I'd checked out from the public library in Champaign-Urbana, Illinois. It was her *Greatest Hits* album, and it didn't even have a cover.

In the 1970s, almost no one I knew had heard of Patsy Cline. The library had no books or articles about her, and the country music encyclopedias had only a brief paragraph about her life and death. I couldn't even find out what she looked like. I became obsessed with finding out more about her, so the next summer I went to Nashville to do research on her life.[1] There I was met with cordial bemusement by both country music historians and industry participants. Why was some graduate student interested in this obscure pop-crossover singer, after all these years? Patsy Cline wasn't famous—heck, she wasn't even country.

By the early '80s the Patsy Cline revival had begun. Today Patsy Cline has become a popular icon, often heard, widely known, and usually beloved. She's certainly become "really country." What happened? How and why did Patsy Cline move from the relative obscurity of the '60s and '70s to iconic star status? What explains her posthumous celebrity? How is the Icon Patsy connected to the Pre-revival Patsy I found in 1979? And what can we learn about the processes of posthumous celebrity from her example?

From Obscurity to Icon

It is important to understand how completely Patsy has been revived and transformed since the late '70s. My personal discovery was only a year or so ahead of the wave of popularity that began after the movie *Coal Miner's Daughter* (based on Loretta Lynn's autobiography) was released in 1980. The Patsy I found in 1979 was significantly different from the one that has become public property; exploring those differences can help us understand more about how and why posthumous reputations work.

Until the early 1980s, Patsy Cline was publicly invisible. Older country music fans remembered her, of course, and the musicians and performers I interviewed had lively stories to tell. But no one in my graduate student life had ever heard of her. Most of my friends and colleagues thought I was nuts to spend all my savings going to Nashville to do biographical research on a long dead country music has-been.[2]

But I was on a quest—eager to salvage this no-doubt wonderful woman from the anonymity into which she had inexplicably fallen. I had only the sound of her voice on that vinyl record, the knowledge of her tragic early death, and the recognition that she was being ignored. That was enough for me to feel a deep connection to her, and to begin to imagine "my" Patsy. I longed to give her sound a context, a life, an explanation. I yearned to understand what made her so extraordinary. It felt, at the time, like a calling.

I was mystified by her absence from country music scholarship. What explained it? Was it because she was a woman? I was quick to assume this, but during my first summer of research in Nashville in 1979 it became clear that there was much more to her obscurity than her gender. Patsy Cline's role in the development of country music was ambivalently understood, and her personal style was antithetical to much of what country music was deemed to stand for.

It's hard for contemporary fans to understand how and why Patsy Cline was not (then) defined as "really" country. But from the 1960s to the 1970s she was a marginal figure because she had "crossed over" into the pop charts in the early '60s, during the then-maligned Nashville Sound period. The staff of the Country Music Hall of Fame library was supportive of my research, but it was clear that Patsy Cline did not count for much in the history of country music as it was then understood. Both scholars and fans, at the time, believed that the early '60s was a time when country music was "almost ruined." Patsy figured in this, somehow, as someone who had helped the music "sell out."

In the summer of 1979 there were no readily available books or articles about her. To get a sense of her life and career, I had to leaf through hundreds of old newspapers and fan magazines in search of references, and track down performers, managers, and songwriters I had not, up until then, ever heard of. Her music had

disappeared from the airwaves, except on a few oldies shows, or in cover versions on albums. Her albums had to be special-ordered, and only a few were easily available. A generous record collector and cataloger, Don Roy, offered to tape her songs for me, chronologically, so that I could track her vocal development.[3] The article I wrote from those interviews and tapes became the first scholarly account of Patsy Cline's career (Jensen, 1982); Don Roy's work became the first Patsy Cline discography (Roy, 1982).

Then came the movies *Coal Miner's Daughter* and the Patsy Cline biography *Sweet Dreams*, and Ellis Nassour's (1993) revised and reissued biography, *Honky-Tonk Angel: The Intimate Story of Patsy Cline*, and k. d. lang's homages, and reissues of Patsy Cline records and remade duets with the also dead Jim Reeves, and within a few years "my" Patsy had become "the late, great Patsy Cline."

It is difficult, now, to find anyone conversant with American culture who hasn't heard of Patsy Cline. Her life has been condensed into a few key phrases—"hard life, tumultuous marriage, incredible voice, changed country music, tragically killed in 1963, finally found fame that had so long eluded her." She even had her own U.S. postage stamp.

Her records have been reissued, including early live performances, with thorough analyses of each session. Concurrently, her biggest hits have become classics, and the Nashville Sound she represented has come to be seen as a lost age of more authentic country music (see Jensen, 1988; 1998). Now there are carefully researched biographies (Jones, 1994), definitive boxed sets (MCA, 1991) popular plays, numerous articles, casual references, and—the final imprimatur of fame—Patsy Cline impersonators.

Explaining Fame

Her "rediscovery" has been puzzled over. Like me, other reporters, commentators, fans, and performers have asked—why is Patsy now more renowned and admired and successful than she ever was in life? What explains her posthumous fame? To answer this question, we need to briefly turn from this case study to cultural and social theory. Why do some figures, or forms of culture, become popular, and not others?

There are at least four perspectives that can be used to explain the popularity of a style, item, or figure. We can view renown as primarily a function of production, consumption, aesthetics, or semiotics. Each perspective makes different assumptions about how culture operates in society.

If we imagine that popularity is a phenomenon of production, we presume that the media can cause fame—at the very least, they can coax things into renown. But popularity can also be seen as a phenomenon of consumption—we presume that

the audience needs or desires something, selecting something from an abundant, diverse media environment. But popularity can also be seen as an aesthetic phenomenon—greatness simply shines through, in that aesthetically superior things excel, becoming widely desired and disseminated. And finally, and most recently, we can see popularity as a semiotic phenomenon—the most popular cultural items are flexible, rich, polysemic texts that speak differently to different people across time and space.

All these explanations can be mobilized to explain Patsy Cline's posthumous fame.

Production Explanations

Obviously, the media renditions of Patsy Cline's life have played a part in her renown. Loretta Lynn's (1978) book, *Loretta Lynn: Coal Miner's Daughter*, sold well enough to become a movie (Schwartz and Apted, 1980), and Beverly D'Angelo's portrayal of Patsy in it was particularly engaging. The movie was successful, and it introduced people to some of Patsy's most famous songs. The re-released Ellis Nassour (1993) biography was widely distributed, and offered a disjointed, gossipy account of a rowdy, sexually active "fighter" who became a star. The movie *Sweet Dreams* (Schwartz and Reisz, 1985) offered a classic tale of triumph and tragedy, with Jessica Lange portraying Patsy as fighting for honor and integrity in a troubled, violent marriage.

Meanwhile, k. d. lang was in her "torch and twang" persona, publicized as believing she was Patsy Cline reincarnated, and performing extraordinary versions of previously obscure Cline songs like "Three Cigarettes in an Ashtray." Women country music performers began citing Patsy as "opening the door to women" in the country music business, and Nashville's somewhat awkward embrace of k. d. lang connected '60s Nashville Sound performers to contemporary alternative music fans and performers.

So yes, we can find evidence for a production-based explanation. We can say that there was a media "creation" of Patsy Cline, that she was portrayed and memorialized in movies, books, and records in ways that explain her popular appeal. It could also be argued that "the media" shaped her persona in ways that ensured her popularity. As one commentator notes:

> [the movies] glamorised the struggle that was much of her life. In these movies Patsy was revealed as a woman who was forced to fight for her craft. She fought against agents who exploited her, she fought the misogynist Nashville establishment, and most of all, she fought her husband, Charlie Dick. (White, 1993, p. 18)

Part of the production perspective is an argument about Zeitgeist—the spirit of the times. The times were ripe for these particular media renditions for several

reasons. Previously ignored women writers, artists, and performers were being rediscovered in a number of fields, and Patsy Cline offered yet another example of a woman who had to "fight her way to the top" in a male-dominated business.

Also, country music was continuing its chronic quest for wider social and commercial success, by staying "country, but not TOO country." Loretta Lynn's biography showed that country music performer stories could resonate outside of the established country music world. The beginning '80s country music boom involved (as always) defining country music as simultaneously traditional and innovative, and Patsy Cline offered exactly that combination, especially through k. d. lang.

Finally, spousal abuse was becoming a prominent social issue, and the Patsy Cline story offered an ambiguous version of being a triumphant battered wife.

Consumption Explanations

But none of these renditions would "work" if there weren't audiences eager to respond. The production explanation founders on the Edsel example—there are many instances where full media promotion fails. Clearly there is more to popularity than publicity, although it is usually a necessary prerequisite.

From a consumption perspective, people were "ready" for Patsy Cline's voice, life, and persona. I can use myself as an example. I was already primed to fall for Patsy's voice by exposure to women soft-rock, semi-country singers like Emmy Lou Harris and Linda Ronstadt. The sound Patsy had did not seem to me at the time to be "too country" (by which I and others meant nasal or whiny) and yet it had enough steel guitar to satisfy my new-found love of the honky-tonk style.

Her voice was astonishing in its range and power, but her life drew me, too. I imagined her, with very little evidence, to be a woman who had the courage and independence to make it in a man's world on her own terms. I sensed, from her songs, and then from the stories I began to collect, that she combined a brash and self-assured veneer with inner kindness and vulnerability. I also assumed she was a victim of scholarly discrimination—as a woman and as a country music performer she was being pushed aside. Her death at the peak of her career added piquancy to this victim image, and helped me believe I had a duty to restore her to her rightful place in the world.

As an audience member, I was predisposed by a number of situating factors to become a Patsy Cline fan: developments in music, trends in popular feminisms, social narratives of tragedy and triumph, the idea of repairing damage, and a dream of posthumous restoration combined to ensure her appeal for me. These factors are consumption factors, making me and other audience members likely to respond and embrace a figure that sounds right and acts in ways that catalyze and enact stories

that engage us. My personal desire to write the biography that would retrieve Patsy Cline for renewed fame can be seen as my personal version of posthumous fandom. As a graduate student and aspiring writer, I wanted to be the one to do research and write her biography. But listening to records, reading biographies, visiting grave sites, and hanging out on websites are comparable forms of fandom—through our affections we protect and defend a figure fate has taken from us, and fame has given us back again.[4]

Commentaries from the 1990s offer evidence of just these kinds of consumption processes. Patsy's voice is described as "contemporary" in that "if you didn't know that Patsy Cline was dead, you would take her for one of today's recording stars." (Wilson, 1994, p. 15) In another instance, "Patsy Cline sounds like a product of the past to be sure, but the past of only a few moments ago" (Kimberley, 1991).

This semi-modern sound implies that Patsy does not sound "too country." Unlike Kitty Wells, whose voice is always described as "nasal" or "twangy," Patsy Cline's voice is called "smooth" and "rich." This vocal difference, combined with arrangements that relied on strings and vocal groups, rather than steel guitar and fiddle, are what marks the difference between "too country" and "contemporary."

As another writer noted, in her early years, "many doubted that Cline's powerful, bluesy voice was right for the twangy, hillbilly sound associated with Nashville" (Carey, 1993, p. M-1). Bill McCoy, who knew Patsy in her teen years, describes her first recordings as more "real country," but notes that it was her later arrangements that made her famous. McCoy says "Her first stuff was more with the steel guitar, but the last stuff, the big hits, were strings" (quoted in Ferguson, 1992, p. E1). McCoy then criticizes current country music as "too citified," thus placing Patsy back with "real" country music, even as he notes the distinction between her earlier and later recordings.

Unlike her "not dated" and "not country" voice, her life story has a mythic quality that is connected to country music and the past. Harron summarizes her life:

> She was born poor in Virginia and her father walked out when she was 16, reducing her to singing on street corners for her family's supper. She worked behind a drugstore counter, sang at night and made a true country-music marriage to the aptly named Charlie Dick, who loved her but also drank, sponged, cheated on her and beat her up from time to time. (Harron, 1993, p. 23)

As another put it, "The girl from the wrong side of the tracks in Winchester worked hard and played hard; her reputation as a forward, at times promiscuous woman, stayed with her for life" (Carey, 1993, p. M-1).

But the overall story is that this hard, "country" life didn't get her down. In fact, the Patsy Cline persona offers a vivacious woman who was ahead of her time: "Patsy

Cline was spunky, audacious and boldly sexy by the standards of the day" (Carey, 1993, p. M-1).

"Ahead of her time" has complex meaning in relation to Patsy. Those in the Nashville community can use it to describe the style of her singing, but they also used it, in interviews with me, as a coded way to say that she slept around. But in general, being ahead of your time is desirable—biographer Ellis Nassour says she was "not only 20 years ahead of the pack musically—the female singer responsible for changing the course of country music—but also 20 years ahead as a feminist" (quoted in Wilson, 1994, p. 15).

Tragically, of course, this "ahead of her timeness" is always shadowed by the inescapable fact of death "before her time." The fight to rise from poverty to stardom is juxtaposed by the tragedy of a life cut short. Such a death is not only memorable and moving, but offers a form of persona protection. As Paul Kingsbury (1991) notes, "We will always remember her as a feisty woman on the way up, with everything to live for, not as someone who had her day, who is embarrassingly unwilling to get offstage" (p. 5).

These accounts suggest that Patsy's fame involves an audience who is responsive to things she apparently represents—a voice that isn't country but a life that is, a feistiness and sexiness that wasn't country then, but can be now, a prescient force for music and feminism, and a death that both stopped her too soon, but allows her to live again through our responses to her.

Aesthetic Explanations

Explaining fame by arguing for some combination of media attention and audience need ignores the thing that connects media and audiences—the content itself. The dominant popular explanation for why Patsy Cline has become posthumously famous is that she was so great that she HAD to be rediscovered.

This aesthetic perspective sees Patsy Cline as extraordinarily gifted. As an artist, her oeuvre consists of a body of work that can sustain critical scrutiny and continues to offer intense emotional experience across time, space, and social groups.

Such an argument assumes that there is a connection between the essential qualities of a cultural form and its later success—it "stands the test of time."[5] Belief in a canon of works that radiate their greatness across time, space, race, gender, and class has been soundly critiqued in recent academic discussions. But it characterizes a number of explanations of Patsy's revival—her "greatness" has rightly made her into the star she is today.

Comments about Patsy Cline's "timeless sound" are aspects of the aesthetic perspective. "There's nothing dated about her approach or presentation. If you look

at pop acts from the fifties and early sixties they fitted a sound of that moment whereas Patsy's was an indefinable sound" (Tony Byworth, quoted in Wilson, 1994, p. 15).

Patsy's "indefinable" sound implies that she has transcended the barriers that confine lesser figures. Thus Patsy is distinguished, often, from Kitty Wells, who is seen as being confined to the past and the genre that Patsy has escaped. One article refers to Patsy's "boundary blurring signature sound." It describes her first hit, "Walkin' After Midnight," in glowing terms, arguing that it "combines the emotional transparency of country, the robust tonality of Tin Pan Alley pop and a hint of gritty R&B into a sound that was Cline's alone" (Himes, 1991, p. N-17).

Having a "signature sound" implies that you, the artist, have something unique and inimical. Kimberley (1991) argues that it is the "teardrop" that gives country music its authenticity, and suggests that Patsy's artistic triumph is her mastery of "the teardrop":

> The teardrop can take many forms. It can be a break in the voice, close to a sob; it can be a willingness to sing a note flat or through clenched teeth; it can be all manner of melismatic embellishments. Such mannerisms can sound sentimental and crass, but a singer like Patsy Cline, whose voice encompassed almost every teardrop possibility, makes them superb emotional vehicles. (p. 15)

Kimberley describes various examples of "a voice luxuriating in its craft" and complains that some of her recordings are "sullied" by vocal group intrusions. He concludes by saying "There is a gossamer thread between sentiment and sentimentality. Patsy Cline walked that thread with the precision of an artist" (p. 15).

From an aesthetic perspective, unique artists create great works, ones that deserve careful, detailed appreciation. The following analysis of "I Fall to Pieces" demonstrates how close aesthetic critique can be used to illuminate a single song:

> The male vocal group is there, but well back in the mix balanced by the authentically Country [sic] steel guitar. The first phrase, the song's title, provides a neat resume of Cline mannerisms: the slight hesitancy in finding the note on "fall," a delicate portamento on "pieces," the note then extended over the beat on the final syllable, the whole line delivered with an almost imperceptible gruffness. Each vocal trope is understated, barely hinting at the emotional turmoil the words describe. . . . Cline scoops up to notes, drifts downwards, and, most tellingly, feigns a moment of difficulty in getting the note at all. Each repetition of the title is handled slightly differently, not with the outrageous abandon that a jazz singer might relish, but with a careful attention to tiny variations. (Kimberley, 1991, p. 15)

Because the aesthetic perspective presumes that renown is based on the qualities of the work, not the life, there is an insistence, in the aesthetic analyses, on

this separation: "It wasn't the plane crash that made Cline important, though; it was the music, and this [boxed CD] set makes sense of her complete body of work for the first time" (Himes, 1991, p. N-17).

Semiotic Explanations

So far, explanations of fame have involved imagining certain forces that determine popularity—from a production perspective that force is the media, from a consumption perspective it is the audience, and from an aesthetic perspective it is the work itself. But in a semiotic perspective, popularity is not caused or determined, but rather "made possible" by the symbolic complex of the cultural form. Thus, focusing on semiotic issues, Patsy Cline becomes a collaborative construction of all three—the media, the audience, and her body of work are what have combined to make her up. She is a bricolage, an assemblage of accrued meanings that can be variously read. Her fame is enabled by the multiplicity of readings her symbolic complexity allows.

From this perspective, Patsy Cline is not just an artist or a person, but a polysemic subject position, someone whose life and work can be made to mean a variety of things for a variety of people. Patsy Cline is socially constructed to have enough power to appeal widely, without enough specificity to exclude or repel. This explanation parallels '50s critique—forms designed to appeal to everyone, and thus no one in particular. As Handlin put it, such commercialized forms are "designed to appeal to the empty outline of the residual American" (Handlin, 1961, p. 68).

It is important to note that much popular commentary on Patsy's iconic status seeks to cut through these symbolic accretions, to retrieve the "real" Patsy. Only a few commentators directly address the possibility that the currently popular Patsy, like any celebrity icon, must always be a fabrication.

For many, the "real" Patsy Cline has not been captured by the movies and books that have been written about her. The ability to discern the "real" Patsy involves having known her, or knowing those who have known her, or knowing more than those "other" fans. Bill McCoy, one of her early supporters in Winchester, says that the movie *Sweet Dreams* "was a bit uptown. That's Hollywood style." The "real" Patsy would never have stood for such abuse from her husband, Charlie Dick, "Like I've heard alot of people say, if he'd have treated her like that, she'd have took a 2 by 4 and busted him over the head" (Ferguson, 1992, p. E1).

Ellis Nassour (1993) criticizes the movie, too—"It is a good movie if you know nothing about Patsy Cline" (quoted in White, p. 18).

Charlie Dick, Patsy's second husband, dismisses the Nassour biography as well as the movie, and describes Patsy as "just an ordinary girl. She loved home life, you know, cookin', cleanin', lookin' after her family. Sure we argued, we were fightin' all the time, we had a passionate relationship. But we didn't do knock-down, drag-out fightin'. Not once" (quoted in White, p. 18)

The Nashville performers' community who knew Patsy has also responded with some dismay to the movie versions of Patsy's life. They criticize them as Hollywoodized, and suggest that they do not accurately portray her complex personality.

But IS there a real Patsy Cline? My interviews in 1979 offered an only partly narrativized Patsy Cline, a semi-formed story of a rough, rowdy woman with a beautiful voice and a heart of gold. The people I interviewed were cautious, hesitant, spoke to me in a semi-code about her sexuality, "toughness," marriage, troubles, reputation. In later visits, in 1980, the stories were much more polished, and impermeable. The Nassour biography was dismissed as full of gossip, the movie as too uptown, but the revival defined as a tribute to her tremendous talents. The "real" Patsy, based on the account of her friends and family, is also, always, revisionist.

Roseanne Cash has written one of the most insightful accounts of this tendency in Nashville, and of its frustrations for her. She is herself country music "royalty," the daughter of Johnny Cash, who later married June Carter, of the Carter family. Her essay appeared in a 1996 issue of the *New York Times Magazine*, among others by well-known women about "Heroine Worship." In the issue, the '90s are dubbed the age of the female icon, and Patsy is included with Elizabeth Taylor, Eleanor Roosevelt, Oprah Winfrey, Martha Graham, Indira Ghandi, Coco Chanel, Doris Day, Aretha Franklin, and Jackie Onassis, among others.

Cash's (1996) account describes how "those with real memories of her have been somewhat revisionist in their collective retelling." She suggests that this is because " . . . she was so damned great . . . that perhaps they felt a need to polish and repair her wild and willful personality in order to complement the magnitude of her talent, particularly since she was a woman in an era that did not suffer female accountability gladly" (p. 66). The Cashes had Patsy over to the house shortly before she died. When pressed about the disjuncture between the voice and body and Patsy's "roughness," June Carter backs off—when Roseanne asks if her mother was disappointed when she met Patsy, her mother answers "Well I wouldn't want that to be said—she was ahead of her time, that's all" (p. 66). From the semiotic perspective, we see how Patsy becomes what the particular reader needs or wants her to be. As Sandall (1995) notes, "Posterity has seldom inherited such a promising bundle" (p. 29). Her contradictions, in combination with her life and her gifts, readily support a variety of readings.

Patsy has been particularly popular among gays and lesbians. Andy Medhurst, a Sussex University professor who writes about gay icons, calls Patsy "The nearest thing to a diva country music has" (as quoted in White, 1993, p. 18). According to White (1993), Medhurst explains her appeal for the gay and lesbian community in terms of her image as someone who "overcame abuse by a brutish uncaring husband who tried his best to stifle her career" (p. 18). White goes on to suggest that Cline has "all the requisite elements" to be a "gay favourite," including "tragic early death, a portfolio of dark and poignant songs, and an allegedly miserable personal life" (p. 18).

A more nuanced interpretation is offered by Caz Gorham, who organized an all-Patsy night that "drew 900 lesbians to a nightclub in South London." Patsy's appeal involves a combination of her "strong image as a woman" and her musical persona. "Her music has a sense of unrequited passion, you know, heartache, which is meaningful to those who are unable, because of outside pressures, to express feelings openly. But there is also a tongue-in-cheek element. Those clothes, that style. I don't think you can buy into it without a sense of irony" (White, 1993, p. 18).

The irony that Gorham describes is complex. It is not parody or pastiche, but more of a playful postmodern bricolage—Patsy is constructed to be idolized and ironized. The gay diva Patsy is a "knowing" Patsy, a way to play with the ways that Patsy is both real and constructed. Such a "postmodern" Patsy can still serve to inspire or orient the fan. As the *New York Times Magazine* collection on heroines suggests, icons that help us invent and sustain identities.

It is this inspirational Patsy that Roseanne Cash describes; the Patsy she imagines is much like the Patsy I first sought. She is/was, as Cash (1996) writes:

> A woman who is truly and spontaneously alive, who is rooted in her body like a redwood in the earth, who is in command of a startling sexuality that infuses everything and who is the vehicle for a preternaturally affecting voice that both reveals and obscures her essence. (p. 66)

Cash realizes that her voice "both reveals and obscures" but goes on to describe how Patsy is a:

> . . . profound source of inspiration to those of us without immediate memories of her, those of us whose voices weren't so full-bodied and fully formed from the beginning and whose values were not so exquisitely self-determined . . . In my private quandaries, musical and otherwise, it gives me a lot of satisfaction to connect her teeming personality to the gifts she possessed. She lived a life utterly her own, messy and self-defined, and it all fed and merged with that voice. (p. 67)

This iconic Patsy Cline has been effectively detached from the messy particulars of her life. She has become mythic—her marriage, her troubles, her struggles

have all become a story of triumph over tragedy, in life and now, again, in death. The "messy, self-defined life" is disheveled in ways that will inspire the fan, not trouble or repel her.

This is best illustrated in the evocative comments of Mary Harron (1993), as she analyzes the appeal that Patsy Cline has for her. Harron argues first that "A singer constructs a persona simply by the songs she chooses. "She uses the most famous Patsy Cline songs to describe the Patsy persona: "Patsy's true mode is existential loneliness: an isolation so complete that it comes as a surprise to hear she had a husband and children." This, Harron argues, sets her apart from singers like Tammy Wynette and Loretta Lynn, where "personal history seeps into their music until it seems the function of personal tragedy is to provide more songs" (p. 23).

> What is noteworthy, what makes her special is that:

> Patsy Cline doesn't give you that kind of detail. There's no Tennessee mountain home, no trailer park, no runny-nosed kids or dishes in the sink. I always picture her in two settings. One is walking along that midnight highway. The other comes from what may be her best song, "She's Got You," where she sits alone in her living-room, late at night, with a few objects in front of her: a photograph, a ring, a record spinning on the turntable. (Harron, date 1993, p. 23)

The semiotic Patsy, then, has been constructed in ways that suppress or eliminate the particular life, the specific husband, children, sinks, and trailer parks. Instead, she offers a "promising bundle" of signifiers that can be detached from their origins in an actual life, while gaining significance from the hints of that life—abuse, misery, loneliness—and beliefs about triumph over it.

The Consequences of Transformation

Does it matter how Patsy is interpreted? Does it make any difference if the "real" Patsy is different from the constructions of her? A key aspect of posthumous fame is the inability of the figure to counter the personas that are ascribed to his or her image—death prevents authorial revisions. But others still insistently take up the battle, offering corrective claims to show the "real" figure behind the image, as the image evolves and transforms.

This desire to retrieve the real from its symbolic packaging is a continuing feature in modern life. (Boorstin, 1972; Orvell, 1989; Percy, 1975). Is there anything about the "real" Patsy that might be worth saving? Why do people, with Patsy and others, endlessly return to the idea of a "real" or "essential" celebrity? Why don't they just revel in a postmodern carnival of constructedness?

Concern with saving the "real" in a celebrity parallels Patsy's role in the development of a form of country music that was not originally deemed "real country"

but that now has become, retrospectively, "real." Concern with the real also connects to 1950s concerns with the homogenization of culture, the ways that the particularity of folk and high arts were being watered down for wider dissemination. This dilution of a cultural form's particularity, its pungency, was described as commercialization—the cultural form had been corrupted in order to make money (Jensen, 1992b, 1998).

The country music sound that is associated with Patsy, and with the Nashville Sound, was dismissed, in the late '70s, as a dilution, a homogenization, a commercialization of country music. Those on Music Row were accused of having "sold out" country music. This is a longstanding concern in country music circles. As country music becomes more popular and lucrative, it is invariably accused of having "lost its soul" (Jensen, 2000a).

Yet today, when that question is asked, it is in relation to a Nashville Sound that has become "authentic" in retrospect. Patsy Cline, among others, is now revered as not only ahead of her time, but "really" country. She, and her music, represents a form of genuineness that contemporary performers honor. In fact, this Patsy is seen as also having triumphed over the attempts to subdue or commercialize her, she has escaped the "discipline" that current critics like Sandall (1995) see as having softened and weakened country music in the past thirty years.

Thus the "real" Patsy is yet another construction, one that can be made to represent a heritage, a tradition, a mode of being, that is being lost in today's even more commercialized, homogenized country music world. She is, therefore, relatively real.

What is interesting in this re-imagination of Patsy is that the battle that defined her recording career, and helps to explain her choices and performance style, has been reworked to form her iconic image. She was, in life, an aggressively lower-class, down-home woman who loved rowdy, twangy country music and had to be convinced, over and over, to do the kinds of smoother music that won her fame. She, like many country music fans of the time, equated the use of violins and background vocals with pop music, and pop music with "them": upper-class, wealthy people who disdained country fans and music. To "cross over" into the pop charts was also to sell out one's friends, family, and heritage. It was to abandon class position, to assimilate, to try to "pass."

The Decontextualized Patsy

This battle has disappeared, now that the Nashville Sound has been redefined as an age of authenticity. The heritage of the Nashville Sound is still with us, except now it is used to criticize today's hat acts. The new form is "country-tinged" music, without the hayseed image. Like the decontextualized Patsy, shorn of any actual connection to snotty noses and kitchen sinks, the newer version of country music

is seen as having been progressively detached from its earlier authenticating elements. It has been reconfigured as "good" and "honest" music, that uses real emotion, rather than as twangy, nasal, hillbilly music.

Similarly, the Patsy we get has been decontextualized. The Patsy I found in the late '70s was a Patsy defined by the country/pop tension in her music, and one who was clearly lower class. That made it easier for me, as a middle-class academic, to focus on analyzing her music rather than writing about her life. My personal discomfort will help illuminate why Patsy "works better" without full context.

My initial trip to Nashville was a quest to find out who Patsy Cline "really" was. I sought clues, angles, insights that would tell me who the woman was who could sing in ways that knocked me out. My initial Patsy was a tantalizing, talented, powerful, intelligent woman who was, it seemed, speaking to me from beyond the grave, waiting for me to find her. She was Roseanne Cash's Patsy—an icon that could inspire me.

My early interviews with those who worked with her gave me a series of stories that tried, awkwardly, to construct a rowdy Saint Patsy—rough but with a heart of gold, always generous and giving. Later interviews, as I showed that I knew a fair amount about her personal life but wasn't trying to smear her, involved cautious analyses of her contradictions, temper, difficulties. The more I found out, the more I sympathized with, but was confused by, her temperament and motives. I sought, as all biographers do, a narrative that would make sense of disparate glimpses. Was there a story line? What was it?

Three incidents steered me away from writing her biography. They showed me that the Patsy I had created for myself was significantly different from the Patsy I was finding, in ways that meant I couldn't really understand her life, although I could probably analyze her musical role. The first was a birthday card she'd given Owen Bradley—he'd saved it over the years, and it was the kind of card you get in a truck stop, tacky-cute. "My" Patsy would not have sent it.

The second was my visit to her home town of Winchester, where at that time she was barely acknowledged. The town showed clear class divisions in ways that mystified and troubled me. The newspaper had no file on her, and no intention of putting one together. The Chamber of Commerce had no material, and seemed insistent on keeping it that way. The people I found who knew her told stories about ostracism that were distressing but also entirely alien—what kinds of class conflicts were these, and how was I to ever get inside of them? "My" Patsy was immune to all this stuff, could laugh it off and move on, but clearly, class issues were key to her character.

And finally, I met her husband Charlie Dick and could not possibly imagine "my" Patsy having anything to do with him. During my first summer of research he was courteous to me, and told me his collection of Patsy Cline stories, but I knew,

after talking to him, that if she loved this man then I could not understand her well enough to write a good biography.

The Patsy I had constructed, from the voice and the outlines of her life story, was one that I needed for myself—a powerful, independent, gifted Patsy—the "redwood" Patsy that Roseanne Cash describes, and that the movies reference. The Patsy I wanted to find would never send a tacky card, be crude enough to be ostracized, or marry Charlie Dick.

The Consequences of Repositioning

In Patsy Cline's current iconography, the particular issues of class and commerce that defined her life have dropped into the background, while the more general issues of temperament, personality, and "overcoming barriers" have been toned down, and foregrounded. Class and commerce figure in her story as things she was able to transcend—her "greatness" becomes her ability to "be herself" in a world imagined as trying to trap or inhibit her.

This is how celebrities manage to speak to "everyone." Things that might limit or drive away parts of the audience have to be incorporated, refined, made into something that isn't crude or repellant. Tammy Wynette, Loretta Lynn, and Kitty Wells have the concrete specificity, the trailer and runny nosed kids, the twang or the whine. They are, therefore, defined as "dated" or "too country," in comparison with Patsy.

But Patsy also had those "country" defined traits—they were her life, too, and she fought hard to keep them in her music. But she was convinced, by those who recorded with her in Nashville, that her key to success was a softer, smoother, more pop sound. Owen Bradley and the Jordannaires and the other musicians were right. Her temperament was honky tonk, but her voice was best suited to crossover pop, and it is with the crossover that she found her audience, and laid the foundations for her posthumous fame.

This means that the particularities of her class origins have been erased from her music, and they continue to be diluted in her iconic image. Piquant elements—the abusive husband, the rough language—remain, but as examples of spunk and feistiness, not trailer-trashhood. Much like the steel guitar that still appears in songs to signify "country," selected elements of Patsy's life lend a touch of authenticity, but just a touch—not enough to cause anyone to turn away.

Patsy Cline is firmly ensconced in Hillbilly Heaven, that place that a series of country songs invented for their late, great stars. But her embattled relationship to that ambiguous term hillbilly—the reason that country music isn't pop or rock and roll, but also the reason it is ridiculed—has almost disappeared. She has become posthumously repositioned within the biographical and musical issues that defined

her. Thus repositioned, she is better able to speak to all kinds of fans across time, space, age, sexual orientation, and nationality.

Three Final Questions

First: *Has something been lost in this "unmooring" from the concrete specificity of the music, and of the life?*

What is the value of concreteness and specificity? Why do country music fans insist that country music used to be more real, based mostly on whether there is a steel guitar in the mix? What is actually lost in the transformation of musical genre? It's only music, after all, only instrumentation and vocal stylings. Why do people care so much about whether country music is "losing its soul?" And, in parallel fashion, why should I care if the iconic Patsy Cline has been sweetened, refined, shorn of her class origins and musical battles? It's only stories, after all, all the way down.

After twenty years of pondering why people care about generic shifts in cultural forms, I have decided that people balk at generic change for two related reasons. They fear the inevitable loss of their access to the past, and they realize that genre shifts change the ways a cultural form locates and defines a social group. The country music world that was located and defined by honky tonk music was smaller and more particular than the world defined by the Nashville Sound, which is smaller and more particular than the world defined by subsequent country music, as exemplified by, say, Garth Brooks.

Garth Brooks is still insistently country, but he speaks to all kinds of people. He and other current country stars feel pressure to remain distinctly country, to honor its past and its tradition, while still crossing demographic boundaries. This is done by changing both the style and the content of the music, making it evoke a more general, diffuse, emotional landscape. The Nashville Sound world and the iconographic Patsy are less rural, less Southern, less class-bound, more emotional, more existential. The emotions, not the setting, become the "reality" that country music represents.

What has been lost, then, in the switch from the honky-tonk sound, and in the transformation of Patsy, is the ability to speak for and to a specific group. The honky tonk music fan, stigmatized in the shift as a hayseed, yokel, or white trash, no longer has the music that defined him as a fan, not a hick. And the girls and women who get dismissed as cheap and crude and loud, like Patsy, get pushed aside in the construction of Saint Patsy, rowdy but refined, with a heart of gold. They too have lost the chance for a cultural expression of their own life—except for the hints of it left in the repositioned version to give it "authenticity." What has been gained in both the music and the persona shifts is an ability to speak to a larger

number of people about general feelings. What is lost is a conversation about lived experience and class position.

This is not exactly what troubled mass culture critics as they saw high art and folk being "eroded" by commercial forces. They weren't worried about poor white trash having their own cultural forms. But the concept still works—social groups who evolve their own forms of culture against other forms lose out when those forms merge. When country music sounds like pop, when troubled, promiscuous women become "independent" or "ahead of their time," when rap sells hamburgers, when alternative music starts selling well—what is lost is the connection between experience and expression, and the ability of the form to say "You, the fan, are this and not that."

It could be argued that commercialization, popularization, the mass mediation of culture offers us better ways to connect to each other—we are linked more loosely, and thus have less social conflict. And we are connected more inclusively, because no one feels totally excluded. By this logic, capitalism can be defended as an excellent vehicle for democracy and world peace—the market allows loose, inclusive, non-ethnic connections to be created and sustained. But such relationships do not yet feel as "genuine" as those of family, neighborhood, community, country. Those relations, of course, are the very ones that country music celebrates.

Second, *is it really so bad to turn dead celebrities into anything we want? Isn't all this just the postmodern fun that the media, and modern technologies, make possible?* I think we should be wary of the process of celebrity transformations, but understand that it is there from the beginning—live celebrities are no more "real" than their dead counterparts, just less limited in their semiotic possibilities. We now have the technology to reproduce, ironize, reassemble, morph all kinds of images, and we have a long history of projecting onto celebrities all kinds of interpretive possibilities. This combination of media process and audience need offers us an array of people to admire, emulate, deplore, use as cautionary tales, learn from (Braudy, 1986; Klapp, 1964; Schickel, 1985).

It is the "learn from" aspect that concerns me most. When some aspects are ignored, and others accentuated, the celebrity, dead or alive, is made to suit our own purposes. These purposes may or may not be ones that are worthwhile, valuable, or trustworthy.

Something seems wrong about using the images of Humphrey Bogart, John Wayne, and Fred Astaire to sell products. In life, they themselves did not choose to "speak" the value of colas or vacuum cleaners. Now their images are being made to do so, and when we go back to Fred Astaire dancing with a broom, we will have to "see through" the vacuum cleaner his image had been given to sell, try to get back to a previous image—the dance and movie that was the original effort.

It is not that something "authentic" has become commercialized—movies and records are money making efforts, and celebrities are always trying to sell us something: their performance, the vehicle, themselves. But what is "authentic" is the originating context, in all its complexity and contradiction. We may have something to learn from that contextualization. What also concerns me, then, is that we lose access to whatever we could learn from the originating context, once the image has been taken from it, and turned to different purposes.

We should be wary of the dangers of solipsism. Other people may have important things to tell us, even after their death. If all we do is impose our meanings onto them, then we can only learn about our own narcissism—hear and see what we want to see. Patsy Cline may have something to say about class and stigma and sexuality, about what it means to grow up in a class-bound town, to hang out in taverns at an early age, have affairs with married men, get labeled a slut, be ridiculed, be promiscuous, be ambitious, have talent but little education, "make it big," be disfigured in a car accident, hide your pregnancy, flaunt and disparage your looks, but she can't tell us these things very clearly from her current persona.

She can instead stand as an inspiring, mysterious figure of triumph—"rooted in her body like a redwood in the earth." But can we genuinely learn from these figures, if they aren't real, aren't rooted in any body beyond the body of our constructed need? Can and should they offer us public examples of the possibilities of life, if they are creations of the media, the audience, our sense of their greatness, or some semiotic amalgam of these? We need to recognize the limits to what we can learn from the pantheon of people we create with our admiration.

Finally, *Why should we become aware of the process that keeps celebrity going? Doesn't this guarantee cynicism and a loss of mystery?*

I am suggesting that we should become knowledgeable about the processes through which images are constructed, so that we can choose more wisely how to live our own lives. But I recognize the Faustian bargain I am recommending here. When we become aware of the process that shapes our images, we can no longer respond as directly to the images themselves. We gain mastery, but lose mystery.

The postmodern condition implies that, unlike Dorothy in the *Wizard of Oz*, we always know that something is going on behind the curtain, even as we feel awe for the Great and Powerful Oz. But our reactions are semi-detached, and include a bemused admiration for how the whole thing is put together, and manages to move us.

I often yearn to get back to 1978 and the scratched, coverless black LP, when I felt I was in contact with the "real" Patsy. Like a new film student who can no longer enjoy the movie because all he or she sees is camera angles, I know too much

about Patsy Cline to watch the movies, read the biographies, or to listen to her music with pleasure or surprise. As any scholar and fan can attest, I know too much to be taken in.

In fact, deep fandom, the kind where you know every possible detail about your idol, is a form of preventing adoration. It becomes, I believe, a form of scholarship. It is knowledge so detailed and contextualized that it cannot be swept away by fantasy, passion, or projection. Is this knowledge worth the price? I am arguing that it is, but note that I'm in the business of mastery, not mystery, and that part of what professors do is make fans into scholars, every semester.

Conclusion

Posthumous fame allows celebrity figures to slip loose from the moorings of biography and geography, so they can better serve the current purposes of those who need them—to sell, to enjoy, to identify with, to interpret. Aspects that might speak strongly to a particular segment of the audience might repel others, so they tend to disappear, in favor of those elements that will allow a figure to speak to many audiences. In Patsy's case, she has been made to speak mostly about loneliness, triumph, and whatever is still called "real" in country music.

And, as you have just witnessed, she can also be made to speak, through a scholarly essay, about class conflict, culture production, genre development, and posthumous fame

Notes

1. My first trip to Nashville was in the summer of 1979, where I did archival research at the Country Music Library and Media Center in the CMA sponsored Country Music Hall of Fame. The librarians there at the time were extremely helpful, particularly Bob Oermann and Ronnie Pugh.
2. Patsy Cline had an imaginative location in popular culture memory much like pop singer Connie Francis has today (at least for now).
3. Record collector and independent researcher and discographer Don Roy, of Nashville, has been consistently helpful in my research into country music.
4. For how scholars can be compared with fans, see Jensen (2000a; 2000b).
5. This is Hannah Arendt's argument, in the '50s mass culture debate, see "Society and Culture," (Arendt, 1971). It is also the argument of the New Humanists during the early part of the century, see, for example, Foerster (1930/1976, Rev. ed.).

References

Arendt, H. (1971). Society and culture. In B. Rosenberg and D. M. White (Eds.), *Mass culture revisited* (pp. 93–101). New York: Van Nostrand Reinhold.

Boorstin, D. (1972). *The image: A guide to pseudo-events in America.* New York: Atheneum.

Braudy, L. (1986). *The frenzy of renown: Fame and its history.* New York: Oxford University Press.

Carey, B. (1993). Gone 30 years, fans still crazy for Patsy Cline. *The Atlanta Journal-Constitution,* p. M-1.

Cash, R. (1996, November 24). Patsy Cline, honky tonk angel. *New York Times Magazine,* p. 66–67.

Ferguson, T. (1992, August 23). Country tuneup time. *The Washington Times,* p. E1.

Foerster, N. (Ed.). (1976). *Humanism and America: Essays on the outlook of modern civilization* (Rev. ed.). Port Washington, NY: Kennikat Press.

Handlin, O. (1961). Comments on mass and popular culture. In N. Jacobs (Ed.), *Culture for the millions? Mass media in modern society* (pp. 63–70). Boston: Beacon Press.

Harron, M. (1993). Is she lonesome tonight? *The Independent: The Sunday Review,* p. 23.

Himes, G. (1991, November 15). How Patsy Cline put the pieces together. *The Washington Post,* p. N-17.

Jensen, J. (1982). Patsy Cline's recording career: The search for a sound. *Journal of Country Music,* IX(2), 34–46.

———. (1988, Spring). Genre and recalcitrance: Country music's move uptown. *Tracking: Popular Music Studies,* 1(1), 30–41.

———. (1992). Walkin' after midnight: Patsy Cline, musical negotiation and the Nashville sound. In G. H. Lewis (Ed.), *All That Glitters: Country Music in America* (pp. 38–50). Bowling Green, OH: Bowling Green Popular Press.

———. (1998). *The Nashville sound: Authenticity, commercialization and country music.* Vanderbilt University Press.

———. (2000a). Taking country music seriously: Coverage of the 1990s boom. In S. Jones (Ed.), *Pop Music and the Press* (pp. 183–201). Philadelphia: Temple University Press.

———. (2000b). Fandom as Pathology: The Consequences of Characterization. In C. L. Harrington and D. D. Bielby (Eds), *Popular Culture: Production and Consumption* (pp. 301–314). Blackwell Publishers.

Jones, M. (1994). *Patsy: The life and times of Patsy Cline.* New York: Harper Collins.

Kimberley, N. (1991, December 16). Tears of a Cline: In the first of a series on voices, Nick Kimberley follows the emotional breaks and strains of country singer Patsy Cline. *The Independent,* p. 15.

Klapp, O. (1964). *Symbolic leaders: Public dramas and public men.* Chicago: Aldine Publishing.

Lynn, L. (1978). *Loretta Lynn: Coal miner's daughter.* Lincolnwood, IL: NTC/Contemporary Publishing.

Nassour, E. (1993). *Honky-tonk angel: The intimate story of Patsy Cline.* New York: St. Martins.

Orvell, M. (1989). *The real thing.* Chapel Hill, NC: University of North Carolina Press.

The Patsy Cline Collection. (1991). Universal City, CA: MCA Records.

Percy, W. (1975). *The message in the bottle.* New York: Farrar, Straus and Giroux.

Roy, D. (1982). Patsy Cline's Recording Career: the search for a sound [Discography]. *Journal of Country Music,* IX(2), 34–46.

Sandall, R. (1995, March 19). The big country. *The Times, London,* section 10, p. 29.

Schickel, R. (1985). *Intimate strangers: The culture of celebrity.* Garden City, NY: Doubleday.

Schwartz, B. (Producer), and Apted, M. (Director). (1980). *Coal Miner's Daughter* [Motion Picture]. United States: Universal Studios.

Schwartz, B. (Producer), and Reisz, K. (Director). (1985). *Sweet Dreams* [Motion Picture]. United States: Tri-Star.

White, J. (1993, April 16). Is Charlie making Patsies of lesbians? *The Independent*, 18.

Wilson, K. (1994, March 31). Still 'crazy' . . . for Queen of the Heartbreak Ballad. *The Herald, Caledonian Newspapers Ltd.*, p. 15.

chapter 8

Collectively Remembering Tupac

The Narrative Mediation of Current Events, Cultural Histories, and Social Identities

GEORGE KAMBERELIS AND GREG DIMITRIADIS

In this chapter, we draw upon theory and research on collective remembering and narrative mediation, as well as the history of hip-hop and rap music, to interpret and partially explain how a group of African-American adolescents socially constructed the apparent murder of their cultural hero, Tupac Shakur, as well as how they used their constructions of this event to forge their own cultural identities and identity politics. That their responses to this event were articulated with identity work and identity politics was not at all surprising to us given the plethora of research on media effects and the identity functions of cultural icons (e.g., Lewis, 1992; McCarthy, Hudak, Miklaucic, and Saukko, 1999). However, the idea that collective remembering figured so prominently in this process did surprise us. Almost as soon as the first news reports of Tupac's shooting were aired, our adolescent participants began to deny that Tupac had actually been killed, and they generated all manner of stories to account for what had actually happened to him, where he was "hiding," what he was doing, and why. These stories prompted a host of questions for us. Why, for example, the preponderance of these particular kinds of stories? Why did these adolescents have such absolute faith in the veracity of their constructed accounts? Why did they dismiss competing stories out of hand? As we thought about these questions, plausible answers seemed to lie neither in the facts of the events around which they were spun nor in the thoughts and feelings of our participants as individuals. Rather, they seemed to lie in these young

people's participation in and construction within the collective remembering of African-American people and the stories that embody this process and dynamically produce and reproduce collective remembering across generations. In other words, our participants' stories were produced within a cultural logic of remembering and commemorating that is rooted in and sustained by stories told both within and across generations. Chief among these stories were those of the "Shine" or "Stackolee" figures (as well their contemporary incarnations in various "gangsta" rappers). These stories feature virtually invulnerable culture heroes who both embody and stand for the liberatory and transformative possibilities of a marginalized people in a violently racialized society. These figures represent particular tokens of a more generalized narrative form that we have come to call the "invincible-hero-who-prevails-against-insurmountable-odds," which has circulated within African-American culture for countless generations. Not quite as important, but also salient within the stories our adolescents told to make sense of Tupac's murder, were stories of salvation. Although these stories mostly focused on heaven as a "scene" rather than on "agents" or "agency" of salvation, they vaguely indexed Jesus Christ and linked this figure to Tupac's salvation.

The remainder of the chapter is organized in the following way. First, we briefly describe the processes of collective remembering and narrative mediation. Next we provide a short history of hip-hop culture and rap music, drawing attention to the ways in which they are constitutively connected to the broader histories and the cultural tropes of African-American people. Following this history, we introduce, describe, and share key findings from an ethnographically informed study that we conducted with a group of African-American children and adolescents that focused on their understanding of and investments in vernacular culture. We conclude the chapter with a summary of our key findings and with some implications of our work for continuing to understand and theorize the relations among collective remembering, narrative mediation, and the socio-cultural-political identities of individuals and groups.

Relevant Theory and History

Collective Remembering and Narrative Mediation

Like many human activities, remembering, commemorating, and memorializing are constructive and reconstructive activities that occur at the intersection of cultural resources and individual agency (Bartlett, 1932; Bruner, 1986; Hutchins, 1995; Lave and Wenger, 1993; Neisser, 1967; Vygotsky, 1978; Wertsch, 1991, 1998). Chief among the cultural resources involved is collective remembering. Collective remembering is a dynamic social process that is always distributed and continual-

ly negotiated and contested. Collective memories are produced within the ongo-ing activity of particular socialcultural collectives, and they function primarily to construct a "usable past" for those collectives that lend coherence and legitimacy to their identities and commitments (e.g., Zamora, 1998). In this regard, Bodnar (1992) discussed the usable past function of collective remembering under the rubric of "public memory." Public memory is a body of beliefs and ideas about the past that help a public or society understand its past, present, and by implication, its future. As such, collective remembering is "interested," in Habermas's (1968) sense of this term. "Collective memory simplifies; sees events from a single, com-mitted perspective; is impatient with ambiguities of any kind; reduces events to mythic archetypes" (Novick, 1999, pp. 3–4). It is "an integrated dictatorial mem-ory—unself-conscious . . . a memory without a past that ceaselessly reinvents tra-dition, linking the history of its ancestors to an undifferentiated time of heroes, origins, and myth" (Nora, 1989, p. 8). Once established, collective remembering "comes to define [an] eternal truth, and along with it, an eternal identity, for the members of that group" (Novick, 1999, p. 4). As a key force of identity politics, collective remembering incites intense emotional investments that are funda-mentally tied up with who we are as classed, raced, and gendered beings. Importantly for our purposes here, the intensity of these investments reaches a peak in a generation's adolescent and early adulthood years. Thus, reconstructions of events that occur during this time are particularly powerful in determining the form and content of a generation's collective memory and thus the moral and political sensibilities of its members for the rest of their lives (Conway, 1997; Schuman and Scott, 1989). Finally, collective remembering is a tacit or a "transparent" cultural process, which makes it seem incontrovertibly "real." Because they seem so real, collective memories are particularly powerful and pervasive forces in the media-tion of cultural knowledges and identities.

Narratives (especially cultural narratives) are centrally involved in the creation and perpetuation of remembering, especially collective remembering. This seems to be the case largely because of the unique functions of narratives, which include (a) mediating between ordinary (canonical) and exceptional (non-canonical) ideas and events, (b) affirming or validating moral or ethical imperatives, (c) reg-ulating affect, and (d) constructing and maintaining coherent social and cultural identities. Because narratives are organized around the dimension of time in lived experience (e.g., Bruner, 1986, 1990; MacIntyre, 1981; Witherall and Noddings, 1991), they allow groups of people to interpret their pasts, envision their futures, and understand the lives of others with whom they interact. Narratives also func-tion within cultures to give relative cohesion and legitimacy to beliefs, values, expectations, and practices. Because narratives engage people in the exploration of human possibilities rather than in stated certainties, they provide "map[s] of pos-

sible roles and possible worlds in which action, thought, and self determination are permissible or desirable" (Bruner, 1986, p. 66).

Narratives are also resources for moral and ethical contemplation and action. The mere fact that events are rendered in narrative form (as opposed, for example, to some categorical form) means that they must be interpreted in terms of struggle (usually moral struggle) that ends in success or failure. Thus, stories "permit us not only to judge the moral significance of human projects, they also provide the means by which to judge them, even while we pretend to be merely describing them" (White, 1981, p. 253).

Narratives also function to regulate affect. According to Bartlett (1932), rendering remembered events as coherent narratives creates "sympathetic weather," a sense that all is right in the world. Rosaldo's (1989) findings about how narratives of headhunting (and later narratives of Christianity) function as ways to mitigate the rage associated with grief over the loss of a loved one are also instructive here.

Finally, narratives bind individuals and cultures because they are always articulated to and index wider social and cultural ideologies and practices. Our understanding of society is thus a function of the repertoire of cultural stories we have read, heard, and inherited. These stories constitute the "dramatic resources" that we use to construct our identities, our tastes, and our motivations. Without such stories, we remain "unscripted, anxious stutterers in our actions as in our words" (MacIntyre, 1981, p. 201). Conversely, "there is no way to give us an understanding of any society . . . except through the stock of stories which constitutes its . . . dramatic resources" (MacIntyre, 1981, p. 216).

If remembering, commemorating, and memorializing are mediated largely by collective remembering, and if collective remembering is mediated largely by cultural narratives, then any analysis of these co-constitutive activities has to attend closely to the texts and voices of the past that inhabit current constructions of remembered events. These texts and voices are quite likely to constitute internally persuasive discourses (e.g., Bakhtin, 1981) that function to render particular events and the world at large from an "interested" or a "committed" perspective (e.g., Habermas, 1968). Once linked to collective remembering, remembered events both provide groups of people with resources for their identity work and galvanize the identity politics of the group(s) to which they belong.

Historical Traditions, Rap Music, and Cultural Icons

Cultural icons are open to multiple interpretations, retellings, and performances. To understand the meanings and practices that develop around such icons, we need to interrogate the larger discourses in which they are embedded. It is thus impor-

tant to situate rap music within broader discursive/cultural formations. In the decade of the 1990s, rap music was driven, in large measure, by individual rappers, with often clearly explicated personal biographies that informed much of their music and videos. Master P (from the South), Biggie Smalls (from the East), and most especially Tupac Shakur (associated with West coast rap) are exemplars of this trend. Additionally, rap music developed from being largely spectacle-driven to largely narrative-driven. Hip-hop began as a largely party-oriented musical formation, almost entirely dependent on face-to-face action and interaction. The musical event itself was more important than any particular verbal or vocal text that might occur in it and later be lifted out for reproduction and marketing. Loose collectives such as the Sugarhill Gang and the Furious Five traded verses in live interactive settings, all with the primary goal of getting live crowds involved in an unfolding event.

As rap grew in popularity, the individual icon and the self-contained narrative text became increasingly important. The first such figure or character type was the "gangsta." In large measure, the gangsta was a larger-than-life character or figure whose exploits existed at the surface of exaggerated violence and brutality. These gangstas became the most visible and important part of hip-hop culture during the late eighties as rap became wildly successful in recorded commodity form. Importantly for our understanding of how Tupac Shakur was remembered and commemorated is the fact that the gangsta grows out of and is implicated in an African-American tradition with a long history—that of the figure of Shine or Stackolee. Folklorists Abrahams (1970) and Jackson (1974) have both documented the ways this character or archetype was—and has remained—historically salient for this beleaguered population. Stackolee probably reached its most popular manifestation in 1958 with Lloyd Price's hit "Stagger Lee." However, as Marcus notes (1975), a bluesman named Mississippi John Hurt recorded a version, "Stack O'Lee Blues," as early as 1929 (p. 66). All of these are variations on a single story, the conflict between Stackolee and Billy Lyons and the murder of the latter by the former. As Marcus (1975) so eloquently wrote:

> Somewhere, sometime, a murder took place: a man called Stack-a-lee—or Stacker Lee, Stagolee, or Staggerlee—shot a man called Billy Lyons—or Billy the Lion, or Billy the Liar. It is a story that black America has never tired of hearing and never stopped living out, like whites with their Westerns. Locked in the images of a thousand versions of the tale is an archetype that speaks to fantasies of casual violence and violent sex, lust and hatred, ease and mastery, a fantasy of style and steppin' high. At a deeper level, it is a fantasy of no-limits for a people who live within a labyrinth of limits every day of their lives, and who can transgress them only among themselves. (p. 66)

The gangsta rapper who emerged as a cultural force in the mid-to-late 1980s is a modern-day version of this cultural figure. During the early-to-mid 1990s, more

personal and more complex portraits of this figure began to emerge. Most importantly, rappers like The Geto Boys, Biggie Smalls, and Tupac Shakur psychologized the gangsta type, adorning their stories with disturbing personal and psychological insights. The goal was no longer only to present a violent snapshot of gangsta life, but to help us understand what was happening inside the figure of the hero. Biggie Smalls (or The Notorious B.I.G.), for example, framed his debut album *Ready to Die* (1994) as an aural/musical biography, beginning with his birth and ending with his suicide. Smalls thus used his biography to contextualize his music, blurring the line between the personal and the public, between information and entertainment. This album was not only intended to get dance crowds dancing (as in early hip-hop), or to relate violent exploits (as in gangsta rap), but also to give us a peek into Biggie Smalls's psyche—his motivations, desires, and feelings as explicated in deeply psychological narratives.

Tupac Shakur is another prime example of the psychologized gangsta. His biography became a crucial part of his public image, and the details of his life, which were talked about on record and off, have become almost legendary. In a key example, the song "Dear Mama" (Shakur, 1995) chronicles his early life in explicit detail including his lack of a father, his reliance on his mother, her use of crack cocaine, and his turn toward crime. Again, Tupac went beyond a two-dimensional sketch of his life to present a complex, deeply structured, and highly textured portrait of it. In weaving together the narrative of his mother and her struggles, he simultaneously constructed an "account" that functioned to justify or explain the choices he made in his life (Buttny, 1993).

Tupac's self-revelations often positioned him at the nexus of complex and seemingly conflicting social forces. In fact, the personal narrative of "Dear Mama" was made all the more poignant by the widely known fact that Shakur's mother, Afeni Shakur, was a famous Black Panther, one of the famed Panther 21 who were arrested for allegedly attempting to orchestrate a series of bombings in New York City. According to popular accounts, Tupac inherited much of his mother's militant black-power perspective. These accounts emphasized, for example, the fact that he had a black panther tattooed on his arm and that a number of his songs depicted or celebrated the historical struggles of all African-American people (e.g., "White Man'z World" [Shakur, 1996c] and "Keep Ya Head Up" [Shakur, 1993]). To a large extent, then, Tupac was heralded as a contemporary bearer of 1960s-inspired Black Nationalist attitudes and sentiments—attitudes and sentiments central to the "invincible-hero-who-prevails-against-insurmountable-odds" formula.

Yet Tupac was as much gangsta as revolutionary—a tension inherent in most of the Shine and Stackolee stories. In this regard, Marcus (1975) reminded us that famed Black Panther Bobby Seale named his son after Stackolee, the image being a central one for the organization as a whole (p. 66). Indeed, the Panthers fought,

and ultimately lost, the battle to channel the outlaw energies of Stackolee into a productive political agenda, a point Marcus makes as well.

Tupac, the son of Black Panther Afeni Shakur and godson of recently freed Panther, Geranium Pratt, was this same figure fighting the same battle. For example, he was involved in a number of shootings (including one with two off-duty police officers); he was sentenced for up to four and a half years in prison for sexual abuse; he was almost fatally injured in an assassination attempt and robbery; and ultimately he was murdered in a drive-by shooting. Much of his music reflects this gangsta lifestyle, as evidenced, most especially, on *All Eyes on Me* (Shakur, 1996a) (see, for example, "2 of Americaz Most Wanted" and "Can't C Me"). Additionally, many interviews and news stories on Tupac have stressed his complex and divided soul, pointing out how his internal struggles between "good" (fighting for Black rights while detailing his inner life) and "evil" (his uncritical gangsta posturing) were central to his music, which, again, ran the gamut from the radically "positive" to the wildly "negative." *Rap Pages*, for example, subtitled their December 1996 tribute to Tupac "Exploring the Many Sides of Tupac Shakur," which included a feature article entitled "Loving Tupac: The Life and Death of a Complicated Man."

Many rappers, such as Biggie Smalls and Tupac, have become near-mythic public figures whose personal struggles were and are an integral part of their music and whose exploits maintained and extended the Shine and Stackolee narrative tradition. These facts were set into high relief in the feud that erupted between Tupac (and his record label, Death Row Records) and Biggie Smalls (and his label, Bad Boy Records). The history of this feud is complex. According to Tupac, he and Biggie had been friends early on in their careers. In 1994, however, Tupac was ambushed and shot while heading to a recording studio to meet Smalls. He was shot five times but survived. Although the shooting was never solved, Tupac publicly accused Biggie Smalls of organizing the attack. A number of seemingly related incidents and popularly disseminated accounts followed. A friend of Suge Knight (head of Death Row Records) was killed at a party, and Knight blamed Puff Daddy (head of Bad Boy Records) for the murder. An entourage of members from Death Row Records, brandishing guns, threatened Biggie Smalls at an industry awards party. Finally, Suge Knight, reputedly associated with the L.A.-based gang the Bloods, was rumored to have threatened Puff Daddy's life.

These real-life events overlap and blur into events chronicled on a number of recorded singles released by these two artists. Biggie Smalls, for example, released the caustic "Who Shot Ya?" (The Notorious B. I. G., 1995) as a b-side to the hit "Big Poppa." This single plays off the phrase "who shot ya?" presumably alluding to Tupac's earlier and apparently unsolved shooting. Thus, Tupac is the private audience targeted by this ostensibly public message. Lines such as "Cash rules every-

thing around me, two Glock 9s for any motherfucker whispering about mines" abound in this song, along with various threats and boasts by Biggie and Puff Daddy (e.g., "Didn't I tell you not to fuck with me! . . . Can't talk with a gun in your mouth?").

Tupac, in turn, released his scalding "Hit 'Em Up" (Shakur, 1996d) in which he viciously attacked both Smalls and Junior Mafia (Smalls's protégés). This song explores, in explicit detail, the personal falling out between Tupac and Biggie. Tupac begins the song by saying, "That's why I fucked your bitch, you fat mother-fucker," an allusion to the rumor that he slept with Biggie's wife, R&B singer Faith Evans. Faith has denied the claim but it gained factual status within the pop-ular imagination. Tupac went on, during the course of this song, to threaten Biggie, Junior Mafia, and all of Bad Boy Records with attacks grounded in their personal histories. At one point, Tupac rapped about their early friendship, "Biggie, remem-ber when I used to let you sleep on the couch?" And later, he chronicled its demise, "Now it's all about Versace? You copy my style/Five shots couldn't drop me/I took it and smiled" (Shakur, 1996b). According to Tupac, Smalls returned his friendship by trying to imitate Tupac's musical style (which revolved around the expensive tastes of the "playa" lifestyle, as evinced in the reference to Versace), and eventually orchestrating his attempted assassination.

This particular conflict demonstrates how the distinctions between what hap-pens in the real life of artists, what gets memorialized through their lyrics and through media coverage of them, and what gets remembered both by individuals and collectives are very blurry indeed. This blurriness is in no small measure relat-ed to the tendency within the rap music industry in the 1990s to foreground the inner lives, experiences, and conflicts of its artists—artists who were portrayed as mythic figures with complexly explicated biographies. Importantly, the mythic dimensions of such portrayals have also been central to the construction of the African-American hero (e.g., Shine and Stackolee) for many generations. Thus, the "openness" of Tupac-as-icon is, at least in part, a sedimented element of the col-lective remembering of the race.

An Empirical Study of Collectively Remembering Tupac

Context, Participants, and Nature of the Study

The site for the study that inspired this chapter was a neighborhood community center in a small midwestern city.[1] The center serves over 300 economically mar-ginalized and mostly African-American children and adolescents. After becoming familiar with the center, its goals, and its participants, we developed and ran week-ly discussion groups that focused on African-American vernacular culture, espe-

cially hip-hop and rap music. Although group composition and group size varied over time, we usually ran two discussion groups each week: one for children (ages 10–12) and another for adolescents (ages 13–17). In any given week, three to ten participants usually participated in each group. The younger group typically attracted larger numbers of participants than the older group. The younger group was usually composed of more boys than girls, while the gender balance was more even in the older group. Depending on the nature of discussions, we sometimes collapsed the two groups into one.

In these groups, we discussed many aspects of African-American vernacular culture, but the topics that commanded the most attention were usually popular songs, music videos, and recording artists. Intentionally, we tried to "lead" the discussions in ways that kept them dialogic and conversational. Sometimes we initiated discussions with prompts (e.g., copies of song lyrics). Sometimes they were initiated and guided by the desires, interests, and enthusiasm of our participants. We usually began the discussion groups by asking participants to talk about the meanings and relevance of particular cultural artifacts. Invariably, these discussions evolved to include links to key events in participants' daily lives, family and community histories, and local politics.

As time went on, we also conducted individual interviews with some participants. These interviews were designed to elicit life history information that was less likely to surface "naturally" in the more public context of discussion groups, as well as to "fill in" our understandings of issues and events that had not been explored thoroughly in the groups. Like the group discussions, these individual interviews were explicitly nondirective and conversational.

Finally, in addition to leading these discussion groups and conducting individual interviews, Greg went on to occupy many different roles at the community center. In addition to conducting research, he became a volunteer staff member responsible for a range of activities including answering the phones and monitoring the main game room. He occupied this role for almost three years. During one summer, he was also hired as a regular staff member responsible for developing and running educational and recreational programs for children in three different age groups. Greg also played a key role in developing and opening a teen center within the larger community center and for developing and running activities within it. His multiple and shifting positions within the center afforded him invaluable insights about the center itself, the community it serves, and the children and adolescents in the particular programs he ran.

The particular discussions from which most of the data for this chapter were drawn occurred following the shooting of Tupac Shakur, and they involved participants from both our child and adolescent groups. These discussions began almost as soon as the first news report broke announcing that Tupac had been shot out-

side a Las Vegas nightclub. They were initiated not by us but by our young partic-
ipants, who were all but obsessed with the news. We continued to discuss Tupac
almost exclusively for most of the next two months. Toward the end of this time,
we suggested working on a writing project together, perhaps a tribute to Shakur.
We elicited or suggested a number of different kinds of texts that the members of
the groups might write, including biographies, music reviews, movie reviews, per-
sonal reflections, and essays. We encouraged participants to use tape recorders as
they generated ideas for their texts (either alone or in small groups). Their record-
ings functioned both as data for us and as props for subsequent texts and perfor-
mances that the children created or planned to create.

Tupac in/for the Everyday Lives of Young People

As we have already noted, Tupac embodied the Shine or Stackolee tradition. He
was an invincible outlaw who settled his problems swiftly and violently, providing
feelings of physical invulnerability to an often intensely vulnerable population. Yet,
more than most such figures, Tupac was also a radically personalized version of this
invulnerable figure ("the Shine next door," if you will). In this regard, and draw-
ing on the work of Fairclough (1995), Tupac seems to have been constructed (and
constructed himself) at the intersection of a historical narrative tradition and the
contemporary tendency toward the conversationalization and psychologization
of public discourse. This kind of public discourse is extremely common in all
media but especially in tabloids, television news magazines, and radio and televi-
sion talk shows, and it has several defining characteristics that are particularly
important for our arguments here. Conversationalized and psychologized public dis-
course utilizes informal rather than formal language registers, including highly
affective language and idioms from popular culture. It blurs the line between infor-
mation and entertainment. It also blurs the distinction between the public and pri-
vate, rendering previously inaccessible people (movie stars, royalty) as "nice,"
"common," "down to earth" and bringing previously forbidden topics (sex, person-
al finances) into the forefront of discussions. And it recasts social and political issues
and their causes in terms of individual agency and everyday social practices.

The dual construction of Tupac at the intersection of traditional invulnerabil-
ity narratives and vulnerability narratives born of conversationalized and psychol-
ogized public discourse seems to be a key reason why his music reached
unprecedented sales heights and why he spoke to an entire generation of young peo-
ple in unprecedented and unique ways. In fact, this dual or hybrid construction
spawned an almost constant flow of public debate and discussion both before and
after his death. And his music, which drew on the complex details of his life, was
valued in almost unparalleled ways. Indeed, Tupac was viewed both publicly and

in the personal lives of many people (including the adolescents with whom we were working at the time of his apparent murder) as "the coldest" of all rappers, a person who could stand up "against all odds" but whose inner emotional life was also touchingly accessible to all. In short, Tupac was "read" as a conversationalized and psychologized embodiment of the "invincible-hero-who-prevails-against-insurmountable-odds." This social fact was abundantly evident in the remembering and memorializing activity of our adolescent participants as they talked and wrote about Tupac in the weeks and months after the news of his shooting aired. A few examples of their manifold and complex reactions to this news will suffice to support this claim.

Early on in our work with these young people, one of our "projects" was to construct a newsletter documenting our favorite artists from the past and present. Many chose to write about Tupac, who was still alive at the time. One young man wrote that Tupac "has been through things we have been through." In a similar vein, another noted Tupac's constant harassment by the police, stressing the ways he himself had been harassed:

> what strike me [about Tupac's music] is really the way the police be harassin' him 'cause I be gettin' harassed the same way. It's like most of the stuff he be talkin' about . . . that's how I be feeling. (Field Notes, 1996, March 18)

Taking a slightly different approach, one young woman eloquently wrote:

> Tupac is an inspiration to me because he talks about everything that happens in the real world. The stuff he be talking about—his momma and how she was a drug addict but how she still loves him and tries to do what she can for him and how he still loves her because his momma loves him a lot even though she was in jail and his grandma took care of him. And his father was never there for him. (Field Notes, 1996, March 25)

This wide range of responses reflects the complex and multiple character of Tupac as a public icon. Tupac was a complex figure who appealed to different young people in different ways—from his bold confrontations with the police to his tender relationship with his mother. Indeed, Tupac's life story and his music intermingled with the everyday lives of many different young people with a broad range of day-to-day concerns. Young people who had experienced personal confrontations with the police, for example, were well aware that such experiences had been common among Black Americans for generations, and it angered them. This anger was also expressed in Tupac's music, which is one reason why it resonated so powerfully among young Black people: "Like when he's talkin' about the police harassin' him all the time? . . . Every time the police see me, they got something to say to me, about my daddy, and my brothers . . . tellin' me I sell dope and all this" (Field Notes, 1996, March 18). This young man's feelings toward the police and his gen-

eral philosophy of life seem clearly grounded in the collective memory of African Americans, the emergence of invulnerability narratives, and a kind of grim resignation to death in response to generations of racial exploitation and abuse. In relation to this last point, one young man extemporaneously produced an unusually eloquent soliloquy that embodied his "philosophy of life" and that stopped one of our focus group discussions in its tracks:

> To live in fear is not to live at all. You can't run from every damn thing all the time. You might as well not even live. It's like you dead anyway, you keep thinking motherfuckers gonna kill you. I ain't trying to say make yourself die, [but] don't worry when it comes to you 'cause it's gonna happen anyway. We live to die. You know what I'm saying? That's one thing we know for sure. Like, like you say you're gonna go to college when you get older? You might not make it to older. Like you say, I finna go down to the gas station and get some squares? I might not make it to the gas station. But I know I'ma die. I know I'ma die. We live to die. (Field Notes, 1996, March 18)

This young man's philosophy echoed themes from Tupac's music: "Don't fear no man but God. . . . Just like Pac said . . . he talk a lot about not fearing death." Tupac's songs, it seems, provided young people like this one with a certain kind of "equipment for living" (Burke, 1957), a set of discursive strategies for confronting and coping with the specific exigencies of day-to-day life in their community.

Again, Tupac's life story and his music—his confrontations with the police and his seeming resignation to his own death (as evidenced by songs such as "Only God Can Judge Me" and "If I Die 2 Nite")—gave voice to the everyday reality faced by many young people with whom we worked. As another young man who also had a history of trouble with the police commented, "I like Tupac because I like the way he expresses his feelings, and he's a role model for us thugs." When asked what he meant by "thug," he responded, "A thug is a person who don't like them crooked ass cops, and make money the best way he can, and a person with a strong mind" (Field Notes, 1996, March 18).

Other dimensions of Tupac's life appealed to these young people in other ways. For example, Tupac's life history, including the valorization of his mother, registered in profound ways for many adolescents living in single-parent households. As one young woman put it:

> Tupac's life is kinda like mine, except I ain't never been in jail, because my momma been the only one there for me. I really don't know my daddy so I'm havin' mix feelings about him. Sometimes I feel like I hate him and other times I really love what we did when we was together. (Field Notes, 1996, March 25)

Tupac's anxieties about his mother and his father (about whom he once commented "the coward wasn't there for me") clearly affected and resonated within the experience of this young woman. In addition to his vitriolic attacks on other rappers

and his defiance of the police, Tupac was capable of expressing great respect and tenderness to and for women, including, and perhaps most notably, his mother. This was an important theme for many of our young participants who were raised by single, struggling mothers and who were deeply devoted to them. Speaking about her male friends, for example, one young woman commented, "Even though they be trying to talk hard and stuff, they still got respect and much love for they mama." In addition, Tupac recorded a number of odes to women, including "Keep Ya Head Up" (Shakur, 1993) and "Just Like Daddy" (Shakur, 1996c), songs that addressed many of the specific concerns of young people in relationships today. For example, this same young woman said that she liked the song "Just Like Daddy," which contains the line, "You never had a father or a family, but I'll be there, no need to fear so much insanity." She noted:

> That's like true, 'cause that happen to a lot of girls, they like don't have a father at home, so they look for like a boyfriend or whatever, find that father figure, have a father role model in they life. And that happen a lot of time, but he still giving her respect . . . he ain't just saying 'yeah you ain't got no daddy, I'ma be your man.' He saying even though you didn't have a father, I understand. (Field Notes, 1996, March 25)

To summarize much of what we have said in this section, Tupac appealed to young people in many different ways. In fact, much of his appeal seemed related to his multiplicity and even the contradictions in his persona. For example, the two songs that resonated most powerfully with young people—"Dear Mama" (Shakur, 1995) and "Hit 'Em Up" (Shakur, 1996d)—could hardly be more different from each other. The range of his music seemed to map onto the range of their experiences and desires from their positioning within institutionalized racism, to the sense of invulnerability embodied in the Shine and Stackolee tradition, to their personal experiences of poverty and crime, to their experiences in female-headed, single-parent households, to their fractured yet robust emotional lives, to their dreams of a better life for themselves and their loved ones. In connecting with Tupac's life and his songs, they connected with and refracted their experiences through the collective remembering of African-American people. In doing so, their practiced lives were far from representations of them in mainstream narratives that often construct African Americans as monolithically violent, aberrant, nihilistic, opportunistic, and pathological.

Remembering Tupac

When the news broke that Tupac had been shot, our young participants responded with unabashed disbelief and immediately began producing narratives to account for the event, many of which negated the fact that Tupac was actually dead. These

stories were born of internally persuasive discourses, and as such they were open to dialogue and mediation between and among participants. They functioned to memorialize Tupac as a cultural icon connected to a long history of cultural icons, all of whom—some more proximally, others more distally—mediated their understandings of Tupac's apparent fate, the world, and their own identities as African-American youth.

As we noted earlier, Tupac had taken on an aura of invincibility previous to this tragic event. He was shot five times two years earlier and he survived, even leaving the hospital against doctor's orders to attend his upcoming criminal trial. At the scene of the first shooting, he was photographed being lifted on to an ambulance and giving his middle finger to a police officer, the ultimate act of defiance and a gesture most clearly in line with the imperatives of the figure of Shine and Stackolee. He was widely photographed years later, bearing the scars of this shooting, and even bragging about surviving it in a song: "Five shots couldn't drop me, I took it and smiled" (Shakur, 1996b). This image—so deeply enmeshed in the myths of invulnerability that are part of the African-American tradition—has become part of the public imagination within and beyond the world of hip-hop aficionados.

It was no wonder, then, that when Tupac was shot a second time, many people expected him to survive. He was in the hospital for five days, and the medical reports were apparently positive up to the moment of his death. When the first reports of his death broke, they were met with shock and anger. Reports of panic by Tupac's associates at the hospital were widespread, and members of the Death Row entourage reportedly accosted doctors asking why they had "let" Tupac die.

Closer to home, when the news of Tupac's death was announced, Greg was watching Black Entertainment Television (BET) at the community center where we conducted our research. One young person watching the newsflash angrily punched the air and left the room. Soon afterward, a large number of young people of all ages congregated around the television set, uncharacteristically quiet, listening to the reports. Some very young children were crying. Greg distinctly remembers one young girl—perhaps seven or eight years old—coming up to him teary-eyed, asking, "Is Tupac dead?" He told her that he was not sure. In truth, none of us were sure what to believe.

Shock was generally the first reaction to the announcement of Tupac's death, and it inspired many stories about how much Tupac meant to our participants. Although stories generated to mitigate shock persisted as a fundamental response to this event well after the first reports of Tupac's death, other kinds of stories emerged as well. Some of these stories seemed like attempts to explain the event by attributing blame to Tupac's rivals, particularly Biggie Smalls. Other stories

affirmed that Tupac was still alive. These stories circulated not only among our participants, but also across the nation and the world. In mentioning these various types of stories, we do not mean to imply some sort of a linear progression of our participants' emotional responses to Tupac's death—from shock to anger to denial—assuming lock-step phases that precede or succeed others. Rather, we want to explore how different explanatory frameworks emerged and how they jockeyed with each other for salience and believability in the months that followed the announcement of Tupac's death. Following Fairclough (1995) and others, the competition between explanatory frameworks indexes broader cultural tensions and struggles. For our purposes here, these tensions and struggles have serious consequences for collective remembering of African-American people, especially with respect to the kind of usable past that might emerge from them.

The "facts" that were called on to support the various stories used to explain Tupac's apparent murder were culled from an explosion of available information—details from the crime scene and its aftermath as well as verses from Tupac's last, almost prophetic albums and videos, which were slowly released by Death Row Records in the months that followed. Tupac's fans were all mobilized by the surplus of stories that claimed Tupac was still alive. Parenthetically and interestingly, when his rival Biggie Smalls was later killed, none of these myths emerged, even though the facts, similarly construed, could have supported such a story. These young people were much less invested in Biggie's life, perhaps because he had much less purchase as a contemporary, psychologized, tenderized Stackolee, as well as his presumed role in Tupac's apparent murder.

So, how Tupac was remembered—including the denial of his death—changed over time and was mediated by a variety of cultural resources including the collective memory of the African-American people. In sharing with us the process of her grieving, one young woman offered what might be considered a microcosm of the various stories that emerged to account for Tupac's apparent death:

> I was over his [her cousin's] house, and I was, um, talking to my girl cousin Jill. And she told me that the night before they had announced that he was dead. I was like, please he can't be dead. I was like, "I can't believe it, Tupac wasn't never supposed to die." I didn't believe that he was dead at first, but then when they said he was dead, it just made me holler and then I was like, okay, I finna see. And so when we was at school, we was readin' magazines, into the week. We was reading magazines about how it had happened and all that stuff, then I was like, how can that be? And they started saying how maybe the police did it and maybe Biggie. All these people were supposed to have did it. And then they was like, uh-huh, that man ain't dead. Tupac ain't dead. He ain't dead. (Field Notes, 1996, November 4)

The many kinds of stories that people generated to explain Tupac's death or non-death were testimony to the intense affective ways in which people invested in Tupac's life and music. They also indexed the traditional beliefs and values

embedded within the culture and collective memory of African-American people. During one conversation, for example, one teen commented:

> I ain't trying to say, like he ain't my god or nothing, but I kinda got faith in him . . . I don't think he gone yet. His music was too good for it to be just over. I ain't crazy, trying to rationalize in my mind. But, I just don't think so. (Field Notes, 1996, November 4)

Thus, these young people "kept" Tupac alive, mobilizing the facts around his death in a variety of highly specific ways.

As we mentioned earlier, another set of stories that emerged in the aftermath of the announcement of Tupac's death focused on assigning blame for the event. The most common person blamed was Biggie Smalls. The very night Tupac was murdered, one young person commented that it must have been over Faith Evans, Biggie's ex-wife. During the first organized discussion group around Tupac's death, there was a lot of talk about Tupac's single "Hit 'Em Up" (Shakur, 1996d) and how it must have angered Biggie enough to want to kill him. The intricate conflict between the two was often foregrounded in such discussions in the weeks following and allowed the young people we worked with a way to understand this conflict in highly personalized terms. As we noted in another article, these young people appropriated the television talk show genre—a quintessential example of conversationalized and psychologized public discourse—to process this event, allowing them to foreground the violent "feelings" that these men had for each other as a result of their personal differences and grievances (Kamberelis and Dimitriadis, 1999). These included, most especially, the rumor that Tupac had slept with Biggie's wife.

As much as our participants focused on Tupac's conflict with Biggie Smalls, the effort to assign blame for his death went far beyond this conflict. During our second discussion after the announcement of his death, for example, one participant noted that Tupac had been registering young black people to vote and that this might have gotten certain white people mad. There was also talk in this discussion about how Tupac had been taken off life support too early, thus assigning blame to his doctors. In the words of one teen, "they wouldn't have done the president like that." Clearly, these young people were trying very hard to make sense out of Tupac's death, often turning from shock and disbelief to honest and engaged attempts to ascertain specific "truths" about his death in order to explain it away.

Importantly, no matter who was blamed for Tupac's death, almost all of the narratives of blame generated by our participants constructed Tupac not so much as an active agent but as a victim of forces beyond his control. In some ways this was quite surprising. Tupac had been constructed as the "invincible-hero-who-prevails-against-insurmountable-odds." In other ways, it made sense. Our young participants

were not strangers to the violence of the street, and many had even witnessed or experienced violent beatings, drive-by shootings, and murders. These facts notwith-standing, however, Tupac's "agency" was restored over time as accounts of invul-nerability began to supplant accounts of victimization. And to restore his agency, our participants deployed some very interesting discursive tactics. Some people, for example, argued that Tupac was omniscient and knew about his death beforehand. Evidence for this position often came from videos such as "I Ain't Mad at Cha," a visual narrative that portrays Tupac being shot and killed and going to heaven and meeting other famous black singers and entertainers including Billie Holiday, Jimi Hendrix, and Sammy Davis Jr. In one of the clearest examples of restoring agency through an omniscience/resurrection/salvation argument, one of our participants noted—quite accurately—that Tupac left his house that night without a bulletproof vest. Although interviews with Tupac's fiancée revealed that the decision not to wear the vest had to do with the scorching Las Vegas heat, this young person was not convinced and insisted that Tupac knew he was going to die. To lend veraci-ty to his account, this young person also noted (or imagined) that right after he was shot, Tupac leaned back and spread his arms as if he were on a crucifix and said "death's come to Tupac." This image indexes a curious kind of agency, one that posi-tions Tupac as a knowing agent in his own death, someone who, like Jesus Christ, willingly sacrificed himself. Importantly here, Jesus Christ figures in general, the resurrection, and the reward of salvation in the afterlife for the pain and suffering endured in this life are every bit as much a part of the collective remembering (and the oral and written literature) of the African-American people as the invulnera-ble hero myths are.

Evidence to support the Christian subtext of these kinds of stories was not hard to find—the posthumously released album entitled *The Don Killuminati: The 7 Day Theory* (Shakur, 1996c) for example. While in prison, Tupac read *The Prince* by the Italian philosopher/strategist N. Machiavelli and, upon his release, decided to record an album under the pseudonym. The album liner notes read "Exit—2Pac/Enter—Makaveli" and the cover features, most notably, a drawing of Tupac nailed to a cross. This image (and other religious images and texts) functioned as mediational tools used by some people to regulate their affect and to restore agency to Tupac by constructing omniscience/resurrection/salvation stories to account for his death. However, such strategies and claims were not above reproach. As anoth-er teen in the discussion responded (quite logically), "Man, stupid, if he know he was gonna die, he woulda worn his vest!" Indeed, tensions such as this one, which revolved around reason/history versus faith/collective memory, were common and never completely went away in the month's following Tupac's death. As we noted earlier, such tensions are central to negotiation and contestation involved in the historical production of collective memory, and the ways in which such tensions

are resolved determine the kinds of mediation tools that are available for any given generation.

Intermediary between narratives of omniscience/resurrection/ salvation and narratives of absolute cunning and invulnerability were narratives that claimed that Tupac had actually been shot, escaped from the hospital, faked his death, and was caught. One young person, for example, said:

> I think Tupac got set up. They shot him but he survived. But then nobody knew he survived, 'cause I think he probably, say like during the night he, he had snuck out . . . he, he had started feeling better and snuck out. (Field Notes, 1996, November 18)

He continued, noting how Tupac had been caught and was now in jail, "They got him on some top security. They know Tupac's smart. He can deal some schemes, try to get out and stuff, but they got him on top security." Like the omniscience/resurrection/salvation accounts, these kinds of accounts stressed Tupac's agency, albeit mitigated by the idea that he was caught and now in jail, in effect beaten by a system he fought, in one way or another, his whole life. This diminished agency was viewed as temporary, however, because Tupac was smart and would "deal some schemes" to get out.

While many young people offered evidence to back up their claims (e.g., new films, videos, and recordings), others relied more clearly on circular reasoning, informed by something like blind faith. Many young people simply said "Tupac's not dead" when the subject came up without offering more evidence. A typical response was "Tupac ain't dead because I just know." During one discussion, when an older teen said she thought Tupac was dead, a younger person covered his ears. When she said she was going to leave the room if he did not stop, he responded, "Leave, 'cause you talk too much that Tupac dead." Perhaps because Tupac was so central to the individual and collective imaginations of his fans, stories based in faith/collective memory often won out over stories based in reason/history. In this regard, when we watched a video detailing the disarray of Tupac's estate and the problems his mother was having, a very young child in the group said "Man, that was stupid. But I ain't worrying about it 'cause Tupac ain't dead."

Although various stories of shock and blame continued to circulate among our participants (and among people throughout the nation and the world), the stories that rendered Tupac as still alive became most salient. And it is these stories that are most important for our purposes in this chapter. The primary way in which Tupac was "remembered" was as the cunning and "invincible-hero-who-prevails-against-insurmountable-odds." He was, quite simply, too good, too smart, and too tough to get caught. He must be hiding out somewhere, living the good life. Not only did Tupac know he was going to die (at least publicly), but he planned the attempted murder and, in fact, faked it. Why would he simply let himself die?

Something more had to be going on here. The reasons offered for these kinds of accounts ranged from the idea that he was going to orchestrate a surprise attack on Biggie Smalls to the idea that he was evading the IRS. Rumors soon circulated that Tupac had paid a doctor a large amount of money to help him in this scheme and that Tupac was now hiding out in the Bahamas, Cuba, or Africa. Alternatively, some people suggested that he was caught and was now in jail.

It is thus no wonder that so many young people constructed all manner of stories to "prove" that Tupac was still alive. Not only did he embody key invulnerability narratives of the collective remembering of the African-American people, he also reached out to (and reached) everyday African Americans everywhere. Additionally, the fact that Death Row Records continued to release Tupac's work after his death helped fuel stories that he had orchestrated his apparent death and that he was still alive, which indeed were packed with posthumously released material. Tupac reportedly left behind several hundred unreleased tracks, both alone and with other rappers including his "crew," the Outlawz. Several of these have been released on albums (e.g., *The Don Killuminati: The 7 Day Theory* [Shakur, 1996c] and *Still I Rise* [Shakur and Outlawz, 1999]) and movie soundtracks (e.g., *Gang Related* [Various artists, 1997]). Others have been released in bootleg form (e.g., *Makaveli 2 through* 6).

Tupac also starred in several popular movies and videos, many of which were released after his death and all of which helped fix his place in the lives and hearts of young people. The fact that Tupac was rendered visually is not trivial here. His physical presence was a striking and highly charged part of his public image. As two teenage girls wrote in a collaborative essay: "Tupac is fine. He got a body. He built." He often posed shirtless on stage and on film, showing his taut, muscular physique adorned with tattoos. Yet he did not present himself as simply hyper-masculine. Critics and fans often commented on his eyes, which were called piercing and even doe-like—in fact, family members recall his being picked on as a young person for his (somewhat) girlish facial features. Tupac was a charismatic figure in a music-performance genre increasingly constituted through the visual. Importantly, the visual medium has been inextricably entwined with the emergence of the gangsta rap music genre. Films such as *Menace II Society* (Scott, 1993) and *Juice* (Heyman, Moritz, and Frankfurt, (1992) told narratives similar to the ones featured in gangsta rap and often featured rappers as actors. Thus, the release of videos and movies (e.g., *Gang Related* [Bertolli, Bigelow, Stabler, and Krevoy, 1997]) after Tupac's death made these nascent claims resonate with all the more force because they rendered Tupac's physical presence not only in a way that indexed the invulnerable hero of collective memory but also in a way that was both heart-stopping and strikingly "real."

The role of the visual media in mediating how Tupac was remembered was brought into high relief by one of our young participants. She noted that the

videos for "I Ain't Mad at Cha" (Shakur, 1996b), "To Live and Die in L.A." and "Toss it Up" (Shakur, 1996c) all came out after Tupac's supposed death. She went on to say that she would "let the first one slide [but] ain't no way two more videos can come out." "I Ain't Mad at Cha" is particularly interesting here. As we mentioned earlier, this video portrays Tupac being shot and killed and going to heaven to meet other famous black singers and entertainers. It was released mere days after his death and many young people, quite understandably, commented on the strange coincidence. Many also argued that this video was proof of Tupac's foreknowledge of his death, and thus, they reasoned, his complicity in it. And many presented this video as incontrovertible evidence that he was alive.

In sum, Tupac's music and his image were so affectively charged for young people that any thought of his being dead was simply incongruent and too threatening to their individual and collective identities. They struggled to reconcile what they viewed as fact from what they viewed through the lenses of desire, hope, and collective memory, and fueled by ambiguous representations from the recording and visual media industries. "His music [and by implication, Tupac the man] was too good for it to be just over." Finally, the aural and visual imagery of Tupac that our participants brought to bear in their accounts of his invulnerability and non-death achieved much of their power not simply in their own right but also because they were mediated by the collective remembering of all African-American people, by the conjuring up of a usable past as it is symbolically embodied in the "invincible-hero-who-prevails-against-insurmountable-odds" narrative formula. Stated even more powerfully, remembering Tupac as "still alive" was realized by welding images and tales of Tupac as the tough yet beautiful boy next door who had endured a difficult life but emerged as accessible, tender, and loving onto a generalized narrative form that has been central to collective remembering of African Americans for generations.

Commemorating Tupac

Many of the accounts we have just shared were neither reconcilable with each other nor even internally coherent. However, as Rodman (1996) has argued, myths and mythic formations need not be internally coherent or collectively reconcilable:

> Whatever the facts connected to a specific event might be, it is ultimately their articulation to particular myths—and the subsequent organization of those myths into mythic formations—that renders them culturally significant. . . . A mythological formation . . . is a set of related myths that revolve around a particular point (or points) of articulation. . . . The myths that comprise such a formation won't be mutually compatible; in fact, they may even contradict one another. (p. 31)

Indeed, Tupac became a mythological formation in the month's after his shooting. Believing that he was alive and well was mediated by the "usable past" of the race and its rearticulation by contemporary media forces. These beliefs, embedded as they were in narratives of invulnerability, functioned in ways that many narratives function: (a) to think through and explain complex, multivalent, and difficult to understand events, (b) to reduce tension and conflict and to restore a sense of the canonical, (c) to regulate affect, usually intense negative affect, and (d) to construct/reconstruct individual and collective identities and moralities. That these functions were at work was evident in many conversations we had with our participants. For example, after one young woman explained that Tupac had paid his doctor $200 to fake his death, had been later caught, and was now in jail, we asked her how Tupac and his intimates could keep such a massive series of events a secret from the general population, a standard problem with such conspiracies. The young woman simply sighed, smiled and said, "I know, I know." Yet the stories kept pouring forth, galvanizing Tupac as a mythic formation, as an indelible element of the collective remembering of African Americans.

As we noted earlier, young people ascribed different kinds of agency to Tupac. However, all construed him as a hero in and for their lives, a Shine or Stackolee for their generation. One particular theme that persisted across several discussions will bring this fact into high relief. By and large, Greg knew much more about rap and hip-hop history than all of the discussion group participants combined, and they often asked him for "history lessons" of particular events or figures. During one discussion group that took place about two months after Tupac's death, Greg mentioned something about the first time Tupac had been shot. Some group members did not even know that this had happened and others were unclear about the details. They asked Greg to tell them the story about the first attempt to take Tupac's life. He explained that Tupac was going to a recording studio to record a verse for an artist named Little Shawn and was ambushed inside the building by three gunmen. As the official account goes, Tupac went into shock after the assault and initially didn't realize he had been injured. He took the elevator up to meet his friends (including Biggie and Puffy), all of whom were shocked when they saw him and nearly became hysterical. Tupac, too, started screaming when he realized what had happened. This relatively simple official account of Tupac's first shooting was extremely difficult for our students to hear and it eventually became imbued with many unanticipated and unofficial meanings.

As soon as Greg finished telling the story, group members began expressing surprise and disbelief that Tupac had actually screamed, and they began to revise various aspects of the account. One young person, for example, claimed that if he were in the same position, "I be like, 'what's up y'all?'" indicating that he would have

been considerably more nonchalant about the whole incident. This group member then commented: "The only reason why I think Tupac didn't die when he got shot five times, because he didn't feel it. He didn't feel it. But if he woulda felt it, I think he woulda died" (Field Notes, 1997, April 4). Thus, Tupac going into shock—a medical fact—was recast as his invulnerability to pain. Because he did not feel the pain, he lived. And his screaming was downplayed if not ignored or negated altogether.

Elements of this discussion theme resurfaced one month later. Biggie Smalls had just died, and we were watching an episode of the TV show *Unsolved Mysteries*, which dealt with both of their deaths. The show drew speculative links between the two murders, and it aired an extended version of a Tupac video, "2 of Amerikaz Most Wanted" (Shakur, 1996a), in which Tupac confronts "Piggy" and "Buff" (i.e., Biggie Smalls and Puff Daddy) for setting him up. In this video, Tupac enters what looks like a darkened office, bleeding with his arm in a sling, and he confronts a surprised "Pig" and "Buff" who believe he is already dead. The scene alludes in every way—in the dialogue, in the use of props, etc.—to the 1983 film *Scarface* (Bergman, 1983), when Tony Montana (played by Al Pacino) confronts a mob boss who set him up. The video draws clear parallels between Tupac's real-life shooting and this Hollywood fantasy. However, in the Tupac video, Tupac does not kill "Piggy" but says: "I ain't gonna kill you, Pig. We was once homeboys once, Pig. Once we homeboys, we always homeboys." He then walks away. In *Scarface*, however, Montana says: "I ain't gonna kill you. Manolo [his partner], shoot that piece of shit."

After watching a clip from *2 of Amerikaz Most Wanted*, one young person called out, "He didn't feel it!" He wasn't crying!" Intentionally or not, these claims reach back to the official story of Tupac's first shooting that Greg had shared and negate the facts of this story with evidence from the video version, which portrayed Tupac as stoic and invulnerable, certainly not a person who would scream when shot. Tupac's response in the video is much like the one our young participants imagined for themselves—"I woulda been like, 'what's up y'all?'" The group obsessed over this one scene and all but demanded that we replay it over and over again. Every time we played it, they became mesmerized. Many referred to this scene as "the best part ever." The "ever" here was quite extensive, referring to many documentaries, Hollywood films, music videos, and made-for-TV biographies that we had watched throughout the year. Some of our participants even insisted that the scene was actual footage of Tupac after this failed assassination attempt. And many said that they wished Tupac had actually killed Biggie. In the words of one young person, "If he woulda shot me, I'ma like, 'even though I can't feel it, and it ain't hurt, you tried to kill me!' Pow, pow, pow!" Another said, "That cigarette he had, I would light it up and throw it on the ground . . . Burn 'em up."

Tupac's myth-forming potential was unique among rappers. The same young people who valorized him could not have cared less about the death of Biggie Smalls who was killed some months later. In fact, they did not want to talk about him or his death even when we asked. In this regard, one teen commented: "I don't never want to know about Biggie because I hate him. He shot Tupac." Another young person noted that if Biggie Smalls came to his town "he'd be tore up." Other comments included, "I was like, 'it's about time'" and "I was like 'oh well, he shouldn't of been messing with Tupac.'" One older teen summed up her feelings about Tupac and Biggie as such:

> I'm sorry, I don't know why, I kinda smirked [when I heard Biggie had died]. It wasn't like I was like 'ha ha he's dead' but I was just like, 'hm' . . . I ain't feel like I felt about Tupac. (Field Notes, 1997, April 14)

There are a number of possible reasons why remembering and commemorating Tupac and remembering and commemorating Biggie were mediated by such different sets of cultural resources and in such different ways. For example, these young people did not have the same affective investment in Biggie's life that they had in Tupac's. Importantly, no one ever suggested that Biggie was still alive, as they had done with Tupac and continue to do to this day. Yet Biggie's life and music could have spawned such rumors. For example, his first album was called *Ready to Die* (The Notorious B. I. G., 1994), and he followed it up with *Life After Death* (The Notorious B. I. G., 1997), released posthumously. However, our participants made no efforts to build stories of blame or invulnerability around these strange (and familiar) details. Instead, Biggie's death was accepted as fact. In this regard, one teen noted that "he said he was ready to die!" suggesting "so who cares?" Most likely this same young person would have marshaled a similar set of "facts" quite differently in the case of Tupac to construct a contemporary version of the "invincible-hero-who-prevails-against-insurmountable-odds" narrative so central to the collective memory of African Americans.

Additionally, for whatever reasons, Biggie's life and music did not seem to activate the collective memory of African Americans in the same way that Tupac's did. Nor did Biggie play into the conversationalization and psychologization of public discourse in the same way that Tupac did. He did not detail his life history in the highly emotional and tender ways that Tupac did on songs like "Dear Mama" (Shakur, 1995). Nor did he touch the everyday realities of women in the ways Tupac did in songs like "Keep Ya Head Up" (Shakur, 1993) and "Just Like Daddy" (Shakur, 1996c). Nor did he ever survive a highly publicized assassination attempt and later exclaim, "Five shots couldn't drop me, I took it and smiled." Nor did Biggie play into the deeply religious sensibilities of many African Americans. In one of our discussions, for example, one young participant asked whether we

thought Tupac went to church. Virtually all discussion participants were adamant that he did. He then asked us whether we thought Tupac prayed. Again, almost all agreed that he did, and one person added: "I think he prayed before he go to bed" to which another responded, "I pray, too." Then our self-appointed discussion leader asked the same questions about Biggie. Few hands went up. Much discussion ensued. Among other things, one young person suggested that "Biggie just be like 'oh man, uh, Tupac a punk, and I want to kill that fool.' Then he go to sleep. He don't say nothing about no prayers or nothing" (Field Notes, 1997, April 14). The consensus was that Tupac was a man of faith who prayed and that Biggie was not. Clearly, Tupac came to occupy a very special religious, moral, and spiritual space for these young people, and Biggie did not. A final reason why Biggie's death was met with neither a bang nor a whimper seems linked to the intense rivalry between Tupac and Biggie and their beliefs about Biggie's central role in Tupac's murder. With Tupac as their hero, Biggie could only be a villain.

In sum the power of Tupac as a contemporary mythological formation seemed to involve the lamination of highly personal, psychological, and conversational narratives of the man in the flesh with various narratives central to the collective remembering of an oppressed yet amazingly resilient people. For a diverse and complex set of reasons, Biggie simply could not evoke such a lamination, and he thus remained just a "thug" in the memories of our participants and hip-hop fans the world over.

Concluding Comments

Remembering and commemorating Tupac was clearly a very complex discursive affair that was mediated by a variety of cultural discourses. Chief among these discourses were key elements of the collective memory of black people including the "invincible-hero-who-prevails-against-insurmountable-odds" and the figure of the resurrected savior. A more contemporary hero type also mediated these processes, a type that is tough but gentle, a beautiful but fierce outlaw who is not afraid to reveal his inner emotional life and to defy the boundaries of hyper-masculinity. The man, his life, and his music were all read through these various discourses in much the same ways that mythic heroes have been read throughout time. As such, remembering Tupac and recreating him as a mythological formation was another moment in the dynamic production of the collective memory of a people. As we noted in our earlier discussion of collective memory, such production processes are a distributed set of complementary, negotiated, and even contested representations of the past that "live" in the present. They function to construct a usable past for present and future cultural work. Despite their universalizing tendencies, these processes rearticulate the contents of collective memory over time because both

the need to create a usable past and the kind of past that is most usable change over time, especially from generation to generation. Finally, these processes are "transparent" and usually function outside of the awareness of the people who contribute to them. Indeed, their naturalness and transparency probably account largely for their pervasiveness and power.

Likening the narratives of remembering and commemoration that grew up around Tupac to the long and rich history of black folklore, hampton (1997) had this to say:

> If Zora were still trekking backwoods (today they'd be postindustrial ghettos), searching for our essence, I have no doubt she'd add the speculation around Tupac's death to her collection of Br'er Rabbit-like tall tales. These improvisational tales of burrowing underground serve as symbolic resistance and, at least in Tupac's case, as a way of coping with loss by breathing life into his legacy. (p. 134)

Indeed, the young people we worked with appropriated and redeployed a variety of cultural resources to construct Tupac as a mythological formation that would function as one dimension of a usable past to resist official discourses of race, to assert their individual and collective agency, and to mitigate against intense feelings of vulnerability—as young, Black, poor, and gendered subjects in the United States today. In rendering Tupac as a hybrid formation at the intersection of traditional invulnerability narratives and the vulnerability narratives of contemporary public discourse—a kindly, gentler, more tender, more emotionally complex and available "invincible-hero-who-prevails-against insurmountable odds"—they created an "internally persuasive discourse" of agency that had real and immediate purchase for constructing or claiming who they were, for deciding which history was theirs, and for figuring out where they belonged.

Our analyses have implications for theorizing the processes of remembering and commemoration. Clearly, for example, they offer one more powerful exemplar for the dynamic and reconstructive nature of memory. In relation to this point, the way in which the events of Tupac's shooting and apparent murder were rendered by these young people is one more testimonial to the power of collective remembering mediated by generalized cultural forms to shape how people understand, remember, and memorialize experienced or witnessed events. The stories our adolescent participants told to remember and memorialize Tupac were based not so much on current "fact" but on a set of narrative resources developed over generations. The tacit invocation of the Shine and Stackolee narrative tradition and its apparent influence on our participants' remembering of the events surrounding Tupac's shooting indexed the operation of a force of cultural continuity or what Lotman and Uspenskii (1985) have called the "regeneration of archaic forms" (p. 33). In addition to being a regeneration, such invocations also seem to enhance

collective remembering and its effects on the thinking and acting of the collectives that produced (and continue to produce) them.

Our analyses also have implications for research practice. For example, they lend concreteness to more theoretical claims that both remembering and commemorating are complex, socially distributed activities that are mediated by multiple cultural resources. They also show how understanding this distributed process and its effects thus involves listening for (and searching for) the texts and the voices that inhabit any particular text we are interested in (e.g., the narratives of Tupac's non-death). These texts and voices provide clues about the ideological commitments of the collective(s) that furnish the narrative forms and contents used by people to construct their own narratives about issues and events that matter to them.

Notes

1. The data from this ethnographically informed study are very rich, and we have used them to pursue different empirical, rhetorical, and theoretical projects in other publications. For strategic reasons, we have also used different narrative voices in these different publications. In Kamberelis & Dimitriadis (1999), for example, we used some of these data to discuss the enablements and constraints of conversationalized media genres on children's understandings of cultural events and icons. In this publication, we used the first person plural narrative voice ("we") throughout. In Dimitriadis & Kamberelis (2001), we used some of the data to demonstrate how cultural icons and cultural tropes were used by children and adolescents to forge highly specific identities and social relations. Because this publication was the only co-authored chapter in a book otherwise written by Greg, we used the first person singular narrative voice ("I") throughout. In the present chapter, we have returned to the first person plural narrative voice ("we"). Also worth noting is the fact that, for each publication, we arranged the order of authorship to reflect, more or less, the relative contributions each of us made to conceiving, framing, analyzing, and writing up the work. In reality, however, our thinking and writing is generally quite synergistic and often defies the assumptions embedded in a linear representation of authorship attribution.

References

Abrahams, R. D. (1970). *Positively Black*. Englewood Cliffs, NJ: Prentice Hall.

Bakhtin, M. M. (1981). *The dialogic imagination* (C. Emerson, Trans.). Austin: University of Texas Press.

Bartlett, F. C. (1932). *Remembering: A study in experimental and social psychology*. Cambridge, England: Cambridge University Press.

Bergman, M. (Producer), and De Palma, B. (Director). (1983). *Scarface*. Hollywood, CA: Universal Studios.

Bertolli, J., Bigelow, L., Stabler, S., and Krevoy, B. (Producers), and Kouf, J. (Director). (1997). *Gang related* [Motion picture]. Hollywood, CA: MGM/UA.

Bodnar, J. (1992). *Remaking America: Public memory, commemoration, and patriotism in the twentieth century*. Princeton, NJ: Princeton University Press.

Bruner, J. (1986). *Actual minds, possible worlds.* Cambridge, MA: Harvard University Press.

———. (1990). *Acts of meaning.* Cambridge, MA: Harvard University Press.

Burke, K. (1957). Literature as equipment for living. In *The philosophy of literary form: Studies in symbolic action* (2nd ed., pp. 253–262). New York: Vintage Books.

Buttny, R. (1993). *Social accountability in communication.* London: Sage.

Conway. M. A. (1997). The inventory of experience: Memory and identity. In J. W. Pennebaker, D. Paez, and B Rimé (Eds.), *Collective memory of political events: Social psychological perspectives* (pp. 21–45). Cambridge, EG: Cambridge University Press.

Dimitriadis, G., and Kamberelis, G. (2001). The symbolic mediation of identity in Black popular culture: The discursive life, death, and rebirth of Tupac Shakur. In G. Dimitriadis, *Performing Identity/Performing Culture: Hip Hop as text, pedagogy, and lived practice* (pp. 93–118). New York: Peter Lang.

Fairclough, N. (1995). *Media discourse.* London: Edward Arnold.

Habermas, J. (1968). *Knowledge and human interests.* Boston: Beacon Press.

hampton, d. (1997). Holler if ya see me. In *Vibe* (Eds.), *Tupac Shakur* (p. 134). New York: Crown Publishers.

Heyman, D., Moritz, N. H., and Frankfurt, P. (Producers), and Dickerson, E. R. (Director). (1992). *Juice* [Motion picture]. Hollywood, CA: Paramount Pictures.

Hutchins, E. (1995). *Cognition in the wild.* Cambridge, MA: The MIT Press.

Jackson, B. (1974). *"Get you ass in the water and swim like me": Narrative poetry from the black oral tradition.* Cambridge, MA: Harvard University Press.

Kamberelis, G., and Dimitriadis, G. (1999). Talkin' Tupac: Speech genres and the mediation of cultural knowledge. In C. McCarthy, G. Hudak, S. Miklaucic, and P. Saukko (Eds.), *Sound identities: Popular music and the cultural politics of education* (pp. 119–150). New York: Peter Lang.

Lave, J., and Wenger, E. (1993). *Situated learning: Legitimate peripheral participation.* Cambridge, England: Cambridge University Press.

Lewis, L. (Ed.). (1992). *The adoring audience: Fan culture and popular media.* London: Routledge.

Lotman, Y. M., and Uspenskii, B. A. (1985). Binary models in the dynamics of Russian culture (to the end of the eighteenth century). In A. D. Nakhimovsky and A. S. Nakhimovsky (Eds.), *The semiotics of Russian cultural history* (pp. 30–66). Ithaca, NY: Cornell University Press.

MacIntyre, A. (1981). *After virtue: A study of moral theory.* South Bend, IN: Notre Dame University Press.

Marcus, G. (1975). *Mystery train: Images of America in rock 'n' roll music.* New York: Plume Books.

McCarthy, C., Hudak, G., Miklaucic, S., and Saukko, P. (Eds.). (1999). *Sound identities: Popular music and the cultural politics of education.* New York: Peter Lang.

Neisser, U. (1967). *Cognitive psychology.* New York: Appleton Century Crofts.

Nora, P. (1989). Between memory and history: Les lieux de mémoire. *Representations, 26,* 7–25.

Novick, P. (1999). *The holocaust in American life.* Boston: Houghton Mifflin.

Rodman, G. (1996). *Elvis after Elvis: The posthumous career of a living legend.* New York: Routledge.

Rosaldo, R. (1989). *Culture and truth: The remaking of social analysis.* Boston: Beacon Press.

Schuman, H. and Scott, J. (1989). Generations and collective memories. *American Sociological Review, 54,* 359–381.

Scott, D. (Producer), and Hughes, A., and Hughes, A. (Directors). (1993). *Menace II Society* [Motion picture]. Los Angeles, CA: New Line Cinema.

Shakur, T. (1993). Keep ya head up. On *Strictly 4 my N.I.G.G.A.Z.* [Compact disc]. Beverly Hills, CA: Jive Records.

———. (1995). Dear mama. On *Me against the world* [Compact disc]. Beverly Hills, CA: Jive Records.

———. (1996a). *All eyez on me* [Compact Disc]. Santa Monica, CA: Polygram Records.

———. (1996b). I ain't mad at cha. On *All eyez on me* [Compact Disc]. Santa Monica, CA: Polygram Records.

———. (1996c). *The Don Killuminati: The 7 day theory* [Compact Disc]. Beverly Hills, CA: Interscope Records.

———. (1996d). Hit 'em up. On *How do u want it* [Compact disc-single]. Beverly Hills, CA: Death Row Records.

Shakur, T. and Outlawz (1999). *Still I rise* [Compact Disc]. Beverly Hills, CA: Interscope Records.

The Notorious B. I. G. (1995). Who shot ya. On *Big poppa* [Compact disc-single]. New York: Bad Boy Records.

———. (1994). *Ready to die* [Compact Disc]. New York: Bad Boy Records.

———. (1997). *Life after death* [Compact Disc]. New York: Bad Boy Records.

Various Artists. (1997). *Gang related.* [Original motion picture soundtrack on compact disc]. Los Angeles, CA: Priority Records.

Vygotsky, L. S. (1978). *Mind in society: The development of higher psychological processes.* Cambridge, MA: Harvard University Press.

Wertsch, J. V. (1991). *Voices of the mind: A sociocultural approach to mediated action.* Cambridge, MA: Harvard University Press.

———. (1998). *Mind as action.* New York: Oxford University Press.

White, H. (1981). The narrativization of real events. In W. J. T. Mitchell (Ed.), *On narrative* (pp. 249–254). Chicago: University of Chicago Press.

Witherall, C., and Noddings, N. (1991). *Stories lives tell: Narrative and dialogue in education.* New York: Teachers College Press.

Zamora, L. P. (1998). *The usable past: The imagination of history in recent fiction of the Americas.* Cambridge, England: Cambridge University Press.

Who Owns Him?

The Debate on John Lennon

JANNE MÄKELÄ

How has John Lennon's stardom been understood, constructed, and used since his murder on December 8, 1980? First, even though Lennon stands as an individual artist, he is inseparable from the Beatles. He was a Beatle in the 1960s, continued to be a (former) Beatle in the 1970s, when he was constantly asked to evaluate his past, to comment on the meaning of the Beatles and whether the group might re-form one day and revive the spirit of the Sixties; and he is still remembered as a Beatle. The fact that the Beatles defined Lennon's star image and identity long after the official dissolution of the group in 1970 illustrates that the history of the Beatles ended at one particular level only, that of active and creative artistic cooperation of four musicians. I have elsewhere argued (Mäkelä 2001) that besides the artistic narrative, which has dominated the Beatles historiography, there are other historical approaches to the subject, like the history of the Beatles as active discourse, as consumption, as (re)production, as cultural industry, or as an active remembrance, and that these approaches have been largely neglected. Considering the pervasive presence of the Beatles, from regular rereleases of the Beatles' records to tourism and from fan culture to abundant media coverage, there is unlikely to be a significant decline in fascination with the group in contemporary culture. On the contrary, the history of the Beatles continues to unfold as a cultural narrative.

This leads us to the second aspect of Lennon's posthumous career. All those changing and diverse facets of Lennon's stardom in the 1960s and the 1970s did

not die with him in 1980. In fact, Lennon's murder was the catalyst for a new phase, which has now lasted longer than the period of his celebrity while alive. Whether understood as a living person operating in the 1960s and the 1970s or as a part of his continuing history, Lennon was and remains constantly constructed and reconstructed as a cultural phenomenon. Since we can find abundant historical examples of "great men" who have been re-evaluated as well as debated after their deaths, this in itself is unremarkable. Such phenomena have, however, become more prominent during the age of digital and mechanical reproduction, when the image of a public person can continue to survive and develop without the celebrity herself/himself being physically present. In some cases, star afterlife may surface as a significant cultural force. The profitable posthumous career of Elvis Presley, with thousands of "Elvis goes Las Vegas" clones and other recyclings of his star image, has arguably been as interesting and important as his actual career and a target for more or less serious study as well (e.g., Marcus, 1992; Rodman, 1996; Plasketes, 1997). If stars die, but star images do not, it is therefore reasonable to suggest that we have not yet reached the end of John Lennon's story. New and old Lennon products are distributed and sold, he is consumed and experienced and his meaning is still discussed.

As a public person who aroused much controversy even in his lifetime, Lennon continues to be a source of mixed feelings. He has been central to debates over who has the right to use the star and in what ways, when the star himself is no longer there to authorize himself. My essay explores this debate and its two major strands, personal and cultural, which are closely linked. While I shall scrutinize the first strand through the biographical debate that took place in the 1980s, the main focus will be on those aspects of Lennon's posthumous career that deal with his artistic and cultural heritage. Using the concept of stardom as a methodological starting point, I concentrate primarily on the British context and explore three major issues that clarify contemporary discussions and cultural ideas on Lennon: attempts to utilize Lennon's musical products, efforts to locate him, and his idealization by fans.

Lennon in the Starnet

Stardom is a phenomenon that is characterized by different media-oriented public actions—whether conducted by the star or people commenting on the star. In general, star images, "all that is publicly known about the star" (Gledhill, 1991, pp. 214–217), are complex because they are constructed by a range of media texts or public actions that, as they interplay and intertwine, form a web-like texture. I call this construction the *starnet* of popular music. My categorization of this construction is loosely based on Richard Dyer's study of film stardom and his assumption

that the star is a person who is known by people through different media texts (1986, pp. 68–72). Dyer arranges these texts in four main divisions: promotion, publicity, films, and critics/commentary. Although pop stardom and film stardom have a lot in common—notably, that they are both media creations—between them there are some decisive differences that are related to the technology of production and reception, the form of address, the industrial and commodity configuration of the musical product, and the audience's collective and individual relationship to the music and performer (Marshall, 1997, pp. 187–198).

Dyer's theory of media texts, as such, is of limited use for studying pop stardom. It is, however, possible to extrapolate from it a set of categories that takes account of the dimensions of popular music and includes various defining aspects of stardom. Within the starnet of popular music, the most visible component is the star with her or his public activities. In popular music stardom, music in various forms (records, music videos, television appearances, live performances) is central. In addition, the star's publicity mechanisms, interviews, film roles, autobiographies, and other public utterances also define the star image. What is fundamental here is the star's own public actions.

The second part of the starnet is constructed by promotional strategies of the music industry, especially those conducted by the particular institutions behind the star. These strategies include producing and distributing official star material such as records, press photos, advertisements, and record company newsletters. Basically, the task is either to create new stars or to maintain pre-existing modes of stardom. With already established acts, the usual practice is "branding," the attempt to "structure continuities in consumer culture, where a sense of trust and security is indicated by certain symbols and companies" (Marshall, 1997, p. 245). This "brand," for example John Lennon as a rock legend, is promoted and regulated by the music industry and then distributed in various media forms.

The third part of the starnet is the media and their commentary on stars. Within this loosely organized category we can find critiques, news, columns, sketches, parodies, exposures of tabloid press, unauthorized biographies, as a few examples of media that shape star images in significant ways. The division of labor between the music industry and the media is often a line drawn in water. In the history of popular music, there are numerous examples of this symbiotic relationship starting, for instance, from the early music press and its role as a presenter of the industry's own public view of itself and continuing with current play lists of many radio stations. What is fundamentally shared by these parties is their role as mediators since both the music industry and the media are involved in distributing and transmitting star material from the domain of the star to that of the audience.

In the study of popular music stardom, the concept of mediation is a promising line of inquiry. It provides a key to the ways in which the information regarding particular stars is distributed, and how different parties construct different meanings within this scheme (Negus, 1996, pp. 66–98). However, the process of constructing meaning is not concluded until the consuming of the star. The fourth and perhaps the most significant starnet group is formed by the audience, which in the end "produces" the star by "consuming" her or him—directly, by purchasing recordings, audiovisual material, T-shirts, other fan products, concert tickets, or, more indirectly, by attending fan club activities. Stars are for consuming. There can be no star without an audience: in popular music this fact is even more crucial than with other forms of stardom. The reason for this is, according to Marshall (1997, pp. 187–198), that if the celebrity system of film is organized around auratic distance and that of television around identification with the familiar, popular music stardom is characterized by communality, the mutual commitment between artist and audience.

The interactive relationship between star and audience is only one illustration of how the whole star phenomenon is based on public discourses about the star's role in society. Although the star image is constructed by an elaborate networking of all the participants in the starnet, it is also more than the sum of these factors. Within the pattern of the starnet it is usual that "shapers" of stardom and their interests conflict—sometimes to profound effect. In the history of popular music there are abundant examples of how stars are unhappy with the promotional activities; journalists and biographers are bored with official PR material and proceed to publish their own stories; fans dislike ungrateful record reviews, and so on. Lennon's star history contains all variations of the structure. Promotional practices and fans' reactions played significant roles during Beatlemania 1963–1966, whereas in the late 1960s Lennon's own range of activities, which were linked to his new self-identification as a celebrity, became more crucial as well as in some cases led to confrontations with the record company (e.g., the controversy over the nude cover of *Two Virgins* in 1968), the media (the ridiculing of Lennon's peace campaigns), and the audience (fans' disappointment with the Beatles' decision to retire from concert stages).

What is significant for Lennon's posthumous career is, of course, the fact that Lennon himself can no longer participate in defining his position and is thus unable to act as a prime authorizer of his stardom. The absence of this authoritative point of reference has allowed fuller range to controversies between the estate, promotional agencies, biographers, documentarists, journalists, and the audience.

The Man behind the Myth

To approach the debate on Lennon's personality, questions like "Who was he really?" "What were his aims?" and "What was the background for his psyche?" have been asked in various articles and biographies on him. This was especially so in the 1980s. At first there was a spirit of consensus, as there usually is in cases of sudden, dramatic, and premature deaths of famous people—take, for instance, the deaths of Elvis Presley in 1977 and Diana, Princess of Wales in 1997, both of which caused extravagant outpourings of grief. Lennon's murder was considered by many to be the end of an era (the Sixties), and he himself was treated as a cultural hero who was sacrificed on the twin altars of peace and love (see Fogo, 1994, pp. 41–61, 83–112; Elliott, 1999, pp. 141–153). The tragic paradox was that while the assassinated John Lennon was now physically separated from other people, as an image he was, in the early 1980s, more present than he had ever been in his lifetime.

Uncritical praise cannot continue forever. Beginning with May Pang's (Lennon's mistress in the 1970s) *Loving John* and Peter Brown's (the Beatles' assistant) *The Love You Make*, both published in 1983, various memoirs and biographies have questioned Lennon's saint-like image and ideas of his martyrdom. The most notorious attempt to reveal "the man behind the myth" has undoubtedly been Albert Goldman's mammoth *The Lives of John Lennon*, which provided scandalous stories about Lennon's violent behavior, (homo)sexual activities, and drug use. The book, which was published in 1988 and immediately became an international bestseller, was, unsurprisingly, received with rage both by critics and fans. Philip Norman, the writer of the Beatles' history *Shout!*, set the tone by confessing that Goldman was the only author whose works he had physically destroyed (Williams, 1988). In the United States, *Rolling Stone* magazine, in particular, took up an active defense of Lennon and refutation of Goldman. Lennon's friends and colleagues urged a boycott of the book and it was rumored that in Liverpool fans openly burnt copies of it (see Fogo, 1994, pp. 115–142; Elliott, 1999, pp. 17–26).

John Lennon's widow, Yoko Ono, was disgusted at Goldman's effort to rob her former husband of dignity and the fact that "John isn't here to answer the things said about him" (Norman, 1988). Goldman's response was that stars will do their utmost to ensure that biographical material more nearly resembles a press release than the "truth." If they are dead, they cannot, Goldman said (quoted in Sweeting, 1988). Later he was to claim that the biography of rock stars is becoming a more and more misleading genre because it gives the impression that the stars invent themselves when, instead, the real protagonist is always the public: "It's the audience's manias, the audience's images, the audience's cravings, yearnings, delu-

sions, that's really decisive. The performers are the puppets of what the public wants" (quoted in Miles, 2000, p. 102). However, in his biography, Goldman was not really writing for the benefit of the audience but concentrated on attacking the myth of a creative and authentic rock hero. The decisive error for Goldman was to ignore his own power in the process of (post)stardom and not to recognize himself as a part of the "real protagonist," the public. Furthermore, he arguably projected his own fantasies of the dark side of rock stardom onto Lennon (Elliott, 1999, pp. 20–26) and supposedly succumbed to distortion of the facts. Despite hundreds of interviews conducted for the book, it has been argued that Goldman's main sources were not reliable and that he had a tendency to give credence to the vilest gossip on Lennon (Fogo, 1994; Hertsgaard, 1995; Elliott, 1999).

Whatever the truth behind Lennon, the fact remains that Goldman, whose earlier biographies on Lenny Bruce and Elvis Presley had provoked similar indignation, is still regarded as an iconoclast. Attempts to understand both Goldman's own intentions and the rage over his work have appeared only recently (e.g., Fogo, 1994; Elliott, 1999; Miles, 2000). Nevertheless, it is obvious that at least for Lennon's widow, Yoko Ono, and his fans, *The Lives of John Lennon* will stand as a "form of primitive attack" while Goldman, who died of a heart attack in 1994, will be remembered as an "assassin with a pen" (Ono, 2000). The reputation of the book was tellingly summed up by a fan called King of Marigold (1998) on an internet review page: "The Lennon biography that fans love to hate—even if they haven't read one word of it."

Two months after the publication of Goldman's book, the biographical film *Imagine: John Lennon* was premiered in New York. According to Fred Fogo (1994, pp. 121–135), who in his study *I Read the News Today* gives a thorough account about the biographical battle over the memory of John Lennon in 1988, the film seemed to be an official counterdocument to Goldman's book. It emphasized the positive aspects of Lennon and attracted more sympathetic reviews than *The Lives of John Lennon*. However, since the film was fully authorized by Yoko Ono and was heavily marketed, critics also noted its role as a public relations battle over Lennon's memory and were to some extent disappointed with its sycophantic and superficial portraiture. Although Yoko Ono became an object of sympathy following Lennon's death, that sympathy, as Fogo notes (1994), "apparently was short-lived" (p. 132).[1]

Since Goldman's biography, there has been no major controversy regarding John Lennon's personality. Two subsequent biographies, Robert Rosen's *Nowhere Man* (2000) and Geoffrey Giuliano's *Lennon in America* (2001), have provided convergent portraits of Lennon. Both writers claim that their descriptions are more or less based on Lennon's personal diaries, which give a picture of an isolated, depressed, and tormented star obsessed with astrology, numerology, drugs, and

Jesus Christ during his final years. It is instructive that these books did not provoke significant reaction. This suggests that the biographical debate here has followed the route typical of the posthumous careers of cultural heroes. The discussion starts with elegies, praise, and idealization arising from the atmosphere of shared grief; it proceeds to a more distanced tone, criticism, and even iconoclasm, and, finally, results in some sort of reconciliation of the two positions. We can find such a pattern in Elvis Presley's posthumous career. After the waves of grief abated, more controversial interpretations about Elvis appeared, culminating in Goldman's major biography (1981) on a psychologically ill star. These revelations have subsequently been replaced by imaginative uses and celebrations of a "living legend" (Rodman, 1996). Likewise, in the case of John Lennon, a certain consensus now prevails. What is at issue now is not the personal secrets of Lennon but his musical, artistic, and cultural heritage. The cultural debate on John Lennon lies at the heart of the triangle of promotion, media, and audience, that is, all those participants in the starnet who are actively involved in producing images of Lennon.

Virtual Reunion

One interesting aspect of John Lennon's posthumous musical career is that it has coincided with the past, becoming more of a presence in contemporary popular music culture. Although this could be attributed to the nostalgia of an aging rock generation (resulting, for example, in the legions of re-formed bands), it has also been due to new expanding practices in music culture. In the 1980s, both CDs and music videos established themselves as central to the marketing and selling of popular music and contributed to the increase in world sales of music recordings. Together with new music technology (like samplers) and the expanding volume and new formats of the media (cable television and satellite channels), this development promoted the boom in reissues as well as enabling the more effective exploitation of musicians' posthumous careers and the reconstruction of old materials in popular music. As with many deceased artists, through such practices, John Lennon's past achievements became more present and commonplace. Even though Lennon's posthumous catalogue does not represent the most exploited one in popular music, it is rich in variety.[2] An important question underlying this development has been whether Lennon himself would have endorsed this exploitation of his artistic remains. One particular case, the "reunion" of the Beatles, was specifically fuelled by this kind of question.

The Beatles' reunion in 1995 was a project that incorporated a number of scheduled events under the title *The Beatles Anthology*, including the first release of three double CDs with rare recordings and outtakes and the production of an

authorized television series on the band's history. The centerpiece of the project, which would be completed five years later with the major release of the printed version of the band's story, was the reunion of the three remaining Beatles—or, in fact, the reunion of the four, since during the project Paul McCartney, George Harrison, and Ringo Starr finished two songs that Lennon had recorded as home demos in the late 1970s. Thus, the artistic history of the Beatles did not really end in 1970, but temporarily resumed a quarter of a century later.

In Britain, the rock press, in its special editions on the Beatles, was primarily in favor of the reunion (Elliott, 1999, pp. 159–163), perhaps because the Beatles' project coincided with the climax of Britpop and its flirtation with national issues and references to the 1960s pop revolution. After all, the Beatles embodied—and now concretely revived—the patriotic past of British pop music better than any other band or artist. Other papers took a more critical view. When rumors of the Beatles' project surfaced, Caitlin Moran (1994) of *The Times* predicted that it would "diffuse the memory and cheapen the past," since to her mind pop music was primarily meant to catch the moment rather than to dig among the graves of history (p. 36). Later Moran (1995) concluded that the remaining Beatles had clubbed John Lennon "to death with video treatments and bank statements" (p. 37). Generally, the CD Anthology and new songs were regarded as less disappointing than the television series, which was declared to be "uninformative," "pure Reader's Digest TV" and "terrifyingly bland," yet also enjoyable. The authorized status of the series—it was produced by the Beatles' own company, Apple—led some critics to complain that the story had little controversial or new things to say and appeared "more of a corporate PR exercise than an objective study" (see the summary of press reception in Davis, 1996, pp. 28–30).

The physical absence of Lennon provoked speculations as to whether he would have been in favor of the reunion and, particularly, of the reconstruction of his home demos. His original comments on the subject were rummaged through and his friends were interviewed, while journalists and fans were given opportunities to represent their viewpoints. For example, Tony Barrow (1996, p. 6), former Beatles press officer, was convinced that while Lennon would have taken a less negative view of the Anthology television series, he would not have been agreeable to the release of the two songs, which he had already rejected years earlier. Discussing the merits of "Free as a Bird," Giles Coren (1995) of *The Times* suggested that Lennon "would have been ashamed to think it would ever see the light of day" (p. 17). In *The Beatles Monthly Book* (1996, pp. 12–16, 22–23), fans were divided between the "John would have hated it" school of thought and those who were openly delighted by new Beatles products.

To reconstruct posthumous tapes or mix new material into them was not a new practice in popular music. Buddy Holly was supposedly the first rock star to "get

the Lazarus touch" when after his death in 1959 his solo demos were supplement-
ed by a backing group, ensuring a steady flow of new Buddy Holly products. Later
examples of similar, if more elaborate, practices have included cases such as The
Doors' musical backing to a tape of Jim Morrison reciting his poetry for the album
American Prayer, Natalie Cole's duet with her father, Nat King Cole, and Queen's
additional accompaniment to unreleased Freddie Mercury vocals. When digital
technology became commonplace in the 1980s, it contributed to "necropop," as
journalist Patrick Humphries (1995) sarcastically calls it, becoming a popular
music phenomenon. Even though virtual participations of dead music stars in
new productions had by the mid 1990s become a fashionable practice, and posthu-
mous Lennon material had already been issued to some extent, the resurrection of
the Beatles provoked an animated discussion—mainly because the possibility of a
comeback of the most famous pop group in the world carried with it the hopes and
expectations of a quarter of a century. More concretely, since Lennon had forbid-
den the publication of "Free as a Bird" and "Real Love" in the first place, the pro-
ject lacked the ultimate blessing. This led to the collision of opinions within the
communication network of Lennon's posthumous stardom.

In *The Mourning of John Lennon*, Anthony Elliott (1999) suggests that the
debate over Lennon's likely involvement in the reunion reflected "an inventive,
though anxious, redemption of our personal investment in his art, [entailing] a con-
sideration of the complexity of our feelings about Lennon [and] the ways in which
he is remembered" (p. 164). Taking a positive viewpoint on the discussion, Elliott
argues that as much as the reunion project and the overall 1990s surge in Beatles
activity was about returning to the past, it was also about escaping from the drab-
ness of contemporary musical standardization (pp. 158–159). The reunion, with its
reconstructed music, was thus nostalgic but not in regressive terms: it was an
attempt to return to the past for the purpose of dealing more constructively with
the present and the future. According to Elliott, the nostalgia encountered here
had a certain transformative quality, permitting the recovery of lost memories,
thoughts, and feelings as a medium for contemporary artistic experiences (p. 177).
Yet since Lennon as an artist strove for authenticity and represented a star seek-
ing to reconfigure utopianism and realism, politics and aesthetics, celebrity and gen-
uineness, the reunion's rehabilitation of the past for the present raised thorny
questions about the legitimacy of such a process.

In this connection, Elliott does not really focus on the question of Lennon's
image in the reunion process but discusses his past identity and, in the end, leaves
him a mythical rock hero. For example, in his song analysis, Elliott suggests rather
conventionally that "Free as a Bird" and "Real Love" can be viewed as maps of the
mental territory Lennon was charting in the late 1970s (p. 178). But what kind of
territory did they represent in the 1990s? To develop Elliott's conclusion, "Free as

a Bird" and "Real Love," and the overall reunion project, did not merely stand as an artistically autonomous interaction between the past, remembrance, and nostalgia, but also represented the technological and industrial development of popular music in the 1990s, and were just another—if major—continuation in a tradition of attempts to reuse and relocate the Beatles and Lennon in contemporary culture. In fact, what the 1990s demonstrated in terms of John Lennon's stardom was the increasing attempts to place and locate him concretely.

Locating Lennon

To Elliott's (1999) mind, the Beatles' reunion constructed Lennon as an identity transacted between the eternal and the evanescent, past and present, memory and image, materiality and metaphor (p. 172). If this list of oppositions seems ambiguous, it nevertheless matches some characteristics of the phenomenon of stardom. In his notable cultural study on the posthumous career of Elvis Presley, Rodman (1996, pp. 99–101) argues that stardom is typically an ethereal, non-spatial phenomenon. To Rodman's mind, it is difficult if not impossible to confine stars within any specific context since stardom, after all, is a phenomenon entirely dependent on a strong infrastructure of interrelated media institutions. Stars are famous primarily because of their activities within the realm of this infrastructure. They may walk and talk and move about in the same world as "ordinary" people, but since their existence as public personae is dependant on the media, to the vast majority of the audience they primarily travel in the ethereal nonspaces of media texts and public imagination.

With deceased, "nonphysical" stars this is even more evident since they enter various places and times as re-mediated public figures of a technological landscape. According to Rodman, the only real exception to this rule is Elvis and his home Graceland:

> From almost the first moment of his stardom, Elvis was associated with a very specific site on the map, a mansion in Memphis he bought in 1957, in a way that no other star ever was—or has been since—with the longstanding connection between these two icons working to transform the private, domestic space of Elvis's home into a publicly visible site of pilgrimage and congregation. (p. 102)

It is arguable that as a famous tourist attraction, Graceland has no equivalent in contemporary popular music culture. A few hundred fans may go on a pilgrimage to Jim Morrison's grave in Paris every July to participate in rituals based on the cult of a rock hero, and the anniversary of John Lennon's death may be marked by a small informal gathering of fans outside the murder site, the Dakota apartment

building in New York, but these statistics come clearly second to two thousand or more daily visits at Elvis's *locus sanctus*, his grave in Graceland.

What Rodman overlooks is that in popular music, attempts to identify and locate stars with particular places have not been rare and that there are places that have associations with particular stars and musical sounds, respectively.[3] Stars may be dependant on a non-spatial media realm but their star identity is still, in most cases, connected to more concrete determinators, which usually partake of their national, ethnic, and geographical backgrounds. In popular music studies, scholars (e.g., Cohen, 1991; Straw, 1991; Shank, 1994; Negus, 1996, pp. 164–189) have frequently emphasized how local cultures and "scenes" have played important roles in creating the imaginaries and authenticities of particular styles and stars.

Within the posthumous starnet of John Lennon, there have been several attempts to locate him. It has for various reasons, however, been a difficult task and has provoked some disagreement. Even though Liverpool and Liverpoolness certainly characterized Lennon's personal identity as well as his star image, in artistic terms his most celebrated phases occurred in London where he stayed from 1964 to 1971, and in New York where he lived the rest of his life (apart from his drunken "lost weekend," the fifteen-month period in Los Angeles from 1973 to 1975). As a rock cosmopolitan, Lennon left his mark on the most famous cities of popular music, but not exclusively. A further reason why no particular *locus sanctus* has emerged is that there is no physical landmark indicating the place of rest of the deceased hero.[4] Finally, although in the late 1960s and the early 1970s Lennon appeared as an enlightened messenger of world peace and a political activist, he later repeatedly forbade people to consider him any kind of leader. In one of his last interviews Lennon spoke against worship and the personality cult:

> Don't expect Jimmy Carter or Ronald Reagan or John Lennon or Yoko Ono or Bob Dylan or Jesus Christ to come and do it for you. You have to do it yourself. . . . I can't wake you up. You can wake you up. I can't cure you. You can cure you. (Sheff, 1981, p. 144)

In spite of the series of "refusals," surprisingly frequent attempts to locate the heritage of Lennon or at least to confer various degrees of respectability on his name have surfaced. Recently a John Lennon Museum was opened in Saitama, near Tokyo; in St. Petersburg there were in the late 1990s plans to build a John Lennon Rock'n Roll Temple, which would have operated as a center for various art and educational activities; in Prague one of the latest tourist attractions is the spontaneously developed "Lennon Wall" with its graffiti epitaphs and paintings of Lennon; in London similar writings and messages are to be found on the front wall of Abbey Road studios where the Beatles recorded most of their work in the 1960s. Apart from the studios, which were opened to the public in 1983, London has provided

other Beatles-themed activities, like sight-seeings and walks. In New York, a spe-
cial section created in memory of Lennon and conceived by Yoko Ono as an
international garden of peace was opened in Central Park in 1985 and named
Strawberry Fields after one of Lennon's songs—which, interestingly, originally
had nothing to do with New York but referred to a now famous Salvation Army
orphanage in Liverpool.

Given the fact that Liverpool stands as a mythologized birthplace of John
Lennon, and that the Beatles were the first rock group to make their local identi-
ty and cultural background a fundamental part of their fame and image (see
Mäkelä, 1999; Nurmesjärvi, 2000), it is hardly surprising that efforts to locate the
heritage of Lennon and the Beatles have most conspicuously taken place there.
Being a Londoner or a New Yorker never defined Lennon to the same extent as
Liverpoolness. Furthermore, whereas Liverpool is famous for being the home of
Lennon and the Beatles, metropolises like London and New York are too dispersed
to be identified with just one man or one pop group.

Liverpool's efforts to harness Beatles tourism has been multiphased and ad hoc
(see Cohen, 1997b). It was only in the mid 1980s that more concerted efforts took
place, replacing previous attempts by dedicated fans and enthusiasts. Currently
there are three main players involved. The most influential of them, Cavern City
Tours Ltd., organizes, among other things, the daily sightseeing Magical Mystery
Tour and the Beatles Festival to which tens of thousands of fans and dozens of trib-
ute bands travel every August. Two other businesses are the Beatles Shop and the
Beatles Story, a heavily merchandised Beatles exhibition at the Albert Dock area.
While there are various tourist attractions scattered around the city, the center of
activities is located on Mathew Street, which is lined by a number of cafés, pubs
and speciality shops devoted to the Beatles' history, and a replica of the legendary
Cavern Club.

Sara Cohen (1997a; 1997b) has noted that while rock music as a form of
tourism plays an important role in Liverpool, the shift of thematic emphasis has
changed from the "live" to the "past." Most of the rock tourists do not arrive to see
new groups but to experience Beatles history. This has occasionally attracted crit-
icism that strategies of urban regeneration are excessively based on Beatles tourism
and nostalgia and that music as consumption and leisure has replaced aspects of pro-
duction and creativity. In this connection the relationship between the Beatles and
Liverpool appears as a "contested process" in which the Beatles are typically con-
sidered either a curse or blessing to the city (1997b, pp. 102–103). Another issue
is that questions of authenticity, a culture of replica, and the overall recreation of
the past, have led to debates as to who is allowed to define and canonize the Beatles'
history in Liverpool (1997a). Is this privilege reserved for local authorities, politi-

cians, and tourist organizations or do fan clubs, tourists, shop keepers, or their employees have anything to say in the matter? Who owns the Beatles?

One occasion that focused the relationship between John Lennon and Liverpool and the controversies of ownership was the John Lennon Tribute Concert in May 1990. The press release (cited in Gray, 1990) preceding the concert asserted that the charity event dedicated to the "genius of John Lennon could only be held in Liverpool, his birthplace and the city which had cradled his unique talent" and that "Liverpool's gain is New York and Los Angeles's loss" (p. 14). The concert, which was supported by the Estate of John Lennon, faced heavy criticism not only because of its marketing rhetoric. Many of Lennon's former colleagues as well as local, prominent rock identities were excluded, and the evening was organized more around televisual than live concert practices; the beneficiary of the charity was unclear and there was little advance notice that some "top international stars" who were billed would appear only on video. The event gave the national papers a chance to needle Liverpool about a supposed attempt to cover up the city's decline and deprivation. More important, however, was the conjecture that Lennon himself might not have approved the event. In a report to *The Guardian*, Robin Thornber (1990) concluded: "Lennon, the wayward iconoclast, the proto-Green in a stretch-limo, might have shrugged off his municipalisation. Let it be. But would he have appeared on the same bill as Kylie Minogue?" (p. 27).

The last paragraph in *The Times'* review, written by David Gray (1990), carried a more cynical tone:

> If he had still been alive, I am perfectly certain that, like George Harrison, he would have had the instinct and taste to stay away. And if he had watched it on television and heard his songs sounding so bland and boring, he might have felt like killing himself. (p. 14)

In reply to the latter, Dave Edmunds (1990), the musical director of the evening, attacked the gratuitous viciousness of the review. For him, standing on stage at the end of the evening with other artists, the seventy-piece orchestra behind them, and the 20,000 Liverpudlians singing "Imagine" in front, the moment was deeply moving and by no means any kind of musical disaster. Edmunds concluded his letter: "The world does not need Mr. Gray to tell it what John Lennon would or would not have liked" (p. 13).

In Lennon's case, this kind of appeal has been rather common. The variety of Lennon's star afterlife demonstrates that his history or that of the Beatles is certainly not confined to the ideology of artistry and the vaults of the past, but continues to unfold as a remarkable cultural narrative conducted by Lennon's estate, various heritage organizers and the media. As a further dimension to this narrative, fans also play a significant role in the starnet of John Lennon's posthumous career.

Fans and Villains

Compared, for example, to Beatlemania during 1963–1966, when both John Lennon as a star and the fans as his most devoted audience were interdependent, the death of Lennon meant a new configuration of the pattern: the star was no longer present to react to fans' hopes, desires, and demands. Central to Lennon fandom after 1980 has been, not the interaction between the star and the fan, but rather, the ways fans imagine and consume the star, how they communicate to each other and how fandom is established in the overall starnet.

Current fan activities related to the Beatles and Lennon are very vigorous and diverse, including conventions, fan clubs, fanzines, tribute bands, and collecting memorabilia.[5] Instead of mapping and studying them—which in itself would be a valuable task for understanding the continuous fascination of the Beatles—I want to focus on one particular area of Lennon fandom that, I think, crystallizes his "star afterlife" as well as clarifies the current debate on him.

The internet is a relatively new forum for fans to comment on Lennon's career and personality. Reflecting the larger debate on the internet and modern communication technology, some Lennon fans have taken the web world as a potential access to some kind of utopia. One Lennon fan stated in his web site:

> When you are using the internet tonight, think about how you can use it to make our world a better place. Remember John Lennon's song Imagine. Perhaps he really wasn't such a dreamer after all! (Homer, 1998, n.d.)

On the other hand, the internet has raised awkward problems, which are primarily related to questions of copyright. As one particular case demonstrates, they have also applied to John Lennon.

In December 1994, a fan called Sam Choukri (1997) launched a web site, *John Lennon Web Page*, which included photographs, sound files, films, record covers, and other Lennon-related material. It remained a very popular site up until November 1996 when Choukri was informed that the owner of the web server, the University of Missouri, had turned it off because of "potential copyright infringement." The request was initially made by the Estate of John Lennon, or through its lawyers, who then sent a letter to Choukri charging that "our client has not granted you the right to exploit the copyrighted artwork or our client's trademarks." Choukri tried to respond that he did not make any money off his site and he did not have anything there demeaning to Lennon's character; on the contrary, in his opinion, the site only helped increase the wealth of the Lennon estate. After some negotiations and proposals, Choukri received a rather aggressive letter repeating that he had no authority to utilize any copyrighted material owned by the Estate. Meanwhile,

Choukri had launched another Lennon-site, *Bagism*, this time with legal materi-
al, and finally decided to tell the story to the rest of the world—or at least to other
Lennon fans.

This case manifests in many ways the potential collision between fan activi-
ties and production companies. Henry Jenkins (1994), who has researched *Star Trek*
fans, claims that fans' cultural activities can encounter problems if a clear border
of ownership and copyrights is crossed. Jenkins writes that fans respect the origi-
nal "text," yet fear the measures that might be taken by production companies. The
usual scenario is that the original creator, like *Star Trek*'s Gene Roddenberry,
remains almost a holy figure, while the faceless industry becomes the villain of the
piece. In such a configuration the audiences do not usually possess institutional
power, but their role as consumers and meaning-makers may play an important part.
As Negus (1996) has pointed out, while audiences have historically been physical-
ly separated or dislocated from most of the sites of musical production, they have
not been separated or dislocated from the processes of musical production.

In Choukri's case the debate concerned a person no longer alive. If he exist-
ed as a "trademark" it was only through the mechanism of the estate. Reflecting
this, Choukri (1997) wrote:

> I'm proud for what Bagism has become and I like the direction it's headed. It's been a chal-
> lenge to create a compelling site without all the "eye candy" that I used freely on the for-
> mer site. To me, that shows that John Lennon is not a "thing" that a lawyer can give you
> permission to use, but rather John Lennon was a person, a real person, who left indelible
> imprint on a generation of people (and now, a second generation) that no lawyer can ever
> take away from us. The lawyers only represent John Lennon's money . . . his fans represent
> the man himself.

Choukri received a lot of support from other fans, some of whom had faced simi-
lar problems. The usual comment was that John Lennon was a believer in freedom
of speech and he would not have agreed to such activities (see "What do you
Think?" 1998). The question again returns: Would John have agreed? In this case
fans answered that, no, he would not have agreed to the "business side" and its
activities that worked against fan culture. Even though we do not know what
Lennon really would have said about Choukri's case or other similar incidents,[6] it
is obvious that people appeal to a certain image and authority of his for help.
Lennon himself is outside the debate, but since he was known as a person who
dreamt of "a better world," he is continually implicated as well as often idealized.
It could be concluded that while the post-Lennon phase of fandom is a site that
may lack institutional power, it nonetheless can contribute to maintaining certain
ideals of Lennon's stardom.

Auteur Revisited

John Lennon's star afterlife seems to be closely connected to the question of whether he would have assented to various ways of treating his life, works, and image. This question, which has perpetually been raised by critics and fans in particular, is entangled with that of the cultural ownership of Lennon's posthumous career. In this starnet pattern, Yoko Ono, the Estate of John Lennon, and tourist officers have their own ideas on the heritage of Lennon, opinions that may not satisfy critics and biographers seeking to respect or, as in some cases, sensationalize Lennon. Fans' idealization may oppose all the other elements of the starnet.

The significance of the question of cultural ownership sets Lennon apart from the majority of other dead music stars. Do we ever ask the same question with the same frequency and emphasis about Elvis Presley, Billie Holiday, or Jimi Hendrix? One reason for the significance of the question in Lennon's case presumably rests in his *auteur* status, which derives from the change of the Beatles' career in the mid 1960s. The posthumous career of Lennon may be a contested process in terms of ownership and legacy, but the view that Lennon *per se* is authentic—independent, original, innovative, visionary—is widely shared, and evidently dates from the early 1980s and the canonization process in which the unambiguous profile of a "Sixties hero" was constructed. In fact, the idea of the authentic rock auteur has become so established in retrospective thinking about Lennon that it has achieved a degree of hegemony, resulting in an obsessive search for the "real" Lennon, and the fruitless objective of establishing the "true" reading of his works. Lennon's image and reputation as a conscious, self-defining, and authoritative rock artist perpetuates his star afterlife with a force that has no equivalent in popular music culture. If Elvis today is more ubiquitous than Lennon it may partly be because he carries no such ideological controversies and is free—apart from legal restrictions—to appear everywhere. As Rodman (1996) notes, although Elvis's fans and critics have occasionally tried to put together a case for Elvis as a musical auteur of one sort or another, this dimension plays a rather insignificant role in his posthumous career (pp. 140–146).

Within the starnet of John Lennon, all controversies seem to come back to the personal qualifications of the deceased star and what he would have thought and what he would have agreed with in the world of today. Lennon is remembered as a man of opinion and as a man of voice, if not a spokesperson, for a generation. It is obvious that because of his auteur status and the tragic manner of his death, which carried connotations of the fates of political and religious leaders rather than rock stars, Lennon is not only considered a rock hero but an icon of social change and utopian impulses. Yet there are many Lennons waiting to emerge. One paradox is that just before his death Lennon was more willing to promote his survival

from "rock life" and joys of fatherhood more than world peace and political activism. These are not the qualifications Lennon is primarily remembered for now.

Regardless of whether different versions of John Lennon as a person appear, questions of legitimacy and ownership will persist in his star afterlife. Because of different interests articulated by the participants in the starnet, Lennon's stardom remains a complex and contested texture. As further recollections and hitherto unpublished Lennon products appear; as Lennon continues to be consumed, debated, and remembered; and as his stature has been almost irrevocably established, the narrative of his stardom and the question of ownership will continue to unfold. Indeed, considering the persistence of Lennon in contemporary culture, from regular rereleases of his music to forms of rock tourism and tribute concerts, and from fan culture to protean media coverage, we are simply living through another phase of the career of a star. I have a feeling that the true history of John Lennon is only just beginning.

Notes

1. Journalists have often angrily commented on Ono's authority as an executor of the Estate of John Lennon and her role as a shaper of Lennon's star image. There is no doubt that Ono has made use of this power. Take, for example, the video film arranged around "#9 Dream," released in *The John Lennon Video Collection* in 1992, which reiterates the images of the love story of John and Yoko; the song itself, however, derives from Lennon's "lost weekend" in the mid 1970s, when he had an affair with his secretary May Pang. Ono has also upset Lennon's fans by allowing Lennon's music and trademark to be used for various commercial purposes (see further Harry, 2000, pp. 271–272, 694–695, 762–764).

2. The prime case of posthumous exploitation is Jimi Hendrix: the four albums that he released during his lifetime have been supplemented by more than thirty official subsequent releases. With Lennon, by Spring 2004, the official posthumous catalogue includes two greatest hits compilations (*The John Lennon Collection*, 1982, and *Lennon Legend*, 1997), one four-CD boxed set on Lennon's solo career (*Lennon*, 1990), another four-CD box set of outtakes, home demos, and live recordings (*The John Lennon Anthology*, 1998), two albums of demo songs (*Milk and Honey*, together with Yoko Ono, 1984, and *Menlove Avenue*, 1986), one interview album (*Heart Play: Unfinished Dialogue*, with Ono, 1983), two soundtracks (*Live in New York City*, also issued on video, 1986, and *Imagine: John Lennon*, 1988), and various single records as well as remastered releases of Lennon's solo albums with bonus tracks. Other Lennon products include a posthumous collection of his writings (*Skywriting by Word of Mouth*, 1986), *The John Lennon Video Collection* (1992), and the *Lennon Legend* DVD (2003).

3. Furthermore, even though contemporary popular music stardom is characterized by regular appearances of stars in the media, the practice of live performance—the *presence* of the star—is still regarded as important (see e.g., Goodwin, 1990, p. 269; Marshall, 1997, pp. 158–159, 193–195).

4. In fact, there is even some uncertainty about the fate of Lennon's ashes after his cremation. It has been rumored that they were scattered in the sea, interred privately in England, or transferred

to some other secret place. According to Bill Harry's encyclopedia of Lennon (2000, p. 510), they were scattered in New York's Central Park.

5. Since the first post-Beatles convention in Boston, 1974, events concentrating on the celebration of the Beatles have frequently been arranged around the world. In England fan conventions with flea-market, auctions, special guests, sound-alike tribute bands, and video shows are currently organized almost every month. One area where the enthusiasm for the Beatles and Lennon seems to be constant is collecting memorabilia. After Lennon's death, items relating to him and the Beatles emerged as market leaders of pop memorabilia in the auction room, reaching a peak in the world record price of $ 2.3 million, which was paid by a Canadian millionaire in 1985 for Lennon's psychedelically painted Rolls-Royce Phantom V. The Rolls was, at that time, the most expensive used car in the world. See Harry, 1984, pp. 135–174; 1985, pp. 133–192; 1992, pp. 179–180, 240–241; Clifford 1999, p. 13.

6. It is, however, possible to ask help from a virtual Lennon. John Lennon Artificial Intelligence Project site (http://triumphpc.com/johnlennon/) re-creates the personality of a dead Beatle by programming an artificial intelligence engine with his own words.

References

Barrow, T. (1996, February). The reunion. Would John have agreed? *The Beatles Monthly Book*, 238, 5–11.

Brown, P., and S. Gaines (1983). *The love you make: An insider's story of the Beatles*. London: Pan Books.

Choukri, S. (1997, March 30). *Cease and desist*. Retrieved July 11, 1997, from http://www.bagism.com/library/cease-n-desist.html

Clifford, S. (1999, Nov/Dec). Chasing the shadow of John's (in)famous Rolls-Royce Phantom V. *Beatlology*, 5–14.

Cohen, S. (1991). *Rock culture in Liverpool: Popular music in the making*. Oxford: Clarendon Press.

———. (1997a). From the street to the museum: Popular music ethnography in the city. *Rock as Research Field*. Lecture presented for a doctoral colloquium, Magleås, Denmark.

———. (1997b). Liverpool and the Beatles: Exploring relations between music and place, text and context. In D. Schwarz, A. Kassabian, and L. Siegel (Eds.), *Keeping Score. Music, Disciplinarity, Culture* (pp. 90–106). Charlottesville and London: University Press of Virginia.

Coren, G. (1995, November 21). The Beatles: All you need is hype. *The Times* (London), p. 17.

Davis, A. (1996, February). Beatles '96: A diary of recent news and events. *The Beatles Monthly Book*, 238, 27–44.

Dyer, R. (1986/1979). *Stars*. London: British Film Institute.

Edmunds, D. (1990, May 14). The Lennon tribute. *The Times* (London), p. 13.

Elliott, A. (1999). *The Mourning of John Lennon*. Berkeley: University of California Press.

Fogo, F. (1994). *I read the news today: Social drama of John Lennon's death*. London: Littlefield Adams Quality Paperbacks.

Giuliano, G. (2001). *Lennon in America, 1971–1980: Based in part on the lost Lennon diaries*. London: Robson Books.

Gledhill, C. (1991). Signs of melodrama. In G. Gledhill (Ed.), *Stardom: Industry of desire* (pp. 207–229). London and New York: Routledge.

Goldman, A. (1981). *Elvis*. New York: McGraw–Hill.

———. (1988). *The lives of John Lennon*. New York: William Morrow.

Goodwin, A. (1990). Sample and hold: Pop music in the digital age of reproducing. In S. Frith and A. Goodwin (Eds.), *On record: Rock, pop and the written word* (pp. 258–273). London: Routledge.

Gray, M. (1990, May 7). Instant bad karma by the Mersey. *The Times* (London), p. 14.

Harry, B. (1984). *Paperback writers: The history of the Beatles in print.* London: Virgin.

———. (1985). *Beatles for sale: The Beatles memorabilia guide.* London: Virgin.

———. (1992). *The ultimate Beatles encyclopedia.* London: Virgin.

———. (2000). *The John Lennon encyclopedia.* London: Virgin.

Hertsgaard, M. (1995). *A day in the life: The music and artistry of the Beatles.* London: Macmillan.

Homer, R. (1998, n.d.). *Imagine.* Retrieved April 8, 1998, from http://mypage.direct.ca/r/rhomer/rob.html

Humphries, P. (1995, August 18). Dead pop stars mean big bucks. *The Guardian*, p. FR 13.

Jenkins, H. (1994). Star Trek rerun, reread, rewritten: Fan writing as textual poaching. In H. Newcomb (Ed.), *Television: The critical view* (pp. 448–473). New York and Oxford: Oxford University Press.

King of Marigold. (1998, Feb 24). [Untitled review]. Retrieved April 8, 1998, from http://www.bagism.com/library/book-reviews.html

Mäkelä, J. (1999). The outsider within: The Beatles and the re-evaluation of the North in the early 1960s. In M. Leskelä (Ed.), *Outsiders or insiders? Constructing identities in an integrating Europe* (pp. 126–136). Finland: University of Turku, Doctoral Program on Cultural Interaction and Integration 4.

———. (2001). The greatest story of pop music? Challenges of writing the Beatles history. In Y. Heinonen, M. Heuger, S. Whiteley, T. Nurmesjärvi, and J. Koskimäki (Eds.), *Beatlestudies 3: Proceedings of the Beatles 2000 conference* (Research Reports 23) (pp. 47–55). Finland: University of Jyväskylä, Department of Music.

Marcus, G. (1992). *Dead Elvis. A chronicle of a cultural obsession.* London: Penguin Books.

Marshall, P. D. (1997). *Celebrity and power: Fame in contemporary culture.* Minneapolis and London: University of Minnesota Press.

Miles, B. (2000, Winter). Nemesis! *Mojo Special Edition*, 100–103.

Moran, C. (1994, June 24). Whisper words of wisdom: Let it be. *The Times* (London), p. 36.

———. (1995, December 1). Let me take you down, 'cause I'm going to. *The Times* (London), p. 37.

Negus, K. (1996). *Popular music in theory: An introduction.* Cambridge and Oxford: Polity Press.

Norman, P. (1988, September 11). My John. *The Sunday Times*, p. A15.

Nurmesjärvi, T. (2000). Liverpudlian identity of the early Beatles (1957–62). In Y. Heinonen, J. Koskimäki, S. Niemi, and T. Nurmesjärvi (Eds.), *Beatlestudies 2: History, identity, authenticity* (Research Reports 23) (pp. 87–110). Finland: University of Jyväskylä, Department of Music.

Ono, Y. (2000, Winter). "Assassin with a pen:" Yoko Ono breaks her silence on Goldman. *Mojo Special Edition*, 103.

Pang, M. and H. Edwards (1983). *Loving John.* New York: Warner.

Plasketes, G. (1997). *Images of Elvis Presely in American culture 1977–1997: The mystery terrain.* New York and London: Harrington Park Press.

Rodman, G. B. (1996). *Elvis after Elvis: The posthumous career of a living legend.* London and New York: Routledge.

Rosen, R. (2000). *Nowhere man: The final days of John Lennon.* London: Fusion Press.

Shank, B. (1994). *Dissonant identities: The rock'n'roll scene in Austin, Texas.* Hanover: Wesleyan University Press.

Sheff, D. (1981, January). Playboy interview: John Lennon and Yoko Ono. *Playboy*, 75–114, 144.

Straw, W. (1991). Systems of articulation, logics of change: Communities and scenes in popular music. *Cultural Studies, 5*(3), 368–388.

Sweeting, A. (1988, December 8). A raker's progress. *The Guardian*, p. 25.

Thornber, R. (1990, May 3). Are they gonna crucify Lennon? *The Guardian*, p. 27.

What do you Think? (1998, February 26). Retrieved April 8, 1998, from http://cgi.dreamscape.com/southrup/page-closings.html

Williams, R. (1988, August 10). With a little help from his friends? *The Times* (London), p. 9.

Taming the Wildest

What We've Made of Louis Prima

JOHN J. PAULY

For over forty years, Louis Prima had survived one change after another in the pop-ular music business. He was, in succession, a trumpet section player in his home-town of New Orleans, the front man for a popular New York City jazz quintet, and the leader of a touring big band. In the 1950s, with his career flagging, he reinvent-ed himself as a spectacular Las Vegas lounge act, then nudged his career through the 1960s with help from his old friend, Walt Disney. He explored many forms of popular music along the way, but aspired only, in his own words, to "play pretty for the people." The same man who wrote the jazz classic "Sing, Sing, Sing," would also record easy listening instrumental music, Disney movie soundtracks, and Italian-American novelty songs. In all these reincarnations, he performed with an exuberance that inspired his Vegas nickname, "the wildest." Prima's career would end in deafening silence, however. He spent the last thirty-five months of his life in a coma, following a 1975 operation in which doctors partially removed a benign tumor from his brain stem. The inscription on his crypt in Metairie Cemetery out-side New Orleans left his fans with one last, familiar lyric—"When the end comes, I know, they'll say 'Just a gigolo,' as life goes on without me."

Not quite, as it turns out. Twenty-five years after his death, Prima is with us still, an inescapable virtual presence. He lingers on, as a familiar voice on movie soundtracks and television commercials, an avatar of the swing music revival, and an icon of masculine excess. I want to interpret Prima's resurrection (his latest, real-

ly) as an example of the afterlife that now awaits many dead performers. His traces are everywhere—in reissued recordings, movie soundtracks, television commercials, documentaries, styles of dance and dress, homages and imitators, legal disputes, websites, and revived careers for former colleagues. The technology and economics of digital recording have done much to power his revival. Prima's music never quite went out of circulation, and through the 1980s and '90s many older fans still remembered his Vegas, club, and television performances. As younger listeners began to discover his music, too, "Louis Prima" became a profitable marketing concept. And his value continues to appreciate as family members fight media conglomerates for ownership of his voice and persona, his virtual body. Thanks to the new digital technologies of preservation and dissemination, musicians, like writers, need never die. They will survive, if nothing else, as economic and legal artifacts. Indeed, the dead celebrity has become a valued commodity, a wasting resource always ready to meet the voracious demands of the culture industries (Beard, 1993; 2001).

And yet, technology and economics cannot wholly explain the renewed interest in Prima. As a cultural icon, he continues to intrigue Americans, though in many respects his virtual resurrection would seem unexpected. His career, after all, had peaked for the last time in the early 1960s; his style of New Orleans jazz had fallen into disfavor long before he developed his Vegas act. Nor did he ever achieve the artistic reputation of many other players, composers, or bandleaders; Louis Armstrong, who greatly influenced Prima's style, thought him a fine trumpeter (Armstrong, 1999, p. 34), but many critics found his work derivative or dismissed him as a mere entertainer. Prima was aggressively commercial, constantly adapting his music to the demands of the marketplace. He often impressed others as less polished than Italian-American contemporaries like Frank Sinatra, Dean Martin, and Tony Bennett. Many simply found him difficult to fathom—hard and calculating in his business dealings, withdrawn and private when off stage, given to profligate infidelity, a man with four ex-wives and not many close friends. In short, a person unlikely to inspire adulation.

Why Prima, then? No single answer will suffice. Prima still headlines at a small number of venues, most notably in the acts of imitators, in a biography and a documentary, and on a handful of websites. But, for the most part, he has steadily blended into the cultural scenery. His revival, revealingly, has been more aural than visual. Prima's image circulates, but not nearly as widely as his sound. CDs of his reissued music commonly use drawings or photographs of him; one can find old promotional photographs of Prima for sale on eBay; and at least one fan has designed a Prima tattoo (www.bulztattooz.com). But there is no Prima iconography analogous to that of other dead performers like Elvis, Jim Morrison, Jimi Hendrix, and Sinatra. It is Prima's voice that lingers: on the playlists of jazz and retro radio pro-

grams, on the soundtracks of movies with Italian-American characters and themes, as an echo in the performances of Keely Smith and Sam Butera, as the animating spirit of King Louie in the Disney film *Jungle Book* (1967).

If we listen closely to all these voices, however, we can hear the whispers of another tale. The Prima revival can plausibly be interpreted as a fable of cultural assimilation. This may, in fact, be one of Americans' common uses of dead celebrities: to render ethnic groups more recognizably American. While alive, Prima neither hid nor softened his Italianness. His virtual presence simultaneously resurrects his ethnicity and buries it. He reappears among us as a wild, swinging Vegas showman, but disappears as the driven, restless Italian American who, though popular, never quite earned a place of honor in either the white or black music communities. Prima was often popular with all sorts of audiences. His exuberance and sense of swing made him a favorite performer in Harlem theaters of the 1940s (Dance, 1973, pp. 413–15). And yet Prima, the musician, has often been dismissed or ignored by both white and black critics. His blending of musical styles made him hard to categorize. White mainstream publications increasingly portrayed his act as vulgar or corny, and black jazz critics have simply ignored his contributions, despite the obvious influence of Armstrong on Prima's style.

So my purposes are two. First, I want to document the range and depth of the Prima revival, and the economic, technological, and social forces that have propelled it. Second, I want to interpret the meaning of that revival. In particular, I will suggest that, in American culture, the afterlife promises that all groups can be assimilated, and the wildness of cultural difference tamed. But, deep in the shadows of that afterlife, we can discern other images as well. "Louis Prima" has survived and prospered, but Louis Prima remains inscrutable, a reminder of the persistent contradictions of American ethnicity.

Origins of the Revival

Louis Prima's music never entirely disappeared from the market—a simple fact that would make his revival more plausible to recording companies. The albums he recorded in the last years of his life, under his own Prima Magnagroove label, sold badly. But much of his work remained available. In 1974 Columbia House released two albums of greatest hits, one with mostly Italian, the other with mostly Vegas songs—a sign that, while Prima was no longer news, an identifiable audience continued to remember his work. Compilations of swing and jazz music regularly included his recordings. For example, he appeared on a 1987 Columbia release of tracks by singers of the 1930s. His international reputation has persisted, too. Europeans have long admired his style of jazz, despite the fact that Prima was afraid to fly and thus did not tour Europe as so many other jazz musicians had. This inter-

est has continued since his death. In the 1980s, for example, Capitol released Prima's 1957 album *The Wildest Show at Tahoe* in France, and in England, Magic released an album of Prima's orchestra music from the 1940s. In the 1990s, the London-based publisher Jasmine would rerelease many of his older recordings on CDs.

These albums, tapes, and CDs catered to aficionados with special interests in jazz and swing. The popular resurrection of Prima, however, began elsewhere, with rocker David Lee Roth, formerly lead singer of Van Halen. Roth kicked off his solo career in 1985 with a popular cover of one of Prima's most famous medleys, "Just a Gigolo/I Ain't Got Nobody," on his album *Crazy from the Heat*. (Sam Butera, saxophonist and leader of Prima's Vegas band, the Witnesses, would later complain that Roth had copied—and copyrighted—his arrangement with no recognition or compensation [Jensen, 2002].) Occasional covers of Prima songs marked the early days of the revival. In 1988, for example, Los Lobos recorded a version of the *Jungle Book* showstopper "I Wan'na Be Like You" as part of a project called *Stay Awake*, in which contemporary artists interpreted classic Disney songs. Another mark of the building interest was journalist Garry Boulard's 1989 biography of Prima, published through the Center for Louisiana Studies at the University of Southwestern Louisiana. (More recently, Boulard has benefited from what he helped create. In August 2002, the University of Illinois Press published a paperback version—another sign of how much the Prima market had expanded in the 1990s.)

And yet, apart from Boulard's biography, Prima has figured little in the official histories of either jazz or popular music. By comparison, more famous artists like Louis Armstrong and Frank Sinatra have been the subject of dozens of biographical works, and many other jazz and swing musicians have attracted more serious, sustained attention. It is a simple but stunning fact that Prima's name can barely be found in the recent histories of jazz. Prima appears nowhere in James Lincoln Collier's (1993) *Jazz: The American Theme Song*, Burton Peretti's (1997) *Jazz in American Culture*, or Geoffrey Ward and Ken Burns's (2000) *Jazz: A History of America's Music*. In other works, he receives just one or two mentions, as a passing example in discussions about other musicians. In Gunther Schuller's (1968, p. 802) *The Swing Era* or Gary Giddins's (1998, p. 132) *Visions of Jazz*, he appears in relation to fellow musicians, such as the clarinetists Sidney Arodin and Pee Wee Russell; in Ted Gioia's (1997, p. 67) *The History of Jazz*, and Alyn Shipton's (2001, p. 589) *A New History of Jazz*, he is mentioned as an example of Armstrong's influence. Where given more attention, as in Richard Sudhalter's (1999) controversial *Lost Chords*, Prima appears as an instance of a larger argument about the racial hierarchy of jazz, or he surfaces in books on specialized topics like Vegas (Vera, 1999), 52nd Street (Shaw, 1977), or swing (Yanow, 2000). A simple comparison dramatizes the general absence of a public discourse about Prima. Leonard Mustazza

(1998) notes that Frank Sinatra received steady press coverage across his career, from his debut at the Paramount in 1942 until his death in 1998. In that time, Sinatra's name appeared at least once in every volume of *Reader's Guide to Periodical Literature*. From his 1935 debut at the Famous Door in New York City through the end of 2002, Prima's name appeared just five times in *Reader's Guide*—in a 1945 article in *Life*, three 1950s articles in *Life*, *Newsweek*, and *Time* on his Vegas act, and an obituary in *Downbeat*—despite the fact that his music sold steadily through most of that period. In the 1990s, at the height of the revival, *Reader's Guide* contained just one cite—a 1998 article in *Vanity Fair* on him and Keely Smith.

How, then, should we explain these interwoven processes of remembrance and amnesia? Why have Prima's voice, music, and persona spread so quickly in some domains but, in the long run, left so slight a mark on our memory of jazz and popular culture?

Memory as a Marketing Concept

In retrospect, the trajectory of the revival, at least, is clear. One can detect five key moments that have made "Louis Prima" a viable marketing concept: (1) Disney's steady, assertive promotion of *Jungle Book*; (2) the inclusion of Prima music in movie soundtracks with Italian-American themes and characters; (3) the increasing general interest in swing music, the 1950s, and Las Vegas; (4) the Gap's use of "Jump Jive an' Wail" in an acclaimed television ad campaign; and (5) a well-regarded 1999 documentary by Don McGlynn, shown on the American Movie Classics cable channel and in film festivals across the country. Each successful appropriation of Prima's music and style sparked new interest among producers as well as consumers, creating the echoes that we interpret as signs of popularity. Music fans in America and Europe probably could have sustained a modest market for Prima's CDs, even in the absence of large-scale promotions like the Disney movie or the Gap campaign. The power of commerce and cross-marketing, however, turned up the volume, widened the potential audience, and extended "Prima's" shelf life.

The 1967 recording of the *Jungle Book* song "I Wan'na Be Like You" would set the stage for the revival. Though highly regarded by Prima fans and subsequently covered by groups from the Royal Philharmonic Orchestra to Big Bad Voodoo Daddy, the song does not resemble the usual Disney fare. An August 2001 story on the Disney fan website laughingplace.com does not even include it on a list of the 101 greatest songs in Disney movies. The composers, Robert and Richard Sherman, generally wrote what one might loosely describe as Broadway songs for children. Their more than 150 songs for Disney in the 1960s included the entire score for *Mary Poppins* (1964), songs for animated films such as *The Sword in the Stone* (1963), and *The Aristocats* (1970), the theme song for the *Winnie the Pooh* short

films, as well as individual songs like "The Wonderful Thing about Tiggers," and music for animated features in Disney theme parks, including "It's a Small World (After All)"—originally written for the 1964 New York World's Fair (Lyons, 2000).

But "I Wan'na Be Like You" is perhaps the jazziest number in the entire body of Disney animated films. (By comparison, the company's 1968 album *Disney the Satchmo Way* was much tamer, with Louis Armstrong singing well within conventional Disney arrangements.) In *Jungle Book*, Prima provides the voice for King Louie, an orangutan who commands an army of monkeys deep in the jungle. The monkeys capture the boy Mowgli and bring him to Louie, who hopes to learn the secret of fire so that he can move up the evolutionary ladder. The song features, among other things, a rollicking scat duo with Phil Harris and a brassy Dixieland-style trumpet bridge. Such music might have seemed at home in Disney or Warner Brothers cartoons of the 1930s and 40s, but in an age of rock and roll, it seemed an anomaly, especially in a film for children. "I Wan'na Be Like You" was not even the film's featured song. Phil Harris's performance of "Bare Necessities" was the one nominated for that year's Academy Award for best song.

The choice of Prima for the role represented only one moment in a decades-long relationship between Walt Disney and the singer. The two had first met at the Los Angeles Famous Door club in the 1930s. Over the years the two men shared an interest in horses, and in the 1950s Disney would occasionally catch the singer's Vegas act. Before *Jungle Book*, Prima had sung the theme song for *That Darn Cat* (1965) and recorded *Let's Fly with Mary Poppins* (1965), an album of cover versions of songs from the movie. Disney may have chosen Prima to play King Louie because he remembered the singer's 1947 novelty hit "Civilization (Bongo, Bongo, Bongo)," in which the narrator refuses to leave the jungle for the supposed benefits of civilization. But he was also shrewdly capitalizing on Prima's well-known style of performance. Indeed, *Jungle Book* marked a change in the way the Disney studio produced animated features. The film's characters closely imitated the personas of the stage and film actors who played them. As one Disney historian (Grant, 1987) notes, "Shere Khan the tiger *is* George Sanders, Baloo the bear *is* Phil Harris, and King Louie *is* Louis Prima" (p. 255). This approach to casting voice actors soon became standard in Disney animated films (Robin Williams *is* the genie in *Aladdin*). The animators even mimicked the actors' style of gesture. For decades they had sketched animals at zoos, and the studio had even created a life-drawing class on the lot in 1932, to help artists make their life drawings more realistic (Canemaker, 1999, p. 11). But ultimately artists controlled the style of animation. For "I Wan'na Be Like You," however, the company filmed the performance of Prima's Vegas band, then instructed the animators to copy the movements of Prima and his musicians. (Footage of this filming is included as extra material at the end of the thirtieth anniversary videotape of the movie, issued in 1997.)

"I Wan'na Be Like You" (sometimes referred to as "The Monkey Song") is now widely regarded as the last great hit of Prima's career. By carefully planning rereleases of both *Jungle Book* and its soundtrack, Disney has kept Prima's performance alive for decades. When originally released in 1967, the film grossed $26 million. The company rereleased it in theaters in 1978, 1984, and 1990, and throughout Europe in the mid '80s. In its 1990 release, *Jungle Book* grossed $44.6 million, making it one of the top twenty-five earning films that year (Zad, 1991, p. Y6). Its total theatrical revenues, in its four releases, were $130 million by 1991, making it the second-highest grossing Disney film in history at that time (Stevenson, 1991, p. 9). A digitally mastered videotape was released in 1991, then rereleased in 1997 on the film's thirtieth anniversary, with extra footage about the making of the film; the 1997 release also included tie-ins with McDonald's Happy Meals, Amtrak tickets, and Kid Cuisine coupons (McCormick, 1997). The Disney Channel played the film in May 1992 to celebrate the twenty-fifth anniversary of its original release. In 1994 Disney made the story into a live-action film, and in 2003 released an animated sequel. (For reasons I will explain later, the sequel does not include the King Louie character.) The film's music went through parallel cycles of packaging and repackaging. The original *Jungle Book* album and a subsequent *More Jungle Book* album went gold. In 1979, and again in 1985, Disney released audiotape versions. From 1988 to 1992, it released various covers of the song as part of different collections. In 1997 it released a remastered CD that included two demo tracks not on the original. In 1998, with interest in Prima increasing, Disney rereleased a CD of *Let's Fly with Mary Poppins*—an album he had made with his last wife, Gia Maione.

Though Prima appeared in twenty films of varying length, the revival has not resuscitated his movies. The singer had moved to Los Angeles in 1935, hoping to break into the movies and use them to promote his music. Prima ultimately found little success there. Like other musicians of the period, he appeared in musical shorts such as *Manhattan Merry Go Round* (1937). And his success in New York and Los Angeles occasionally won him minor roles in feature films such as *Rhythm on the Range* (1936) and *Rose of Washington Square* (1939). But, like other bandleaders, he was often hired to depict himself. His later music films such as *Hey Boy, Hey Girl!* (1959, with Keely Smith) and *Twist All Night* (1961) capitalized on the popularity of his Vegas act. Such movies have not figured at all in the Prima revival. His voice, however, has lingered in several soundtracks in the 1990s. Most famously, of course, Stanley Tucci's film *Big Night* (1996) treats him as an Italian-American Godot. Two brothers who own a struggling Italian restaurant allow a competitor to convince them that a visit from Prima would create the buzz needed to make their restaurant popular. Prima's music also appeared in the soundtracks of many other Hollywood films, including *Mad Dog and Glory* (1993), *Casino* (1995), *Forget*

Paris (1995), *Smoke* (1997), *The Bachelor* (1999), and *Mickey Blue Eyes* (1999). In *Mad Dog and Glory*, the shy and sad murder investigator, played by Robert De Niro, invokes Prima as his passionate alter ego. Most frequently in such films, Prima's music helped create the aural signature for Italianness, establishing the presumed authenticity of the ethnic setting and characters.

Prima's popularity in the 1990s was frequently interpreted as evidence of a retro swing movement. Histories of that movement often traced its beginnings to the formation of the Royal Crown Revue in 1989 (Yanow, 2000, p. 475). A parade of other popular groups soon followed, such as Big Bad Voodoo Daddy, Indigo Swing, New Morty Show, Squirrel Nut Zippers, and Cherry Poppin' Daddies. Scott Yanow's *Swing* (2000) highlighted thirty-seven contemporary retro groups; one website identified over 150 retro-new swing groups in the United States alone (http://64.33.34.112/.WWW.swing.html). This swing revival echoed a long-felt nostalgia for the big band. After World War II, such bands had expired—the victims of free television, an expanding leisure market, and their own extravagant economics. Older fans, discouraged by rock's domination of popular music, have periodically yearned for a return to swing. (And occasionally, always unsuccessfully, an individual musician such as Benny Goodman had attempted a comeback.) But retro swing did not feature big bands. With rare exceptions such as the Brian Setzer orchestra, most retro bands are comprised of between six and eight musicians. What they borrowed were the visible signs of swing: its energy, rhythms, brass and saxophone orchestration, dance steps, and costumes. The popularity of these new bands also encouraged the growth of a support network—an infrastructure of secondhand clothing stores, dance lessons, radio formats, websites, and clubs.

Commentators often cited Prima as both cause and effect of the retro swing movement. New swing musicians, for example, often named him as one of the performers who had inspired their work. Sometimes the homage to Prima was explicit. Brian Setzer, former lead singer of the rockabilly group Stray Cats, often acknowledged Prima's influence. Setzer, who organized a swing orchestra in the 1990s, even recorded a song about Prima, "Hey, Louis Prima," for his 1996 CD *Guitar Slinger*. At about the same time that Gap clothing stores were using Prima's "Jump, Jive an' Wail" for its ad campaign, Setzer released a cover of the song, winning himself a Grammy in 1998. The swing trend, in turn, created new opportunities to hear Prima's recordings at dance clubs and on specialized radio programs. Even now, one hears his Capitol greatest hits CD surprisingly often as background music in restaurants. Similarly, small, local groups and DJs frequently advertise themselves as playing Prima standards.

And yet Prima has probably influenced the actual music of the most popular retro groups less than their encomiums suggest. From the beginning, those groups freely mixed swing rhythms with ska, punk, jump blues, R&B, and rockabilly.

They made a point of writing and arranging their own songs, not merely reviving older tunes. And though they may have performed Prima in concert, they rarely recorded his songs. In all the recordings of the major swing bands listed above, one can find covers of "Swing, Swing, Swing" by Royal Crown Review and "I Wan'na Be Like You" by Big Bad Voodoo Daddy, and versions here and there of songs Prima recorded but did not make famous, such as "Mack the Knife," "Caledonia," "My Baby Just Cares for Me," and "Just One of Those Things." Not one of these groups has recorded any of the Italian hits, or the Prima-Smith Grammy winner "That Old Black Magic," or Prima standards like "I've Got You Under My Skin." The retro swing bands made their own way, borrowing the musical conceits of swing when it suited them—citing Prima when interviewed—but only rarely imitating him. They, too, hitched their stars to "Louis Prima" the marketing concept, invoking him to mark off a space in the marketplace that they, too, hoped to occupy. They referenced his work in order to make their own more commercially and culturally plausible. The publishers of Prima's work benefited, too, for they could point to retro swing as evidence of the singer's legacy.

The truest Prima imitators may be overseas. These groups, which rarely perform in the United States, have made the Prima revival an international phenomenon. Bands in Europe, Canada, New Zealand, and Australia have often played his music in the spirit of homage, staying rather close to the Prima standards and Butera arrangements. For example, the French septet Les Gigolos (http://lesgigolos.free.fr/) promises a program of "Louis Prima memories" that tries to capture the "Primalchimie" of the "grand crooner natif de las Nouvelle-Orléans." The German groups Vitello Tonnato and the Roaring Zucchinis (http://www.zucchinis.de/) and Jive Sharks (http://www.jivesharks.com/) both advertise themselves as admiring interpreters of Prima's work. Toronto's six-piece band Prima Donnas (http://www.makeitrealrecords.com/primadonnas2.htm) says it began by playing jump swing, Prima style, then began mixing jump blues, swing, ska, and rock 'n' roll. Prima Swing Riot (http://www.primaswing.co.nz/) advertises itself as the "hottest show band" in Auckland, New Zealand; a seven-piece group, it features covers of the Prima-Smith-Butera hits of the 1950s and 1960s. In Australia, the eight-piece band Zooma, Zooma (http://www.thegov.com.au/artists/z/zooma_zooma.htm) advertises itself as a "tribute band playing the music of Louis Prima, the doyen of Italian / American jazz." Prima is also the name of a seven-piece Swedish band that performs the Italian-novelty songs with comic grandeur and more than a hint of polka rhythm and instrumentation (http://hem.passagen.se/prima1/?noframe).

Not surprisingly, the revival has produced its share of outright imitators, especially of the Vegas act. When their singing careers lagged, Sonny and Cher modeled their new television act after Prima and Smith—he the bombastic lecher, she

the bored cynic. But other pairs have cast themselves explicitly as tribute groups. While Prima was still alive, his third wife, Lily Ann Carol, had already begun performing a Prima-style act with Joe Barone (Wilson, 1982). Similarly, trumpet player and singer Russ Marlo began imitating Prima in the 1960s (on a dare, he said) and went on to develop a Prima-Smith show with a series of women partners (Kirby, 1989). New Orleans musician Bobbie Lonero, who performed with Prima in the 1970s, plays a tribute show with his wife, Judi (Lind, 2000). The performer who most closely follows Prima's style (and approaches his talent) may be the British saxophonist and singer Ray Gelato. In 1980s London, he had performed with the Chevalier Brothers, one of the earliest new swing groups. He formed his own band in 1988, now known as Ray Gelato and the Giants. Gelato's style bears strong marks of Prima's influence. For example, half of the songs on his 2000 CD *Live in Italy* are Prima standards, like "Buona Sera," "Oh, Marie," and "Lazy River." Keely Smith and Sam Butera have similarly prospered in the revival by staying rather close to the style they developed working in Vegas. Even Prima's daughters have prospered from public interest in their father's work. Joyce, daughter by Prima's first wife, Louise Pollizi, periodically performs around New Orleans. Luanne and Toni sang backup vocals on their mother Keely Smith's 2000 CD *Swing, Swing, Swing*. And Lena, daughter by fifth wife Maione, is pursuing a career playing her father's music at Italian-American festivals and clubs.

Swing's popularity made it attractive as an idiom for advertising and marketing. Most famously, the Gap clothing store chain used Prima's "Jump, Jive an' Wail" as the soundtrack for its wildly popular 1998 television ad "Khakis Swing" (Cuneo, 1998; Elliott, 1999). That ad was one of three (the other two were titled "Khakis Rock" and "Khakis Groove"). Each was created by a well-known director around a musical theme. To describe the ad—young couples in khaki pants swing dancing against a white background—does not begin to capture its stylishness and energy. The song itself is pure Prima. He wrote both the melody and the lyrics, and the arrangement prominently showcased Smith and Butera and the Witnesses. The song, as viewers heard it at that moment, perfectly blended '50s Vegas and '90s retro swing. It featured a classic shuffle rhythm with strong rock 'n' roll undertones, and its dancers resembled the young people who were jitterbugging in the clubs. "Khakis Swing" ran again the following month during the *Seinfeld* finale (Ross, 1998). Public and professional response to the ads was so positive that Gap brought them back the following fall, for the season premieres of *Monday Night Football*, *ER*, *Felicity*, *Ally McBeal*, *Party of Five*, and *The Practice*. Over the next year, "Khakis Swing" set the model for subsequent Gap ad campaigns. In spring 1999, Gap used the Academy Awards ceremony to debut three new spots, featuring go-go, soul, and country music. All this publicity soon forged "Jump, Jive an' Wail" into a handy

cultural shorthand for all swingness, and newspaper and magazine writers, cultural critics, and marketers cashed it in (as when Hal Leonard Publishing issued its *Louis Prima Songbook: Jump, Jive An Wail* in 1999).

The enhanced value of "Louis Prima," the marketing concept, has fueled legal battles over royalties and ownership. Consider the career of "Sing, Sing, Sing." First written and performed by Prima in the 1930s, Benny Goodman and Gene Krupa soon made it their own. (Goodman considered it a "killer diller" number.) In the 1980s and 1990s, the song served as an anthem of swing in many venues. Bob Fosse used it in his 1978 musical *Dancin'*; by summer 2000, it had served as featured finale in three Broadway musicals: *Fosse*, *Contact*, and *Swing!* The royalties from these uses have been substantial. Maione estimates that "Sing, Sing, Sing" has generated as much as $100,000 annually over the last several years (Spera, 2002).

Since Prima's estate was finally settled in 1993, among the conflicting claims of his many families, Maione has tried to consolidate control of his legacy. She has tenaciously pursued companies who used the singer's persona without permission or compensation. In 1998, she sued Campbell Soup over a Prego spaghetti sauce ad lyric sung by a Prima sound-alike (Von Bergen, 1998). In the following years she sued Darden Restaurants over an Olive Garden ad that prominently featured "Oh, Marie" performed in Prima's style by a sound-alike singer, though with a different arrangement (Louis Prima's widow, 2000). Both companies settled out of court. More recently, Maione has sued Unidisc Music Inc., a Canadian company that acquired Prima's songs at auction in 2000, alleging that Unidisc (like Simitar, the company that first owned the songs) had failed to pay royalties. In the same spirit of consolidation, she has established an extensive official website (www.louisprima.com), and in 2002 she published remastered CDs of eight albums the singer had recorded and produced on his own label in the last decade of his life.

The Unidisc suit sounds like a familiar battle over music royalties. But Maione's other suits have tested the emerging legal right of publicity. Frankel (2000) notes that "the early right of publicity statutes and cases prohibited only the use of a person's name, portrait and likeness," but recent cases have protected voice imitations and "personality and style of performance" as well. The very qualities that made Prima attractive to Disney and other media companies—his distinctive voice and persona—have strengthened Maione's claims. Most revealing has been the outcome of Maione's suit in 2000 over royalties due Prima's estate from videocassette and DVD sales of *Jungle Book*. Prima had been paid $1,500 a day for his voice work and granted royalties on "all forms of recording and reproduction manufactured by any method and intended primarily for use as home entertainment" (Miester, 2001). Maione's was the latest in a line of similar suits against Disney. In 1991, singer Peggy Lee had won $2.3 million in damages for unpaid royalties on *Lady and the Tramp*

(1955). Mary Costa, the voice of Sleeping Beauty, and Phil Harris had settled similar cases out of court. Following these precedents, Maione's lawyers argued for a more generous interpretation of "home entertainment."

Disney settled out of court in May 2001, but has subsequently acted to limit future royalties to Prima's estate. Over the years, the company incorporated King Louie into other materials it developed. For instance, the orangutan had appeared in two Disney animated television series in the 1990s—*Tale Spin* and the prequel *Jungle Cubs*—with Jim Cummings imitating Prima's voice. But, given the outcome of the Maione and other suits, Disney told the producers of the recent animated television series *House of Mouse* that they could no longer use King Louie the same way. The producers renamed the character King Larry and asked Cummings to alter his voice impression slightly to forestall future claims. The 2003 theatrical sequel *Jungle Book 2* does not even include the King Louie character (Hill, 2002). As the final credits roll, "I Wan'na Be Like You" is performed by the band Smash Mouth. Disney's actions in this case likely foreshadow the strategies they and other media companies will use to sidestep artists' claims.

The Prima revival of the 1990s culminated in Don McGlynn's documentary *The Wildest* (1999), which focused exclusively on Prima's life and music. The film portrayed Prima as much more than just another influence on the contemporary music scene. In fact, the film does not mention retro swing. Instead, Prima's former colleagues and family describe him as the very epitome of the modern entertainer. Like other documentaries, *The Wildest* was screened at a variety of smaller venues, such as film festivals, art museums, and university campuses. Its popularity grew after it was run, then rerun, on the American Movie Classics cable channel. Reviews of the film were generally positive. Many critics praised McGlynn for including so much footage of Prima performing on the Ed Sullivan television show, in movies, and in clubs. The filmmaker also interviewed many people who had worked with or known Prima, including fellow musicians like Butera, Smith, and drummer Jimmy Vincent, Maione and other family members, jazz musicologists and archivists, and Italian-American *paesani*. The effect, in general, was hagiographic. After years of neglect, Prima had received his due. Yet, as many critics noted, the film softened the contradictoriness and difficulty of Prima's life and career. A darker tale remained to be told.

Memory and Ethnicity

After a decade of publicity and promotion, had any aspect of Prima's work and life escaped documentation? Actually, yes. Significant silences still abound. The revival has arguably obscured the deepest source of Prima's identity as well as of his truest

fans' identification with him: his Italian-American heritage. McGlynn's documentary may have been uncritical in its assessment of Prima, but it saw this point quite clearly. As one character in the documentary puts it, many Italian-Americans considered Prima's music the soundtrack of their communal life (Lauro and McGlynn, 1999). The revival, by contrast, has merely glossed Prima's ethnicity. He has been praised most for his deracinated qualities—for his boundless energy, hipness, and good-time spirit. For new fans, he is King Louie and Vegas and 52nd Street. And yet, for Italian-Americans, the revival has deeply affirmed Prima's ethnicity and secured his place in the history of American music. It is they who honor him as a son of New Orleans, put his face on the medal of the Italian-American Foundation, and lobby for a stamp with his image. It is they who fondly remember him not just for "That Old Black Magic" and "Just a Gigolo," but for "Oh, Marie," "Angelina/Zooma Zooma," and "Felicia No Capicia"—the very songs that virtually no other musicians (except those of Italian descent) have covered.

Prima's ethnicity clearly defined his place in American music in his own time. The 1959 *Time* magazine piece on Prima and Smith, entitled "The Wages of Vulgarity," aptly illustrates the ways in which others constructed his reputation. It opens as follows:

> The brassy, bulb-nosed, toupeed trumpeter, seeming like a frayed hangover from the night before, began to sing and prance. Somehow, his grinding, gravel-voiced antics made the simple lyrics of "When You're Smiling" as suggestive as the spiel of a strip-show pitchman. (p. 50)

The story then reflects on the fact that Prima and Smith's "doggedly vulgar" act is "one of the hottest things on the U.S. nightclub circuit." It describes Prima's sidemen as "writhing" and Prima as "salting [his songs] with off-color phrases and gyrations." Smith is described as "all bumps and grinds, suggestive lilt and lyrics"—behavior that causes Prima to "yowl around like a hopped-up tomcat." The story briefly traces his rise, from a struggling "ham-and-egger" who "bounced around clubs in the '30s, then flopped with his big band in the '40s." It dismisses his Italian novelty numbers as "garlicky dialogue records . . . of little appeal." What was the secret of Prima and Smith's success, according to the *Time* writer? The low tastes of the Vegas lounge audience and Prima's ability to make his "bull bellow" heard above the noise of the lounge. The singer's formula, a subheading suggests, is "garlic and corn." His motive, the story concludes, is money: "The dollars come tumbling down the chute, but never fast enough for Prima."

It takes no talent for cultural studies to recognize the glaring stereotypes in this passage. Most striking, however, is the timing of the story. It appeared at the very height of Prima's career—in 1959, a year in which he commanded $10,000 a week at the Sahara, had won a Grammy, would appear two weeks later on a television tribute to Jerome Kern, and enjoyed the release of his first feature film in twenty

years. *Time*'s tone of WASP contempt was surely evident to many readers, especially Italian-Americans. (How often in its history, after all, has *Time* used the word "garlic" twice in the space of a 700-word story?) But the timing—three years after the *Life* profile, over a year after the *Newsweek* story—suggests a deeper sense of purpose. There was no obvious news peg for the story. *Time* was simply surveying the cultural scene, trying to figure out why Prima and Smith continued to be wildly popular, more than four years after their Vegas debut. The magazine proposed to put the nation's cultural categories back in place.

Prima invited such scrutiny because his persona embodied two contentious cultural discourses—one about the status of ethnic Americans (especially those who chose not to hide their origins), and one about aesthetic standards. Critics coded Prima as both other and low, and discussions of his music constantly drew upon these invidious distinctions. Italians, in fact, have a word for this combination of ethnicity and vulgarity: *gavone*. In southern Italian dialect, it signifies a low-class person. Italian-Americans apply the term—sometimes critically, sometimes fondly—to anything extravagantly expressive, audacious, tacky, and sexualized. Versace was *gavone* (and Armani is not). As the journalist Maria Laurino (2000, p. 52) has noted, the concept of *gavone* echoes a general stereotype of southern Italians as "amoral/uncivic/smelly." In essence, then, the *Time* story dismissed Prima as *gavone*: loud, crude, and sexually suggestive.

Italian-Americans find themselves both employing and defending themselves against this stereotype. On one hand, *gavone* extravagantly displays and performs their Italianness; on the other, it positions them in the wider society, often to their disadvantage. Prima lived on the cusp of this contradiction. He was an example of what Michael Novak (1996) once called "the unmeltable ethnic." He never hid his Italianness. He performed his novelty songs even during World War II. His style was always highly sexualized, more direct and less dreamy than Sinatra, his lyrics more likely to ask than to hint ("I eat antipasto twice just because she is so nice, Angelina," "You can't tell the depth of the well from the length of the handle on the pump," "Closer to the bone, sweeter is the meat"). He also played to the *gavones* in the audience. Billy Vera (1999) admits that this was how he first reacted to Prima's music in the early 1960s. Vera characterized Prima's fans as men who wore "white-on-white shirts; silk neckties; flashy continental suits two inches out from the edge of his jacket sleeve, gaudy, initials-in-diamonds pinky rings; and way too much cologne" (p. 55). Scholars have argued that Prima's style of performance continues a southern Italian-American comedic tradition that dates back to the *commedia dell' arte* (Primmeggia, Viviono, and Varacalli, 1993). Prima's songs, they argue, blended familiar themes of Italian-American life, an Itaglish dialect that included Cajun slang and Creole colloquialisms, call and response with Smith and Butera, and sexual double entendre (p. 203).

The revival, in effect, has constantly referenced Prima's Italianness without grasping its significance. What remains untold is the familiar ethnic tale of liminality and passing. Here and there, in all the discourse about Prima, one can hear whispers about moments of mistaken identity. Prima's dark Sicilian features apparently led others, at times, to think he was black. This story appears in a variety of forms: as an anecdote about wary club owners refusing to hire him in 1930s New York, about Sammy Davis Jr. thinking he was black, about Apollo Theatre fans responding exuberantly to his act. The story persists in the words of a young fan who, having heard Prima's music and seen his photo on the Capitol greatest-hits CD, asks others on an online bulletin board about his race. The exact truth of these stories matters not. Their very telling recognizes the difficulty others have experienced trying to place Prima in the musical and cultural landscape.

In ignoring Prima's musicianship, jazz criticism has practiced its own form of ethnic erasure. Prima remains largely absent from the jazz canon despite his popularity (or perhaps because of it). The main impediment seems to be what *Time* called Prima's "vulgarity." He worked too hard to entertain and please the audience, and his carelessness with money led him to play commercially profitable songs that other jazz musicians disdained as trite and inauthentic (like the popular but relentlessly schmaltzy "Wonderland by Night"). For jazz sophisticates committed to the cerebral, high-church traditions of bebop, Prima's concessions to the audience and his comfort with the Vegas lounge scene branded him as an apostate. For such critics, Prima must have seemed a kind of jazz vaudevillian—a corny entertainer who watered down his music with jivey patter, jokes, and slapstick.

Prima has not been the only jazz musician to be criticized in such terms. Gary Giddins (1988) writes of another prominent musician who was "beset by damning reviews for nearly forty years." That musician, Giddins writes, "was excoriated for playing pop tunes, fronting a swing band, appearing with media stars, sticking to a standardized repertory, engaging in vaudeville routines, making scatological jokes, mugging, entertaining" (p. 4). That musician, of course, was Louis Armstrong, and the critical indictment of Pops eerily echoes that leveled against Prima. The two, after all, shared many musical traditions. Both were born in New Orleans, within ten years of each other. During their careers they recorded many of the same songs. By every measure, of course, Armstrong was the greater figure in American music and culture—more musically inventive and accomplished, more astute in his cultural crossings, more politically courageous in his public life. But Prima was surely Armstrong's most loyal acolyte—the single musician most deeply influenced by his style and stage presence. Indeed, Jack Stewart, a musician and jazz historian, reminds us that "The three Louis Armstrong imitators are all white, all from New Orleans and all Italian: Louis Prima, Sharkey Bonano and Wingy Manone" (Elie, 1999, p. B1).

The differences in jazz critics' evaluations of Prima and Armstrong are sharply inscribed in Ken Burns's monumental television series *Jazz* (2001). Armstrong emerges from the series as an exemplary individual artist (just as Duke Ellington emerges as the exemplary bandleader and composer). And Prima? Though "Sing, Sing, Sing" does show up on the soundtrack (without acknowledgement of Prima's authorship), he himself receives not a single moment anywhere in the series—not one performance among its hundreds of tracks, not one photo in the series book or one citation in its index. One can imagine different reasons for this exclusion. Burns builds his narrative around set pieces that focus on a smaller number of prominent musicians, such as Armstrong, Ellington, Goodman, Bix Beiderbecke, and Miles Davis. To the extent that Burns had already included Wingy Manone (New Orleans Italian) as well as Armstrong and Beiderbecke (early trumpeters), he may not have felt it necessary to include Prima. And there is probably nothing personal in the exclusion. Critics have detected a similar arbitrariness in Burns's other choices. For example, the series pays scant attention to Frank Sinatra, and largely ignores most contemporary jazz practitioners. Under the powerful influence of Wynton Marsalis as senior creative consultant, the series strives to demarcate pure jazz and consistently excludes crossover forms, especially those not deeply rooted in African-American traditions.

Prima's combination of New Orleans jazz, swing, and (by the 1950s) rock and roll will likely never win favor among purists. The origins and ownership of the jazz tradition continue to absorb many jazz critics (e.g., Early, 1998; Gennari, 1991; Lees, 1994; Levine, 1998; Sudhalter, 1999). Musicians, for their part, just play. And audiences listen. For cultural historians these aesthetic evaluations of Prima matter less than our sense of what his life and music meant. The virtual absence of Louis Armstrong from the Prima revival ought to trouble us, for it marks the revival's limitations as a form of public memory. Better to notice that both men came to professional prominence in the age of swing, at a moment of racial and ethnic crossings. As Lewis Erenberg (1998) reminds us, that moment deserves to be remembered. "What is notable about the swing era is how its creators, promoters, and fans saw it as part of a cultural rebirth," Erenberg writes. "Swing was more racially and ethnically mixed than any other arena of American life" (pp. 249–50). Here, then, is a story that the Prima revival has implied but never proclaimed. Louis Prima's career reminds us of the wildness of our cultural differences, and of Americans' persistent desire not just to tame that wildness, but also to let it run free.

Bibliography

Armstrong, L. (1999). *Louis Armstrong, in his own words: Selected writings*. New York: Oxford University Press

Beard, J. J. (1993). Casting call at Forest Lawn: The digital resurrection of deceased entertainers—A 21st century challenge for intellectual property law. *High Technology Law Journal, 8*, 101, 111.

———. (2001). Clones, bones and twilight zones: Protecting the digital persona of the quick, the dead and the imaginary. *Berkeley Technology Law Journal,* 16,1165.

Boulard, G. (1989). *"Just a gigolo": The life and times of Louis Prima.* Lafayette, LA: Center for Louisiana Studies, University of Southwestern Louisiana.

Brammer, J., Caesar, I., Casucci, L., and Graham, R. (1929). Just a gigolo/I ain't got nobody [Recorded by David Lee Roth]. On *Crazy from the heat* [LP]. USA: Warner Brothers. (1985).

Canemaker, J. (1999). *Paper dreams: The art and artists of Disney storyboards.* New York: Hyperion.

Collier, J. L. (1993). *Jazz: The American theme song.* New York: Oxford University Press.

Cuneo, A. Z. (1998, April 20). Gap's first global ads confront Dockers on a khaki battlefield. Retrieved January 31, 2003, from www.adage.com.

Dance, S. (1973). *The world of swing.* New York: Charles Scribner's Sons.

Disney, W. (Producer), and Reitherman, W. (Director). (1967). *Jungle book* [Motion picture]. USA: Buena Vista Pictures.

Early, G. (1998). Pulp and circumstance: The story of jazz in high places. In R. G. O'Meally (Ed.), *The jazz cadence of American culture* (pp. 303–430). New York: Columbia University Press.

Elie, L. E. (1999, August 23). Exploring Black, Italian connections. *Times-Picayune,* section B, p. 1.

Elliott, S. (1999, January 18). The latest music form to find resurrection by mainstream marketers is swing, in all its glory. *New York Times,* section C, p. 6.

Erenberg, L. (1998). *Swinging the American dream: Big band jazz and the rebirth of American culture.* Chicago: University of Chicago Press.

Filley, J. (Producer), and Scott, C., and Tucci, S. (Directors). (1996). *Big night* [Motion picture]. USA: Samuel Goldwyn Company.

Frankel, C. J. (2000, August 7). In star-struck America, broader protection sought by celebrities; the right of publicity has become a significant tool. *New York Law Journal.* Retrieved January 31, 2003, from LexisNexis Academic database.

Gennari, J. (1991, Fall). Jazz criticism: Its development and ideologies. *Black American Literature Forum, 25,* 449–524.

Giddins, G. (1988). *Satchmo: The genius of Louis Armstrong.* New York: Da Capo Press.

———. (1998). *Visions of jazz: The first century.* New York: Oxford University Press.

Gioia, T. (1997). *The history of jazz.* New York: Oxford University Press.

Grant, J. (1987). *Encyclopedia of Walt Disney's animated characters.* New York: Harper and Row.

Hill, J. (2002, October 23). What's in a name? Plenty! (At least according to Mickey's lawyers). Retrieved February 3, 2003, from http://www.jimhillmedia.com/articles/10232002.1.htm

Jensen, L. (2002, April 27). Sam's back in town. *Times-Picayune,* Metro section, p. 1.

Kirby, S. (1989, May 26). Musician keeps Prima's music alive. *St. Petersburg Times,* p. 10.

Laurino, M. (2000). *Were you always an Italian? Ancestors and other icons of Italian America.* New York: W. W. Norton.

Lauro, J. (Producer), and McGlynn, D. (Director). (1999). *Louis Prima: The wildest* [Motion picture]. USA: Historic Films.

Lees, G. (1994). *Cats of any color: Jazz black and white.* New York: Oxford University Press.

Levine, L. W. (1998). Jazz and American culture. In R. G. O'Meally (Ed.), *The jazz cadence of American culture* (pp. 431–47). New York: Columbia University Press.

Lind, A. (2000, September 8). Prima time: Bobby Lonera is a leading practitioner of that old Louis Prima magic. *Times-Picayune,* Living section, p. 1.

Louis Prima's widow asserted valid right of publicity claim against the Olive Garden based on Prima sound-alike recording in restaurant's TV commercial. (2000, May). *Entertainment Law Reporter*, 21. Retrieved January 31, 2003, from LexisNexis Academic database.

Lyons, M. (2000, April). Sibling songs: Richard and Robert Sherman and their Disney tunes. *Animation World Magazine* 5.01. Retrieved February 3, 2003, from http://www.awn.com/mag/issue5.01/5.01pages/lyonssherman.php3

McCormick, M. (1997, October 18). Tie-ins abound for Disney "Jungle Book" reissue. *Billboard*, 109, 77.

Miester, M. (2001, August 21). The monkey vs. the mouse. *Gambit Weekly*. Retrieved February 3, 2003, from http://www.bestofneworleans.com/dispatch/2001–08–21/news_feat.html

Mustazza, L. (Ed.) (1998). *Frank Sinatra and popular culture: Essays on an American icon*. Westport, CT: Greenwood.

Novak, M. (1996). *The rise of the unmeltable ethnics*. New Brunswick, NJ: Transaction.

Peretti, B. W. (1997). *Jazz in American culture*. Chicago: Ivan Dee.

Primmeggia, S., Viviono, F., and Varacalli, J. A. (1993). Southern Italian-American comedy: The cases of Matteo Cannizzaro, Lou Monte, Louis Prima, and Dom DeLuise. In F. J. Cavaioli, A. Danzi, and S. J. LaGumina (Eds.), *Italian Americans and their public and private life* (pp. 194–211). Staten Island, NY: American Italian Historical Association.

Ross, C. (1998, May 11). Super Sein-off. *Advertising Age*. Retrieved January 31, 2003, from www.adage.com.

Schuller, G. (1968). *The swing era: The development of jazz, 1930–45*. New York: Oxford University Press.

Shaw, A. (1977). *52nd St.: The street of jazz*. New York: Da Capo Press.

Sherman, R. M., and Sherman, R. B. (1967). I wan'na be like you [Recorded by Los Lobos]. On *Stay Awake* [LP]. USA: A&M Records. (1988)

Shipton, A. (2001). *A new history of jazz*. London: Continuum.

Spera, K. (2002, October 13). Louis lost and found. *Times-Picayune*, Living section, p. 1.

Stevenson, R. W. (1991, August 5). 30-year-old film is a surprise hit in its 4th re-release. *New York Times*, section C, p. 9.

Sudhalter, R. M. (1999). *Lost chords: White musicians and their contribution to jazz, 1915–1945*. New York: Oxford University Press.

Vera, B. (1999). Vegas rocks and Reno rolls: Louis Prima. In C. Escott (Ed.), *All roots lead to rock: Legends of early rock 'n' roll: A Bear Family reader* (pp. 53–72). New York: Schirmer Books.

Von Bergen, J. M. (1998, April 3). Singer's widow files lawsuit against Campbell Soup for Prego ad. *Philadelphia Inquirer*. Retrieved January 31, 2003, from Lexis-Nexis Academic database.

The wages of vulgarity. (1959, September 7). *Time*, 72, 50.

Ward, G. C. and Burns, K. (2000). *Jazz: A history of America's music*. New York: Knopf.

Wilson, J. S. (1982, September 22). Cabaret: Duo in Prima style. *New York Times*, section C, p. 25.

Yanow, S. (2000). *Swing*. San Francisco: Miller Freeman.

Zad, M. (1991, April 28). "The Jungle Book" reappears on video shelves. *The Washington Post*, section Y, p. 6.

The Strange Career
of Robert Johnson's Records

Eric W. Rothenbuhler

Today, Robert Johnson is one of the most recognized names in blues music. His records sell well; his songs are regularly recorded; his name and story often invoked; his praises sung by critics, musicians, and audiences; control of his legacy contested. This is strikingly at odds with the short and obscure life of the man. His career was almost entirely posthumous, based on twenty-nine songs and some alternate takes recorded in 1936 and '37; only one record sold particularly well. He died in 1938. He had been an itinerant musician from the Mississippi Delta performing on the street, in stores and juke joints, and at parties. He was known among other Delta musicians as an enthusiastic hobo who wandered and womanized widely, but he was not really known outside of the region. Yet one of his records found its way to the New York City music producer John Hammond, who went on to play a key role in promoting Johnson's records and his reputation.

This chapter examines the career of Johnson's reputation as a blues musician among college educated whites since his death, through analyzing liner notes and popular music histories and criticism. His name and stories about him have become more widely known than those of almost any other blues musician; certainly he is the most well known of the prewar musicians. At least one magazine actually named him among the artists of the decade in the 1990s, fifty years after his death. Why has his posthumous reputation grown so spectacularly? Why has such a mythology developed and persisted? What we find is that the Robert Johnson

story has been told in many different ways, each useful for its audience. Robert Johnson the person has become "Robert Johnson" a multivalent symbol, a term of conversation and storytelling. "Robert Johnson" plays a key role in stories about the history of popular music, in accounts of artistic genius, in visions of African-American dignity under exploitation, in stories about artistic craft, about the search for truth, about literary interpretation and audience reception, about the machinations of the music industry, and about the powers and costs of dealing with the devil.

Just a few months after Johnson's death, Hammond played one of his records from the stage of Carnegie Hall during his famous *From Spirituals to Swing* concert as an express substitute for the living presence of Johnson himself. Surely a precedent of some sort, Johnson's record was presented along with Hammond's eulogy prior to the formal show. Though Robert Johnson remained relatively unknown and his records mostly unavailable until the 1960s, from this moment in 1938, "Robert Johnson" and his records were symbols—characters in a story about music, history, and American culture.

The career of "Robert Johnson" continued after the Carnegie Hall debut with the slow climb of reputation and increasing demand for his records on the collector's market through the early 1960s, when CBS released a John Hammond produced LP. The exponential takeoff point of the growth of his reputation arrived soon after as Johnson's records become a major source of inspiration for blues rock in the 1960s and for rock criticism in the 1970s. The progression continued to accelerate through the Christmas release of *Robert Johnson: The Complete Recordings* (1990), accompanied by an unprecedented promotional campaign and record-setting sales. The boxed set obtained Gold Record status and won a Grammy. The growth of media presence for Robert Johnson and his records continued across the nineties and on to this year, with celebrities and rock guitarists such as John Fogerty, Peter Green, Eric Clapton, and others visiting his home territory and grave, covering his songs, and telling stories that attach their name to his. In 1986 he was inducted into the Rock and Roll Hall of Fame, and was the subject of a scholarly conference and honorary musical performances there in 1998. Today his legacy also includes a legally contested estate—worth over a million dollars—that holds copyright on the records and has ventured into licensing use of the name. Johnson is now subject to a revisionist literature including Pearson and McCulloch (2003), Wald (2004), and the present chapter.

The ironies are worth pausing to enjoy: a Gold Record, a Grammy, the Rock and Roll Hall of Fame, scholarly articles, and a million-dollar estate for an itinerant musician escaping field labor who did not even record thirty songs and died fifty years before any of this. How did it happen?

Robert Johnson's Life

The basic facts of Robert Johnson's life are now fairly well known. The brief account here follows the biography by Guralnick (1989) and the reports available elsewhere. Robert Johnson was probably born May 8, 1911 in Hazlehurst, Mississippi, the eleventh child of Julia Major Dodds; but unlike the other ten, he was not the son of Charles Dodds. Through his childhood and into his teens he was moved from family to family and town to town, being accepted or not as various people's son and using various first and last names. About 1930 or a little earlier he was married and working to become a professional musician. There are stories about him playing harmonica and Jew's harp, about Son House showing him the rudiments of guitar, and about him being a bad player who was a bit of a pest to older musicians. These stories could well be from earlier in his teens. About 1931 he set off on a year or so of wandering, which other local musicians recall as a time when he had disappeared. When he returned to the Delta area he was an expert guitarist. This sudden appearance as an expert guitarist is a key event in the Johnson myth.

Like Tommy Johnson before him, Robert Johnson appears to have promoted the story that he sold his soul to the devil in return for proficiency on the guitar (though Pearson and McCulloch, 2003, challenge this conventional account). This was probably a standard form of bravado in the culture of the Delta at that time. Certainly it is not out of keeping with treatment of devil themes in both blues music and spirituals. Levine (1977) and others point out that the devil was a familiar figure in African-American culture of the time, and the devil often appeared as a trickster here on earth. Peetie Wheatstraw, for example, a successful recording musician in the Delta blues style, billed himself as the Devil's Son-in-Law—the High Sheriff from Hell—and his songs were full of braggadocio and good humor. Siems (1991) analyzes several of these stories about blues men as part of the tradition of trickster tales common to African-American and older traditions, and the appeal of these tales to white audiences.

Johnson traveled incessantly, gaining a reputation for wandering and womanizing, as well as for his music. He had many temporary homes, married a number of women and lived with more, used several names, and left several children. He had a reputation for appearing and disappearing with no warning.

Musical performances of the time included whatever the crowd wanted, and there is evidence that Johnson listened to a lot of records, admired diverse styles, and could play whatever people asked for, including country music and songs popularized by Bing Crosby. He also developed a reputation for being a perfectionist with his own songs and secretive as to his guitar techniques. He is said to have practiced in secret and is remembered for turning his back or even leaving a show if

other musicians were watching him too closely. Some stories report that he never performed a song in public until he had it down, and that once he had performed it he hardly changed it. But at least one story often used as support for this idea of someone who practiced secretly and treated songs as finished texts to be performed (something out of keeping with the larger blues culture), appears to contradict it. This is a story (from Henry Townsend, reported in Guralnick, 1989, p. 58) that Johnson played a beautiful song once and then muttered on leaving the show that he would never play it again. When asked about that, he reportedly said that the song just came to him, that it fit the moment, and that no moment would ever be like that again. This story does not fit the model of someone who crafts his songs and repeats them; it does, though, fit the romantic model of art as perfected expression—another mythical element into which the Johnson story is fitted.

In 1936, Johnson approached H. C. Speir, who owned a store in Jackson and worked as a talent scout for the American Record Corp (ARC). ARC had been releasing very few of the sides Speir recorded, so he passed Johnson's name on to Ernie Oertle, who heard Johnson and took him to San Antonio to record in November 1936. By that time the peak had passed for solo blues singers accompanied by guitar; but Johnson was recorded anyway. (Johnson's most prolific predecessors in the self-accompanied rural styles included Charley Patton who recorded forty-two sides between 1929 and 1930 and another twenty-six in 1934, Blind Blake who recorded seventy-nine sides from 1926 to 1932, and Blind Lemon Jefferson, who sold the most and probably recorded about one hundred sides from 1926–1929.) Sixteen songs were recorded (by Don Law); one or another take of most of them were released sooner or later on Vocalian. "Terraplane Blues" sold well and appears to have had a positive effect on Johnson's reputation and his ability to travel and earn money. None of the other sides sold well.

In June of 1937 Johnson recorded thirteen songs in Dallas (recorded by Don Law); one or another take of most were released sooner or later, again on Vocalian, but none sold well. Johnson took off on one of his biggest trips, including St. Louis; Chicago; Detroit and Windsor, Canada; and on to New York City.

Johnson's guitar technique is admirable, some of his chord choices unique at his time, his singing highly expressive, and his lyrics quite striking; his influences are also obvious. His work can be seen to grow out of the blues culture of the place and time, as well as the developing culture of recorded blues music. Palmer (1981) as well as the album anthology *The Roots of Robert Johnson* (1990) point out that many specifics of his musical technique can be traced to the music of other regions of the country and music that was available on record at the time. It may be that his sudden appearance as a proficient guitarist was due to a media effect, to his breaking free of the local oral tradition to some degree and entering a growing national blues culture mediated by the phonograph (Rothenbuhler, 2000).

Certainly this would allow him to assimilate more stylistic elements more quickly than was normal for people who learned their instruments in local networks of musicians.

In 1938 on a Saturday night, Johnson was poisoned during a break in a show by a jealous husband, reportedly the owner of the juke joint he was working at the time. He died in Greenwood, Mississippi, on August 16, three days later.

The Lives of Johnson's Records and Reputation

This section establishes a chronology of the posthumous career of Johnson's records and reputation, similar to the outline of the facts of his life. The first thing to notice is the pattern of exponential growth. Like the offspring of a small and scattered reproducing population, events in the posthumous career are at first few and widely spaced. Eventually they begin to cluster in time and space, like a population growing into an unexploited ecological niche. Finally, events in the story become so frequent as to appear ubiquitous, like the offspring of a booming population.

In 1938, the same year as Johnson's death, John Hammond had heard some of the records and wanted to include him in his Carnegie Hall show *From Spirituals to Swing*. He contacted Don Law, who contacted Ernie Oertle, who eventually reported back that Johnson was dead. Hammond "announced the death just prior to the concert in an enthusiastic, if somewhat impressionistic, elegy . . . and he played recordings of 'Walkin' Blues' and 'Preachin' Blues' from the stage in tribute" (Guralnick, 1989, p. 53).

From 1938 to circa 1970, Johnson was remembered in the African American blues community as someone who died young, was talented, but who was not particularly successful. Few of the facts of his life were written down: those that were, were not treated as special and later could not be found; most was left to the memory of friends. In the white community, interest in Johnson grew slowly and steadily, apparently based primarily on a poetic response to his records and carried on in books about the blues. But nothing was known about him and all reports were filled with errors. For example, the liner notes for *King of the Delta Blues Singers* in 1961 portray Johnson as a naive, shy kid who had never been off of his home plantation, often used and mistreated by women—"dead before he reached his twenty-first birthday, poisoned by a jealous girl friend." The legend of a tormented man, fleeing the devil—so popular in the decades since—is also present in these liner notes from 1961, supported by quoted song lyrics from "Crossroads Blues," "Me and the Devil Blues," "Hellhound on My Trail," "Kindhearted Woman Blues," "Walking Blues," "Come on in My Kitchen," and "Traveling Riverside Blues." All of Johnson's lighter material is ignored.

Guralnick (1989) claims that his records were always of interest to collectors and never as hard to find as Charley Patton's or other earlier blues artists. Alan Lomax and Hammond were apparently talking about a posthumous anthology of Johnson's recordings—but that didn't happen until 1961.

It should also be noted that until the last fifteen years or so, many respectable books on the blues were written without much commentary on Johnson. Especially work that was self-consciously historical could give him little attention because, historically, he was a small figure—this is a point that now has to be recovered in revisionist work such as Wald's (2004). The work that does discuss him has been more poetic, more addressed to the music and lyrics, and the author's responses.

In 1939, folklorist Alan Lomax began research on Johnson, looking for his sources and inspiration. In 1941, while in the Delta researching Johnson (among other things), Lomax discovered McKinley Morganfield (Muddy Waters), who also tipped him that Son House was a key guitar influence on Robert Johnson and told him where to find House. Interestingly, the story persists that Lomax was looking for Johnson. Lomax (1993) even says so in his own book, *The Land Where the Blues Began*. But by 1941, certainly someone with Lomax's knowledge and connections would have known that Johnson was dead. Had his previous research failed to turn up the fact that Johnson's death was announced by his friend John Hammond and published in a New York newspaper? Should we imagine that Hammond was chuckling to himself at an uptown cafe while Lomax was dragging his recording equipment around rural Mississippi looking for a dead man?

Yet in Lomax's repetition of a story that is either false or throws question on his own expertise we have a hint of the narrative value of searching for Robert Johnson. This figure of a lost Johnson becomes central in one story after another; the missing Johnson creates the starring role for the searcher. Hammond was once searching for Robert Johnson; not finding him created the opportunity to put himself at the center of the Johnson story, as the author of his eulogy, the announcer of his death to the civilized world assembled in New York. Lomax, too, had to search for Robert Johnson, and he was still telling the story decades later. On through the 1990s, one folklorist, blues researcher, rock star, and music critic after another tells a story of searching in which he or she and the missing Robert Johnson form a special connection. When a Johnson biography was finally published in 1989, it was called *Searching for Robert Johnson*.

In 1946, in *Shining Trumpets: A History of Jazz*, Rudi Blesh singles out "Hellhound on my Trail" for comment. His elaborately poetic "description" of the music is picked up by Guralnick (1989) over forty years later to "evoke that same sense of awe" (p. 3) with which he and his friends approached their first Robert Johnson recordings. Very early, then, the book-world of music criticism chose

"Hellhound" as the key Johnson song. While "Terraplane Blues," with its light sound and sexual innuendo lyrics, sold well when first released, and Hammond chose two more traditional blues to play at Carnegie Hall, Blesh draws attention to the brooding "Hellhound" with its image of a pursued man too frightened to settle anywhere: "I got to keep movin', I've got to keep movin', blues fallin' down like hail" (Johnson, 1990). This image becomes central to the subsequent Robert Johnson commentary. Whether influenced by the Blesh book or some other source, Mack McCormick, a folklorist in Houston, has reported that he began getting letters from blues record collectors in Europe about 1948 asking for information about Johnson's death.

Samuel Charters's 1959 book *The Country Blues*, was the first of its type, widely influential, and still widely read. He pointed out that:

> the young Negro audience for whom the blues has been a natural emotional expression has never concerned itself with artistic pretensions. By their standards, Robert Johnson was sullen and brooding, and his records sold very poorly. It is artificial to consider him by the standards of a sophisticated audience that during his short life was not even aware of him, but by these standards he is one of the superbly creative blues singers. (1975, p. 207)

If Hammond launched Johnson's records into a new discourse world, this chapter in Charters's book may be the lever that loosed Johnson's reputation from his life. Certainly Charters indicates awareness that he is beginning to evaluate Johnson's music by the standards of a different community from the one in which it was composed. Charters begins his account admitting that "almost nothing is known about his life" and then proceeds to tell us about it anyway. What may be key for the later reception of Johnson is that his analysis of the themes of Johnson's music centered on "Hellhound on my Trail" and "Me and the Devil Blues." While the former sounds haunted by fear, the vision of the latter is more flat out evil, with Johnson and the Devil being comfortable traveling companions. The Charters book has been routinely cited by many later musicians and critics as an important early influence.

In 1961, *Robert Johnson: King of the Delta Blues Singers*, an album anthology of about half of Johnson's songs, was released. The album title dubbing Johnson "King," when he was long dead and mostly unknown, was a bit of revisionist history aided by the supertitle *Thesaurus of Classic Jazz*, which lent it the air of a reference work. It proclaimed to potential listeners: You don't know the King; you had better listen and learn. The pay off came decades later, when even the most casual commentators on the blues show an obligation to mention Johnson's preeminence. On Monday, January 20, 2003, for example, the very morning of the day I am editing this, New York Times op-ed columnist Bob Herbert, who usually writes about politics and justice issues, devoted his column to an upcoming documentary

series on the blues; Robert Johnson, described as "perhaps the greatest bluesman of them all," is the only artist mentioned by name.

The liner notes to the CBS album claimed that "Robert Johnson is little, very little more than a name on aging index cards and a few dusty master records in the files of a phonograph company that no longer exists" (Columbia, 1961). The author goes on to claim Johnson "was already a legend in 1938." Here we see an image of lost treasure—once a legend, now just a name on dusty cards. The image functions in this case to invite the reader to become a searcher for Robert Johnson; "see if you can hear the treasure," it challenges. Despite the claims for Johnson's legendary status, most indications are that this record was put out largely in response to John Hammond's personal interest in the project. Guralnick (1989) reports that it sold "ten or twelve thousand copies in its first ten years of existence" (p. 5). Its success was not in direct sales, but in the slow accumulation of influence.

Across the 1960s and 1970s there was a revival of interest in recorded blues associated with recognition of the blues as a source of musical ideas and inspiration for rock bands. Covers of Robert Johnson songs showed up regularly, starting with "Ramblin' on my Mind" on *Bluesbreakers: John Mayall with Eric Clapton* in 1965 and "Walkin' Blues" by The Butterfield Blues Band on *East/West* in 1966, followed by other songs covered by Captain Beefheart, Cream, Fleetwood Mac, Taj Mahal, and The Rolling Stones on albums released from 1966 through 1973. "Dust My Broom," "Walkin' Blues," and "Sweet Home Chicago" have become commonplaces and continue to be covered by countless bar bands in performances every weekend.

The late 1960s and early 1970s period of rock was dominated by virtuoso guitarists defined by images, fashion, album cover and poster art, lifestyle reputations, literate criticism, and magazine interviews as well as by their musical performances. The search for roots was an important part of that process, and Robert Johnson was often discussed. The ethos of the time emphasized authenticity and genuineness. White kids becoming wealthy stars by playing music written by long-dead impoverished Black men were vulnerable to serious criticism. Demonstrating extensive knowledge about their African-American predecessors and great respect for their music and person was more than a useful defense. It raised the status of the young, white rock star who showed that he knew more than others about the origins of the music, and perhaps could even claim a special, personal connection with those origins.

Eric Clapton in particular was mystic in discussing Johnson, including frequent references to Johnson's soul, the devil, bad dreams, and ghosts. The story still circulates that he had a dream after Hendrix died in which he was walking with the ghosts of Johnson and Hendrix. He has said that at one point he planned to do one Robert Johnson song per album, but the idea haunted him and the Rolling Stones began to do Johnson songs, so he let them bear that cross. At one point he

foreswore ever playing another Robert Johnson song; in 1994 he released a blues album billed as a tribute to his influences—it included no Robert Johnson songs. Yet such is the power of association with Johnson that in spring 2004 Clapton released an entire album of Johnson songs, titled *Me and Mr. Johnson*. It has generated more publicity than any Clapton release in several years.

In 1968, the folklorist and blues scholar Gayle Dean Wardlow discovered Johnson's death certificate. Mack McCormick independently also found the death certificate, and identified leads to possible witnesses to the murder. Sometime around this time McCormick figured out that almost none of his friends and family knew Robert Johnson as Robert Johnson—they used a variety of other names. In 1970, McCormick found and interviewed two witnesses to the murder, in Indianapolis and Flint, who gave more or less the same story. In March of 1972, he found Robert Johnson's half-sister Bessie. From this lead McCormick uncovered other relatives and found family pictures. He, Wardlow (1998), Calt (1994) and others remain rivals in methods, findings, and claims of precedent in the search for details of blues history. Consistently enough, the story of the search continues to sell at least as well as the results of the research.

In 1970, *Robert Johnson: King of the Delta Blues Singers, Vol. II* was released, including the rest of the Johnson songs. The liner notes claim:

> The twenty-nine compositions recorded by Robert Johnson for the American Record Corporation in 1935 and 1936 [sic] rank as the most expressive and poetic body of work committed to record by any blues singer. . . . Johnson's songs represent the ultimate flowering of Mississippi Delta blues. (Welding, 1970)

They declare him "the greatest down home blues singer of all time." Note the incorrect dates, the hyperbole, and the obliviousness to the influences from outside the Delta present in Johnson's music.

In 1973 Samuel Charters claimed in *Robert Johnson* that:

> as a guitarist he almost completely turned the blues around. . . . When Muddy Waters started his first bands in Chicago six or seven years later all he had to do was have the bass player and the drummer pick up on the treble. (pp. 14–15)

What musical sense these sentences make is unclear. They do, though, represent a growing sense that Johnson was very important, in some not quite defined way, for music like rock and roll that came much later.

In 1975, Greil Marcus's *Mystery Train* devoted a key early chapter to Robert Johnson and made his music a point of comparison throughout the book. *Mystery Train* became one of the best selling books on rock and roll ever and established the legitimacy of a literary-interpretive approach to understanding rock and roll. It is still used in college-level English and American Studies courses. Marcus says:

> Nearly forty years after his death, Johnson remains the most emotionally committed of all blues singers; for all the distance of his time and place, Johnson's music draws a natural response from many who outwardly could not be more different from him. He sang about the price he had to pay for promises he tried, and failed, to keep; I think the power of his music comes in part from Johnson's ability to shape the loneliness and chaos of his betrayal, or ours. Listening to Johnson's songs, one almost feels at home in that desolate America; one feels able to take some strength from it, right along with the promises we could not give up if we wanted to. (Marcus, 1982, p. 23)

Also:

> A good musical case can be made for Johnson as the first rock 'n' roller of all. His music had a vibrancy and a rhythmic excitement that was new to the country blues. On some tunes. . . . Johnson sounds like a complete rock 'n' roll band, as full as Elvis's first combo or the group Bob Dylan put together for the *John Wesley Harding* sessions, and tougher than either. (p. 23)

More from Marcus:

> Johnson's vision was of a world without salvation, redemption, or rest; it was a vision he resisted, laughed at, to which he gave himself over, but most of all it was a vision he pursued. He walked his road like a failed, orphaned Puritan, looking for women and a good night, but never convinced, whether he found such things or not, that they were really what he wanted, and so framing his tales with old echoes of sin and damnation. (p. 24)

In 1976 McCormick announced that he had completed a manuscript which he called *Biography of a Phantom*. His idea was that Johnson was a cipher; someone about whom we know little more now than we did before we knew the facts of his biography—perhaps someone in whom we have to see a code for something else (see Guralnick, 1989).

In 1978, William Ferris's *Blues from the Delta* gives Johnson little attention, as other serious, historical books from the period (e.g., Evans, 1982; Titon, 1977) also paid Johnson little regard.

In 1986, in the article on "Blues" for the New Grove encyclopedia, Paul Oliver observed:

> Of these later singers, it was Robert Johnson . . . with his highly introverted, sometimes obsessional blues sung to whining guitar and throbbing beat, who left the deepest impression. Ten years younger than Son House, he was the singer-guitarist who established the link between the rural Mississippi tradition and modern Chicago blues. But he was indebted too to the records of other singers. (pp. 85–86)

In 1981, Robert Palmer's *Deep Blues* began with the story of Alan Lomax looking for Robert Johnson in Clarksdale in 1941, and finding McKinley Morganfield instead. Johnson is nearly omnipresent throughout the rest of the book: everyone is compared to him; he is mentioned whenever anyone who knew him

is discussed. He receives more index entries than anyone else but Muddy Waters—despite all of the additional years that Muddy Waters recorded.

In 1983, Alan Greenberg's screenplay *Love in Vain: A Vision of Robert Johnson* was published. It did not attempt biography, but rather evocation. It is not the Robert Johnson story, it is a story inspired by an idea of Robert Johnson. This is apparently a useful tactic. The 1986 Hollywood movie *Crossroads* was built around the "deal with the devil at the crossroads at midnight" story; only in this case a blues playing white kid saves the old Black man from his fate by outplaying the Devil's own guitar player. (For what it is worth, the white kid and the old Black man played the blues; the Devil's guitar player played heavy metal.) Wardlow and Komara (1998) report that after the movie, white folks began showing up in Mississippi looking for The Crossroads, as if there would be a specific place by that name and something to see there. Since that time, the state of Mississippi has used the crossroads theme to promote Delta tourism. In 2000, the movie *O Brother Where Art Thou* featured a dapperly dressed young Black character, picked up hitch hiking at a lonely crossroads with a guitar; he said he'd had to be there at midnight the night before to sell his soul to the devil. Sure enough, he later demonstrated a powerful guitar technique. Many viewers interpreted the character as Robert Johnson, though the writers demonstrated their insider knowledge by naming him Tommy Johnson. The less well-known Tommy Johnson had preceded Robert, both as a recording bluesman and as the subject of the crossroads story.

In 1989, William Barlow's *Looking up at Down: The Emergence of Blues Culture* devoted six serious pages to Johnson. He was labeled:

> the key transitional figure working within the Mississippi Delta's blues culture. He bridged the gap between the music's rural beginnings and its modern urban manifestations, but he died before receiving any national recognition. Over the years, both his stature as a Delta blues trailblazer and the legends surrounding his life have grown considerably. (p. 45)

In 1989, *Searching for Robert Johnson* by Peter Guralnick was published. It is as much about the legend and the appeal of the mystery as about the person and the music; it is the story of the work that has gone into uncovering Johnson's biography. Along the way it sets the facts straight, but maintains a style in keeping with the romance of mystery. A closing chapter points out that any given bit of Johnson's biography, musical style, lyrical themes, etc., can be explained, but still "the central mystery of Robert Johnson will remain" (p. 64).

In 1990, with the release of *Robert Johnson: The Complete Recordings*, Johnson was promoted from King to god:

> One of the true geniuses of American music, blues singer extraordinaire Robert Johnson. . . . the most influential bluesman of all time and the person most responsible for

the shape popular music has taken in the last five decades . . . For as fantastic as it all seems this day, Robert Johnson did live; he was a real live human being. (p. 5–7, 23)

No longer a person about whom the mystery is where he lived and how he wrote his songs; now Johnson is a messiah, about whom the mystery is that he walked amongst us at all. Clapton says "it was as if I had been prepared to receive Robert Johnson, almost like a religious experience" (p. 22). Pushed by an unprecedented promotional campaign in the Christmas market, the boxed set broke all records—if there were any—for sales by people dead over fifty years who never got any commercial radio play. Soon it had sold a half-million copies, achieving Gold Record status, and won a Grammy award. It is still in print in multiple formats and a regular inventory item with steady sales.

The release of the boxed set also generated a bit of a literary event. It was reviewed favorably in all of the usual music publications, and also received reviews and accompanying articles of historical or cultural analysis in such journals as *American Heritage, Esquire, Newsweek, The Atlantic, The New Republic,* and *The Nation.*

There are a couple of other interesting things to note. The Robert Johnson songs, previously released by CBS records as in the public domain, were now copyright controlled by an entity called King of Spades Music, which turns out to be controlled by Steve LaVere, a blues researcher, record collector, and entrepreneur who had simply claimed the songs for himself back in 1978. He had also found and promptly copyrighted the only two known photographs of Johnson. Owning both the songs and photographs, very little Johnson business can be done without the cooperation of LaVere; and indeed, he was the producer of the boxed set and author of a significant portion of its liner notes. His promotion of Johnson to deity status is certainly not disinterested.

In 1994, Greenberg's *Love in Vain* was republished with a new forward by the filmmaker Martin Scorsese, who notes that of all of the blues artists he and his friends listened to when they were young, Robert Johnson "was also the most obscure. . . . he only existed on his records. . . . That for me charged the Johnson legend with an irresistible appeal" (p. vii). Scorsese is the executive producer of the series of documentaries on the blues mentioned above. Greenberg's screenplay has not yet appeared as a film but continues to be successful as a book. How many other unused screenplays have been published as books in multiple editions and sold in the music section of the bookstore?

Through the 1990s the Robert Johnson phenomenon continued with his name, image, and songs serving ever more purposes. His grave was found and a headstone bought by a foundation funded by rock stars. More recently another grave was found and the location of his body is again in dispute. John Fogerty, who

had for years refused to play his earlier hits with the band Creedence Clearwater Revival because of a dispute over copyright ownership, said he had an epiphany at Johnson's grave. Johnson never made any money off of his copyrights, yet he gave his music to the people. Fogerty released a comeback album and started a tour in which he joyfully played his old hits. Interviews and album reviews (circa 1997–98) featured a story of Fogerty's years of self-doubt and searching, brought to resolution by his contact with "Robert Johnson"—the story and idea and whatever ghostly presence is available at his grave—and subsequent return to playing his old songs for his old audience. In a very different matter, a lawyer for Disney explained on National Public Radio one day that if copyright had been extended in the 1930s as Disney was asking Congress to do today, then Robert Johnson could have left more for his heirs and he would have had motive to produce more songs. Of course, Johnson never held his own copyrights and at the time of the lawyer's speaking, copyright of his songs, trade mark of his name, and interest in other Johnson documents were all in dispute with Steve LeVere and other entrepreneurs associated with different factions of Johnson relatives. Peter Green, former guitarist of Fleetwood Mac, recording and touring again after years of mental health problems, released an entire album of Robert Johnson songs in a move that could be interpreted as either homage or exorcism. On the other hand, Clapton remained true to his oath and recorded no Johnson songs, until 2004, that is, when things being different, he released *Me and Mr. Johnson*, an entire album of them with publicity playing on his close, career-long association with Johnson's music. In 1998 the Rock and Roll Hall of Fame held an academic conference on Johnson's legacy and a series of concerts in his honor (he had been inducted as an early influence in 1986).

Another interesting phenomenon of the 1990s was that "Robert Johnson" became a kind of figure of speech, a familiar enough character that reference to him could be used to illustrate an author's point, fill out a song lyric, or aid audience identification. Both the Disney lawyer and John Fogerty used "Robert Johnson" in this way. The Steve Earle song "You Know the Rest" (1997) has verses devoted to the legends of Moses, Columbus, Davy Crockett, and Robert Johnson, each ending with the line "you know the rest." The Lucinda Williams song "2 Kool 2 be 4-gotten" (1998) included the lines "Mr. Johnson sings over in the corner by the bar, sold his soul to the devil so he can play guitar" (Williams, 1998). When Tupac Shakur died in 1996, he was compared to Robert Johnson, as if the audience's knowledge of Johnson could help illustrate something not understood about the immensely popular Shakur. The 2002 release of a new Casandra Wilson album was accompanied by a publicity campaign built around her journey back home to her roots, her traveling and recording in the Mississippi Delta, and her visiting places associated with "Robert Johnson." The Herbert column mentioned above is another example.

Today, Mack McCormick's biography of Johnson, and presumably similar manuscripts by others, go still unpublished. Yet what other blues artist is subject to a revisionist literature? Where else is there a market for books about the books about a singer? The search and the mystery really are more interesting than the answers.

Robert Johnson as a Character in a Story

How is the Robert Johnson story told? How is the striking difference between the facts of his life and the life of his records explained? Is there any other artist whose records have found such huge cultural and market success fifty years after his almost unnoticed life and death? The Robert Johnson story is told in several different ways, as it turns out. This surely contributes to its currency as different versions exist for different purposes. His ill-remembered life and long-ago death contribute to this as there is no living character, few documented facts, and few motivated friends and relatives to object.

Johnson as Transitional Figure

One explanation for the success of Johnson's records is that he was a transitional figure, thus the most accessible of the classic Delta blues players to later listeners. Johnson's incessant traveling and certain other stories of his life could be interpreted as evidence that he wanted out of the Delta. LaVere (1990) notes that Johnson was alienated from the rural setting, and that that was reflected in his music; he speculates that Johnson's music "wrapped up" the rural Delta tradition, while also expressing alienation from it, but without yet defining an urban tradition that would come next.

Johnson's assimilation of styles that originated in other parts of the country, but that were available to him on record, is more modern than the style of his Delta contemporaries. Palmer points out that Muddy Waters's first recordings were more old-fashioned even though they came later. Many make the case that his music looked forward to the Chicago blues style as much as it looked back. Marcus (1982) proposes that we can hear more fun in Johnson's music than that of the other Delta greats, and asserts that Johnson appears to enjoy making music and to think of it in artful ways. He proposes that this makes Johnson's music accessible in the way that rock and roll would later be.

On the other hand, Levine (1977) points out that the very idea of a professional musician was a rebellion against the established order. All of the Delta musicians were trying to escape hard labor if not also their geography; Muddy Waters is quoted to that effect in Palmer (1981). The arguments on musical detail

are more compelling, but they also need more work. Muddy Waters would appear to be a more likely nominee as the key transitional figure, uniting as he does in a single career the acoustic Delta and the electric Chicago styles. Howlin' Wolf and Willie Dixon need to be considered carefully too, along with the musicians they worked with at Chess studios. Almost all of the Chicago musicians had origins in Mississippi or other Southern states. Sister Rosetta Tharpe and Memphis Minnie were both important in the transition to electric blues guitar. T-Bone Walker was the first big star of electric blues guitar, and he was born in Texas and recorded in Los Angeles, which was a more important city for early rhythm and blues than Chicago.

As a character whose music "wrapped up" the Delta tradition and ushered in the new, urban rhythm and blues, the singer and harmonica player Sonny Boy Williamson would be a better nominee than Johnson. His southern rural past was already transcended in his 1937–38 Chicago recordings. Though acoustic and clearly reminiscent of the Delta style, his music anticipates rhythm and blues with its distinct urban feel, rhythmic drive, and lyrical themes, including songs about the rural South from the northern city point of view. None of Johnson's songs have this urban reference so important to rhythm and blues. Williamson became a tremendously popular recording artist, and in the next ten years his records helped to define what was called the Chicago beat.

The point is that many blues performers could be nominated as transitional fig-ures. Actually, any of them working in that transitional time of the late 1930s could be called transitional, and the transition was surely brought about by those who lived and worked longer, becoming the artists who produced the new style. To some extent, the argument that Johnson was a precursor to rhythm and blues depends on listening to his music after Muddy Waters's great electric band of the 1950s, hearing a similarity, and giving Johnson credit for the influence of Waters and his band on later rock and rollers.

Marcus's ideas on Johnson as proto-rock and roller can be read as obstinately ignorant of history; but Marcus the author is not so. It must be another point that he is making. Blues singers, Johnson and all the rest, made a living by being enter-tainers. Marcus is not interested in such obviously entertaining figures as Tampa Red and the whole tradition of ribald, funny blues lyrics; there were many perform-ers and recordings that were more successfully entertaining for African-American audiences of the 1930s than Johnson. But Johnson is more successful now. Perhaps what Marcus is doing is asserting that Johnson is like "us," and the words he uses for that assertion are "rock 'n' roll." By not being specific, it appears Marcus is attempting to universalize rock and roll, to make it the spirit that animates and has always animated all great art. This is an interesting approach to an old, romantic idea, cast in new language: the genius of the creative artist relabeled as rock and

roll. It is also a mythical reworking, a method for "Robert Johnson" to carry the romantic ideas of a universal, creative human spirit, in disguise.

Johnson as Self-Consciously Artistic

Another version of the Johnson story is that he was more self-consciously artistic than his contemporaries, honing his music for the record. This is supported by stories about his perfectionism. He is said to have played songs the same way rather than adapting them to situations, as was the blues tradition. The alternate takes from his recording sessions sound similar. Keith Richards notes that Johnson's recordings were "actual songs as well as just being blues" (LaVere, 1990, p. 21). Johnson's 1936 recording of "Walkin' Blues" (which assimilates musical features of Son House's earlier "My Black Mama" and lyrics of his "Walkin' Blues") has a musical and lyrical coherence that wraps up in three minutes. Son House's 1941 recording of "Walkin' Blues" goes on for six minutes, wandering from topic to topic. It reflects the professional context of the street performer, able to keep a song going as long as useful. Johnson's songs are lyrically tighter than that.

On the other hand Johnson was just one member of a community of professional musicians. The only evidence that his orientation to his profession was any different is that our reception of his music is different. That may be sufficient, but it is not necessarily so. We need to be careful when evidence and argument are so heterogeneous. A case can be made that Johnson learned more of his music from records than was typical in the Delta tradition. Combined with other evidence, this can support speculation that he was oriented toward the record and may have thought of his songs as products for the record in some sense (Rothenbuhler, 2000). This cannot, though, be taken as evidence that other blues musicians were not so oriented, and again we could cite a long list of them who had earlier, longer, and more successful recording careers than Johnson.

What is being carried by this story of Johnson being more self-consciously artistic is, again, a familiar and romantic idea about creativity. Johnson is seen as special by comparison with his contemporaries. They are presumed to be folk musicians who channel the collective cultural current; their musical sounds represent their community. Johnson, on the other hand, is nominated as a self-aware artist: in possession of his craft, toiling at his creativity. In this, "Robert Johnson" is an example of virtue for us; he is cast as a hero worthy of emulation.

Literary Criticism and Johnson's Lyrics

The two themes of the Robert Johnson story already identified, that he was a transitional figure and a self-conscious artist, feature its mythical logic. They point to

ways in which the character Robert Johnson is used to retell stories about creativ-ity that endure because they function well for the audience of the story. While this mythical logic is clearly at work in the Robert Johnson phenomenon, identifying it does not explain why Johnson would be chosen from among all the possibilities to carry this load. For that we need to turn attention to more of the specifics of Johnson's recordings and their reception in the 1960s and after.

Johnson's lyrics have received a kind of attention that was not given to any popular music lyrics until after Bob Dylan. He is surely the only Delta blues musi-cian with books, articles, and web pages dedicated to his lyrics and college cours-es that use them as poetry. It is possible that the themes of Johnson's music made more sense to college educated whites who approached it as poetry and had a spe-cial concern for the struggle with evil than it did in its own place and time, and thus it had to find its audience later. The strange career of Robert Johnson's records is based on their success with a mostly college-educated white audience. Marcus (1982) interprets Johnson's music as college freshmen are taught to inter-pret *Moby Dick*. He proposes that the Delta bluesmen were the real Puritans of their time, suggesting that they knew the devil better than anyone: African-American sharecroppers and itinerant musicians in Mississippi as Pilgrims in the New World; drunken, carousing, womanizing, work-avoiding, street musicians as Puritans. That is surely one of the strangest juxtapositions in cultural criticism; there must be rea-sons for it.

What captures the imaginations of these readers of Johnson's lyrics? Most noted is his imagery of the devil and evil. The devil is truly dreadful in Johnson's songs and this has caught the fancy of many a white interpreter since the 1960s, from Charters's 1959 book and the liner notes for the first LP onward. By contrast, as Levine (1977) points out, the devil was a trickster in the spirituals of the nine-teenth century and other popular African-American traditions: often comical, and sometimes an ally because someday he was going to get the white man and make him pay. These same, less threatening (to the Black man) images show up in some of the earlier Delta blues. Peetie Wheatstraw's brag of being the Devil's son-in-law holds no fear; Johnson's "Hellhound on My Trail" evokes a very different image. It is the Hellhound that has held currency over the years; the comic trickster and the ironic familiarity with the devil have faded away.

For tellers of the Johnson story, this literary-critical focus on his lyrics serves at least two functions. First, the focus on evil, devil imagery, and the mortal human's struggle with evil casts Johnson's songs as a vehicle for larger, more impor-tant ideas. Second the literary critical methods cast the interpreter as the medium of that contact. It is the critic, with the creative imagination to see the Delta blues-men as pilgrims, who can elucidate the hidden values of the text; the critic shows

the reader how to do the work of interpretation that makes the song more than a song, but a point of contact with transcendent questions.

The Sound of Suffering

Another way that Johnson's music works for its later listeners is as a distilled sound of suffering, of resignation, and of endurance of wrong. This is not so dissimilar to the literary critical interpretations, but without the wordy explanations. Hammond (1977) tells the story of playing Robert Johnson's music for the director of *Little Big Man* (1970), who wanted a soundtrack that sounded like discrimination. He responded immediately and enthusiastically. Of Johnson's repertoire, it is the haunted suffering songs that the commentary of the last couple decades has been centered on. This emphasis was out of keeping with the definition of blues as dance music, as celebratory song, and as an expression of resistance in desperate situations that was key to the original blues. This might explain why few of Robert Johnson's records sold well in his own community, but why whites who later were looking for something else in blues music responded so well to them.

Johnson as Blank Slate

It is also often reported that Johnson's enigmatic music and lack of established biography made him a blank slate for poetic imaginations. No doubt this is true and imagination began to fill in the blanks as early as Hammond's eulogy. His lack of biography has been filled by the fancies of his audiences ever since and he always comes out being what they fancy. In one account, he is lonely and shy, victimized by women. In another, none can resist his power and the road is paved by those who would serve him.

The mystery, and its attraction, was aided by texts that always began by stating that little was known about him. Guralnick (1989) points out that he and his young friends were fascinated by Robert Johnson even when all they had were several pages from Charter's book and a bad copy of the "not so impressive" "Preachin' Blues." Yet most of the country blues artists had sketchy, if not unknown, biographies. They may not have died early under shady circumstances, but they did provide enough blank slate for imagination to work. The fact that Johnson's biography was, for many years, unknown is not enough to power the "Robert Johnson" phenomenon. It does, though, aid the telling of the Johnson story in so many different ways, thus multiplying its currency.

Given that the Robert Johnson story was being told, for whatever reason, the fact that it was usually told as a mystery has probably aided its reception. The mystery has been cast in many ways. There is the theme of search, as if Robert Johnson

were missing or information about him had some greater value. There is the theme of mystery: some compelling question that must be answered, murderers who must be brought to account, some ghostly presence that must be vanquished. There is the spiritual quest, as if the searcher had lost something that contact with Johnson could provide. There is the invitation for closer examination: liner notes and books on blues history written as if they said between the lines "listen my children and you will hear . . ." as if the music promised more than music but learning.

The Mythic Functions of a Primitive Original

"Robert Johnson" has also functioned in many accounts as a primitive original. One version of this views American musical history as evolving from simpler musical forms, like the blues, to more complex musical forms, such as jazz. In that view the rural blues styles "still" performed in the late 1930s and 1940s were primitive survivals of an evolutionarily older musical form. They were clues to a past that was otherwise unavailable. John Hammond's *Spirituals to Swing* concert was arranged according to such a vision, beginning with what they called primitive blues, then moving through spirituals, boogie, and on to swing. Robert Johnson was his first choice to hold the primitive blues spot on the program. When the first *King of the Delta Blues Singers* album was released in 1961 it had the supertitle *Thesaurus of Classic Jazz*, as if Johnson's recordings had something to do with the history of jazz. The *Smithsonian Collection of Classic Jazz* (1973) repeated this conceit with one of Johnson's 1937 recordings appearing prior to twenty-some other recordings from the 1920s and early 1930s from Bessie Smith, King Oliver, Jelly Roll Morton, Louis Armstrong, Fletcher Henderson, and more—as if Johnson's blues style had something to do with that history. No one promotes this theory explicitly anymore—Johnson was dropped, for example, from the later edition of the Smithsonian collection—but a more implicit idea of the blues, and especially of certain rural players such as Johnson, as more primitive, original, and pure than other recorded examples, still has much currency.

Johnson has also functioned as a kind of primitive original in the search for authentic roots. American popular music is a for-profit, industrial product in a culture that values honest expression and authenticity. Both recording musicians and the record-buying public have reasons to look for something less threatened by the taint of strategic calculation. Prewar blues recordings, especially of the rural styles recorded by people who made little money doing so, can represent that pre-calculated musical expression. One can imagine that the bluesman sang it that way because he felt it that way. Every detail of performance and style can then become a sign of authenticity, redeployed by emulators today. The cheap guitars that the bluesmen played because they could afford them, for example, have come

to be highly prized by white players today (Narváez, 2001). They are thought to aid the player's authenticity.

The Johnson case also fits in a larger history of racial coding in American culture. From the 1920s on, the music industry has profited on African-American musical expression, until recently, under the most exploitative of contractual terms. Through this mechanism African-American culture has been a key source of musical variety and came to be seen as a source for the new and different (Barlow, 1990; Garofalo, 1990). In line with the racial codes of the larger culture, "black" music tended to be seen as more spontaneous, more natural, more to do with the body and the emotions (this complex issue is addressed by Frith, 1996, and Negus, 1996, among others). Performers such as Robert Johnson can, then, in the white imagination, hold some mysterious, precognitive knowledge, something that the over-socialized white man hopes could be regained through contact with Black culture. Such thinking is seldom spelled out explicitly; it is, though, part of the mythical logic of Robert Johnson's attraction for white audiences. (Lipsitz [1997, 1998] has developed this theme at greater length.) He is a symbol of something lost, something simpler and truer than how we live now. He is thought to be an original when everything else is a copy; the search for Robert Johnson makes him deep when everything else appears shallow.

An Industrial Product

Yet another possibility is that the whole Robert Johnson phenomenon is a product of the music criticism industry and record and recording star promotion. No doubt plenty of money has been made on Robert Johnson books and records. The indirect value of the Robert Johnson symbol in myriad other enterprises, from covers of his songs, through rock stars talking about him in promoting their own images, to the state of Mississippi promoting Delta tourism, there is economic value added by association with "Robert Johnson." And the Johnson talk promotes a set of values, ideas, and symbols that help feed all of the rest of the rock and roll criticism industry. Among the key issues promoted are the importance of authentic roots and romantic ideas of creative genius. Whose roots could be more authentic than the man who sold his soul to the Devil to earn them? Who could be more true than the musician who died while performing, even for performing? Who could be more the incomparable creative genius than the Delta musician who did not learn from other Delta musicians, who surprised them with his playing, and whose lyrics were, upon closer examination, so un-Delta-like as to reveal the hidden truth that the blues were hymns and their singers the new puritans? No wonder rock stars from Clapton to Fogerty have claimed a connection.

If the whole thing is just a product of the music business, especially the wordy world of rock and roll magazines, then that would help explain some of the peculiar choices of emphasis. Many know the title and talk about "Hell Hound on my Trail." Yet its most evocative image is already spent in the title; it is not Johnson's most impressive song. It is certainly not as impressive as all the pages of commentary devoted to it. "Stones in My Passway" is equally spooky; "If I had Possession Over Judgement Day" surpasses it in brooding threat, while "Last Fair Deal Gone Down" is a more complete musical expression of fate.

Johnson as Utterly Unique and Inexplicable

Finally we must consider the trump card in the Robert Johnson story: the claim that he was an utterly unique artist, without explanation. No doubt his music has a compelling value; it has a unique place in the catalog of recorded blues. The idea that the artist that produced that music was equally unique and produced his records as pure, unalloyed artistic expressions is an attractive and essential piece of the romantic understanding (cf. Lipsitz, 1997). Yet the romantic age begat sociology, among other things, and now we know that no artist is without explanation. Artists, just like everybody else, are people with jobs. The first explanation is that they get paid for doing their art. More particularly, as discussed above, there is little of Johnson's style that cannot be traced to one influence or another, though he may have been relatively unique in his day for the extent to which he assimilated different stylistic features.

In the telling of the Johnson story, the possibility that he may be without explanation, works in another way without confronting sociology. It is a kind of ghost story that is fun to tell and functions mythologically without presenting the myth directly. Robert Johnson is supposed to have sold his soul to the Devil in return for his blues talent. His talent is, then, otherworldly, not to be understood by mortals. Just like the genius whose creativity is without external cause, Johnson's songs cannot be seen as products of Johnson's working environment. And if you do not believe in the Devil, well, then there is no explanation.

The deal-with-the-devil version of the story draws credence from other circumstances in Johnson's life. He and his contemporaries are said to have said that he did make such a deal (but see Pearson and McCulloch, 2003). He is reported to have been away from his home territory for some time and suddenly reappeared as an expert guitarist. Throughout his professional life he had mysterious habits, or so the story goes. He was a loner in a sociable business; he had few friends, seldom played with other musicians, and left distinctly mixed feelings among his contemporaries. He would appear and disappear in places and towns without warning.

Throughout his travels, hoboing and riding in empty boxcars, he always appeared neat and clean. It is said he had a peculiar power over women. (More prosaically, it is also said he chose older and more homely women, maintaining a relationship with one in each town so he always had a safe house.) Stories are told of his mesmerizing effect on audiences. And then he died. During a break in a show, it is said, he went outside to get air, fell sick, and was soon reduced to crawling on all fours and barking like a dog. Gone from genius to madness in the space of an evening, with death to follow. The Devil gave him magical powers for a time here on earth, and then came to get his due. Obviously.

Reputation, Image, Celebrity

The Robert Johnson story is told in several ways that serve several functions: as a version of traditional, romantic ideas about the inexplicability of genius, about the common wellspring of all creative genius, about the powers and costs of dealing with the Devil, about artistic craft, about literary interpretation and audience reception, about the search for truth, about the music industry itself, and more. These stories, as varied as they are among themselves, can all function together because Johnson's life was so unknown and, basically, irrelevant to the functioning of the stories. What has come to count for Johnson is that he is a hook to hang the stories on. In this he is certainly not alone. This concluding section compares the Robert Johnson phenomenon with other celebrity careers, considering the functions of the Johnson story amid other celebrity stories, for an audience of the history of blues music, and for an audience of his reputation.

The strange career of Robert Johnson's records is, in the most general sense, a career of symbols. Image, reputation, and celebrity are symbolic entities that are sustained in the discourse and practices of networks, communities, and audiences. They have chartable careers of rise and fall, periods of stability and change; they grow and change in an environment of other symbols. Robert Johnson, the person, became "Robert Johnson," a symbol invoked for its semantic and pragmatic utilities. The different ways of telling the Robert Johnson story and the associated ways of listening to his records, serve different symbolic functions within discourse communities. The aggregate produces the pattern that is the strange career of Robert Johnson's records.

Comparisons with other posthumous celebrities show that the disjunction between Johnson's life, on the one hand, and the posthumous success of his records and the rise of his reputation to a type of celebrity status on the other, is not unprecedented, even if his is an extreme case. Indeed, the romantic narrative identification of genius and madness, mysterious origins and early death, excesses

of appetite for sex and stimulants, deals with the devil, and inexplicable success has precedents in the biographies of European writers, composers, and musicians of two centuries prior. At the same time that Johnson's mythology was growing, the same ideas appeared in new mythologies of Jimi Hendrix, Janis Joplin, and Jim Morrison.

Importantly, Johnson's case grew in the soil of a racially stratified society and culture. The Black presence as imagined other, and African-American sources of cultural variety, innovation, and authenticity—real and imagined—are fundamentally important to the history of American popular music. The Johnson case is a key example. The strange career of the records is also inextricably tied to the growth of the recording and radio industries, the development of markets for the history of popular music, and the more general growth of forms of celebrity culture. Recent trends and events, such as auctions of memorabilia from long-dead movie stars, and the recirculating of celebrity biographies on cable channels, can be interpreted as signs of a contemporary cult of celebrity.

In its symbol career, "Robert Johnson" exists for audience members before they encounter him. He is already constructed as interesting, important, and worthy of attention. As Rodden (1989) reports in his study of Orwell's posthumous reputation, "We often inherit literary opinions of educated taste long before we have the wherewithal to judge confidently ourselves" (p. 67). Learning that Robert Johnson was special and that the aficionado should know and admire his work is characteristically a first step in learning more about blues history. Johnson's reputation is crucially dependent on his music being recommended by the authorities and then becoming the one prewar blues musician that many people know. This also produces and maintains the confusion about just when he was alive and what era his music represents, as he functions to represent everything before postwar Chicago electric blues.

For audience members who come to know the Johnson story and can talk about his reputation as well as play his records, there may be another kind of function. One of the types of audience response to celebrity that Gamson (1994) found focuses on the pleasure of gossiping. For these audience members, "an 'as if' position is adopted and story lines trump truth pursuits because what is important here is a process rather than an end-point, a game rather than an outcome, and relationships between players rather than with celebrities" (p. 175). These are audience members for whom the pleasure of celebrity watching is derived from the social participation of trading stories in a group. For them, stories about the celebrity are a kind of currency of social interaction, and an exercise of imagination. The more outrageous and implausible stories could be better for these purposes because of their stretch on the imagination and the incredulity they inspire from fellow-gossipers. Something similar may be at work in the Robert Johnson myth. In what other context today do college-educated Americans talk earnestly about the devil as an ani-

mate being? Could passing the story that Johnson sold his soul to the devil, and wondering aloud if his songs might really be haunted and haunting, be the educated, secular, adult version of ghost stories, a kind of Halloween for music fans?

The response of most fans to Robert Johnson is probably of the same type as Gamson's (1994) second-order believers. They are aware of the industrial processes that produce celebrity and stars. They have a realistic and reasonably informed point of view about the media and its machinations. They also, however, believe in the specialness of their chosen stars, or at least they willingly suspend disbelief. Despite the manipulations, second-order believers hold that some stars really are special and really have earned their status through talent, hard work, or both. Authenticity is important for this type of audience response, alongside realism. Based on a vision of the viability of authenticity within the industry, audience members who respond this way can engage in "activities conventionally associated with star watching, those in which pleasure is derived from a feeling of connection with the celebrity: admiration, identification, modeling, and fantasizing" (p. 169).

Robert Johnson may be a particularly apt candidate for second-order believers. Being dead long before the rise of his reputation to anything like celebrity status, he cannot be seen as either participant or profiteer in the industrial promotion of his music, myth, and image. (With both his life and his life's work sealed, he represents a simple target for projection.) Neither his person nor his character will be making any new appearances—in the news, in gossip, on talk shows, or as the author of new works—to complicate the image. Being an American Black man who signed the kind of recording contract typically offered to Black men in that era— and now universally deemed exploitative—he can be seen as a victim of the industry system, more than its product. Accompanying himself on guitar, playing songs credited as his own compositions, representing for his white audience an African-American sound, he can be seen as a primitive original. Robert Johnson and his music can be readily portrayed as the authentic source, the good origin of so much later music and so many later musicians who were good but tainted by association with the industrial manipulations of the for-profit music business. He is a near perfect foil for second-order believers, for those with a realistic view of the industry, but a strong drive to believe that something and somebody is good, true, special, and authentic nevertheless.

As Rodden (1989) points out of Orwell, his serving as a hero for so many different people of such different political positions for such different purposes depends on his image having had its distinctive edges smoothed down. More generally, it is likely that collective memorialization has a wearing effect, which further enables memorialization. Like wood or rock exposed to wind and water, the remembered becomes eroded by being remembered: it becomes smooth, worn into an appropriate shape by the friction of its environment. The shape an object attains in its own

lifetime—a tree or a person—is a reflection of its living being in its environment. The shape it takes after its lifetime—drift wood or cultural hero—is a reflection of its being still around, though dead, in another environment, one in which it is distinctly a foreign object. So Robert Johnson lives on, though long dead: a mute but ghostly presence, shaped as much by our choosing to be haunted as by the work he left to do the haunting.

Acknowledgements

This paper has a long history and I thank the many friends and colleagues who have provided helpful comments, including especially Steve Bailey, Rob Drew, Joli Jensen, Steve Jones, Tom McCourt, Jonathan Sterne, Steve Wurtzler, and members of the audience at the various places it has been presented. It was first presented at the National Communication Association Annual Convention, November 1998; related papers from the same project were presented at the International Communication Association Annual Convention in May 2000 and the International Association for the Study of Popular Music meeting in November 2000. My thanks to everyone.

References

Barlow, W. (1990). Cashing in: 1900–1939. In J. L Dates and W. Barlow (Eds.), *Split image: African Americans in the mass media* (pp. 25–55). Washington, DC: Howard University Press.

Barlow, W. (1989). *Looking up at down: The emergence of blues culture.* Philadelphia: Temple University Press.

Calt, S. (1990). Liner notes. *The roots of Robert Johnson* [CD]. Newton, NJ: Yazoo.

———. (1994). *I'd rather be the devil: Skip James and the blues.* New York: Da Capo Press.

Charters, S. B. (1973). *Robert Johnson.* New York: Oak Publications.

———. (1975). *The country blues* (Rev. ed.). New York: Da Capo.

Columbia (1961). Liner notes. *Robert Johnson: King of the Delta blues singers* [LP]. New York: Columbia.

Evans, D. (1982). *Big road blues: Tradition and creativity in the folk blues.* Berkeley: University of California Press.

Ferris, W. (1978). *Blues from the Delta.* New York: Da Capo.

Frith, S. (1996). *Performing rites: On the value of popular music.* Cambridge, MA: Harvard University Press.

Gamson, Joshua. (1994). *Claims to Fame: Celebrity in Contemporary America.* Berkeley: University of California Press.

Garofalo, R. (1990). Crossing over: 1939–1989. In J. L Dates and W. Barlow (Eds.), *Split image: African Americans in the mass media* (pp. 57–121). Washington, DC: Howard University Press.

Greenberg, A. (1994). *Love in vain: A vision of Robert Johnson* (Rev. ed.). New York: Da Capo.

Guralnick, P. (1989). *Searching for Robert Johnson.* New York: Dutton.

Hammond, J. (1977). *John Hammond on record: An autobiography.* New York: Ridge Press.

Johnson, R. (1990). Hellhound on my trail (transcribed by S. C. LaVere). In liner notes, *Robert Johnson: The complete recordings* (pp. 38–39) [LP boxed set]. New York: Columbia.

LaVere, S. C. (1990). Liner notes. *Robert Johnson: The complete recordings* [LP boxed set]. New York: Columbia.

Levine, L. W. (1977). *Black culture and black consciousness: Afro-American folk thought from slavery to freedom.* New York: Oxford University Press.

Lipsitz, G. (1997). Remembering Robert Johnson: Romance and reality. *Popular Music and Society,* 21 (4), 39–50.

———. (1998). *The possessive investment in whiteness: How white people profit from identity politics.* Philadelphia: Temple University Press.

Lomax, A. (1993). *The land where the blues began.* New York: Delta.

Marcus, G. (1982). *Mystery train* (2nd. ed.). New York: Dutton.

Narváez, P. (2001). Unplugged: Blues guitarists and the myth of acousticity. In A. Bennett and K. Dawe (Eds.), *Guitar cultures* (pp. 27–44). New York: Oxford.

Negus, K. (1996). *Popular music in theory.* Hanover, MA: Wesleyan University Press.

Oliver, P. (1965). *Conversation with the blues.* New York: Horizon Press.

Oliver, P., Harrison, M., Bolcom, W. (1986). *The new Grove gospel, blues and jazz.* New York: Macmillan.

Palmer, R. (1981). *Deep blues.* New York: Viking.

Pearson, B. L., and McCulloch, B. (2003). *Robert Johnson: Lost and found.* Urbana: University of Illinois Press.

Rodden, John. (1989). *The politics of literary reputation: The making and claiming of 'St. George' Orwell.* New York: Oxford University Press.

Rothenbuhler, E. W. (2000, November). *Robert Johnson's blues style as a product of recorded culture.* Paper presented at the Annual Convention of the International Association for the Study of Popular Music, Toronto, Canada.

Siems, B. (1991). Brer Robert: The bluesman and the African American trickster tale tradition. *Southern Folklore,* 48, 141–157.

Titon, J. T. (1977). *Early down home blues: A musical and cultural analysis.* Urbana: University of Illinois Press.

Wald, E. (2004). *Escaping the delta: Robert Johnson and the invention of the blues.* New York: Harper Collins.

Wardlow, G. D. (1998). *Chasin' that devil music: Searching for the blues* (E. Komara, Ed.). San Francisco: Miller Freeman.

Wardlow, G. D. and Komara, E. (1998). Stop, look, and listen at the cross road. In G. D. Wardlow, *Chasin' that devil music: Searching for the blues* (E. Komara, Ed.), (pp. 196–206). San Francisco: Miller Freeman.

Welding, P. (1970). Liner notes. *Robert Johnson: King of the Delta Blues Singers, Vol. II* [LP]. New York: Columbia.

Williams, L. (1998). 2 kool 2 be 4-gotten. In liner notes, *Car wheels on a gravel road* [CD]. New York: Mercury Records.

part 3

Technology, Process, and Immortality

A Career in Music

From Obscurity to Immortality

Marko Aho

The Opposite Ends of the Scale

We may use concepts such as "star," "icon," "artist," "immortal," "legend," and "larger than life" when talking about notable past and present musicians, singers, and composers, and other characters in popular music. We may easily place a whole bunch of such descriptions in a row. The labels we attach to the protagonists of popular music are for the most part a matter of taste, but at the same time we acknowledge that not every pop singer is a star, that not every star shines equally brightly, and that while some stars eclipse before we know it, many are so enduring that even death itself cannot dim them (in fact, the effect is, at least in the short term, often quite the opposite). With stardom we are dealing with a particular form of public existence. We can imagine two very different characters, who share one trait in relation to us the public: the lack of direct contact. First, there is an ordinary person lacking any media presence. He or she exists, but we don't really know it. Then, at the opposite end of the scale, there is the (Michael Jackson-esque) virtual media-figure, in all aspects spectacular, whose "real" life outside the TV screen is almost impossible to imagine. Does he or she even exist in "real life"? We don't really know. We are only familiar with the image.

Public, private, image and reality are all central aspects when discussing the phenomenon of stardom. In this article I will deal with these aspects with a model

of a star consisting of four parts: "private person," "artist," "celebrity," and "legend." A normative definition of these concepts is not my objective: the concepts as such are not important, although I hope the ones I have used are apt to describe those parts which together form a whole entity, a star in popular music. Placing the concepts within a model or typology has its difficulties given the subjective meanings we give to any such concept. However, the tentative model presented here is a closed one, and the concepts used in it are interdefined.

It may be worthwhile to explain how the impulse to create this model was raised by an acute practical problem, which forced me to explicate rigorously how I understood stardom, and in particular how I perceived deceased stars as differing from living ones. As a result of writing a semi-academic article about certain key figures in the history of Finnish popular music (all of them long since deceased), I received feedback from hardcore fans of these singers and composers: they thought that I was totally "missing the point" as I was studying the timeless popularity of their idols in the context of *discourse* and not in the context of audible music. I wasn't even going to "set the record straight," reveal the "real truth" about their idols, which some of them thought had been forgotten. The fans seemed to refuse to give credit to any extramusical features of stardom. There was confusion over the relationship between historical truth and recitals, and the relationship between musical and extramusical substance of stardom. When talking about stars as products of cultural industry, not encountered by but mediated to the audience, fact and fiction, corporality and image intermingle confusingly. What attracts people to stars? For some it is "the grain of voice," "the impossible account of an individual thrill" experienced in listening to singing (Barthes, 1990, p. 294); for others it is "charisma," or something even more undefinable. Be the case any of these, these features can be received and consumed in a physical sense by listening to the recordings or by going to the concerts, physically taking in the audible music. But audible music is not the only means by which the stars exist among us. They are talked about, read about, some are the subjects of movies—and music is not always present when they are. Here is where death begins to matter. How? Death is the point after which reality will never again have meaning over image.

The Relationship between Star and Audience

Posthumous stardom is one particular aspect of stardom. It can best be approached by first defining some of the key features in the star-audience relationship. Stardom is a multifaceted phenomenon and as such a difficult subject of study. It has, perhaps, not received the amount of academic attention it deserves. Writings on stardom tend to concentrate on single performers (typically on the writers' own

idols) and are thus more likely to prop up the existing star mythology than to unravel it. Also, most explorations of the nature of stardom have been done in cinema and televsion studies, not in the context of popular music. The existing definitions are nevertheless worth considering here: many stars are multimedia phenomena, and in some cases it is quite impossible to define the star's primary artform. *Star* is the central concept when considering the protagonists of cultural industry in terms of *success*, so much so that choosing this term as a center of all definitions seldom needs any accounting for. In most considerations, Star appears as a standard unit of mass culture marketing, and with the ontological commercial nature of mass culture, as a standard unit of mass culture generally. It is noteworthy that in the early days of cinema, the actors were secondary in the marketing of the films: it was not until it was noticed that some actors indeed had more appeal than others that they were brought into marketing, and soon turned into standard units of marketing—a state of affairs we nowadays take as a matter of course. According to deCordova (1991), there was a preliminary stage preceding the star: the "picture personality," who emerged as the principal site of product individuation (p. 24). A picture personality was identified, but only as a performer; knowledge about the picture personality was restricted to the actor's professional existence. Whereas with the emergence of the star, the question of the actor's existence outside his or her work, the paradigm professional life/private life, entered discourse (p. 26).

When discussing stardom, it is common to refer to its mediated nature (see Thwaites et al., 1994; Grossberg et al., 1998)—the fact that, in reality, these real people are connected to the audience only through media. Of course in the field of popular music, stars give live performances (unlike movie stars), but one may well argue whether attending a Michael Jackson stadium concert will give a fan in the audience any real unmediated contact with their idol. The case is the same with any major star, whatever the art:

> . . . we are dealing with the stars in terms of their signification, not with them as real people. The fact that they are also real people is an important aspect of how they signify, but we never know them directly as real people, only as they are to be found in media texts. (Dyer, 1986, p. 2)

Christine Gledhill (1991) has presented the term *star structure*, which consists of (1) the star as a "real person," " . . . the site of amorphous and shifting bodily attributes, instincts, psychic drives and experience"; (2) all of the "roles" played by the star in films, "formed and fixed by fictional and stereotypical conventions"; (3) the star's "persona" which links the previous two together and "forms the private life into a public and emblemetic shape"; and (4) a "star image," which includes all the three other levels plus all of the subsidiary circulation, such as "gossip and speculation" (pp. 214–217). To this Mäkelä (1999) has also added the concept of *star-*

dom, by which he means the notion that the audience has of the lifestyle of the stars. Ellis (1985) on the other hand defines a star as a "performer in a particular medium whose figure enters into subsidiary forms of circulation, and then feeds back into future performances" (p. 91).

Still, in the context of movie stardom it has been argued that the star phenomenon in subsidiary forms of circulation (e.g., photographs or magazine interviews) produces an "invitation" to cinema: the subsidiary forms are incomplete, presenting "only the voice, only the still photo, only the face" (Lury, 1993, p. 69), and paradoxical, as they are showing the star as both ordinary and extraordinary. They propose cinema as a completion of their lacks, the synthesis of their separate and scattered fragments. In many cases, the subsidiary forms are intended to be concieved as revealing the truth about the star, the "real person behind the roles." However, it has been questioned whether the cinema is still capable of synthesizing the independent fragments of the star image, since the truth status of any of these fragments has weakened. The reason for this is the "increasing pervasiveness and self-consciousness of forms of promotion and the expansion of the performative principle in contemporary consumer culture" (p. 70). Lury continues:

> The desire that was offered access to its object only on condition that it was presented as absent was fuelled by the claims to truth offered in the subsidiary circulation of the star image; these claims are no longer either so intended or received. (p. 70)

But Lury points out that at the same time a new kind of star has emerged, whose appeal derives from the ability to make the actual virtual and the virtual actual: "These stars are sustained through the strategic and self-conscious manipulation of performative intentionality across media" (p. 71). Indeed, one may argue whether this has become the mainstream politics as "celebrities take on their own middle-range reality in which selves are simultaneously spontaneous and simulated and staged, doled out in bits and pieces that are simultaneously composed and authentic" (Gamson, 1994, p. 172).

Dyer (1986) points out the American "myth of success" as an underpinning of American movie stardom. The general meaning of the "myth of success" is that American society is sufficiently open for anyone to get to the top, regardless of rank. The myth of success is grounded in the belief that the European-style class system does not apply to America. The dynamics of stars-as-ordinary and stars-as-special are not exclusively American phenomena, as ordinariness and modest background are common to pop stars in Britain, too, for example—one must only look back on those fabulous four boys from Liverpool. Dyer (1986) refers to sociologist Francisco Alberoni's definition (see Alberoni, 1972, p. 75) of stars as a group of people whose institutional power is very limited or nonexistent, but whose doings and way of life arouse a considerable, or sometimes even maximum, degree of interest. So,

stars are a remarkable social phenomenon in the sense that they are an "elite, priviledged group who yet on the one hand do not excite envy or resentment (because anyone may become one) and on the other hand have no access to real political power" (Dyer, 1986, p. 7). Dyer lists some traits of stars which are in accordance with the myth of success: (1) ordinariness is the hallmark of the star; (2) the system rewards talent and "specialness"; (3) lucky "breaks," which may happen to anyone, typify the career of the star; and (4) hard work and professionalism are necessery for stardom (p. 48; see also Ellis, 1985, pp. 94–95).

From an Obscure Amateur to an Immortal Legend

Four different musical characters are presented below. The first two remain anonymous, the latter two are Elvis Presley in two different points in time. The differences between these characters occur with the amount and type of publicity.

1. Hobbyist. He or she doesn't really have an audience, plays almost exclusively at home alone and seldom spontaneously in public—in a way that cannot really be defined as making *public appearances*. Very few people know about his or her playing skills, not that there would necessarily be much to know. In the public eye, he or she is "a nobody."
2. Musician. This person might be an amateur or a high-paid and valued professional. In either case, they are just "one of the guys" in the back part of the stage: his or her name doesn't "ring a bell."
3. Elvis arriving to a studio in Memphis on January 13, 1969. The session starts with "Long Black Limousine." "I mean we were thrilled with Elvis," says session trumpet player Wayne Jackson, "but it wasn't like doing Neil Diamond" (Guralnick, 1999, p. 329).
4. Elvis at the turn of the millenium. Elvis can be "sighted" everywhere:

Sneaking out of songs, movies, television shows, advertisements, newspapers, magazines, comic strips, comic books, greeting cards, trading cards, T-shirts, poems, plays, short stories, novels, children's books, academic journals, university courses, art exhibits, home computer software, cookbooks, political campaigns, postage stamps, and innumerable other corners of the cultural terrain in ways that defy common-sense notions of how dead stars are supposed to behave. (Rodman, 1996, p. 1)

What is the point of these examples? On first glance they might be thought of as points in the narration of a a star's existence. Ultimately, though, they should be thought of as *aspects* of a star. The idea in the model is to break the totality of a star into its parts. As labels for the different parts of the model, I will use terms that are commonly used when talking about the protagonists of popular music. As in

the model, these different concepts portray their object from a slightly different aspect. The dimensions in my model are reality vs. presentation of reality, identification vs. idolization, and nearness vs. distance.

First, there is an ordinary person who attracts no media attention whatsoever: from the point of view of the media, this is a "private person," and from the perspective of the receiving end of media products, he or she has no public existence. Every so-called "public figure" has been a "private person," excluding the children of celebrities and such curiosities who were already, for some peculiar reason or another, in the focus of public attention at the moment of their birth.

A superstar also has, despite all media interest, a private life, however narrow it might be. As an *aspect*, "private person" is that sector from the star's life that does not exist publicly. The audience might receive some kind of a vision of the star's private life, but this is basically only a mediated representation of the real thing. As a "private person," the star approaches in his or her qualities those of the audience: the star, too, has basic physical needs, where there can be no wide variation despite lifestyle. But also *culturally*, many stars lead their private lives in ways that are similar to their audience: as on the average, stars also divorce or drink too much. In conclusion, it can be said that as a "private person," the star is at his or her commonest. Naturally, extreme behavior can be found in the private lives of the stars, but then again it can also be found in the lives of so-called ordinary people. For the audience, the picture of the star's private life is only a representation of reality; despite all the footage pretending to show a star in her/his private moments (e.g., *In Bed With Madonna*) we will never actually see this, or at least cannot be sure whether what we see is spontaneous or staged. Nevertheless, for the star, everything in the domain of "private person" is an ever-passing physical reality—*historical truth* also belongs there. Historical truth cannot be seized: every attempt will only result in a representation of it. Although we have no direct access to historical truth, we nevertheless know that it exists: Something really happened in a certain point in time and space. In this sense, historical truth, and also "private person" as here defined, remain even after the physical person is deceased.

In the second stage, "private person" evolves into a music-maker: a musician, a singer, a composer, a lyricist, or an orchestrator. With "artist," public musical activity begins. The person has crossed a border from receiver to sender, from an inclusive to exclusive group. His or her persona might not gain public attention yet, but public life has nevertheless begun, be the musical activity live performances, recording, or making music only for release under other artists' names.

As an aspect attached to stardom, the "artist" contains the musical output on which the stardom, in principle, is based, although in reality it is highly questionable whether contemporary audiences expect any natural merit for gaining stardom (Gamson, 1994, p. 146). As a private person, the star is indistinctive in his or her

features. But as an "artist," he or she is equipped with distinctive abilities: musical talents. The "artist," similar to "private person," belongs to physical reality—music is heard, the theatrical component is seen. In the age of mechanical music reproduction, the "artist" lives, in part, in sound recordings, and is thus not dependent on the status of the star's mortal body.

Some music-makers become stars, and the music-maker changes in the public eye from anonymity to a person. The attention of the audience, which was not directed toward the personality of a mere musician, concentrates on the personality of a star: media presents the much yearned for information. Marketing begins or increases, and the star in this context also participates with his or her personality, not only with music; "celebrity" is born. The substance of "celebrity" is *extramusical* material: marketing, promotion, T-shirts with the star's picture on them, media coverage of the star's latest happenings. In principle, two kinds of extramusical material can be identified: material produced by the star him/herself together with the commercial institution attached to him/her, and material produced spontaneously by the media without direct input from the former agents. In both cases, though, we are dealing with primary production of different sectors of cultural industry, which is symbiotic in nature; the direction of the flow of information is from the industry to the consumers. Understood in this way, music critique is much closer to promotion than to actual interpretation of the cultural products made by the receivers.

In some instances musical "celebrity" can be born without any musical component attached to it. One can imagine a scenario where *media-hype* precedes the debut record of a pop band or singer who has signed a remarkable recording contract. In an extreme case, no record would ever follow.

As an *aspect*, "celebrity" contains first a representation of the star as "private person." However, this is only a representation of the reality, not reality as it is. Ideally, this representation of the star's ordinary features serves as the particular component of stardom the audience can identify with. On the other hand, reports of the celebrity—an aspect itself—also belong to the substance of "celebrity." The audience can hardly identify with this component: fast cars, castle-like homes, and superattractive partners. Interest toward the "celebrity" focuses particularly on the latest news about the star, with this kind of material forming the bulk of the media reports. In addition, retrospective accounts of the star's personal and career history are made. Regardless of whether the physical star-persona is present when these accounts are made, the existence of the person must be taken into consideration; in an extreme example, untruthful reporting might result in a lawsuit. Even in a less extreme case, the existence of the real person always has an effect on what the media publishes about the star, and how people think of the star in general—historical truth and reality are too near to be forgotten.

However mediated in nature the celebrities are, they are still "near" to the public in a sense that they, in principle, could be reached physically by a fan who was determined enough. Even behind the high walls of their castle-like homes, they inhabit the same city and breathe the same air as fans, and could be made to react to a deliberate impulse. We can't neccesserily see them but we know they are there.

In the fourth and last stage in the evolution of a star, the "legend" materializes, and with it the opposite counterpart of the "private person" has been reached. Roughly put, a "legend" develops from a star, whose fundamental source of substance—the physical individual—retires from the service of the entertainment industry and thus produces no more musical or extramusical substance, but still refuses to fade away from the public: no more new music is produced, no more marriages are bonded, but still more new cultural products around the character are being made. Along with these cultural products, the star attains a *larger than life* or *immortal* status. Stars light and fade away, and only some characters remain to draw public interest among noncontemporary audiences after their acuteness has permanently and eternally ceased. Even after death of the physical body, records, movies, and all the material that creates a recollection of the "artist" remains; and along with the "legend," the life of the "artist" also continues as long as there is a single record left. Paradoxically, with many careers the peak of record sales and marketing is reached just after the death of the person, and long afterward compilation albums and reissues are published and promoted just like in the "artist's" heyday.

The "artist" and "private person" are physical in nature, the "legend" metaphysical: the "legend" is preserved in *recitals*—retellings of the story. Thus, we have legendary musicians whose music no contemporary person has heard. A good example is Buddy Bolden, New Orleans–based "world's first jazz-trumpeter," who, the story goes, had a habit of strolling along the streets of New Orleans with five women on his arms, and whose trumpet could be heard from a distance of fourteen miles on a clear day (Carr et al., 1996, p. 65). Bolden never recorded, so all that is left from his majestic sound are the recitals. This example demonstrates how the recitals that carry the legend are in no fast relation with historical truth—they are either true or not, and as far as the legend is concerned, it is totally irrelevant. One may acknowledge, of course, that historical truth exists, but its accurate contents are destined to remain unclear. As soon as historical truth is being mediated, it turns into a mere image of the historical truth, and to substance of the "celebrity." We can now see that "private person" actually escapes all attempts to approach it.

One cannot grow into bona fide *larger than life* proportions during one's active career, or even lifetime: historical truth and physical reality, *life*, is too near and will always ruin the illusion. Active career is the phase when the star does the things that the recitals will be loosely based on afterward. The "legend" is potentially fur-

ther away from historical truth than "celebrity," since as time passes, fewer and fewer contemporaries even claim to know the historical truth, and after the death of the star the historical truth really draws away, giving room to recitals. Like "celebrity," "legend" also contains a component that represents "private person," with which ordinary people can identify. On the other hand, a component of extreme exaggaration also belongs to "legend," with which no one can directly identify.

From the moment when the star arrives in public knowledge, cultural products are born in the making of which the star, with his or her financial backers, and the symbiotic cultural industry does not participate. These agents have presented the impulse, their cultural texts, and now these texts are out of their hands. This *projection* is changed to *reflection* as receivers make their own interpretations of these products, and according to these interpretations make new cultural products, *reflection cultural products*. These products are made by the fans, but also by the media—or should we say, fans within the media. Nevertheless, the essential feature with these is that they belong to the secondary stage of production, which is based on interpretations made from the products of the primary stage. The star turned into a "legend" continues its life in magazine articles, TV documentaries, and biographical feature films according to its own course.

All the dimensions of stardom discussed above can now be joined together in a three-dimensional chart (figure 12.1) that illustrates the totality of the star with its aspects and parts. The model is of a music star, but the structure is similar in every area of the culture industry: to make the model more general, *musical* could be replaced with a more general *artistic*, and in accordance, *extramusical* with *extra-artistic*.

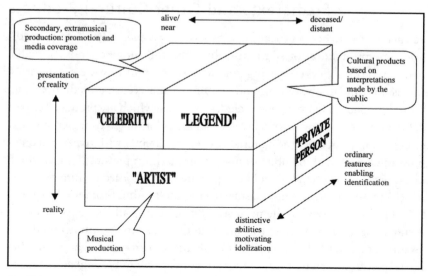

Fig. 12.1.

From the point of view of an individual fan, the appeal of a certain protagonist of popular music might be based entirely on the musical output of the "artist," or on the extramusical substance of the "celebrity," or to both, as propably usually is the case—but similarly the appeal might also be based entirely on the feedback products forming the "legend." The individual behind the character of the star and the musical products in themselves are real, whereas the mediated star-character is virtual reality. The "celebrity" is based on what the star projects, but the "legend" is born only after that projection is received, interpreted, and reflected; this typically takes place after the star is deceased or is "distant" in the fashion of the latter-day Howard Hughes, who lived in complete seclusion, so that the star's projection, always to some extent anchored to the trite reality, ceases to interfere with the escapist reflections produced by the fantastic interpretations of the fans. Finally one should also make a clear distinction between "idolization" and "identification." Stars are idolized because they are special. But to these special assets an individual fan cannot identify him/herself, because he or she does not have these qualities. However, the special qualities of the stars create the need to identify with them. Hence, identification targets the qualities found in stars that are common with the audience, for example, sex or ethnic backround. Indeed, to many members of the audience, a star lacking both extraordinariness and at the same time earthly ordinariness would be a disappointment, since this would rob them first of their dreams of heroism and second of the illusion of the possibility of becoming one her or himself.

Mediatexts and Other Cultural Products

As I noted above, we do not get to face our stars as real people, only as images mediated to us. The production of stardom utilizes the full range of today's media. Every medium in turn offers coexisting practices, which multiply the possibilities. The result is a formidable variation and amount of star-creating mediatexts and other cultural products. (1) *Promotion* includes the texts, which are produced as part of the deliberate creation or manufacture of a particular image or image-context for a particular star. It includes (a) material concerned directly with the star in question—press releases, fan club publications, pinups, fashion pictures, ads in which stars endorse a given merchandise, public appearances as recorded on film or on the press; and (b) material promoting the star in a particular film. Promotion, according to Dyer (1986), is propably the most straightforward of all the texts that construct a star image, in that "it is the most deliberate, direct, intentioned and self-conscious" (p. 68). (2) *Publicity* is of close relation to promotion, and only theoretically distinct from it in that it is not, or does not appear to be, deliberate image-making. It is "what the press finds out," "what the star lets slip in an interview,"

and is found in the press and magazines, radio and television interviews, and the gossip columns (p. 69). (3) *The films* themselves are often built around star images (p. 70). (4) *Criticism and commentaries* refer to what was said or written about the star in terms of appreciation or interpretation by critics and writers. It is found in film rewiews, books on films, and "indeed in almost any kind of writing dealing, fictiously or otherwise, with the contemporary scene" (p. 71).

Mäkelä (1999) has made a grouping (based on Dyer 1986, 69–72) of the different media texts that form the star image of a star in the field of popular music. This includes: (1) Music in all its forms—on records, in concerts, and so on—but also, depending on the star, movie roles, interviews, autobiographies, and other "stars own doings"; (2) promotional material, produced as a part of the deliberate creation or manufacture of a particular image or image-context for a particular star; (3) media commentary, which refers to everything said or written about the star in terms of appreciation or interpretation by critics and writers and appears in the form of critique, news, columns, parodies, and so on; (4) the production of the fans: artifacts, fanzines, fan mail, and the like (pp. 14–15).

The grouping above ties products together according to the source of the products, which can be: (1) the person who is the star him/herself; (2) the record company; (3) the media; and (4) the fans. We can, however, further reduce this classification as two distinct types of material emerge: *projection cultural products,* (Figure 12.2) which the star him/herself and institutions connected with the star in person have produced, and *reflection cultural products* (Figure 12.3)—cultural products treating the star in one way or the other made by other makers than the star him/herself and the directly connected institutions, emerging from the interpretation of the primary public output. As a rough example: a movie with Frank Sinatra playing a part in it is primary public output, whereas a movie about Frank Sinatra is a feedback cultural product. Included in the first category are all the interviews the star him/herself gives, the records he or she makes, meetings with the fortunate fan club members who won the drawing of lots—briefly put, all those means of public existence that the star him/herself applies in the service of the entertainment industry, all the material that the individual star, together with his or her commercial backers, made in order to make profit, or from the view of the star him/herself, for the sake of self-realization. Second-stage cultural products, or reflection cultural products, are made by other agents from the basis of what was created in the first phase: this is the stuff that forms the vehicle for the "legend." Primary public output is what the star, in the form of "artist" or "celebrity," projects, whereas reflection emerges after reception and is an interpretation of what was projected in the first stage. It is worth noting that narrativity is an essential dimension of many of the reflection cultural products: a standard way of remembering the deceased star is to recall the narrative of his or her career and life. Finally, the for-

mats are linked to developements in technology—some formats disappear while some new ones appear.

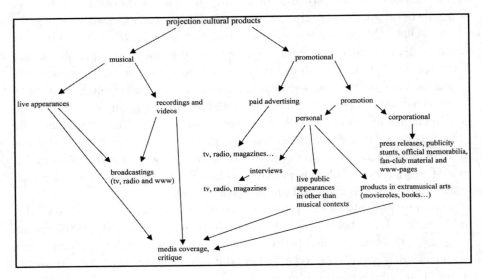

Fig. 12.2.

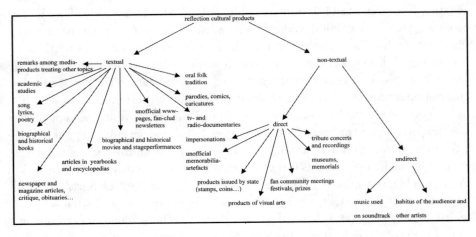

Fig. 12.3.

Return to Graceland

As a brief illustration of the typology above, I will present a few items from the context of the legendary figure of Elvis Presley. During his career, Elvis produced output through every possible channel the technology of the early 1950s to mid 1970s offered. He even participated in a major technological novelty when his concert in Hawaii was broadcast via satellite transmission and reached an estimated 1.5 billion viewers worldwide (Guralnick, 1999, p. 475). He gave live concerts all the way from the early 1950s to the beginning of his military service in 1958, and again on a large scale from 1968 to his death in 1977. During the years from his return from the army to 1968, he made a bulk of movies, as well as their attached soundtrack recordings: these were masterminded to promote each other. All in all, Elvis made records galore, including the endless compilation albums and seemingly countless live concert recordings—the last of which is probably yet to be seen. Elvis's promotion was in the hands of the notorious and ingenious colonel Parker who, with his unorthodox methods, propelled awesome media interest toward Elvis even during the two years he was in the army, out of reach of any personal contact with the media.

Since his death in 1977, Elvis's primary public output has continued on a considerable scale: the stream of reissue and compilation albums has been continuous. As a remarkable novelty, in order to recreate an illusion of authentic Elvis's live performance:

> . . . [t]he producers edited together a collection of Elvis' finest concert performances that exist on film and video and removed all sound from the footage except for Elvis' vocal. The Elvis footage is projected on a large video screen. On stage are a 16-piece orchestra and a group of Elvis' original bandmates from the concert era of his career perform live with the Elvis video. All music heard in the concert production is performed live except for Elvis' voice. On either side of the Elvis performance screen are screens that carry live action from the stage. From the first song it's magic. You're at a real Elvis concert. (Elvis–The Concert, 2001)

Official Elvis memorabilia, controlled by Elvis Presley Enterprises, is offered directly by Elvis Presley Enterprises or by its licensees, and amounts to hundreds of products ("Elvis.com the official website," 2001). But along with these commercial items, which originate from Elvis's estate and other rights holders to Elvis's heritage, it is possible to find literally countless numbers of other cultural products that present Elvis in some form, musical or otherwise. Among these exists the global phenomenon of Elvis impersonation.

By some estimates, there are three thousand such performers working in the U.S. alone (Hinerman, 1992, as cited in Rodman, 1996, p. 6). Elvis impersonations

present a curious case of playful carnivalism. Elvis impersonators, with their art, provide a materialization of their interpretation of Elvis. The acts range from extravagant night club shows to bizarre wedding-party numbers, and the impersonators come in all shapes, sizes, and sexes, with similarly varied abilities. Perfect resemblance in physical appearance or sonority is irrelevant; only a few key elements are needed to establish the required connection to Elvis, and particularly to the 1970s Elvis as the case with the impersonations typically is: sideburns, jumpsuit, sunglasses—that's it. The individual motivations for the impersonation acts must vary, but the underlying common denominator is clearly a fan-idol relationship to Elvis.

Fig. 12.4. People always ask "Why don't you want to be yourself on stage?" Being Elvis is a way of escapism for me. For a couple of hours a week I can be my hero—a hero, a King! So as the great man once said . . ."if I can dream . . ." ("Kim Bridges homepage," n.d.)

Fig. 12.5. Although I am from the Orient, I feel Elvis is beyond race and nationality. Elvis is loved by people worldwide, so I feel I am justified giving my image of Elvis. I feel I have a mission, I take Elvis very seriously. I feel he is leading me. Where to, I do not know, but I definately [sic] feel his precense [sic]. ("Elvis of Taiwan," n.d.)

The copies of Elvis are, to many, as fascinating as Elvis himself. Elvis impersonation itself has become an institution, which can in turn be referred to in cultural products, as is the case with the Warner Brothers feature film *3000 Miles to Graceland*: the movie is situated in an Elvis convention in Las Vegas and includes performances from various Elvis entertainers, as they prefer themselves to be called.

Fig 12.3. Actors playing Elvis entertainers. The cues, sunglasses, sideburns, the jumpsuit, are intended not towards Elvis himself, but towards interpretations of Elvis.

The cultural circulation of Elvis as a star has moved way beyond the power of cultural industry: it is the fans that make Elvis what he is today. There are fans, who love Elvis, who weren't even born when Elvis died. In the mediated image of Elvis, there is something that has the ability to affect people, and perhaps, to see what it is, we should go back to see what it was in Elvis that attracted his audience in the beginning. All we see of Elvis now is the image immortalized in electronic media, but despite all that has been said about the mediated nature of stardom, the fact that we can never know the stars as real people, in the image there is always something deeply intimate too; there has to be. If you want to be as big as Elvis, then you also have to be as small as your fan. Among all the artificiality of the image there is something honest and personal, communicating directly with the single spectator watching and hearing Elvis sweating, panting, moving, singing and talk-

ing in the TV in the corner of the living room. It is how he struggles to reach that top note, in the way he glows when he succeeds, how he moves to send that kerchief to the audience with the exact timing—it was little things like this that mattered, and still matter the most.

Bibliography

Alberoni, F. (1972). The powerless elite: Theory and sociological research on the phenomenon of the stars. In D. McQuail (Ed.), *Sociology of Mass Communications* (pp. 75–98). London: Penguin.

Barthes, R. (1977/1990). The grain of voice. In S. Frith and A. Goodwin (Eds.), *On Record: Rock, pop and the written word* (pp. 293–300). London: Routledge.

Carr, I., Fairweather, D., and Priestley, P. (1995). *Jazz: The rough guide. The essential companion to artists and albums*. London: Penguin.

deCordova, R. (1991). The emergence of the star system in America. In C. Gledhill (Ed.), *Stardom: Industry of desire* (pp. 17–29). London: Routledge.

Dyer, R. (1986). *Stars*. London: BFI Publishing.

Ellis, J. (1985). *Visible fictions: Cinema, television, video*. London: Routledge.

Elvis of Taiwan. (n.d.). Retrieved May 14, 2001, from http://www.Elvisoftaiwan.com/index.html

Elvis the Concert. (2001). Retrieved May 14, 2001, from http://www.elvis.com/concert/

Elvis.com the official website. (2001). Retrieved May 14, 2001, from http://www.elvis.com/

Gamson, J. (1994). *Claims to fame: Celebrity in contemporary America*. Berkeley: University of California Press.

Gledhill, C. (1991). Signs of melodrama. In C. Gledhill (Ed.), *Stardom: Industry of desire* (pp. 207–229). London: Routledge.

Grossberg, L., Wartella, E., and Whitney, D. C. (1998). *MediaMaking: Mass media in a popular culture*. Thousand Oaks: Sage Publications.

Guralnick, P. (1999). *Careless love: The unmaking of Elvis Presley*. London: Abacus.

Hinerman, S. (1992). "I'll Be Here With You": Fans, fantasy and the figure of Elvis. In L. A. Lewis (Ed.), *The Adoring Audience: Fan culture and popular media* (pp. 107–134). New York: Routledge.

Kim Bridges homepage. (n.d.). Retrieved May 14, 2001, from http://www.kimbridges.co.uk/index.htm

Lury, C. (1993). *Cultural rights: Technology, legality and personality*. London: Routledge.

Mäkelä, J. (1999). Tähtisumun taakse. Reittejä populaarimusiikin tähti-ilmiön kulttuuriseen tutkimukseen. *Musiikin Suunta* 4, 12–21.

Rodman, G. B. (1996). *Elvis after Elvis: The posthumous career of a living legend*. New York: Routledge.

Thwaites, T., Davis, L., and Mules, W. (1994). *Tools for cultural studies: An introduction*. Melbourne: MacMillan.

chapter 13

Dead Rock Stars 1900

JONATHAN STERNE

"Never before have musicians tried so hard to communicate with their audience, and never before has that communication been so deceiving."

—JACQUES ATTALI (1985, P. 9)

Today we are surrounded by the voices of the dead: they come to us through computer and Muzak speakers, televisions, headphones, and radios. Famous dead people on recordings sing to millions of people all day, every day. Posthumous fame is a mundane fact of everyday life. As John Peters writes, "what sex was to the Victorians, death is to us: the ultimate but inescapable taboo. . . . We chuckle at Victorian primness, congratulating ourselves on our liberalism on topics sexual, but nothing is so veiled to us as death, so cloaked in euphemisms—or as pervasive in popular culture" (Peters, 1999, p. 147). Death pervades popular culture, but it is rarely commented upon as a cultural phenomenon in its own right.

This chapter is a speculative historical thanatology of sound recording. Thanatology is the study of death. A more archaic use of the term includes descriptions or doctrines of death. Here, I mean it in both senses: as a field of analysis, and as the object being analyzed. The thanatology of media, and specifically the thanatology of recording, provides insight into one of the most fundamental theoretical questions we can ask of media: the relationship between a medium and human subjectivity. To that end, the chapter is oriented around a simple question:

does it matter if the performer on a sound recording is living or dead at the time the recording is heard? It is easy to think that the answer is now a resounding "no," thanks to the pervasiveness of mechanical and electronic media (and thanks also to the fact that we tend to sidestep thanatological questions more often than not). The reproductive power of media now makes it possible for us to hear people's voices in death just as easily as we could hear them in life. Observation of this banal fact has led philosophers to treat death and sound recording as ontological problems—as timeless problems of existence. No doubt, death and sound recording have their ontological dimensions. But by sketching a few of the possible relationships between death and sound recording from two ends of a hundred year period, I argue that sound recording—by extension, other media—are modes of organizing and explaining subjectivity, just as changing modes of subjectivity are used to explain the power of media. Media are not an ontological backdrop to social life or human experience. People use media to shape and explain experiences and we use our self-understandings to explain media; ultimately, we make media part of the constitutive fabric of our social and cultural lives.

As I argue in this chapter, there is more than one possible way of understanding the relationship between sound recording and death. Posthumous fame, then, is not a "historical condition" simply enabled by the reproductive power of media. Rather, in every case of posthumous fame, audiences must negotiate their own understandings of the meaning of death with their understanding of the meaning of the medium. As we will see, there is more than one possible configuration of these meanings, and therefore many possible modalities for the meaning of the posthumous part of posthumous fame.

The early phonograph's Victorian contemporaries obsessed over the figure of "the voices of the dead." When Edison and his employees invented the phonograph in 1878, commentators celebrated the machine precisely because of its purported power to preserve the voices of the dead. This was true in popular culture and in the sober world of science. In its introduction of the phonograph to its readers, an anonymous *Scientific American* writer was keenly aware of the thanatological possibilities of recording:

> It has been said that Science is never sensational; that it is intellectual and not emotional; but certainly nothing that can be conceived would be more likely to create the profoundest of sensations, to arouse the liveliest of human emotions, than once more to hear the familiar voices of the dead. Yet Science now announces that this is possible, and can be done. That the voices of those who departed before the invention of the wonderful apparatus described in the letter given below are for ever stilled is too obvious a truth; but whoever has spoken or whoever may speak into the mouthpiece of the phonograph, and whose words are recorded by it, has the assurance that his speech may be reproduced audibly in his own tones long after he himself has turned to dust. The possibility is simply startling. A strip of indented paper travels through a little machine, the sounds of the latter are magnified, and

our great grandchildren or posterity centuries hence hear us as plainly as if we were present. Speech has become, as it were, immortal. ("A Wonderful Invention," 1878, p. 304)

To the anonymous author of this essay introducing the phonograph—and to countless other Victorian thinkers—the phonograph was nothing short of an ontological revolution. Where once speech began to fade from existence the very moment it began, now it could conceivably be repeated endlessly for future listeners.

In this essay, I will juxtapose two moments in the history of sound recording: first, I consider this early moment, where the fact that performers *could* be dead was one way of explaining the power of the medium. I then move to a more contemporary case, where a voice on a recording is said to prove that a performer is alive—specifically, a somewhat notorious analysis of a voice said to belong to Elvis on a recording in the late 1980s. Though this case is quite singular, it points to a wider phenomenon, where audiences listen to recordings for proof that a dead performer is in fact alive (for another extended example, see Kamberelis and Dimitriadis in chapter eight of this volume). Through this comparison, my aim is to make a problem of the relationship between death and electronic or mechanical reproduction upon which posthumous fame depends. Once we understand that the meanings of death and electronic (or mechanical) reproduction are both variable *and* intertwined, we can better understand the conditions of possibility for posthumous fame. I now turn to late-nineteenth-and early-twentieth-century America, where sound recording was a new and exciting technology, and death was a veritable popular cultural obsession.

Death and Recording, ca. 1900

Scientific American was hardly alone in its assessment of the possibilities of recording for transcending death. Almost from the first moment that there was a sound recording industry, there were ruminations on the thanatological possibilities of sound recording. An early recording industry periodical, *The Phonogram*, cast the preservation of the voices of the dead as one of the most promising possibilities for the phonograph. Consider this tale about a dead actor named W. J. Florence from 1891:

In Boatman's bank, St. Louis, Mo., there assembled since the decease of the great actor, four of his intimate friends, who stood before a phonograph to listen again to his voice. The scene was quaint and odd, and one that the nineteenth century alone could evolve. They listened with feelings of sadness to the quaint humor with which he had amused great audiences during life. . . . [A]ll agreed the record was marvelous, the voices of Jefferson [another famous actor] and Florence being as distinctly recognized as if they were present in person. ("The Voice of the Late William J. Florence," 1891, p. 253)

The voice in death is present as if it were in life—this is a standard trope of representation as correspondence. Perhaps correspondence theory, or what Jacques Derrida (1976) has called "the metaphysics of presence" is nothing more than a tropic doppelganger of representation figured as "dead discourse." Set against the sound of a phonograph in 1891, the evaluation "as if they were present in person" clearly required a little imaginative power on the part of listeners. Sound recordings in 1891 had an incredibly limited bandwidth, a great deal of background noise, and a very short duration (three minutes or less). So for a listener to say that the recording presented the performers "as if they were present in person," he or she would have to ignore the background noise, the eerie timbre (it is difficult to describe, but any person alive now who has heard a recording from this period will likely find the sound of the voice on these early recordings a bit "off"), the limited variations in volume, and the limited duration. In other words, listeners would have to use their imaginations to give the machine a little "help" in reproducing the voice. As I argued in The Audible Past (2003), most early public demonstrations of sound recording (as well as telephony and radio) depended on this kind of imaginative "help" from their listeners. Even today, this trend continues. In the 1980s, John Corbett (1994) wrote a hilarious description of record players in music schools where he considered just how many different experiential facets of the medium music students must ignore in order to talk about "just the music" (p. 32). I would argue that even in informal listening environments, and even with relatively noise-free and wide-bandwidth reproduction formats like compact disc and DVD-audio, we still offer a certain measure of "help" even as we claim our recordings as perfect reproductions of an original somewhere. After all, the "voice" heard on most modern recording is aided by a pile of signal processing equipment: the sound-shaping qualities of the microphone used, deft audio editing, multiple takes, heavy compression, automatic tuning. Oftentimes, multiple recordings of a performer singing the same song are stacked on top of one another to create a stronger and more powerful vocal sound (the solo albums of Peter Gabriel are good examples). So, the claim that a recording reproduces voices "as if they were present in person"—whether at the turn of the twentieth or twenty-first centuries—has a certain dimension of imagination or ideology to it.

But even more interesting about the W. J. Florence story—beyond the feelings of the people in the story or even the reality-effect of the recording itself—is the lesson the story is supposed to provide. A gathering of friends around a phonograph to hear the voice of a dead friend: this was a scene "that the nineteenth century alone" could provide. In other words, this event served as an icon of progress; it certified the modernity and power inherent in sound recording. In this story, the power and purpose of sound recording was to transcend death.

A similar sentiment pervades the inaugural editorial in the *Phonoscope*, also an industry magazine. The *Phonoscope*'s article reads like a lament for the lost voices of the past. The article mourns the lost past just as surely as it celebrates the possibility of preserving the present for future listeners:

> If thus we could but listen to the voice of the great founders of this mighty commonwealth: Washington, Jefferson, Jackson, Lincoln and others, how easy it would be for us to grasp their great ideas and teachings and follow in their footsteps. But in their time the talking machines had not been thought of. To-day we are in a position to reap the full benefit of the genius of our great inventors.

> How salutary and consoling it is for loving children and friends to be able to retain the voices of their dear departed ones for communion in time of trouble, and of pleasure. The voice of that mother whose every thought has been for our welfare, whose last prayer was to call blessings down on us from Heaven; of that father whose stern, unbending, yet loving character first instructed us in the hard realities of life. Death cannot now deprive us of their help, advice and encouragement, if we will but record their voices whilst they live, and treasure them not only in our hearts, but in a certain and lasting form, on the surfaces of phonograph and graphophone cylinders.

> The voice, formerly invisible and irretrievably lost as soon as uttered, can now be caught in its passage and preserved practically for ever.

> The great speakers, singers, actors of to-day have it in their power to transmit to posterity all the excellencies they are so richly endowed with. Art in its perfection need no longer be lost to succeeding generations, who now shall be able to enjoy all its benefit by setting in motion the wheels of a simple machine. . . .

> Death has lost some of its sting since we are able to forever retain the voices of the dead. ("Voices of the Dead," 1896)

Death may have lost some of its "sting" for the *Phonoscope* author, but it retained all of its cultural currency. In this passage, and many others like it, the power of the phonograph was precisely to transcend the untranscendable finitude of death. Ironically, the way the article sets it up, people had to keep dying for the phonograph's power to be authenticated. Only as the bodies faded away and the voices persisted would the valence of sound recording truly manifest itself. For this first generation of sound-recording contemporaries, the phonograph was a time-travel appliance.[1] For these writers, a recording was a promise to the future, a way to move across time by communicating "directly" (i.e., through the voice) with future audiences. Presumably, this communication would run both ways, as the author of the piece clearly believed he could learn a great deal by directly hearing the voices of the dead who preceded him. The sense of loss in the piece plays on this: "we" (the writer and the intended audience for the piece) can make a promise to our

grandchildren that even the "great men" of the past—Washington, Jefferson, Lincoln—could not offer us. So it was in the phonographic press, and so it was in the laboratories where sound recording was first developed.

Long before *The Phonoscope* waxed romantic over mother, father, and selected celebrities and dignitaries, Alexander Graham Bell (who, along with Thomas Edison, worked to innovate sound recording from a novelty to a commercially viable technology) wrote of the following incident in his lab notes for January 22, 1888: "Mr. Chamberlain made a speech to the people of the 20th century!!—followed by his two friends. The phonautogram produced was presented to Prof. Langley for preservation in the National Museum." The same Professor Langley then made an accompanying recording that certified the authenticity of the first (Bell, 1888). We see the same "promise to the future" attitude toward sound recording in Bell's notes as in the industry periodicals that followed him. The promise to the future—guaranteed by the mere possibility that the voice will persist beyond the speaker's own death—appears when a group of inventors are really still trying to simply imagine the technology itself. In other words, the ability to carry "voices of the dead" into the next century may have been an honest attempt to assess the power of sound recording, but it was, at a much more fundamental level, the basis for their understanding of sound recording as a social and technical possibility. The fact that these promises did not last—and indeed, if the Smithsonian ever received these recordings, they are now lost to current staff—is almost immaterial. In the late-Victorian social world, where death was an ever-present fact of social life and "a good funeral" was a common social aspiration (Morley, 1971), the voices of the dead emanating from a machine explained, certified, and defined the power of sound recording.

In the cases we've considered so far, the content of the recording is almost irrelevant. Victorian authors who reflected on the "voices of the dead" rarely reflected upon what the dead actually said. In fact, phonographic "voices of the dead" or "messages to the future" were quite banal: there was nothing special about the *content* of the recording. At the Library of Congress's Recorded Sound Reference Center, one can hear an "early recording" optical disk that contains a message recorded by O. Henry for future generations in the early 1890s, informing listeners such as myself that he hopes we continue to read his books. Another track has P. T. Barnum expressing his gratitude to the queen and the people of England. As Gary Gumpert (1987) has bemusedly pointed out, recorded messages to future generations tend to lack any meaningful content whatsoever: for a more recent example, there are the 1980s-vintage talking tombstones, which, he writes, offer such wisdom as, "Do what's right, come what may" (p. 5). The *content* of these communications with future generations was not particularly important; rather, Victorian commentators were fascinated by the possibility that the communication itself

might get through. Messages to the future, like the possibilities for hearing the voices of the dead, were more demonstrations of the imagined power of sound recording than they were "messages" in the sense of a specific meaning to be conveyed from sender to receiver.

In this sense, the power of sound recording was to store time—and ultimately to stockpile it (Attali, 1985, p. 101; Kittler, 1999, p. 3). Yet this does not go quite far enough for our Victorian sources. It is not simply the storage of time but its transversal that fascinated nineteenth-century commentators. In this scheme, the phonograph was less a carrier of meaning or a storehouse than a transportation device whereby the dead voice could be moved across time. And this sense of the phonograph, as transporter of dead voices, required that speakers continue to die in order to authenticate the efficacy of the medium itself. A recording may have been nothing more than a sonic coffin or a resonant tomb to its early auditors, but its status as a carrier of messages from the living to a future they would never see defined its power, its possibilities, and its promise.

Although early recordings weren't permanent—they were incredibly fragile and often treated as ephemera—the fact that their contemporaries imagined them to be permanent is quite significant. The same can be said for the cultural status of death: listeners used death not only to *explain* the power of sound recording but in a way to justify or guarantee it. Because recordings theoretically *could* present a listener with the voice of a dead person, it was reasoned that recordings *had* in fact changed the status of death. This brings us back to the question with which I began: does it matter if the performer on a sound recording is living or dead at the time the recording is heard?

I have already suggested above that the easy or common-sensical answer is "no." But listeners did (and do) in fact care whether the performer on the recording is living or dead—though not always and not in the same way in every case. The Victorian listeners I have discussed thus far believed that the death of the performer—even the possibility of the performer's death—defined and explained the power of sound recording. I now turn to a contemporary example where listeners have, in some circumstances, inverted this relationship by arguing that sound recordings actually demonstrate that the performer is alive; or rather, that the recording demonstrates the *impossibility* of the performer's death. Sound recording may be a prior necessity for posthumous fame, but the possibility of posthumous fame also shapes the way people understand the power of recording.

Dead Rock Stars and Beyond

I now fast-forward almost a hundred years to offer another episode in my story about sound recording and death. Starting with the widely disputed death of Elvis, and

in selected subsequent cases, fans have used sound recordings and other "traces" as evidence that the performer is still alive (see also Kamberelis and Dimitriadis in chapter eight of this book). In the historical space between *Phonoscope*'s mourning prose and Elvis's demise lies a metahistorical shift in understandings of sound recording and death. For the Victorians, the possible death of the person on the recording helped explained the possibility of sound recording. For our own contemporaries, phonography becomes a means by which a recording can demonstrate the impossibility of the death of the person on the recording. Victorians used sound recordings to anticipate and attempt to transcend the deaths of the people on them. Today, death is more often denied than anticipated. Fans find clues in recordings—and, as I discuss below, sometimes find special recordings—that are said to demonstrate that the performer on the recording is alive. If the Victorians had to imagine a phonograph that actually could preserve the voices of the dead for any significant amount of time—that is, when the actual recordings of their time were more ephemeral than lasting—contemporary listeners may use recordings to imagine that because they can hear a performer on the recording, that person is actually alive.

This shift depends on two relevant cultural changes for our purposes: the normalization of sound recording in everyday life and the concealment of death in everyday life. Over the course of the twentieth century, recording went from novelty to banality. The wonder of recording was no longer in its existence but in its affective power. Countless writers have noted the power of fandom and the importance of specific artists and recordings in the lives of their listeners. To riff on a reading of rock and roll by Lawrence Grossberg (1997, pp. 64–88), recorded music can provide its fans with the affective or ideological materials to make sense of their everyday lives, to deal with empowerment, conflict, boredom, oppression, or whatever other conditions they may encounter. No doubt, fans develop intimate relationships with stars, but they also develop intimate relationships with the recordings that give them access to the stars.

While recording had moved from a remarkable invention to a sometimes-constitutive fact of social life in the interceding century, we can see almost the opposite movement of death in popular culture. Death has become a social taboo—it is both everywhere (pervasive in popular culture) and nowhere (exiled from daily life to hospitals, nursing homes, and funeral parlors). Finitude and death are certainly "facts of life" today as much as they were one hundred years ago, but they are less facts of *everyday* life. Death has moved outside the realm of normality, not because it is abnormal but because it is hidden and taboo. Norbert Elias, in *The Civilizing Process* (2000), argues that over several centuries, the bourgeoisie concealed most of its connections to "nature" and sublimated its stronger emotions in the process of presenting itself as more "civilized." While this is hardly true in every

instance, Elias does present a convincing case for a general tendency in modern life. He charts shifts toward concealing natural functions, danger, and other aspects of embodied experience in dining, hygiene, sleeping arrangement, sexuality, and several other fields of social activity. Though he does not write of the care of the dead, the movement is parallel: where our Victorian appraisers of phonography likely aspired to a good funeral, and where they lived in a world where caring for the bodies of the dead outside the home was still a relatively novel phenomenon, dead bodies moved out of the household and into hospitals, nursing homes, and funeral parlors over the course of the twentieth century. Combined with declining rates of infant mortality and increasing life expectancy, death moved from an oft-contemplated fact of life to a social taboo (though students of public health will no doubt note that growing economic disparity in the United States has led to a resurgence of infant mortality and decrease of life expectancy among poor populations) (Cowan, 1983; Elias, 2000; Quigley, 1986).

In this environment, it became possible to imagine a beloved performer or star, someone whom a fan might never have met, simply *hadn't* died—despite reports to the contrary. The renowned dead of the nineteenth century called forth from the spirit world in séances as well as in recordings, according to Victorian philosophers of the medium. In contrast, the renowned dead of the twentieth century could, under certain circumstances, fake their death and escape from the United States to Europe, Asia, Africa, or South America. The condition of posthumous fame thus overlapped with the bizarre situation where fans might deny the "posthumous" part: some rock stars didn't die in some fans' minds—they simply went missing. Like the past, death became a foreign country (Lowenthal, 1985). The evidence for these fantastic escapes could be contained in a sound recording, an object once guaranteed by death, and now an object that (often combined with other evidence) demonstrated the impossibility of death. For the speculative purposes of this essay, I want to leave aside the very interesting question of why some stars are said to survive their deaths—Elvis, Jim Morrison, Tupac—and others are not—Buddy Holly, Janis Joplin, Patsy Cline, Jimi Hendrix, Aaliyah, and now Jam Master Jay. This is analyzed by Dimitriadis and Kamberelis in the Tupac case (Dimitriadis, 2001, pp. 93–118 and also chapter eight of this book), though clearly there is more to be said on the matter. Instead, let us turn to the locus classicus of the "escaped" dead rock star: Elvis.

"Elvis is alive!" is one of the most familiar and derided of such claims in American popular culture. Gilbert Rodman (1996) has shown that "Elvis sightings" have even engendered their own backlash with a whole "Elvis is dead" discourse. A great deal of the Elvis-is-alive discourse revolves around sightings, where people claim to have personally seen Elvis. But these are common enough that they are rarely reported in the news outside tabloids. Yet Elvis's persistently undead sta-

tus provides important clues to a change in status of sound recording and death in contemporary culture.

If there is an ur-text of the "Elvis is alive" position, it would have to be Gail Brewer-Giorgio's *Is Elvis Alive?* (1988). For the work presented in the book, Brewer-Giorgio received attention from several major news media outlets including ABC's *20/20* and *USA Today*. *Is Elvis Alive?* is a remarkable little book that mixes her own autobiography with insinuations about psychic phenomena and evidence that she suggests demonstrates that Elvis is still alive. Because of its peculiar blend of paranomal phenomena, autobiography, and fact-finding, Brewer-Giorgio's book is quite complex in the claims it makes. But its treatment of documentary evidence, especially recorded evidence, is interesting for our purposes. The Tudor Publishing Company version of the book includes an audiotape that is supposedly an edited amalgamation of phone calls made by a still-living Elvis to an unknown person. This person then edited out his or her voice, and passed the tape on to Brewer-Giorgio through intermediaries. The "voice of Elvis" on the tape explains how he faked his death and went undercover to invent a new life for himself. Presented alongside an enlargement of a picture taken in 1978 that purports to show Elvis sitting in the bathhouse at Graceland, the audio tape is allowed, at the end of the book, to "speak for itself" regarding Elvis's continued existence. As John Fiske (1993, pp. 112–119) points out regarding evidentiary claims for a living Elvis, the actual contents of the photograph and the audiotape are somewhat contradictory, as the "voice" of Elvis claims he has been traveling the world outside the United States, while the photo has the still-living Elvis hanging out at home (though I suppose one could argue that he simply "happened to be home" the day the snapshot was taken).

Brewer-Giorgio, who elsewhere discusses and interprets evidence at length, has considerably less to say about the tape. Most of her discussion revolves around how she acquired the tape, and her efforts to determine if the voice on the tape was indeed the voice of Elvis Presley. The tape is itself a long monologue, with parts erased or edited, supposedly to conceal the identity of the interlocutor on the other end of the phone line. Brewer-Giorgio presents it thus:

> I contacted voice print expert L. H. Williams of Houston, Texas. He took a known voice [ostensibly, a voice recording] of Elvis Presley and through analysis indicated in his conclusion that the unknown speaker (mystery tape) and the known speaker (Elvis Presley) are the same.
>
> However, I want to make it clear that I have no idea when this recording (supposedly over the telephone) was made. Mr. Williams also stated that the entire cassette was not made at one sitting and was instead the result of more than one recording. This could have been done in many ways:

1. If Elvis had telephoned someone on various occasions and unknowingly been recorded, that person may have put the majority of recordings on one cassette, deliberately leaving their voice and identity off.
2. (I was told the reason the person Elvis is supposedly talking to wants their identity unknown is for fear of being involved in a death hoax).
3. The tape could have been spliced together by taking dialogue from various films and creating a story whereby people think he's hoaxed his death.
4. It is a splicing from other interviews.

I've thought each possibility out. But when I listen to the tape and read the dialogue there are too many instances when "Elvis" refers to being in hiding, growing a beard, to having friends fear he will be found out. I have chosen to include the tape transcription here, as well as the Voice Identification Report. (Brewer-Giorgio, 1988, p. 180)

Brewer-Giorgio's language here suggests that the recording can "speak for itself." Except that the book offers a word-for-word transcription of the recording, which immediately suggests that the accompanying tape requires supplementation. If that weren't enough, she adds a number of signed "official" documents as to the tape's authenticity. I consider each supplement in turn.

The transcription doubles the tape word for word, right on down to the "I've been uh"s and the "anyway, uh"s. This doubling accomplishes two things. First, it makes the recording seem all the more transparent, as now the person reading the book and auditing the tape no longer has to listen to discover if she or he can understand what's on the tape. The writing guarantees the intelligibility of the recording, and it helps to ground the message. This is one of the oldest tricks in the book for demonstrating the authenticity of an audio recording: the earliest public demonstrations of telephony and sound recording, either choose to use a passage with which an audience might be familiar ("To be or not to be"; "Mary Had a Little Lamb"; or even "Can You Hear What I Am Saying?!?") or provide a written libretto of sorts so that the audience would know exactly what was being said at all times (Sterne, 2003).

The writing also reinforces the supposed *message* of the recording. On the surface, the message spoken by the person on the recording might seem quite important for someone looking for evidence of Elvis's continuing to walk this Earth. But the message simply doubles facts widely available elsewhere in the "Elvis-is-alive" discourse. It offers no significant new information whatsoever. Like Gumpert's talking tombstones, Elvis's life-after-faked death is wholly unremarkable in what it actually says. The man on the tape verifies that he faked his own death; he says that he is occasionally recognized despite having grown a beard; he travels around the world; he's come around to clean living and exercise; and he has a new girlfriend. As with the messages to the future of a century prior, the message arrives like an

empty envelope—it is the fact of communication and not the content of communication that is significant. Brewer-Giorgio hears the words, not as words per se, but proof of something external to them. For Brewer-Giorgio, *these things could only be said if Elvis were alive to say them.* But of course, the words alone are not enough, and the written text relies equally on the tape for *its* authenticity. We are supposed to know the written text is real only because we can hear the tape, and that is why the audio tape is such an important accompaniment to the book.

In considering the recording, one might expect a discussion of Roland Barthes's (1977) idea of the grain of the voice: "the 'grain' is the body in the voice as it sings" (p. 188). After all, it is the body in the voice that Brewer-Giorgio and other Elvis fans seek: a living, breathing, traveling body of Elvis Presley. Such a reading might be bolstered by considering the voice analysis that was applied to the tape. Brewer-Giorgio's "voice print expert," L. H. Williams, writes that he applied both "aural and spectrographic" analysis to the tape in order to determine its authenticity, but that "the full Voice Identification process as prescribed by the International Association for Identification, Voice Identification, and Acoustic Analysis was not possible." Williams reports that the tape in question was low in volume with a lot of additional ambient noise. Using audio processing equipment that was widely available at the time, Williams filtered out the frequencies containing the noise (4000hz and above, which are above "normal speech level" as Williams writes[2]), and raised the overall vocal level. After comparing thirty-five randomly selected words of unknown text against thirty-five words of known text from a 1962 recording of Elvis's voice, Williams concluded that "there is [sic] data indicating that the unknown and known speaker are the same with a moderate level of confidence" given the constraints under which he operated. He also noted that there were several edits, dropouts, and other modifications to the recording (Brewer-Giorgio, 1988, pp. 187–189).

What does this tell us? It tells us that Williams was cautious enough to note the limitations of his knowledge from a standpoint of scientific certainty, and that Brewer–Giorgio is somewhat less cautious in her interpretation of Williams's analysis. But consider what Williams actually did in his laboratory. He performed a kind of sample-and-cut-up art that would make any contemporary sample-based act proud. First, he modified the sound of the voice itself. Although Williams is technically right that frequencies at or above 4000hz are above the normal vocal range of humans, adjusting them through equalization *does* change the sound of the voice. Second, he abstracted the voice from speech. He took individual words— some monosyllabic and some polysyllabic—and compared them with the sounds of words spoken by Elvis in a 1962 film. More importantly, a significant part of this "listening" was accomplished with Williams's eyes through spectrographic analysis, where he compared visual representations of the two different sounds to see if

they appeared similar. This is a long way from Barthes's "body in the voice"; it is a game where the voice leaves traces, and where the traces of the voice are in turn induced to leave more traces that can then be compared to one another. Far from letting the "recording speak for itself," Williams's efforts represent a kind of synaesthetic transference, where through a minute dissection of the recording, some truth about it might be reached. To his credit, Williams did not claim to have reached that truth. Brewer-Giorgio, meanwhile has it both ways—offering Williams's official (though light) endorsement and the imperative "listen for yourself."

In this single event, then, we can see one possible inversion in the binary system of recording and death that continues on down to the present day. Where once the death of the speaker certified the authenticity of recording as such, in a gesture worthy of accolades from nineteenth-century spiritualists, an audio recording—*especially because* it is a bad recording—now, under certain circumstances, can become proof of life. Perhaps most interesting here is that the attitude we find toward recording in Brewer-Giorgio's book both makes use of the ideology of transparent representation and meticulously destroys it. The recording demands supplementation because we have to know that it is authentic, and through this supplementation (voice prints, transcripts, explanations), it simultaneously speaks for itself. In a dizzying synaesthetic display of circular reference, the meaning is both manifest on the surface of the recording and latent just beneath it, with each layer simultaneously attracting and repelling the other.

One can find other contemporary examples of this phenomenon, and in fact they go considerably further than the Elvis case. Greg Dimitriadis and George Kamberelis, for instance, discuss reactions to the death of Tupac Shakur among youth at an African-American community center. The teens used Tupac's own recordings and videos (along with other kinds of evidence), several of which appeared shortly after his death as evidence that he had in fact faked his own death. Some of Tupac's posthumous material suggests to fans that he in fact anticipated his own death and planned for it. The video for "I Ain't Mad at Cha" features Tupac being shot and killed (Dimitriadis, 2001; also see chapter eight of the current volume). Web sites dedicated to proving Tupac is alive also quote lyrics extensively: Tupac lines such as "I've been shot and murdered, can't tell you how it happened word for word/but best believe that niggas gonna get what they deserve" and "I heard rumors that I died, murdered in cold blood, traumatized pictures of me in my final states, you know mama cried, but that was fiction, some coward got the story twisted" are offered as evidence that Tupac planned and faked his own death, and announced it in his music ("Robby Robb'$ Reasons Tupac is Alive," 2002).[3] In the Tupac case, discussed elsewhere in this volume, his recordings both "speak for themselves" and require additional interpretation in order to demonstrate that Tupac

is still alive. As with Elvis, the medium guarantees the continued life of a dead rap star. For listeners who want to believe, Tupac's voice does not persist in death. Instead, the medium guarantees the continued life of the body and the persona. In a weird twist, posthumous fame through sound recording now allows for fans, in some cases at least, to question the "posthumous" dimension of that fame.

Conclusion: Dead Rock Stars 2003

In telling the story this way, I don't mean to offer a truly comparatist account. It is true that I compare the apples of industrial discourse with the oranges of reactions to recordings almost a century later by fans, audio specialists, and a self-described psychic journalist. But documents from both moments are ultimately artifacts of the culture from which they emerge, and this juxtaposition demonstrates one possible shift in the ways that people have conceived of death and sound recording over the course of a century. Where sound recording was once explained by the inevitable march of death, it can now just as easily prove the impossibility of the death of the performer. In both cases, it mattered intensely to auditors whether the performer on the recording was alive or dead. And so, at least, we return to the questions of media theory that began this speculative journey.

Like our Victorian counterparts, we can use a thanatology of communication to learn about the social existence of media. The thanatology in these past few pages repeats some widely accepted "truths" of media studies: that media never *simply* represent, but rather are called forth to represent by their auditors or viewers in multiple and complex ways; that media are not external forces that act upon society but rather are caught up in it. The changing social status of death transformed sound recording: voices of the dead became proof of life. But it also challenges us to question the boundary between the social and the ontological in our theories of media. Finitude is not some kind of final litmus test for sound recording. Rather, it has itself become a shifting standard. The limits of the body are not so clear, so present to us, that we can use them as safe gauges for understanding what communication is, what it does, or how it works. Actual living and dead bodies do not limit the imagined parameters of communication. The imagined parameters of communication do not simply determine the boundary between life and death. If this thanatology can teach us anything, it is that whatever happens in the media world, like whatever happens after death, demands a measure of belief from those of us in the world of the living. This may be especially true in moments, like those of undead Elvis and Tupac, where fragments of a culture rise up against the impossibility of truly transcending human finitude—and demand that we consider the real as evidence of the impossible.

For all that, I will end on a much more mundane note. For the Victorian audiences I discuss at the beginning of this piece, posthumous fame was a condition enabled by recording that simultaneously explained the power of recording. For them, the real promise of recording lay in the possibility of hearing the voices of dead people. In our moment, the power of recording is much more mundane: every day of the year, millions of people hear the voices of dead singers serenading them from televisions, car stereos, Muzak speakers, and hold music on telephones. In every sense of the word, the persistence of the voices of the dead has become an "unremarkable" phenomenon. In those early Victorian cases, the mere fact of being a posthumous voice made one a kind of celebrity (even if it was only in the Andy Warhol "for fifteen minutes" fashion). Today, countless dead celebrities parade through our consciousness. But for a select few, the mere facts surrounding their celebrity—the deep personal relationships felt by many of their fans and the wide dissemination of their recordings—combine with a changed culture of death itself to produce a unique condition. It is now a condition of posthumous celebrity that fans may, in some circumstances, dispute its posthumous dimensions. Thus, the phenomenon of fame-after-death has a history of its own for which we must account.

Notes

Author Note

Many thanks to Carrie Rentschler, Steve Jones, and Joli Jensen for their helpful comments. Thanks also to Gil Rodman for his lead on the Brewer-Giorgio books. This chapter builds upon material originally developed in the last chapter of *The audible past: Cultural origins of sound reproduction*.

1. Writers from Theodor Adorno to James Lastra have noted parallels between the ways in which people talked about photography's supposed ability to transcend death and the same possibilities in phonography (see, e.g., Adorno, 1990 ; Barthes, 1981; Lastra, 2000). Yet, as I argue, there is an important difference that has less to do with how the media function (though certainly, it is important that cameras reproduced a still likeness while phonographs reproduced a voice in motion) than with the ways in which death was practiced. Shortly before sound recording was invented, embalming was popularized in the United States, and this led to a very different understanding of the meaning and importance of preserving physical aspects of the dead (see Sterne, 2003).

2. While frequencies of 4000hz and above are technically outside the "normal" range of the human voice, they do—when adjusted—significantly affect the timbre of the voice on audio recordings.

3. As of this writing, a web search on the phrase "Tupac is alive" will turn up hundreds of sites, many offering similar evidence.

References

Adorno, T. (1990). The curves of the needle. *October* (55), 49–56.

Attali, J. (1985). *Noise: The political economy of music* (B. Massumi, Trans.). Minneapolis: University of Minnesota Press.

Barthes, R. (1977). *Image-Music-Text* (S. Heath, Trans.). New York: Hill and Wang.

———. (1981). *Camera lucida: Reflections on photography* (R. Howard, Trans.). New York: Hill and Wang.

Bell, A. G. (1888). Laboratory note books [Transcription of excerpt]. (Vol. box 256, folder *Phonograph-Smithsonian*). Library of Congress: Alexander Graham Bell Collection.

Brewer-Giorgio, G. (1988). *Is Elvis alive?* New York: Tudor Publishing Company.

Corbett, J. (1994). *Extended play: Sounding off from John Cage to Dr. Funkenstein.* Durham, N.C.: Duke University Press.

Cowan, R. S. (1983). *More work for Mother: The ironies of household technology from the open hearth to the microwave.* New York: Basic Books.

Derrida, J. (1976). *Of Grammatology* (trans. Gayatri Chakravorty Spivak). Baltimore: The Johns Hopkins University Press.

Dimitriadis, G. (2001). *Performing identity/performing culture: Hip hop as text, pedagogy, and lived practice.* New York: Peter Lang.

Elias, N. (2000). *The civilizing process: Sociogenetic and psychogenetic investigations* (E. Jephcott, Trans.). Malden, Mass.: Basil Blackwell.

Fiske, J. (1993). *Power plays, power works.* New York: Verso.

Grossberg, L. (1997). *Dancing in spite of myself: Essays on popular culture.* Durham, N.C.: Duke University Press.

Gumpert, G. (1987). *Talking tombstones and other tales of the media age.* New York: Oxford University Press.

Kittler, F. (1999). *Gramophone-Film-Typewriter* (G. W.-Y. and M. Wutz, Trans.). Stanford, Calif.: Stanford University Press.

Lastra, J. (2000). *Sound technology and American cinema: Perception, representation, modernity.* New York: Columbia University Press.

Lowenthal, D. (1985). *The past is a foreign country.* New York: Cambridge University Press.

Morley, J. (1971). *Death, heaven, and the Victorians.* Pittsburgh: University of Pittsburgh Press.

Peters, J. D. (1999). *Speaking into the air: A history of the idea of communication.* Chicago: University of Chicago Press.

Quigley, C. (1986). *The corpse: A history.* Jefferson, N.C.: MacFarland Publishers.

Robby Robb'$ reasons Tupac is alive. (2002). Retrieved October 20, 2002, from http://www.angelfire.com/tx/2pac50/

Rodman, G. (1996). *Elvis after Elvis: The posthumous career of a living legend.* New York: Routledge.

Sterne, J. (2003). *The audible past: Cultural origins of sound reproduction.* Durham, N.C.: Duke University Press.

The voice of the late William J. Florence is always with us, thanks to Mr. Edison's phonograph. (1891, November/December). *Phonogram* I, 1, 253.

Voices of the dead. (1896, November 15). *Phonoscope,* 1, 1.

A wonderful invention—Speech capable of indefinite repetition from automatic records. (1878, November). *Scientific American,* 17, 304.

conclusion

Echo *Homo*

STEVE JONES

Rock star, pop star, everybody dies
All tomorrow's parties
They have happened tonight
And I know that I won't see tomorrow

COURTNEY LOVE, "SUNSET STRIP" (2004)

Fame adds a hundredfold echo to everything that happens to us. And it is uncomfortable to walk
the world with an echo.

—MILAN KUNDERA, *IMMORTALITY* (1999, P. 143)

In the beginning of the classical Greek myth of Echo and Narcissus, the nymph Echo finds herself stalling the goddess Juno so her fellow nymphs, who had been cavorting with Juno's husband, can scamper away. Juno learns of Echo's effort at distraction and, knowing Echo's fondness for talking, punishes her: "You shall forfeit the use of that tongue with which you have cheated me," Juno says, "except for that one purpose you are so fond of—talking back. You shall still have the last word but no power to speak first" (Bulfinch, 1998, p. 109).

In the era of recording, celebrities have the last word, but after death no longer can speak first. The echo remains in our compact discs, video recordings, in our minds. And yet it is not unchanging. Like an echo in a valley, it morphs, sometimes fading, sometimes phasing, and other times resounding; but unlike the natural echo it never fades away for some celebrities. Silence, it seems, is not an option. The echo, of the recording may be altered, sounds shaped and reshaped,

meanings metamorphosed. The recorded sounds that remain posthumously may even recombine with new sounds, creating juxtapositions of the dead and the living, as was the case with Natalie Cole's duet with her father Nat "King" Cole. And with those posthumous sounds our memories are reborn, rekindled, and reshaped. The meaning and character of the performer, performance and performed, changes—even if only ever so slightly—with each hearing of the echo, its meaning relived and re-implicated in our lived experience.

How and why does a celebrity's reputation continue to develop and change after his and her death? What does such development and change tell us about what music means and how music is mediated in contemporary culture? What can we learn about how media, music, and performance are meaningful to their audiences from tracing the ways in which fans grieve and memorialize, and reputations evolve?

These were the questions on our minds when we first began to think about posthumous reputation and celebrity. From the time that we organized a panel of scholars in 1997 to explore the topic at a conference through to the formation and writing of this book, we have grappled with matters of memory, loss, technology, commerce, the law, and fandom, among others. We and the other contributors to this book have also grappled with highly personal issues and memories of celebrities who are now with us only due to their recorded output. Like Kundera's walking echoes, we often hear them, and see them; we know that they are light and shadow, script and groove, bit and byte, but they can still provide meaningful comfort and knowledge.

Daniel Boorstin, in his examination of the role of image in the U.S., noted that celebrity itself is not sufficient to ensure longevity. "The celebrity," Boorstin wrote, "even in his lifetime becomes passé" (1961, p. 63). Boorstin is particularly interested in the media and with publicity as the driving forces behind the making, and unmaking, of celebrities. Leo Braudy (1997) in his analysis of fame also highlights the role of the media in what he calls "the frenzy of renown" and notes that fame and celebrity are attempts to gain a reputation that will live on past death.

But our concerns in this book have been less to do with how celebrity is made or why people seek it and more to do with how and why celebrities live on after death. Certainly, as contributors to this volume note, media and technology play important roles in the process. But so too do individuals, fans, and so too does memory.

In *Remembrance of Things Past*, Marcel Proust (1934) recounts a moment when upon tasting tea and a biscuit a memory is involuntarily evoked. Memories may be evoked by various means: taste, smell, touch, all of the senses known (and perhaps some unknown). Memories are built from the senses, too, and among the strongest of memories are ones created by hearing. Sound and music have long

served as mnemonic devices, and in this volume we wish to specifically concentrate on music and sound, on the nature of memory and celebrity, musician and fan, that we may better understand posthumous celebrity, mourning, and meaning in a mediated world.

In a tribute to June Carter Cash, David McGee (2003) wrote, "I cannot claim to have been a close friend of June Carter Cash, but like so many others, I felt I knew her. Her music and her effervescent spirit seemed ever present when I was growing up" (p. 96, 98). Acquaintance, it might be said, is one of the most taken for granted aspects of mediation and the media. How do we come to feel we "know" our favorite singers, for instance? While notions of authenticity and feeling have long been discussed in popular music studies and in the study of popular culture (Cohen, 1991; Frith, 1982 and 1996; Grossberg, 1993; Jensen, 1998; Jones, 1992; Redhead and Street, 1989), little attention has been paid to acquaintance, to the fans' feelings of connection and attachment to, and relationship with, musicians. While some have noted the role played by identification, the "expression of an emotional tie with another person" (Fraser and Brown, 2002, p. 187) in relation to celebrities, identification is more closely tied to social influence, to the ways in which celebrities may serve as role models. Still, identification with celebrities over time should be a greater area of research for media scholars. Basil (1996), relying on research into "parasocial relationships" from the 1950s, wrote that "Individuals who are exposed to media personalities over time, even though this exposure is entirely via the media, are believed to develop a sense of intimacy and identification with that celebrity" (p. 482), and others (Horton and Wohl, 1956; Rubin and McHugh, 1987) have noted the importance of such relationships. Indeed, each of the essays in this book points, in one way or another, to their importance.

Unlike many, perhaps most, other types of celebrities, musicians seem to fall into a particular category of acquaintance. Perhaps it is because they are assumed to be different from actors playing a role, from politicians out for personal gain, or from athletes who are "in it for the money." Perhaps it is because musicians are assumed (whether songwriters or not) to be expressing their true feelings to us. Our goal in this volume is to understand how musicians become, if you will, our friends for life even after their life ends, and not how they influence us as role models (though, admittedly, this can be a very fine distinction).

How do fans become acquainted with musicians? The simplest answer is that it is through music that fans come to know musicians. The nature of music, of songwriting itself, is such that interpersonal address predominates, and the nature of the media is such that it amplifies interpersonal content. A slightly more elaborate answer would note that there is a large complex of media, along with friends and family (and possibly other institutions like school and work) that can provide

knowledge of and about a musician and that can provide opportunities for fans to discuss and explore what music and musicians mean. No answer is likely to be entirely satisfactory insofar as the process in question is a very complicated one, involving individuals, communities, and interpretive practices of most any variety.

Our focus here, however, is not as much on the formation of acquaintance in these terms as it is on its maintenance after a musician's death and on the processes of posthumous celebrity. Music has long been an accompaniment to emotion, and vice versa. Scherer and Zentner (2001) note two reasons for music's connection to emotion and memory:

> First, music is quite a pervasive element of social life and accompanies many high significant events in an individual's life—religious ceremonies, marriage, burial rites, dancing, and other festivities, etc. Thus, there are many associations between musical elements and emotionally charged memories. Second, music, like odors, may be treated at lower levels of the brain that are particularly resistant to modifications by later input, contrary to cortically based episodic memory. (p. 369)

De Nora (2000) and others have found that music listeners employ "emotional self-regulation" to use music in their everyday lives. Among the most prominent functions that one study of emotional self-regulation with music found was its use as a "reminder of a valued past event" (by far the most popular use), "spiritual experience," "source of comfort/healing," and "moves to tears/catharsis/release" (Sloboda and O'Neill, 2001). Music is, as De Nora (2000) noted:

> . . . a medium that can be and often is simply paired or associated with aspects of past experience. It was part of the past and so becomes an emblem of a larger interactional, emotional complex . . . subject, memory and, with it, self-identity, [are] being constituted on a fundamentally socio-cultural plane where the dichotomy between "subjects" and "objects" is, for all practical purposes, null and void. (pp. 66–67)

The emotional bonds that exist between us, as audience, and musicians are enough to cause us to mourn. Fraser and Brown (2002) noted that "the image of a celebrity can be more tightly held and more powerful than the real person on which it is based" (p. 202). De Nora provides another means by which we can understand the role music plays in relation to these tightly held and powerful emotional bonds, and in mourning and the degree of mourning the death of a musician, for it is possible, perhaps probable, that one reason we mourn them is that we lost someone who provided (to use the cliché) some of the soundtrack of our life.

It is important also to consider the imagined communities to which music and musicians bind us, and the very real sense of communal mourning that ensues after a musician's death. Seale (1998) noted "that the dominant scripts offered to bereaved people in Western or anglophone societies are in fact culture bound" (p. 198). In a way we all hear the echoes. The contributors to this book repeatedly show

that there are, if not scripts, then at least culturally appropriate (and in some cases inappropriate) reactions to celebrity death and posthumous fame, just as there are industrially appropriate and inappropriate ones (for example, the "tribute album" that seems to "cash in" on a musician's death is an example of the latter, whereas a "tastefully assembled" boxed set of recordings might be an example of the former).

When it comes to the death of popular musicians, particularly ones involved in rock 'n' roll, we have become rather familiar with the archetypes. There is one overarching category, or theme (or cliché) that one might term "death by fame." Its variations are many, ranging from overindulgence in drugs to murder, from suicide to car, helicopter, and plane crashes. One might well term this category "death by lifestyle," or even "death by celebrity itself." On an interpretive level we may consider the stories that we tell about these to be a form of morality play. They serve as reminders that there is a price to be paid for stardom, and allow us to marvel at celebrity but also to be reassured that its glamour is not free.

But there is a relatively new category that is only recently beginning to take shape, largely due to the aging of those who survived the variety of possible causes of death in the first category. George Harrison, Warren Zevon, June Carter Cash, and Johnny Cash, among others, died of natural causes, causing at least a slight shift in media coverage. Instead of hastily written obituaries we were given lengthy and well-prepared retrospectives. Fans' mourning in these cases preceded the death of their idols. Nowhere was this more evident than in the video for Johnny Cash's "Hurt," directed by Mark Romanek.

The death of these "intimate strangers," whether of natural causes or related in some fashion to their celebrity status, help us learn about death and dying. As Heaphy noted, "there is a poverty of cultural responses to death and a lack of resources for facing it," and "the experience of dying has become individualized in Western worlds and is now a private problem" (2000, p. 164). The collective experience and expression of loss that typically follows the death of a famous musician may give us some means of making the experience of dying less private, while subsequent mourning, often mediated (as when we hear a song by the musician, or participate or read an online discussion group about them) is privatized. The media of mass communication are the sites at which we learn many of our cultural responses, so it should be no surprise that they are also sites at which we learn about and practice responses to death. In an era of electronic media, in which memories can be recorded and recovered with technology, mourning indeed becomes electric. It may also be rewound, replayed, edited, and manipulated.

"In mourning," James Siegel (1999) noted, "each memory is revived to be lived through vicariously, and through its vicariousness—or the realization of its vicariousness—to be sealed off from the present" (p. 276). Celebrities, seemingly everpresent but always and already sealed off from *our* present except by means of media,

are in some ways not easily mourned. Though their physical being is gone, it was never physically before us, and our interaction with them can be little changed, if at all. But as Siegel, in his analysis of events immediately after the death of François Mitterand, goes on to note:

> Electronic mourning, particularly that of strong public personalities, engages not merely personal memories but those soon to be designated as "historical." The pervasiveness of transmission, which seems to be unavoidable and to occur without being solicited, eradicates the boundary between personal and historical. We want to put it back in place . . . As we are invaded by electronic transmissions, we construct memories rather than recalling them. (p. 278)

Siegel's comments are more nuanced than those of commentators like Daniel Harris (1998) who believe that "the mass media have had a paralyzing effect not only on our emotional responses to catastrophes but on our intellectual responses, the way we analyze and explain the events we read about in the newspapers" (p. 156). If anything the mass media provide a space for communal mourning, and the Internet, contrary to Harris's observation as a site at which "eulogists revel in a pretense of false intimacy" (p. 161), provides individuals a more participatory space for communal mourning than had mass media. Fraser and Brown (2002), building on earlier work by Spigel (1991), perceptively wrote:

> Spigel suggested that "the Elvis impersonator presents audiences with opportunities to imagine themselves as part of a personal and collective history in which Elvis represents a set of shared beliefs and pleasures" (p. 182). Thus, fans and impersonators are able to reinvent their personal history and to involve themselves in a community of shared values. (Fraser and Brown, 2002, p. 201)

It is likely that the need for those spaces arises from the sense of prematurity surrounding most musicians' deaths (at least one may say this is true of jazz and rock musicians, few, still, of whom have died of old age, and few of whom have had opportunity to do so given the still relatively short life of the genres). As was the case with Princess Diana, there is considerable meaning-making to be done in such instances, for the departed are, as Richard Schickel (1985) put it, "kept alive in memory by the messy untimeliness of their departures" (p. 129). Kear and Steinberg (1999) in relation to Diana's death state that "the performance of mourning in the everyday life of Western culture . . . is a ritualized activity in which the orchestrated and ordered display of grief can be seen as an attempt to compensate for and contain the loss of the other" (p. 6). It should not be a surprise, therefore, that the media of communication provide the ground on which such activity can occur.

But *Afterlife as Afterimage* is about more than death and mourning, it is about life after death. The key question, the one this volume takes up, is asked by Schickel (1985): "Can the fictions that [celebrities'] public lives were support

new fictions after they are gone?" (p. 129). Indeed new fictions can be supported long after celebrities' lives end, as the contributors to this book show. Much as the air supports the sound of the echo, our imagination, individual and collective, the fictions that we tell ourselves and one another, support memory and meaning.

References

Basil, M. D. (1996). Identification as a mediator of celebrity effects. *Journal of Broadcasting and Electronic Media*, 40, 478–495.

Boorstin, D. (1961). *The image: A guide to pseudo-events in America*. New York: Atheneum.

Braudy, L. (1997). *The frenzy of renown: Fame and its history*. New York: Vintage Books.

Bulfinch, T. (1998). *Bulfinch's mythology*. New York: Modern Library.

Cohen, S. (1991). *Rock culture in Liverpool*. Oxford: Clarendon Press.

De Nora, T. (2000). *Music in everyday life*. Cambridge: Cambridge University Press.

Fraser, B. P., and Brown, W. J. (2002). Media, celebrities and social influence: Identification with Elvis Presley. *Mass Communication and Society*, 5(2), pp. 183–206.

Frith, S. (1982). *Sound effects*. New York: Pantheon.

———. (1996). *Performing rites: On the value of popular music*. Oxford: Oxford University Press.

Grossberg, L. (1993). The media economy of rock culture: Cinema, post-modernity and authenticity. In S. Frith, A. Goodwin, and L. Grossberg (Eds.), *Sound and vision: The music video reader* (pp. 185–209). London and New York: Routledge.

Harris, D. (1998). The electronic funeral: Mourning Versace. *Antioch Review*, 56(2), 154–163.

Heaphy, B. (2000). Living with death. In J. Rutherford (Ed.), *The art of life* (pp. 164–175). London: Lawrence and Wishart.

Horton, D., and Wohl, R. R. (1956). Mass communication and parasocial interaction: Observations on intimacy at a distance. *Psychiatry*, 19, 215–229.

Jensen, J. (1998). *The Nashville sound*. Nashville, TN: Vanderbilt University Press.

Jones, S. (1992). *Rock formation*. Newbury Park, CA: Sage Publications, Inc.

Kear, A., and Steinberg, D. L. (1999). Ghost writing. In A. Kear and D. L. Steinberg (Eds.), *Mourning Diana: Nation, culture and the performance of grief* (pp. 1–14). London: Routledge.

Kundera, M. (1999). *Immortality*. New York: HarperPerennial.

McGee, D. (2003, June). All the way home. *Pro Sound News*, 25(6), pp. 98, 96.

Proust, M. (1934). *Remembrance of things past* (C.K.S. Moncrieff, Trans.). New York: Random House.

Redhead, S. and Street, J. (1989). Have I the right? Legitimacy, authenticity and community in folk's politics. *Popular Music*, 8(2), 177–84.

Rubin, A. M., and McHugh, M. P. (1987). Development of parasocial interaction relationships. *Journal of Broadcasting and Electronic Media*, 31, 279–292.

Scherer, K. R., and Zentner, M. R. (2001). Emotional effects of music: Production rules. In P. N. Juslin and J. A. Sloboda (Eds.), *Music and emotion* (pp. 361–392). Oxford: Oxford University Press.

Schickel, R. (1985). *Intimate strangers: The culture of celebrity*. Garden City, NY: Doubleday.

Seale, C. (1998). *Constructing death: The sociology of dying and bereavement*. Cambridge: Cambridge University Press.

Siegel, J. (1999). Electronic mourning: The death of Francois Mitterand. *Salmagundi*, 118–119, pp. 273–278.

Sloboda, J. A., and O'Neill, S. A. (2001). Emotions in everyday listening to music. In P. N. Juslin and J. A. Sloboda (Eds.), *Music and emotion* (pp. 415–429). Oxford: Oxford University Press.

Spigel, L. (1991). Communicating with the dead: Elvis as medium. *Camera Obscura*, 23, 176–205.

Contributors

MARKO AHO currently works as a research director at the Department of Ethnomusicology at the University of Tampere, Finland, where he also received his Ph.D. in 2003. His thesis treated the quasi-religious aspects of fan activity taking place within a context of deceased Finnish pop idols. His research interests include the history of popular music and phenomenological study of music.

JULIE L. ANDSAGER is an associate professor in the School of Journalism and Mass Communication at The University of Iowa. Her research centers on gender and the media, particularly regarding health issues and public opinion. Her Ph.D. is from the University of Tennessee.

MARY C. BELTRAN is an assistant professor of communication arts and Chicana/o studies at the University of Wisconsin-Madison. She is currently working on a book-length project on the marketing of Latina stars since the silent film era and the construction and implications of Latino/a "crossover" stardom today.

PEGGY J. BOWERS is an assistant professor of media studies at Clemson University. A specialist in media ethics and culture, Dr. Bowers has published in national communication journals and book anthologies. She is also an expert on the Carpenters and an aficionado of Karen's music.

VAN M. CAGLE is director of research and analysis at the GLAAD Center for the Study of Media & Society. He has published widely in the areas of media studies, cultural studies, and popular culture. Cagle is the author of *Reconstructing Pop/Subculture: Art, Rock, and Andy Warhol.*

GREG DIMITRIADIS is assistant professor in the Department of Educational Leadership and Policy at the University at Buffalo, The State University of New York. Dimitriadis is the author of *Performing Identity/Performing Culture: Hip Hop as Text, Pedagogy, and Lived Practice* also published by Peter Lang; and *Friendship, Cliques, and Gangs: Young Black Men Coming of Age in Urban America* (Teachers College Press, Columbia University). He is first coauthor, with Cameron

McCarthy, of *Reading and Teaching the Postcolonial: From Baldwin to Basquiat and Beyond* (Teachers College Press, Columbia University).

ERIKA DOSS is professor of art history at the University of Colorado and the author of *Benton, Pollock, and the Politics of Modernism: From Regionalism to Abstract Expressionism* (1991), *Spirit Poles and Flying Pigs: Public Art and Cultural Democracy in American Communities* (1995), *Elvis Culture: Fans, Faith, and Image* (1999), *Looking at Life Magazine* (editor, 2001), and *Twentieth-Century American Art* (2002).

STEPHANIE HOUSTON GREY is an assistant professor at Michigan State University in the Science, Medicine and Technology Studies Program within the Lyman Briggs School. Her work has appeared in *The Quarterly Journal of Speech*, *Critical Studies in Media Communication*, and *Text and Performance Quarterly*. She is currently working on a book on eating disorders.

JOLI JENSEN is professor of communication at the University of Tulsa. Her research interests are in American cultural and social thought. She is author of *Redeeming Modernity: Contradictions in Media Criticism* (Sage 1990), *Creating the Nashville Sound: Authenticity, Commercialization and Country Music* (Vanderbilt 1998), and *Is Art Good for Us? Beliefs about High Culture in American Life* (Rowman & Littlefield 2002). She has also written a number of essays on media criticism, communication technologies, communication theories, the social history of the typewriter, and fans and fandom.

STEVE JONES is professor of communication at the University of Illinois-Chicago. He is author and editor of numerous books, including *CyberSociety*, *The Encyclopedia of New Media*, *Society Online*, *Rock Formation: Technology, Music and Mass Communication*, and *Pop Music and the Press*. He is past president and cofounder of the Association of Internet Researchers, Senior Research Fellow at the Pew Internet and American Life Project, and co-editor of *New Media & Society*.

GEORGE KAMBERELIS is an associate professor in the School of Education at the University at Albany-SUNY. He teaches, conducts research, and publishes in the areas of critical social theory, discourse and identity, genre studies, popular culture/media studies, and the practice of qualitative inquiry.

JANNE MÄKELÄ is research fellow at the Department of Cultural History, University of Turku, Finland. He has published numerous articles on popular music and culture in professional journals.

JOHN J. PAULY is professor of communication at Saint Louis University. His research focuses on the history and sociology of the mass media. He has written extensively about cultural approaches to media research, journalism as a narrative and social practice, and social conflicts over media form and content.

ERIC ROTHENBUHLER (Ph.D. Annenberg School of Communication, USC) is director of graduate media studies at New School University; he was previously professor of communication studies and affiliate faculty member in American studies at the University of Iowa. He is author of *Ritual Communication: From Everyday Conversation to Mediated Ceremony* and many articles on media,

culture, and communication theory. He is coeditor of *Communication and Community* (2001) and of *Media Anthropology* (forthcoming).

JONATHAN STERNE teaches in the Department of Art History and Communication Studies at McGill University. He is author of *The Audible Past: Cultural Origins of Sound Reproduction* (Duke, 2003) and numerous essays on media, technology, and the politics of culture. He also helps edit *Bad Subjects: Political Education for Everyday Life*, the longest-running publication on the internet.

Index

MUSIC
[MEANINGS]

GENERAL EDITORS: STEVE JONES, JOLI JENSEN,
ANAHID KASSABIAN & WILL STRAW

Popular music plays a prominent role in the cultural transformations that are constantly reshaping our world. More and more, music is at the center of contemporary debates about globalization, electronic commerce, space and locality, style and identity, subculture and community, and other key issues within cultural and media studies.

Music[Meanings] offers book-length studies examining the impact of popular music on individuals, cultures and societies. The series addresses popular music as a form of communication and culture from an interdisciplinary perspective, and targets readers from across the humanities and social sciences.

Recent titles include:

Holly Kruse
Site and Sound: Understanding Independent Music Scenes

Janne Mäkelä
John Lennon Imagined: Cultural History of a Rock Star

To order other books in this series, please contact our Customer Service Department:
(800) 770-LANG (within the U.S.)
(212) 647-7706 (outside the U.S.)
(212) 647-7707 FAX

Or browse by series: WWW.PETERLANGUSA.COM